Sounding New Media

Sounding New Media

*Immersion and Embodiment
in the Arts and Culture*

Frances Dyson

UNIVERSITY OF CALIFORNIA PRESS
Berkeley · Los Angeles · London

University of California Press, one of the most
distinguished university presses in the United States,
enriches lives around the world by advancing
scholarship in the humanities, social sciences, and
natural sciences. Its activities are supported by the
UC Press Foundation and by philanthropic
contributions from individuals and institutions.
For more information, visit www.ucpress.edu.

University of California Press
Berkeley and Los Angeles, California

University of California Press, Ltd.
London, England

Library of Congress Cataloging-in-Publication Data

Dyson, Frances.
 Sounding new media : immersion and embodiment
in the arts and culture / Frances Dyson.
 p. cm.
 Includes bibliographical references and index.
 ISBN 978-0-520-25898-3 (cloth : alk. paper)
 ISBN 978-0-520-25899-0 (pbk. : alk. paper)
 1. Virtual reality—Philosophy. 2. Sounds. I. Title.
BD331.D97 2009
302.23—dc22 2008050750

Manufactured in the United States of America

18 17 16 15 14 13 12 11 10 09
10 9 8 7 6 5 4 3 2 1

This book is printed on Natures Book, which contains
30% post-consumer waste and meets the minimum
requirements of ANSI/NISO Z39.48–1992 (R 1997)
(Permanence of Paper).

To my mother, for her endless support, and in memory of my father

Contents

List of Illustrations ix

Acknowledgments xi

Introduction 1

1. Ethereal Transmissions: The "Tele" of *Phōnē* 18

2. Celestial Telegraphies 33

3. Aural Objects, Recording Devices, and the
 Proximate Apparatus 54

4. Death, Silence, and the Tape Recorder 83

5. Immersion 107

6. Embodying Technology: From Sound 136
 Effect to Body Effect

7. Atmospheres 158

 Conclusion: Music and Noise 182

 Notes 191

 References 233

 Index 241

Illustrations

1. Char Davies, *Among the Myriads (@ Reverie), no. 25p* *133*
2. Char Davies, *Among the Myriads (@ Reverie), no. 26p* *134*
3. Catherine Richards, *Spectral Bodies* *164*
4. Catherine Richards, *Charged Hearts* *169*
5. Catherine Richards, *I was scared to death/I could have died of joy*, detail of glass brain *171*
6. Catherine Richards, *I was scared to death/I could have died of joy*, detail of spinal cord *172*
7. Catherine Richards, *Shroud/Chrysalis I* *178*
8. Catherine Richards, *Shroud/Chrysalis II* *179*

Acknowledgments

Many individuals have contributed, in one way or another, to the writing of this book. First and foremost, my heartfelt thanks go to Char Davies and Catherine Richards, for the tenor of their work, and for generously sharing their thoughts and ideas with me over many years. For support, discussion, and helpful comments over the duration, I am sincerely indebted to Douglas Kahn. For her encouragement and interest in this project, and valued friendship, I am grateful to Margaret Morse. Many thanks also go to Sean Cubitt for reading and commenting on the manuscript, to Erkki Huhtamo for his encouragement, and to all for their intellectual engagement over the years. Much of the thinking that went into this book was originally inspired by the work of Don Ihde, whose book *Listening and Voice: A Phenomenology of Sound* (1976) has had an enormous influence on the development of sound studies. In this respect I would also like to acknowledge colleagues and friends in the faculty of Humanities and Social Sciences, University of Technology, Sydney, Australia; and the Audio Arts Unit at the Australian Broadcasting Corporation, who had the courage and curiosity to venture into the little-known field of "sound studies" and audio arts almost two decades ago. Similarly, Paul de Marinas, Nigel Helyer, Ed Osborne, and all those involved in Sound Cultures have been longtime companions in this field, and I have benefited greatly from their insights. My thanks also to Joyce Hinterding, David Haines, Jane Goodall, Anna Munster, Simon Penny, and Leslie Stern for friendship, support, and inspiration. The Banff

Centre of the Arts, the Daniel Langlois Foundation, the Davis Humanities Institute, and my colleagues at the University of California, Davis, have provided material support and opportunities for intellectual engagement, for which I will always be grateful. Special thanks here to Caren Kaplan and Eric Smoodin for their advice and all-round intellectual support; to Jennifer Gonzales at the University of California Press, for reading the manuscript and in particular for her very helpful comments on the introduction; and to Michael Ulrich, for research assistance and manuscript preparation. Special thanks here must go to my editor at the University of California Press, Mary Francis, for her enthusiasm and persistence with this project, and for steering me through the process.

Finally, with a deep sigh of relief, eternal gratitude and salutations to my daughter, Aleisha, and son, Sy, for their tolerance, patience, and good humor throughout.

Introduction

Immersion, interactivity, cyberspace, telepresence, virtuality, artificial life, posthuman—the reader will encounter these terms again and again in descriptions of new or digital media. Although sometimes used independently, they more often than not represent mechanisms or processes that collectively define both the experience of new media and its uniqueness— its absolute difference from "old" media such as television and radio. While "new media" refers to a set of technologies (e.g., virtual reality [VR], the Internet, ubiquitous media, etc.), the array of concepts that describe these technologies promise much more than the merely technological. The term "virtual," for instance, denotes the immateriality of digital media, while also referring to an ontological state or condition. As such, "the virtual" contains within it the idea of a liminal domain wherein existence can take place and where users can "be." This domain is often described as transcendent, sublime, and mystical, uncorrupted by the social and political realities that dominate traditional media. The experience of this immaterial, simulated "space" operates through "immersion"—a process or condition whereby the viewer becomes totally enveloped within and transformed by the "virtual environment." Space acts as a pivotal element in this rhetorical architecture, since it provides a bridge between real and mythic spaces, such as the space of the screen, the space of the imagination, cosmic space, and literal, three-dimensional physical space. Space implies the possibility of immersion, habitation, and phenomenal plenitude. Without space there can be no

concept of presence within an environment; furthermore, there can be no possibility for a full-bodied—embodied—experience that interactivity (another key term) promises.[1] Interactivity—the user's navigation of and engagement with digital content—is said to give the users agency, freeing them from the passive experience of simply watching. With the user "in control," so to speak, new media seems to escape many of the critiques of representation that have been leveled at broadcast media, especially television. At the same time, the user's involvement is theorized as activating new modes of perception and embodiment, and these coalesce in the figure of the posthuman.

The impact and slipperiness of these terms, their ability to articulate what are often fictional scenarios that nonetheless appear as fact, have much to do with their provocative construction. Uniting virtual with reality, cyber with space, artificial with life, and tele with presence opens both terms to reinterpretation—disturbing the once-solid meaning of the latter term while grounding the former in accepted phenomenal and existential concepts. Three key rhetorical maneuvers accompany these constructions: first, the shift from "looking at" to "being in" that VR inaugurated; second, the conflation of "being-in" a virtual environment with "being" in general; and third, the equivalence between "digital" and organic being and the reliance upon a technologically inspired form of evolution that has come to define posthumanism. The first is reflected by the artful dropping of analogical markers: the "it's as if you are there" of screen-based media is truncated to a "you are there": one is in cyberspace, not watching it; one is a navigator, not a viewer. By "being in," rather than "looking at," virtual environments, the viewer is said to occupy the space and time, the here and now, the virtual present of a separate but ontologically real space. As new media artists Monika Fleischmann and Wolfgang Strauss commented in the early 1990s, because "the viewer stands in—no longer merely in front of the picture," one can say "I am in the picture—therefore I am."[2] The second maneuver involves a redefinition of being so that it applies equally to the physical world and digital domain: being-in a digital space is reduced to being in general. With space and being reconfigured, the viewer's physical engagement with digital media—through, for instance, the data glove, or even the point and click of Internet-based works—is said to trigger a new form of virtual embodiment and thereby deliver a new kind of subjectivity. Here, the third rhetorical maneuver comes into play, as digital space and digital being become rhetorically bonded with the concept of the posthuman.

The desire for total immersion, as well as the use of audio to simulate this condition, is certainly evident in old media such as cinema. We need only think of the almost palpable envelopment of film sound, and the way that lip sync unites three-dimensional sound with the two-dimensional image, producing an illusion of embodiment that owes its persuasiveness to the near impossibility of imagining voice and body as separate when the viewer feels his or her own voice to be embodied. Similarly, whether through physical movements in VR or by pointing and clicking a mouse, the user's actual embodiment becomes another component in the simulation of "immersion-in-a-space," with the body providing the here-and-now being, while the simulated environment stands in as the "there." Despite these prefigurations, the rhetoric of new media eschews the theories of simulation, representation, and spectatorship that attend cinema and television, and claims to produce an immersive experience that is ontologically grounded. In this it harbors a self-negation, expressed in the much stronger claim that new media isn't media at all. Indeed, it could be said that new media art—representing the pinnacle of digital media—seems not to aspire to the conditions of media, but rather, paraphrasing Schopenhauer, to the conditions of sound. As I will argue, new media represents an accumulation of the auditive technologies of the past: a realization of the telepresence first offered by the telephone, a computational form of the inscriptive techniques of the phonograph and tape recorder, an appropriation of the ethereal associations of radio, and an embrace of film sound's spatiality. The features that differentiate new media—the ability to "enter the screen," to interact with three-dimensional images or "virtual objects," to acquire a new subjectivity, a liquid identity, to enjoy authentic rather than mediated experience, and to transcend the material—all these features are present in the phenomenality of sound, in the metaphysics of the ephemeral, and in the rhetorics of Western art music. From the first awkward attempts at transmitting "hello" on the telephone, reproduced and transmitted sound (that is, audio) has provided a conceptual model and a set of technologies that together have laid the groundwork for notions of immersion and embodiment: the primary figures that characterize new media. Along with its representations in popular culture, audio has naturalized what could be called the disembodying effects of new media technologies, and thus paved the way for further mediations of the embodied subject.

It is no coincidence, then, that the diverse technologies we associate with new media reconstitute experiences characteristic of the aural, for

sound is the immersive medium par excellence. Three-dimensional, interactive, and synesthetic, perceived in the here and now of an embodied space, sound returns to the listener the very same qualities that media mediates: that feeling of being here now, of experiencing oneself as engulfed, enveloped, absorbed, enmeshed, in short, immersed in an environment.[3] Sound surrounds. Its phenomenal characteristics—the fact that it is invisible, intangible, ephemeral, and vibrational—coordinate with the physiology of the ears, to create a perceptual experience profoundly different from the dominant sense of sight. Whereas eyes have a visual range of 180 degrees, projecting from the front of the subject, ears cover a 360-degree expanse, hearing all around. Whereas eyes can be closed, shutting out unwanted sights, ears have no lids. Whereas seeing positions the subject symbolically as director of its look, always looking ahead toward the future, hearing subverts this role: the listener cannot control what is often overheard, what is muttered "behind my back." Immersed in sound, the subject loses its self, and, in many ways, loses its sense. Because hearing is not a discrete sense, to hear is also to be touched, both physically and emotionally. We feel low sound vibrate in our stomachs and start to panic, sharp sudden sound makes us flinch involuntarily, a high pitched scream is emotionally wrenching: sound has immediate and obvious physical effects. In listening, one is engaged in a synergy with the world and the senses, a hearing/touch that is the essence of what we mean by gut reaction—a response that is simultaneously physiological and psychological, body and mind.[4] These very characteristics rattle the foundations of Western metaphysics and Western culture generally, by questioning the status of the object and of the subject, simultaneously. Because of this, the aural has been muted, idealized, ignored, and silenced by the very words used to describe it. "Sound"— the term itself—is already abstracted: there is sound, inasmuch as there is atmosphere; like a dense fog, it disappears when approached, falling beyond discourse as it settles within the skin. As sound rides the cultural divisions between language and babble, music and noise, voice and the body's abject effusions, it resists theorization, while also invoking techno-gnostic (to borrow from Coyne) notions of transcendence that obscure audio media's technological and cultural origins.[5]

 It comes as no surprise that similar mystifications also permeate new media, for aurality and virtuality have much in common. Just as there are few borders or markers to establish aural identity, in the realm of the virtual, objects and subjects are supposedly mutable, evanescent, fluid, and totally recombinant. As Don Ihde and Christian

Metz pointed out decades ago, "a" sound is always multiple, always heterogeneous; being neither visible nor tangible, sound is never quite an object, never a full guarantor of knowledge. Ontologically vague and semantically imprecise, sound begs the question of its own representation: just exactly what is a "thud" or a "cluck"? one might ask. Since audio shares with new (or digital) media a metaphysics of the virtual, the "almost," one would expect to find common metaphors populating their respective theorizations; thus the phenomenal characteristics of sound and listening—describing a flow or process rather than a thing, a mode of being in a constant state of flux, and a polymorphous subjectivity—also appear as underlying tropes in new media phenomenology. Yet the hefty conceptual quagmires encountered in theorizing the aural seem to bypass the discourse of the equally unstable, enigmatic conditions of (technocultural) virtuality.

As *Sounding New Media* elaborates, the process of mapping the conditions of sound onto technologies of the virtual, supports a series of rhetorical maneuvers that erase what are often ideological assumptions. From the assumed authenticity of unmediated (virtual) experience, to the pseudoscientific claims regarding human/machine coevolution, the aural motif recurs in the reconciling figures of flux and vibration, the plenitude and absolution of silence, and the alterity of noise. Because of the intractable mythologies surrounding the aural and the virtual, we find the phenomenality of sound and hearing, and its sublime, transcendent, cosmic, and mythical associations being transferred to new media—minus the analysis and critique they once carried. Thus, the thinking of technology, like the thinking of sound, becomes shrouded and deferred onto that which aurality represents: primordiality via vibration; omnipresence via atmosphere; alterity via immateriality; transparency and truth via presence; and transcendence via immersion.

I have come to realize that, although sound as a material acoustic medium provides an opening to an alternate metaphysics, it does not in itself constitute that metaphysics, and it would be a mistake to conflate sound, or even the larger sphere of aurality, with the alterity it points to. Similarly, while the "virtual metaphysics" that Michael Heim, an early cybertheorist, associated with digital media provokes a reflection on the nature of the thing, the object, and the possibility for thinking of both object and space outside of a materialist frame, it would be a mistake to assume that one implies the other. To avoid both a form of sonic essentialism and technological determinism, I have focused on the terms, metaphors, and rhetorical maneuvers that outline the discursive fields of

sound and new media. This meta-discursive approach is necessary on two counts. First, as mentioned, there is the slipperiness of the concepts—the ephemeral, immaterial, and synesthetic *qualities* of sound are central to the concept of virtuality, yet these qualities operate within a metaphysics that grounds being and knowledge in the visible, material, and enduring object. As sound studies and new media theory grapple with this conceptual limitation, it is important to attend to the metaphors that are put in place, as they will not only drive the discourse but also, as N. Katherine Hayles points out with regard to military infrastructure, influence technological development.[6] Second, and in a related sense, the discourse that has developed around new media rests, I argue, on prior formulations that attend audio and that were themselves influenced by a desire to elide the technological apparatus on the one hand, and a romantic, essentializing view of sound on the other. The force of these desires has been compounded in new media theory, for although "aurality" (referring to the phenomenal and discursive field of sound) is generally distinguished from "audiophony" (referring to the mediation of sound through audio technology), "virtuality" often refers to *both* the set of technologies that constitute digital media and the ontological state or condition of virtuality. Unlike audiophony, virtuality is often conflated with its pretechnological, philosophical origins, and this confusion produces theories of new media that absorb technology, media, and questions of representation within a poetic and speculative, more than strictly philosophical, landscape. Just as sound theorists have substituted aurality for what is in fact audio, new media theorists have substituted virtuality for what is in fact media. Concurrently, as new media has developed, it has approached aural territories, including not just the frontiers opened by audio technology but the close associations sound has with embodiment (via synesthesia), with the sublime (via music), and with alterity (via metaphysics). In this reterritorialization of aurality's mythos, sound is simultaneously neglected and appropriated by the complicated rhetorics of immersion and embodiment that have inaugurated new media discourse and have announced new media as "new."

The contradictory nature of this process of neglect and appropriation rests, I argue, on a desire to demarcate a unique territory for new media. By using terms such as "immersion," it is possible to conceal all the necessary social and technological interventions and delimitations that go into producing digital media, by foregrounding the all-embracing, all-enveloping condition the term suggests. The use of "immersion" in the

title thus signifies both immersive technologies and the desire to elide the distance that technological mediation imposes—between the user and the apparatus, the real and the simulated, the natural and the artificial, the human and the technological. In undertaking this interdisciplinary excavation, *Sounding New Media* aims first and foremost to expose the cultural and philosophical mechanisms—those built from audio technology, artistic practice, and, most important, the philosophy (or rather nonphilosophy) of aurality that circulate like rumors, like noise, in the tropes of immersion and embodiment. My point is not to represent sound and aurality as the precondition for virtuality or cyberspace, but to show the way that sound, technology, and culture have combined to create a rhetorical structure through which prior notions of embodiment, materiality, humanity, art, and science are reassembled for deployment in the information age. Fundamental to the development of communications technology, these notions are revised, remodeled, cut, and pasted to fit the new techno-epistemological regime, and, as I argue throughout the book, they are never far from the influence of sound—either as a medium, or a model, or a metaphoric ground.

That this remodeling is at all possible relies fundamentally on the absence of either a sonic epistemology or an aural ontology in our visually oriented technoculture. Without a knowledge system that can accommodate a phenomenology of sound, that can represent the listening experience, that gives weight to the ephemeral aural "object," and that recognizes an environment in its acoustic fullness, we see the concepts of immersion, telepresence, and virtuality return endlessly to a rhetorical fault line in order to retrieve yet another set of metaphors, another conceptual framework. But in its denial of the original phōnē that made sense of the first telepresent technology, this framework fails to speak to the real conditions of embodiment. Rather, it fronts this desired condition with a dehistoricized, depoliticized "tele"—as if to explain, but in fact to conceal, the operations of technology in the aesthetics of new media.

Although primarily concerned with new media, I begin this book with a return to old—indeed the very old—prototechnology of metaphysics, in order to outline the processes that sound, and in particular the voice, underwent, long before its audiophonic reproduction or transmission. Moving from the interior to the exterior, carrying traces of the body into evanescent speech, the voice is, and has always been, haunted by its multiple identifications. As I discuss in chapter 1, while generally associated with the production of language (the cornerstone

of intellectual life), the sound of the voice also adheres to a truth sup-
posedly understood beyond language, revealing the physical and emo-
tional state of the speaker as being, for instance, in a state of anger,
nervousness, mirth, congestion, or psychosis. Meaning and rationality
are never fully grounded in the voice. Notice that whenever the materi-
ality of sound becomes the focus of attention sense begins to unravel.
String a series of onomatopoeic words together (crash, thud, tinkle,
burble, thump, etc.), and one rapidly approaches either sound poetry
or—coincidentally—babble—a state close to infancy or insanity. Listen
to hearsay—the gossip and talk circulating on the ground, so to speak,
and one is listening to "rumor" (Fr.: "noise"). Depart from the concord
of well-structured sound (music) and one risks cacophony, with its ety-
mological links to harsh, discordant, dissonant, and meaningless sound,
as well as demons, poison, irresistible urges, and mania. Because of its
volatility, the voice has had to undergo a prior refinement—the trans-
formation of sound into speech—utterance into language. In this
process, a metaphysical filter has been engineered, allowing sound—as
an abstraction—to occupy both natural and cultural realms simultane-
ously, and turning the voice into an instrument—separate from the body
and the world in which it speaks. As Mladen Dolar describes: "[The
voice] makes the utterance possible, but it disappears in it, it goes up in
smoke in the meaning being produced."[7] To this vanishing act, or
becoming invisible, must be added a second: sound itself, which disap-
pears in the necessary distinction between voice and sound, the dis-
tinction that the listener must make in order to hear "a voice." The
mediation of technology adds a third. Throughout such transports, the
voice straddles the body, sound straddles the object, and technology
straddles the human: producing, concealing, and reserving an astound-
ingly generative metaphysical dynamic. Issues that pertain to embodi-
ment, technology, and new media absorb and incorporate this
metaphysical dynamic, this disappearing act that the voice enables and
sound, with its aberrant metaphysical status, encourages. These systems
for filtering, producing, adapting, and adjusting sound and the voice
have operated throughout modern metaphysics, and it is through their
operations that later technological transformations—such as the trans-
mission of the voice in telephony—would be possible, and contempo-
rary notions of (virtual) immersion could either make sense, or gain
cultural acceptance.

As the first attribute to become disembodied through electronic
transmission, the voice has anchored all other transmissions. From

telephony, to television, to digital-simulated environments, the familiarity of the voice blunts the sharp edges of telepresent culture, dampening the potential volatility of troubling questions concerning the self, existence, the real, and the social. Sound disappears into the voice in the same way that the voice encloses and hides the technological means of transmission and reproduction. For even though the transformative potential of sound technology has always been one step ahead of visual media, the nature of audiophonic objects has never been subject to the same kind of discrimination that visual images commonly undergo. The importance of the voice in this respect cannot be underestimated. Why was it, for instance, that even though telephony radically disassociated the voice from the body and the speaker from their geographical presence, somehow, culturally, a person's denuded telephonic voice came to speak for their whole being? Likewise, how was it that while the audio recording automatically announced the voice or sound heard as being both absent and past, it was still heard as if it were present, occupying the same time and space of the listener?

In this respect, the peculiar status of the voice is matched by that of the audio recording, which has been invested with a presence and an immediacy that belic its technological construction. As I discuss in chapter 2, for early writers on sound, the proximity of the microphone to the speaker gave the audiophonic recording a unique ontological status, and early film theorists, impressed with the three-dimensionality of reproduced sound, assumed that if the sound waves of the original and reproduced sound were identical in structure, then surely the reproduced sound must be *the same* sound to have been first emitted, regardless of the mechanical or electrical device used.[8] This scientific/metaphysical claim supported earlier fantasies—articulated by enthusiasts of phonography—that if it is the same sound then the listener must be transported back to the time and place of the recording, in an aural version of time travel. Audio's fantastic properties were particularly celebrated by radio enthusiasts. Initially operated by amateurs who connected to the ether, as they called it, with their magical crystal sets, radio gradually became a medium of intimacy and interiority, while technology itself appropriated any residual sense of the ethereal, cosmic, or otherworldly once associated with radio. An essential component in this transference was the proximity of the apparatus (the technological interface) to the listener, a factor that would be repeated in the reception of VR as a reality. Interrogating the arrival and end points of these arguments highlights, first, the metaphysical constructs that sound is caught within;

second, the contribution audio has made to media realism and natural-
ism (with their attendant ideologies); and finally, the way that sound—
by virtue of its curious ontology—performs, conceals, and negotiates
different technocultural narratives at different historical junctures, and
does this often all at once.

Through the audio recording, sound's temporality was extended
beyond the here and now of the initial sonic event: like the visual object,
it could be collected and stored, transported, transmitted, and infinitely
repeated. As such, it could be both theorized and composed like music,
and this realization was not lost on composers like John Cage, Pierre
Schaeffer, and Pierre Henry, whose experiments with magnetic tape and
amplification produced new forms of music (e.g., *musique concrète*),
new concepts (e.g., the "sound object"), and a set of assumptions that
could be applied to later immersive media. In chapter 3 I outline some
of the intricacies and implications of such theorizations in the context
of early sound theory and the influence of technology. Pierre Schaeffer,
for instance, taking an essentially phenomenological approach, argued
for "acousmatics"—a reduced listening that would bracket sounds from
their musical and cultural origin and focus listening on sounds "in them-
selves" without recourse to their visual or material source. As Schaeffer
argued, the inscrutability of sound—its representational lack and onto-
logical ambiguity—can be compensated by technology (specifically the
tape recorder) to the extent that a rudimentary language of sound (or at
least a definition of a sonic object) is possible. Categorizing sound is
also a process of objectifying the ephemeral and immaterial, of giving
conceptual substance to phenomena that are quasi, liminal, and virtual.
The object-centeredness of this approach is in itself telling and would
contribute to critiques of representation and ocularcentrism that sound
theory has been developing.

Although influenced by Schaeffer's acousmatics, film/sound-theorist
Michel Chion recognized that "reduced listening requires the fixing of
sounds, which thereby acquire the status of veritable objects."[9] Chion's
solution was to think of sound as an event rather than an object, and
in doing so to incorporate a sense of organic process, of movement,
change, and complexity, while maintaining a sense of identity and indi-
viduality. This shift is important, since it introduces a different, perhaps
paradoxical, notion of materiality: the materiality of process, of a multi-
ple, mutating form found in a figure closely tied to sound—the figure of
vibration. Vibration, figuratively and literally, fluctuates between particle
and wave, object and event, being and becoming. Defying representation,

it also gestures toward the immersive, undifferentiated, multiplicitous associations that aurality provokes, without committing to the (massive) representational and ontological ambiguities that aurality raises. Used to reconcile the sound object/event dichotomy in sound studies, vibration appears again in new media theory—often in the guise of flux, or noise—as a unifying force, one that dissolves the distinction between the body and technology, nature, and culture and resolves the problem of representation and mediation.

Perhaps because of its pseudoscientific yet undecidable status, vibration is, in fact, one of the many aural metaphors frequently associated with alterity, within both metaphysics and media theory. Another is "silence," and in chapter 4 I discuss both in relation to philosophers (Martin Heidegger and Jacques Derrida), artist (John Cage), and early sound theorist (Murray Schafer). For Heidegger, vibration, as attunement (*Stimmung*), provides a metaphysical interval, a space where certain rhetorical maneuvers can take place, and a portal through which individuals can access the spiritual center of their "ownmost" being. Heidegger's relevance to the present discussion lies not just in his critique of modern technology but, as I suggest, in the route he takes to establish both this critique and his underlying objection to representational thinking. In many ways, like Cage, Heidegger would seem to be offering a phenomenology that leads us toward sound and listening and away from vision, as a means to retrieve philosophy from its representationalist bent. Instead, Heidegger's philosophy is grounded in the metaphor of silence—not the inner silence of the Cartesian subject, but the silence of *Dasein* (being-in-the-world, literally being-there) in its authentic understanding of Being.[10] Heidegger's aural deliberations provide a template for various substitutions between actual sound and its associations with ephemerality and alterity. The strategies he developed to delimit, order, and ultimately evacuate materiality from sound allowed him to situate the aural within an asocial and transcendental plane. At stake in these negotiations, conducted in different arenas, is the social lying beyond (technological) control; the social that in a sense is carried by the voice: the body from which it emanates, the atmosphere within which it sounds, the meaning it imparts (both through and in spite of language), the ephemeral and immaterial nature of its sonority, and its auto-affective properties.

Like Heidegger's sonic appropriations, Cage's use of sound and silence moved, aesthetically and philosophically, to a redefinition of the self that was grounded in authenticity. However, Cage accomplished

this not by reference to sound, but through recourse to notions of silence and the void, representing sound in precisely the same way that Western epistemology does—as absence itself. Silence, as we learn from Cage, is a wonderful compositional device: moving across metaphysics and music, its abstract, yet paradoxical, permutations create a space that can remain transcendental and absolute while still be very much "in the world." Like silence, transcendental spaces can be filled with almost anything—especially when they are represented as vacant and are connected to a "sounding" technology—as Derrida's choice of the tape recorder, to make audible not just small sounds (like Cage) but difference itself, shows only too well. One quality shared by Pierre Schaeffer's "acousmatics," Cage's all-embracing silence, Murray Schafer's restorative silence, Heidegger's silent *Stimmung,* and Derrida's barely audible *cinder* is that "silence," whether through technological or metaphysical invention, becomes the grounding trope through which certain ideas about the body and technology are to be articulated. Within this "silence" the perceptual apparatus of hearing is also redefined and shaken loose. In what would become a feature of some theorizations of virtual media, perception itself expands beyond the world, or any externality. Cage can hear his nervous system, and the interior monologue of ontotheology established—as Derrida writes, through the autoaffectivity of hearing oneself speak—is reinvigorated via the proximity of the headphones.

But there are problems—subjectivity scatters, the autonomous Cartesian subject can't hear without technological aids, and it must, in the augmenting and amplifying force of technology, find a way to reconcile this deficiency. Attributing a certain amount of agency to technology and importing the idea of a benign, evolutionary force operating through technics have enabled the particular audio technologies (e.g., audio headphones) to be absorbed by the mega-trope of technology and its offshoots: the posthuman—manifested for Schaeffer by "new ears," for Cage by new "electronic souls," and for Derrida (at least in the 1970s) through an always, already inscribed/technologized subjectivity and a sonic, vocal ephemerality that is audible only *through* technology. Through sound and audio, then, a rhetorical apparatus developed in conjunction with, and often as a response to, the technological apparatus: like the equipment, it often broke down; it was always incomplete; and it always promised too much. Nonetheless, it could be retooled to fit the rhetoric of new media: substitute the body for sound, embodiment for aurality, and immersive technologies for audio, and surprisingly similar discursive coordinates emerge.

The stereophonic perspective of traditional hi-fi audio, which delimits the acoustic scene by focusing the microphones in front of the acoustic space, absorbs the listener into a frontal perspective that is antithetical to the 360-degree audience of sound. With headphones creating a sense of intimacy and interiority, and with stereophony delimiting an auditive range modeled on vision, audio established a model for simulated environments that VR was able to step into, literally. Retaining the ocularcentric metaphysics that it would seem to critique, sound, as audio, entered media culture ontologically intact. But perhaps of deeper significance, sounds' silent passage through technology muted the larger question of technological mediation and helped develop a rhetorical repertoire in support of further evasions. Behind the acousmatic curtain, behind the presence of audio, one finds the technological apparatus in retrograde—disappearing into the void that sound represents, shedding some of its history, its presence, and traveling under the radar of media critique to be remediated, to borrow from Bolter and Grusin, in another form.[11] Like Schafer's earphones, the stereoscopic "eyephones" of VR became a support that would somehow override the technological interface, dissolving the difference between viewer and viewed, real and representation. As already mentioned, associating seeing with Being has significantly shaped the development of Western thinking: it has made sight the dominant sense; it has furnished an epistemology with a range of prohibitions against knowledge derived from the other senses; it has been fundamental to the construction of a subjectivity where the eye and I coincide—where vision, abstracted, becomes the ground for all objectivity, certainty, and inspiration. With the eye as an extension of the mind, and the mind divorced from the body, the actuality of sight has been transformed into an ideology: the individual becomes the center of its world, always looking outward, one's gaze like god rays scanning, naming, and colonizing the universe.

The frontal perspective of VR reinforces this ideology through not only the position of the screens but, more important, the cultural associations between vision and modernity. Because the future as a territory is unique to the very concept of modernity, looking ahead is metaphorically equated with enlightenment, evolution, and progress—read technological invention; whereas looking back, or looking behind, is considered regressive, "backward," going against not only the telos of Western civilization but the species itself. And in a very Western move, the future has been placed in front of the individual, and everything else—including the "meat" existing from the head down—is cast

"behind us." In the technology of VR, frontality and futurity coalesce in a simulation of frontality's other by literally blocking out the external environment, enclosing vision in the blinkered space of the stereoscopic screens. Subjectivity is collapsed into a single point of view—the virtual world is nothing other than what is, literally, in front of the user, and it is "navigated" rather than simply viewed by the viewer. At the same time, the interactive component of VR allows the virtual scene to change as the head moves, while the standard navigational device—the data glove—allows the user to point in the direction the user wants to go, which then changes the scene to simulate movement toward that place. Moving forward here becomes an expression of progress, and an amplification of the dominance of vision.

Many artists and theorists of new media have attempted to challenge the Cartesian and disembodying effects of VR, but Canadian artist Char Davies has also challenged this frontal perspective and the aesthetics/ ethics of moving forward. As I discuss in chapter 5, Davies's work is deeply tied to aurality, not just through her use of translucence and transparency to disrupt the object and disrupt the eye/I's acuity, but particularly in this context, by developing a navigational interface based on the breath and body balance. In this respect her work both challenges ocularcentrism and provides artistic representation of the "becoming" that aurality—materially and metaphysically—invokes. The word "aural," from the Latin *auris:* pertaining to the ear, derives from "aura," originally Greek for "air" and adopted by Latin as "a subtle, usually invisible exhalation or emanation."[12] Like the voice, the breath straddles the internal and external; the autonomic reflex that is beyond control, and the signifying expression—such as the well-timed sigh—that is not yet language but has meaning nonetheless. Ironically, the centrality of breath, along with the diminution of vision (through virtual worlds composed of semitransparent objects), was, at the premiere of *Osmose* (Davies first VR work), literally enacted in the users' postimmersion behaviors and subsequent reflections on their experience. Dazed and breathless, the gasp that *Osmose* elicited eventually over-determined the work itself, by collapsing it within and confining it to the "frame" of technology. In this respect Davies's work acts as a mirror that reflects both the deep investments in new media at the time and the impossibility of looking beyond the technological and visual frame to the aural aesthetic that embeds her work. If Davies's emphasis on breath has fallen on deaf ears, this may in part be due to the transformations audio has undergone in the process of becoming digital, and then virtual.

In chapter 6 I explore spatialized or virtual audio, which, far in advance of the virtual image, actually takes the body into account, literally measuring the distance between the listener's ears, the effect of their paunch, their height and breadth—in short, the uniqueness of their flesh—to produce a highly realistic listening experience. Yet, the transformations necessary to create recognizable sounds that simulate location and movement in a material space also produce sounds as "effects," while the computation of the body's contours necessarily results in a degree of standardization and produces the *body* as an effect. Indeed, the concept of the "body effect" allows us to see the body within culture, as mediated but not entirely separate from its source, and retaining a discursive relationship with technology and the cultural context within which it appears.

Listening to virtual audio through standardized ears, we hear simulated sound through a simulated body within a simulated space. It is a far cry from the rhetoric of transcendent immersion perhaps, but not so far from the biotech future that promises enhanced hearing among other plug-ins designed for bodies that have literally internalized the sensorial values of computer models. If the voice has already problematized the boundaries of the subject, virtual audio contributes to their standardization, manifesting a logic whereby immersion in (digital) space dissolves the distinction between self and environment and creates a body/world blend supposedly unique to digital media, and to virtual environments in particular. Through this kind of dissolution the body is (contradictorily) both reembodied and altered through the process of virtualization—it is brought back to its natural state (according to some), to its body image or body construction (according to others), only then to be transformed in a way that is undoubtedly posthuman. As mentioned, this reembodiment has been associated with an evolutionary teleology, and in the latter part of chapter 6 I discuss the relationships between evolution, art, and technology in the context of artificial life. Whereas Artificial Intelligence became trapped in the solipsistic processes of "top-down" computation, Artificial Life from its inception borrowed heavily from the biological sciences, using terms that implied organic existence, sentience, and a certain amount of agency to extend the frame of computation beyond the limits of human programmers. Resting on prior elisions—for instance, that between the real and its simulation—the conflation of biological life and the organizing systems of computer networks has relied heavily on technoevolutionary concepts like emergence. Again sound has been formative in the development of the rhetoric, as sound artists/composers in the 1960s experimented with

interactive, multimodal, somatic, and immersive technologies to produce installations (e.g., *Pavilion*) and performances (e.g., *9 Evenings*). These were often described by writers at the time as "living organisms," heralding the dawn of a new, cybernetic age and blurring the boundaries between not only art and life, but life and technics.

In chapter 7 and the conclusion, and with reference to the work of Canadian artist Catherine Richards and new media theorists Mark Hansen and Katherine Hayles, I attempt to pry the "post" from the "human" in order to show the dependence on the future as a binding concept, and to critique two primary assumptions: first, that there exists a seamless continuity between the identity of the present and that of the "post" human; and second, that the figure of immersion resolves the conflict between autonomy and integration. As Richards has commented, immersion is not simply confined to virtual environments or immersive media, but has been wrapping the globe in waves and signals long before culture felt a need to attach "post" to human in order to signify a particular moment in history defined by particular developments in technology. Richards's work is driven by a desire to uncover the unacknowledged electro/magnetic materiality that is the basis, the "stuff," of new media, and that draws new media technology away from futurological fantasies back to the histories (of art, science, and technology) from which it has arisen. Materializing the electromagnetic spectrum that supports any and all electronic transmissions, Richards's work highlights the importance of looking backwards—to the history of audio recording and transmission. As an atmospheric presence—one that surrounds, envelops, enables, and affects—the electromagnetic orb has been penetrating the bodies of the embodied for millennia. There, invisibly— one could almost say immaterially—it permits the kinds of telecommunications that are part of everyday life. A product of old media such as radio, contemporary wirelessness replaces the historical ether with the concept of the datasphere, yet, as I argue, many of the assumptions regarding ontology and embodiment that ushered in telephony and radio are present in the current discourse.

My point here is that the concept of embodiment, as either a site of resistance to technological incorporation, or a site of excess toward which technology will always aim but never arrive, is no longer adequate to represent the realities of technoculture. For the body has given way to the atmosphere—the resonant, information-filled atmosphere as the site for technological deployment. Like the aural, the atmospheric suggests a relationship not only with the body in its immediate space

but with a permeable body integrated within, and subject to, a global system: one that combines the air we breathe, the weather we feel, the pulses and waves of the electromagnetic spectrum that subtends and enables technologies, old and new, and circulates, as Richards would say, in the excitable tissues of the heart. Adding "digital" to atmospheres connotes a sense of envelopment, which is invisible, intangible, immaterial, and yet is not unknowable, since it is already imbricated with the production of knowledge as "digital" suggests, resonating with the individual as impulse or noise. This is not the conceptual equivalent of the posthuman, or even the cyborg, because technology is neither internalized through implants nor distributed though intelligent systems, but deployed in ways that like the weather are unpredictable, discontinuous, controlled by different and often divergent interests, and often oriented toward surveillance and monitoring more than interaction. An aural metaphor, "atmosphere" is evocative of affective states within social situations. The atmosphere in a board meeting, the "sentiment" of the consumer, the exuberance of Wall Street—all indicate the importance of mood, affect, emotion, and feeling in the outcomes of sociality. Yet the social is the realm of noise and rumor, of pulsing and multiple waves rather than discrete signals, and it moves against technologies and systems (e.g., affective computing) that are oriented toward the individual body. Thinking of atmospheres also returns us to the breath, to the continuous and necessary exchange between subject and environment, a movement that forms a multiplicity existing within the space necessary for sound to sound, and for Being, in whatever form, to resonate.

Ethereal Transmissions

The "Tele" of Phōnē

Despite our best efforts to contain the cough, the sigh, the strain, the hoarseness, the wheeze, or the stammer, the "grain of the voice" (as Roland Barthes would say) pushes through the boundaries of etiquette, articulation, rhetorical flourish, diplomacy, and deception. It is very tempting to read this grain as something both originary and irreducible: an expression of the body that culture has yet to constrain, a manifestation of the purely sonorous voice, unencumbered by language. However, prior to any utterance, the voice is already a metaphysical instrument, and already caught within particular circuits, switchboards, or machines that both literally and figuratively encode, transmit, and give meaning to vocal acts. One way to read this metaphysics of the voice is to link the sonorous emissions of the mouth, the vibratory responses of the ear, and the breathy air circulating between them; to imagine a phenomenal, visceral, and cultural triad, one that constantly interweaves sound and technology, leaving knots and tangles in its wake. One such tangle is apparent in Barthes's analysis of music, voice, and language, read through his notion of "grain" in the context of the audio recording.[1] For Barthes, it is through the voice, when "the voice is in a double posture, a double production, of language and of music" that the grain of the voice, metaphor for the *jouissance* of the body, is most apparent. Barthes describes this grain as having a certain "physique," as being "raised," or more precisely, as "a voice which gets an erection."[2] There is no doubt as to the gender of this voice, which manifests in the

actual predominance of the masculine voice in media, and the implied masculinity of the voice in metaphysics. But putting such bias aside for the moment, it is interesting to note the significance of audio technology in the "double posturing" that the triad of voice-music-language effects. Barthes describes the "grain" of the opera singer Panzera, with whom he studied until illness forced him to stop.[3] Among the singer's unique gifts was his ability to render the resonance of the French vowel with a "virtually electronic purity," a quality obviously tied to the recording.[4] Encoding the electronic within the phonographic, and describing a "physique" reminiscent of Marinetti's electro-machismo, Barthes creates a technological/electronic undercurrent that negotiates the meeting of voice, music, and language in the space between the mouth and the recording or receiving device. This space, for Barthes, has a physicality best expressed not through the 78-rpm records of his teacher, but through cinema: "It suffices that the cinema capture the sound of speech close up (this is, in fact, the generalized definition of the 'grain' of writing) and make us hear in their materiality, their sensuality, the breath, the gutturals . . . a whole presence of the human muzzle . . . to succeed in shifting the signified a great distance and in throwing, so to speak, the anonymous body of the actor into my ear."[5]

For Barthes, the body speaks. And somehow its speaking occurs through a voice that—in its breathy, noisy materiality—also delivers the body to the listener. As he writes of the telephone, this body-trade is also reciprocal: "The order of listening which any telephonic communication inaugurates invites the Other to collect his whole body in his voice and announces that I am collecting all of myself in my ear."[6] But what is the nature of this collected presence? What kind of circuit: what symbolic, material, and technological filters, enhancements, vehicles, and infrastructures—are required for the body's transformation into a full, yet *telephonic,* voice? There are many models for circuits: the Chinese system of meridians or energy flows circulating the body; the Western neurophysiological mapping of the nervous system; transportation networks, money markets, communication grids. The circuitry is as much metaphorical as material or technological and represents the flows and logics of cultural proclivities as much as the movements of material phenomena. But in considering the telephone and in particular its perceived ability to transfer, if not the body, at least the presence of the speakers, perhaps the most archaic and productive circuit is Christian theology's Holy Trinity: Word, the Word made Flesh, and Breath or Spirit, which materialized through the impregnation of

the Madonna by the Word of God, via her ear.[7] In quattrocento paint-
ings, the Word, carried by a dove or a tongue of fire, is often depicted
by transmission through a tube fixed between the mouth of God and the
Madonna's ear. The tube enables a divine transubstantiation: an
exchange between the heavens and the earth that does not require an
exchange between bodies, that negotiates a movement between sound,
voice, breath, embodiment, language, and the cosmos unencumbered
by the materiality of sound, air or throat, and uncontaminated by the
noise usually added to the system in the usual process of transmission.
Working together, these theological, metaphysical, and instrumental
operations can be read as a condensed version of ontotheology, routed
through a protean, audiophonic technology: a "speaking tube" that
contains and redirects the voice in much the same way as a musical note
contains and composes sound. Pointing to a prior technologization of
the voice, these processes transform the voice into a sonic material able
to flow through the wires—transporting speech, but at the same time
opening new frontiers for the accepted contours of presence and knowl-
edge that will, in the late modern era, legitimate the addition of "tele"
to both "presence" and "*phōnē.*"

The travels of the divine Word attest to the need for a conduit
through which the voice can pass while remaining uncontaminated by
either the body that produced it or the atmosphere through which it
passes. Decontaminating the voice has occupied Western metaphysics
for millennia—a process that predates the voice's actual mechanical
reproduction and transmission—and can be roughly characterized in
three phases: first, removing air from the voice—the voice becomes
anaerobic; second, removing temporal and spatial presence—the voice
becomes anechoic; and finally, removing sonority—the voice becomes
static and silent. The concept of "pneuma" is crucial to the first phase,
introduced in early Greek philosophy as a way of representing the soul
without including the body. As Plotinus wrote in the second century AD:
"As the association of the soul with matter implies a degradation it
cannot be placed in immediate contact with the body, so it makes use of
a mediating element, a form of pneuma, in which to clothe itself and be
guarded from a defiling character."[8] From the archaic notion of pneuma
as Breath/Spirit, the doctrine of the humors developed—air/pneuma
fully equipped with its spiritual overtones is conceived almost medically
as a regulating and nourishing principle acting directly on the body.
Augustine, writing in the third century AD, incorporated pneuma into
his model of the nervous system, which consisted of tubes of air.[9]

The evacuation of sound and noise is consistent with both the metaphysical formation and the technological transformation of the voice. It does not begin with technology as it is currently understood, nor are its various epistemic repercussions confined to sound and the voice. Rather, the abstraction and desonorization of the voice, the containment of sound and its exclusion from what counts as knowledge, parallel and penetrate the development of ocularcentrism—of a metaphysics grounded in the visible and material presence of the static and enduring object. As early as the sixth century BC, immateriality, invisibility, and ephemerality become ontological orphans. Defined as the attributes of a "thing," rather than things themselves, they are cast into the shadowy cauls of multiplicity and Becoming. Parmenides, for instance, made the distinction between reason and sense, truth and appearance, aligning Being with the One and Becoming with illusion: "If anything comes to be, then it comes either out of being or out of non-being. If the former, then it already is—in which case it does not come to be, if the latter, then it is nothing, since out of nothing comes nothing. . . . Being simply is, and Being is One, since plurality is also illusion."[10] Plato adopted this distinction, declaring the sensible to be unstable and therefore unknowable, and developing an epistemology where objects of knowledge are ideal, subsistent, immaterial forms that embody eternal order, intelligibility, and meaning.

During this period, broad cosmological principles are geared toward what might be called the mechanics of existence, described in terms of constitutive parts (e.g., atoms) and causal forces.[11] The universe becomes measurable, identity becomes the primary ontological criterion, and the number, ratio, and movement of parts central to the mechanistic viewpoint are necessarily attached to a thing. Ontology and epistemology are united via the being of the object, and the knowledge of this being is given through the sense of sight and touch. Being, knowing, and seeing (in Greek "to be" is etymologically associated with "to know" and "to see") lay the ground for modern notions of eidetic knowledge, which is captured in nouns such as idea, reflection, speculation, enlightenment, and vision.[12] The "total darkness of matter-in-itself" gives way to enlightenment, through the spiritual truths of the cosmos and what will later be thought of as the scientific truths of Reason.[13] Not surprisingly, sound and the speaking voice are banished from this ontological elite, not because of their sonority, but because of what sonority represents—impermanence, instability, change, and becoming. Through an array of epistemological gymnastics, however, the voice is not entirely excluded

(how could anyone ever say that it was?) but rather abstracted via the oxymoronic concept of "inner speech."

Ultimately the processes that allowed the voice to enter the head also created the preconditions for the voice to be carried through telephone wires. This development is particularly evident in the metaphors used to redefine the voice. Plato, for instance, refers to the voice as an instrument not in its modern sense, but rather as a *technikon*, a technology, for revealing *alethia* (truth) and linked to *episteme;* knowledge in the widest sense. Here sonority is the pivot between logos as truth and logos as spoken word, because—like the analog audio recording—it is index-ical and carries the trace of that which it represents. Plato's theory of naming, for instance, proposed the existence of an ur-language handed down by the gods, in which the legislators of language invented words that would phonetically correspond to the nature of the thing, the "letters" [phonemes] in a word expressing certain states of the thing such as motion, or shock.[14] In imitating the nature of the thing or event, the voice sonically re-presents its essence, creating a physical (because acoustic) resonance between the speaker and the thing spoken of, and confirming that words correspond to referents, not through mere imita-tion; but through a sonorous reconnection.[15] Further, as it sounds the names given by the gods, the voice evokes the essences of things that, as forms, are permanent, abiding, and not subject to change. The perma-nence of essences is necessary not only to provide order in the universe, but also to ensure the certainty of language and speech. This is true par-ticularly for the supreme forms—Beauty and Goodness, for: "If [Beauty] is continually escaping from our grasp, how can we properly apply to it the predicates *that* or *of such a kind?*" In a litany against pre-Socratic philosophies of flux, Plato continues:

> How can that be a real thing which is never in the same state? . . . Nor yet can the variable be known by anyone; for at the moment that the observer approaches, it will become other and of another nature, so that you cannot get any further in knowing its nature or state. . . . If that which knows and that which is known exists ever . . . then I do not think that they can resem-ble a process or flux, [for if they did] . . . no man of sense will like to put himself or the education of his mind in the power of names . . . he will not believe that all things leak like a pot or that the whole external world is afflicted with rheum and catarrh.[16]

The special connection that Plato sees in naming is, ironically, very similar to onomatopoeia, often used in sound poetry that, as I will dis-cuss later in relation to Artaud, provides a juncture—a switching site—where sound meets language, and something is released. The truth of a

direct correspondence between word and thing sits awkwardly between absolute pure presence and the chimera of metaphysical construction. For there is only a sonorous gap, a poor imitation, between the onomatopoeic word (crackle) and the sound (crackling). For the onomatopoeic word to fulfill its poetic function, this gap must be ignored—yet at the same time the force of onomatopoeia, that is, its peculiar affect—has something to do with its incomplete and awkward signification. Such words have to be used discretely, because when strung together they cease to signify. Constraint and delimitation, filtering and abstraction attend to the voice whenever its sonority is recognized. Too much grain, too much poeticism, and noise or babble proliferate. But if the voice is an instrument (from the Latin *instru(ere)*— to put together, to train) then certain controls are put in place—both a device and a means: the voice as instrument constrains the vocal apparatus, focusing the sound that would otherwise leak beyond the word or the phoneme, in much the same way that a musical wind instrument contours the air into defined pitch.[17] Still, this is a very delicate position for the voice to occupy, for even as instrument, its "non-representational" imitation given through sound threatens to draw it downwards toward the mute being of matter. For the voice to become the Cartesian voice of Reason and scientific stability, it had to be contained within an overarching design. As Artaud would lament, the voice had to become bodiless and silent:

> I think that the music of instruments, the combination of colors and shapes, of which we have lost every notion, they must have brought to a climax that nostalgia for pure beauty of which Plato, at least once in this world, must have found the complete, sonorous, streaming naked realization: to resolve by conjunctions unimaginably strange to our waking minds, to resolve or even annihilate every conflict produced by the antagonism of matter and mind, idea and form, concrete and abstract, and to dissolve all appearances into one unique expression which must have been the equivalent of spiritualized gold.[18]

Metaphysics, however, is driven by such antagonisms, and thus we find Aristotle declaring that the voice is "a significant sound; not the sound (merely) of air respired, as coughing is" but rather a sound that travels via the windpipe where it is struck by the soul. Further, "there is needed a living being to utter the sound, and some accompanying phantasm."[19] Interpreting Aristotle, St. Thomas Aquinas declares this phantasm to be an image originating in the imagination, and that "operations proceeding from imagination can be said to be from the soul," which uses air inhaled to produce the voice: "Not air, then, is the

principal factor in the formation of voice, but the soul, which uses air as its instrument."[20] Now that the proper voice is devoid of unintentional sound ("the cough or the clicking of the tongue"), it bears no traces of the body, representing or voicing only the signifying image.[21] The metaphor of the breath, with its history as "pneuma" and its associations with inspiration, is now truncated by a speech that issues from the throat upwards and, via a logical calculation, is quarantined from breathing: "We cannot produce voice while inhaling air nor while exhaling it, but only while retaining it."[22] Speech is therefore resistant to the rhythm of the breath: moving through the body, sometimes within, sometimes without, setting up a flow that, while vital, is also a constant reminder of life's impermanence, the perishability of matter, and on a deeper level the flux of existence itself. Aristotle holds his breath in order that the soul might speak, and knowledge articulates the universe in the anechoic and now anaerobic nowhere of *nous*. The absence of breath—absence itself—now has the same ontological status of the "not-being" that filled the spaces between the atoms of Leucippus. Since nothing can be said of not-being, the breath can no longer interfere with the continuation of the ideal presence that metaphysics requires.

But still the coming and going of sound, with its uncertain referentiality, its resistance to any objective anchoring, its movements behind and beyond the subject, in short, its becoming, is an integral part of the voice. Like the breath, sound cannot be held or grasped by a mind already committed to an ontology of presence. Yet as a metaphor rather than a phenomenon, sound has far more possibilities. Jacques Derrida has elaborated the subtle conflation of the presence of the voice with the (temporal) present. Accompanied by the actual bodily presence of the speaker and heard (perceived) at the moment of its production, the voice creates a circuit, a confluence between the ideal phantasms of the mind and the impossible inner voice, now able to express the imagined reality of the image.[23] This conflation comes down to proximity: a brief externalization is enough to give the speaker, in hearing himself or herself speak, proprioceptive access to the world without the necessity of actually inhabiting a foreign exterior. Descartes provides this condensation with his *cogito ergo sum:* one only has to think, with the inner voice, rather than say (and perhaps stutter or cough) "I think, therefore I am" to establish existential certainty. Stealing, or cheating, the passage of time, the potentially eternal presence of the dictum *cogito ergo sum* is "uttered" to oneself in the presence of the infinitely presentable

images of the mind's I/eye; formed from the intentions of the eternal soul. But as the mind now listens to its inner workings without the resonance of the body, the voice of the logos becomes solipsistic, enabling further exclusion of the sounding, noisy, and irrevocably social world to occur. This voice, according to Giorgio Agamben, is now more accurately designated with a capitalized V:

> The taking place of language between the removal of the voice and the event of meaning is the other Voice, whose ontological dimension we saw emerging in medieval thought and that, in the metaphysical tradition, constitutes the originary articulation (the arthron) of human language. But inasmuch as this Voice (which we now capitalize to distinguish it from the voice as mere sound) enjoys the status of a *no-longer* (voice) and of a *not-yet* (meaning), it necessarily constitutes a negative dimension. It is *ground,* but in the sense that it goes *to the ground* and disappears in order for being and language to take place.[24]

The "inner voice," anechoic, anaerobic, and static, is a perfect example of the complexities that aurality negotiates vis-à-vis metaphysics: the sensual (sight and sound) is abstracted in the appropriation of externality: the aural becomes a metaphor, and actual sound is forgotten. As mentioned, this epistemic process is forged through both an actual and an idealized proximity, and it is repeated—often with greater complexity—as sound and metaphysics enter the era of modern technology. This close proximity between vocal emission and reception is not only compelling enough to insinuate the ideality of subject and object through its autoaffective possibilities within metaphysics, but has enormous longevity, appearing in contemporary analyses of new media via the virtual reality (VR) interface. Obliterating the distance between the speaker (now thinker) and listener (now thought) enables the fiction of the inner voice to substantiate (literally) a disembodied subjectivity; similarly, the lack of distance between the eyes and the head-mounted display (HMD) and the affective response of the visual perceptual apparatus (creating depth from the stereoscopic screens) have provided a rhetorical ground for the idea of virtual embodiment, and for the virtualization of the body via new media technologies.[25] It barely needs stating that this embodiment occurs primarily by way of vision.

In the modern era we find the potentially infinite electrical impulses coursing through the machine substituting for the once-divine pneuma and symbolically corresponding to the flows and circuits of the nervous system. As the forces of modernity direct the voice toward the strictly human theater of symbols, myths and meaning, the content of such

transmissions develops a distinctly human inflection, as the theistic pneuma mingles with the electronic ether, to be eventually tapped by wireless radio. Conversely, through the control of electricity, speakers undergo a kind of reverse transubstantiation via the immortality bequeathed to the machine. Because electricity, like air itself, is infinite, in the transition from pneuma to electrical impulse, the human body, now equipped with electronic prostheses, becomes by association a machinelike thing for whom it makes no sense to speak of death. Not only both anaerobic and anechoic, the electronic voice confirms the promise of technology—immortality—as the Voice, grounded in negativity, as Agamben points out, has already made the question of death—absence itself—logically mute. The circuits thus formed ready the voice for electronic reproduction and transmission within a context, a symbology that is both ancient and uniquely modern. As mentioned, the transmissive mappings of the telephonic voice share similar ideas and mechanisms of transference with the elemental/theological circuits of Christian culture. Both are constituted by the triad sender-operator-receiver, through which the voice of the caller is encoded, transmitted, decoded, and amplified. Vocal transmission creates a dialogue that is not just restricted to speech, but that causes transformations within bodies, between bodies, between radically different spheres such as the heavens and the earth, and radically different forms of being—human and celestial. While deeply connected, these circuits also separate, as they route, exchanges that once assumed spatiotemporal continuity between speaker and listener. Charged with theological associations, transubstantiated through electricity, this soul-full but breathless voice would now connect with an ear similarly abstracted: an earpiece that, together with the vocal mouthpiece, descends to the material world and the noise of mass communication. Yet ruminating within this neat exchange, and becoming more vociferous with every decade, is the question of collection. How is it possible to conceive that the ordinary human body can—as Barthes insists—wind up in the ear of the other? In possibly overstating the capacities of audio technology, Barthes nonetheless raises some of the key conceptual obstacles that must be overcome for telephonic voices to have any kind of currency. As he points out, the voice impinges upon subjectivity in the most sublime and guttural of ways; it embraces notions of music and poetics, thought and representation, sonority and noise, solitude and sociality. Yet there is a common tendency to suppress the actual sonority of the voice in its bifurcation along the body/mind axes. The voice of the body has its

origins in the passions; it does not speak so much as babble, its fluid nature continually escapes the grid of the symbolic, of meaning. The voice of the mind, on the other hand, is silent; it produces symbols, language, and meaning; it names the phenomena of the world and produces the self-consciousness of the subject. If Western philosophy can accommodate the idea of a split voice—both sonorous and intellectual—then it is no great leap of faith to suggest that this already abstracted voice can be transformed into electrical impulses, transmitted through wires, and emerge carrying the being, the "there" of the speaker.

In a similar vein, cultural historian Jonathan Sterne argues that sound reproduction technologies were not, as is often thought, inaugural: "Many of the practices, ideas, and constructs associated with sound-reproduction technologies predated the machines themselves," and these practices, ideas, and constructs, as much as the technologies themselves, created the conditions that gave rise to sound reproduction.[26] Sterne emphasizes instead the socially constructed character of sound and listening through what he calls "audile techniques," and his argument is particularly important with regard to the status of the aural "copy" and the mechanical reproduction of sound, that is, audio.[27] While the visualist tendencies of post-Enlightenment thought rendered sound a secondary epistemic object, in the context of modernity they also preempted any serious discussion of sound as a technological object—a problem that also hampers contemporary sound theory. As Sterne argues, because the reproduced sound is heard by already trained ears, within a social dynamic of technology and sound reproduction, then, it is tautological to speak of an "original" sound—there is no "original" sound, because there are no "original" ears. For Sterne, the distinction between the original and the copy is not only unnecessary, but supports a romance for "authentic" sonority and a nostalgia for the lost soundscape. Whereas listening is certainly a learned practice, shaped by sound technology as much as sound technology is shaped by listening practices already in place, the ontological distinction between the sound and its source is important, indeed crucial, to sound theory, because the negation of this distinction has contributed to, if not enabled, the ideology of realism in media, both old and new. To this end I have adopted an approach that distinguishes the sound "object" from the object as such, not in order to create a special place for sound outside of history and culture, but rather to show the connections between aurality and alterity, and technology, and to elaborate that connectivity within the current technocultural disposition. While I argue for a

radical scission between the original and the copy, the source and the representation, the body and technology, I do not locate the original within a precultural condition or the representation with an entirely abstracted technoculture where materiality, including human materiality, is dominated by the signal. It is true that, like everything else, technology dwells in culture and is subject to the learned nature of experience, but, methodologically, my preference is to foreground rather than deny the specificity of sound and aurality. In this respect, sound's "vocabulary" and ontology are serious matters, since any vocabulary begins (and possibly ends) with the near impossibility of approaching sound as an object without first disentangling it from the visualist metaphysics within which it is named. Because sound has played a significant role in negotiating the often-contradictory reality of different media (such as ensuring the credibility of the telephonic voice, while also creating in-credible sonic atmospheres in cinema) the question of its mediamatic ontology (discussed in the next chapter) goes far beyond the difference between original and copy.

TELEPHONIC CIRCUITRY

With its thin, sharp, metallic tone, one wonders how it was that the telephonic voice—lacking the body's resonant cavity, and infiltrated by distortions, interference, signal noise—could have been accepted as "real." This can partly be explained by telephony's association with Spiritism and concepts such as the ether: a netherworld that provided another "there" to replace the one lost in transmission, and countless pseudobodies as substitutes for the fleshy body lost in electronic translation.[28] The ether has served the popular imagination well—offering a relatively benign conceptual construct that can accommodate both material and epistemological contradictions while also providing an unknowable, yet unifying, plenitude. While the innate divinity of the human species was threatened by the discoveries of science and the theory of evolution, purported messages from souls in the ether proved the Christian belief in immortality; at the same time the occult connotations of electricity lent a scientific, technological flavor to many Spiritualist experiments. It was in the neighborhood of the ether that the telephone, and later radio, established both its legitimacy and its conceptual heritage. Telephony invoked early fantasies of teleportation and ushered new electronic presences into the technocultural domain. The Italian Futurists, led by F. T. Marinetti, held great hope in the telephone and its ethereal connections; for

Marinetti it inspired the expression "wireless imagination."[29] It was an imagination that, as Daniel Czitrom notes, was shared by the physicist, philosopher, and cosmologist alike: "For the physicist [the ether] provided a simple unifying principle, for the speculative philosopher and cosmologist it was a gateway to unlocking the secrets of Nature and the universe."[30] Almost at its inception, telephony was associated with the occult, while the cracklings that accompanied telephonic transmission seemed to be the sound of the ether itself. It was no coincidence that the early barkings of telephonic communication would echo with the spiritist's desire to reach beyond the living to "the other side," or that Thomas Edison would experiment with thought transference and communication with the dead. In the phenomenon known as "voice-boxing" or "the wireless telephone," the telephone became a model for deciphering voices from the "other side," with the vocal apparatuses of psychic mediums (generally women) acting as conduits for otherworldly channeling.[31]

To add to this psychic cacophony, the inventions of Edison were celebrated for making audible the "eternal silence" of sound lost to the past. Hubert Greusel, a biographer of Edison, wrote of the "dead spaces of the air, where all these harmonic wonders had all unknown been slumbering, ready at the right moment to come forth at the master's sign, conjured into life by Edison's magical command of mind over matter."[32] Within this early phase of technospiritualism, the ether's role expanded, from the cohesive force of the universe and the transmissive vehicle of all energies to a sphere within which telephonic, telegraphic, and later wireless communications, together with messages from the "other side," could occur. As such, it contained new entities, transformed old identities, and created a spirito-electro-environment that lent a certain amount of substance to the notion of an ethereal "force," equipped with agency, otherworldly contacts, and mystical intention. Part of this intention was decidedly evangelistic: in the era of telephony the mission of transmission was no longer concerned with establishing a direct line to God, but with the "brotherhood of man."[33] At the same time, as an emblem of science, the telephone also exported the technological ethos, by becoming synonymous with the ostensibly civilizing influence of Western culture itself.

While telephony, phonography, and radio, together with their spiritist associations, created the hybrid identities of the recently departed, Freudian psychoanalysis was also appropriating the idea of a desonorized transmission.[34] Freud linked telepathy with telephony and viewed the latter as a medium for the transmission of the former, in the

same way that psychoanalysis was the instrument for analyzing, through interpretation, the telepathic dream. Through psychoanalysis the hidden messages of the unconscious could literally be "given a voice":

> The telepathic process is supposed to consist in a mental act in one person instigating the same mental act in another person. What lies between these two mental acts may easily be a physical process into which the mental one is transformed at one end and which is transformed back once more into the same mental one at the other end. The analogy with other transformations, such as occur in speaking and hearing by telephone, would then be unmistakable.[35]

Through this connection, Freudian psychoanalysis became both the medium (metaphorically the telephone) and the interpretative method of telepathy, or thought transference. Like the breath or pneuma, like the occult electrical impulse itself, psychoanalysis could function as a transducer, with the psychical becoming physical, "speaking" what was previously hidden and inaudible. In affirming what the psychoanalyst might sometimes doubt—that he or she heard "correctly"—the ear of technology itself would produce "correct" speech by embodying the certainty of the machine and transferring that certainty to the analyst in the telephonic trope.[36]

Because Freud's enthusiasm for the telephone as an analog for psychoanalysis was in part due to the mechanical and hence objective nature of the instrument as a recording device, he was happy to assume this role, despite its occult associations:

> In my opinion it shows no great confidence in science if one does not think it capable of assimilating and working over whatever may perhaps turn out to be true in the assertions of occultists. And particularly so far as thought-transference is concerned, it seems actually to favor the extension of the scientific—or, as our opponents say, the mechanistic—mode of thought to the mental phenomena which are so hard to lay hold of. . . . You will not forget that here I am only treating these problems in so far as it is possible to approach them from the direction of psycho-analysis. When they first came into my range of vision more than ten years ago, I too felt a dread of a threat against our scientific Weltanschauung, which, I feared, was bound to give place to spiritualism or mysticism if portions of occultism were proved true. Today I think otherwise.[37]

While Freud and others may have fantasized a device for "correct" interpretation, the full significance of the telephone as a metaphor for transmitting the unconscious must be seen within the (metaphysical and technological) operation of noise reduction—where "noise" is determined as voice concealing Voice. Through the sheer limitation of the

technology, the full sonority of the voice, with all its glissando-like mod-ulations and throaty, guttural interruptions, is muted. Since both the microphone design and the motivation of the listener favor the under-standability of language over the accompanying noise of communica-tion, the sounds of the body are silenced, creating a monovocal communications flow. Without noise (both sonic and informatic), the message becomes closed to change, unable to adapt, tending toward homogeneity and solipsism.[38]

The transmitted voice is everywhere at once during this period: while its subjectivity is still grounded in the unified, self-conscious ego of the Cartesian subject, it is also transformed through electricity, spread across the reaches of the earth, in the manner that "broadcasting," orig-inally a farming term, spreads the seed of the future crop. Via radio (from the Latin *radius* and the derivative *radiare,* to emit rays, and *irra-diatus,* to illuminate, to enlighten intellectually) the voice is both trans-fused throughout the electronic ether and contained within a center or Self that moves outward to the world and cosmos alike.[39] Radiophony could easily be mistaken for aurality's electronic double, distributing sounds and voices through the pulsations of the ether, entering a variety of social spaces simultaneously, transporting sound through and between different symbolic and psychical milieus, and doing this with-out any physical connection. The democratic associations of radio—one world united in a single broadcast irrespective of class or caste, melded with its cosmic reach, and lead to often outlandish predic-tions of radio's grand potential. These ranged from communication across galaxies, to securing world peace, to developing a universal lan-guage, and they attributed to radio a degree of agency that surpassed, by orders of magnitude, the actual technology.[40] Commenting on the reactions to Marconi's announcement in 1919 that he may have picked up signals from beyond the earth, and Tesla's belief that they came from Mars, Susan Douglas writes: "The idea of sending radio signals to Mars was in many ways the most revealing and poignant of the visions sur-rounding radio. It exposed a sense of isolation, insecurity, and dissatis-faction over things as they were. It revealed that, despite the failure of past predictions, many Americans were still inclined to view certain technologies as autonomous, as possessing superhuman or magical powers."[41] These were often framed in organic metaphors that united the listener's ear to the social body and to the spiritual and heavenly bodies existing in the ether that radio tapped into.[42] Similarly, because of its association with technology, radio gave spiritism and metaphysics a credible link to science, conjoining the utopic visions of both.

As Susan Douglas's comment reveals, however, the popular enchant-
ment with radio's unifying potential was in part created by the dis-
placements that early-twentieth-century technoculture was undergoing
as it came to terms with the pressures of industrialism, new modes of
production, and sociality. War had seared the human landscape, adding
to the radiance of radio an apocalyptic residue of explosion and tor-
ment, and in this respect, radio's consort with the "other side"—partic-
ularly with relatives lost in WWI, which were channeled through
mediums in a practice known as "voice boxing," and associated with
the spiritists' "wireless telephone"—also trafficked in finality and apoc-
alypse. In this climate of ambivalence, with its massive technological
change, its ever receding utopian promises, and its shameful record of
war, audio technology produced both the sounds of the cosmos and the
explosions of cosmic catastrophe. The jagged blips and mutterings of
shortwave radio, the skeletal voice of the telephone, echoed with the
voices of those scorched by military and communications technologies
and reiterated the fact that not only voices but bodies could become
skewered by electronic transformation. The electric timbre inflecting the
media voice could be heard as a triumphant announcement that "I can
be in any place at any time" or the desultory and uniquely modern .
refrain "there is no longer any place nor any (human) time."

As a result, the complex and often contradictory forces that the dis-
course of radio, like that of cyberspace and new media, brought into
play were always shadowed by loss. Radio seemed the perfect double
for aurality, but its utopic promise rested on the idea of radio as an
aural and electrical medium rather than an *audiophonic* technology,
one that also mirrors the isolation and dislocation of the social body
within the practices of audio production. Where electricity, sound, and
the ether were thought of as the source, where the ether was understood
as belonging to everyone, open to all types of communication, cheap,
accessible, and essentially democratic, there was also a flourishing rhet-
oric that was successfully recycled in the last decade as the concept of
cyberspace. It could be argued that then, as now, technoutopianism was
a manufactured value, designed to alleviate the horrors of the twentieth
century while establishing an ideological and consumerist base.[43]

Celestial Telegraphies

The complexities of the post–World War I atmosphere come together in the work of the Italian Futurists and the avant-garde. Early "liberators of sound" made the connection between the release of sound and the explosions on the battlefield.[1] Influenced by Marinetti, Luigi Russolo wrote in 1912 of the Futurists' dedication to "add to the great central themes of the musical poem the domain of the machine and the victorious kingdom of Electricity."[2] Contemporaneously, Edgar Varèse, one of the first composers to embrace sound technology, commented on his taste for "music that explodes,"[3] and he wrote of his search for "new technical mediums which can lend themselves to thought and can keep up with thought."[4] Greatly influenced by the philosophy of Henri Bergson and anticipating the metaphysical works of Deleuze, Varèse imagined a "music" of moving sound masses and shifting planes; sound collisions, penetrations, and repulsions; planar transmutation and projection.[5] Perhaps no other work of the period addressed sound—as a compositional material—and the voice—as a bodily emission—within the technoutopian and dystopian themes (mentioned previously) than Varèse's collaboration with Antonin Artaud in his unrealized project, *L'astronome*, begun in 1928. Moving beyond both music and language, Varèse envisaged an opera that would create a feeling "akin to that aroused by a beam of light sent forth by a powerful searchlight—for the ear as for the eye, the sense of projection, of a journey into space," while Artaud wanted to remove the voice from language and return it

to an archaic and primal origin in sound.[6] The work was a projection into the year 2000 and involved the representation of a series of catastrophes caused by "instantaneous radiation." A sketch of the piece was given to Artaud in 1932, and from it he wrote "There Is No More Firmament," dramatizing the instantaneous radiation Varèse had envisaged in a scene where a scientist invents a device that signals "celestial telegraphy," even though this signaling means the end of the universe.

The entire project was, however, fraught with problems. The last scene in Artaud's libretto was not intended to be the final scene; like *L'astronome* itself, it remained unfinished, and its continuing limbo may have contributed to the near-suicidal depression Varèse suffered in the years following. However, in terms of the present discussion, the project's accidental finality foreshadows the reframing of sound as transmitted signal rather than material and temporal event: the unfinished text ends in a universal, utterly nonnegotiable, and infinite silence:

> Sounds rush forward . . .
> Cold light reigns everywhere.
> Everything stops.[7]

Perhaps one of Artaud's "machines of instant utility," this scenario grinds existence to a halt.[8] The physical and metaphysical elements that Artaud sets into a closed and insane orbit are united at last in a silent and resolute nonbeing. Life, theater, necessity, and matter are resolved; "Man, Society, Nature, and Objects" fall into a harmonious stillness—there is nothing more to say.[9] How this resolution came about, and what made it possible, can be seen, in microcosm; the chronology of that last but not final scene: sound rushes forward, cold light reigns—then, and we might say, only then, "everything stops." This cosmic cessation is not a result of accident; rather, in this play, everything stops because of the transmission of a signal, a "celestial telegraphy." To this signal, sound and light, and indeed the very possibility of their presence, must give way. Throughout his writing, Artaud brings into play a sequence of tropes: incantation, vibration, contagion, and transmission, and in the context of his collaboration with Varèse, sonic projection, which lubricates the positioning of these tropes, within a metaphysical machine—one that happens to precipitate the end of the world. Perhaps buoyed by Varèse's similar ideas for sound and music in the theater, Artaud repeats this sequence in the profoundly pessimistic narrative of "There Is No More Firmament" and, through a discipline that becomes increasingly anechoic and automatic, hoists it into the cosmos as an uncannily predictive schedule for the future.

Sound emerges for Artaud as a counter to the despised voice speaking language. As he prefaces in *The Theatre and Its Double,* it is "the rupture between things and words, between things and ideas and the signs that are their representation" that accounts for "the confusion of the times." To escape language and representation, to return theater to its primal, delirious, magical, and revelatory state, to "make metaphysics out of language," Artaud invents a new "concrete language," constituted by voice, music, gesture, volumes, objects, movements, and forces, "intended for the senses and independent of speech." This language expresses thoughts beyond the reach of spoken language, consists of "everything that can be manifested and expressed materially," and creates "a subterranean current of impressions, correspondences, and analogies." Recognizing that words have the faculty of "creating music in their own right . . . independent of their concrete meaning," Artaud includes "objective intonations" in his materialized "poetry in space." In this space, sound is treated like a physical object. It is "divided and distributed," and its ability to shock and shatter is used to "fascinate and ensnare the organs." The sound of this language is definitely not music; rather it "wildly tramples rhythms underfoot. It pile-drives sounds. It seeks to exalt, to benumb, to charm, to arrest the sensibility."[10]

But if it seems that this language engages noise as its medium, Artaud makes sure to situate his sonic shocks well beyond the mundane: for this language helps the spectator to "consider language in the form of *Incantation.*"[11] Via onomatopoeia, for instance, the mechanisms of representation are disrupted, and ordinary language is inhibited. Yet rather than a total disjunction between signifier and signified, speech is still able to "manifest something" through a nonarbitrary relationship between word and thing. As mentioned, the desire for this kind of nonarbitrariness is a common theme in Western philosophy. While Artaud's writings on sound, music, and in particular vibration could be read in terms of Platonic thought, like Varèse, the sound that he has in mind is nothing like the music of the spheres. Artaud describes the essences that sound recalls as "principles" and "forms." They are the shapes, sounds, music, and volumes of an "essential drama" and are in no way intellectual. Rather, they evoke "states of an acuteness so intense and so absolute that we sense, beyond the tremors of all music and form, the underlying menace of a chaos as decisive as it is dangerous."

So, beyond the "tremor" of music lies a chaos of Creation that is without division, corresponding in the spirit to an absolute and abstract purity "beyond which there is nothing," the kind of nothing that Artaud

conceives as "a unique sound, defining note, caught on the wing, the organic part of an indescribable vibration." In this context Artaud evokes Plato's catalytic philosophy. The vibration itself would resolve "or even annihilate every conflict produced by the antagonism of matter and mind, idea and form, concrete and abstract"; it would be a vibration of which sound is the "organic part."[12] But what is a vibration? Here the term is used to represent a transcendence of the material, on the one hand ("beyond the tremors of all music"), and, on the other, an engagement with the fundaments of raw, palpating life. The concept of vibration played an important role in the philosophies and aesthetics of the Futurists—with whom Varèse had been associated—and was elucidated by Bergson, who, as mentioned, influenced Varèse and the avant-garde. Bergson refers to matter, which is always in a state of becoming, as "numberless vibration," not atomic but imbued with and governed by motion— "modifications, perturbations, changes of tension or of energy."[13] Between presence and representation is the interval between matter itself and our conscious perception of matter. In that interval all the artificial divisions that go into constructing and representing matter as a series of independent objects, cast in an infinitely divisible space and existing in a perpetuity of instants, are set in place. Vibration, this quintessentially aural term, is an excellent figure for the kind of phenomenology Bergson and others want to fashion and provides a counter to Platonic idealism, which succeeds in uniting word and thing only by reference to unchanging and atemporal forms and the demands of the deities.

It is no wonder then that Artaud goes back and forth between the materiality and metaphoricity of sound—between its ability to penetrate and vibrate, its communicative function in the speaking voice, its associations with music and the Pythagorean harmonies of the cosmos, and its inseparability from noise. Yet despite these oscillations, Artaud's metaphor of vibration eschews the connotations of transcendence that readers of twentieth-century mysticism are familiar with, and which probably informed Varèse's fascination for volatilization and light. Furthermore, Artaud's interest in noise—etymologically linked to nausea, odious, air, and rumor (spread as "bad" sound)—distinguishes his aurality from the pure, mathematical, theological schema that Plato outlined and further embeds it within the concept of contagion and transmission. The sounds of Artaud's "theater of cruelty" include glossolalist utterances that completely disable the mechanisms of meaning—primal or otherwise.[14] Very often, these sounds are less an incantation or "poetry in space" than the

kind of belch, rumble, or spasm that indicates a digestive rather than cosmic transformation is occurring. With his pile-driven sounds penetrating the organs, the body, the nervous system to become an interior sensation, a delirium both subtle and demonic, Artaud's equivalence between the theater and the plague makes sound the organic part of not a primal vibration but an intelligent contagion. Artaud likens the operations of this "contagious delirium" to the action of subtle acoustic vibrations on the nervous system. However, rather than the organism shimmying to a higher plane of consciousness, the action is a revelation of, or opening to, the chaos that lies beneath all the "tremors of music." This vibratory identification would appear in a similar appeal to primordiality by the founder of artificial life, Louis Bec (see chapter 6), not especially to endorse certain technologies, but like Artaud to create an avenue back to a primeval, precultural state. In a flourish of mixed metaphors, Artaud brings together the creations of nature and those of the writer or composer emanating from nature, yet "as strict and as calculated as that of any written work whatsoever, with an immense objective richness as well."[15]

The concept of contagion is important here, since between the source and its destination there is no difference—the plague, like the vibration or the Platonic incantation, transmits itself in the present without entering into repetition or representation. The plague therefore has a certain purity of being, one that also *purifies* being: it "shakes off the asphyxiating inertia of matter which invades even the clearest testimony of the senses." For Artaud, just as the worst kind of sound is the voice speaking language, so too the worst kind of matter is human: "All the preoccupations [of theater] stink unbelievably of man, provisional, material man, I shall even say carrion man." Theater's stench of man, its "preoccupation with personal problems," disgusts Artaud, because matter and objects relate to individual things, whereas forces, states, and intensities lack individuation and to some extent avoid the possibility for representation. Sound occupies an intensely ambivalent position here, as the material of both proper, individuating speech and meaningless, affective babble—indeed it is on this tension that Western thought and the "carrion" individual has been founded. For Artaud, this tension is a source of continuous anguish. The materiality of sound allows him to avoid the separation that representation imposes; however, noise is itself inseparable from the nauseating stench of matter, which, like the voice, is inevitable, as long as theater is human. While the concrete language of Artaud's "theatre of cruelty" enables him to communicate directly to

a "deeper intellectuality," even so, Artaud cannot leave the matter of humans alone. In his proposed theater, the spectators are "conducted" "by means of their organisms to an apprehension of the subtlest notions." His "carrion man"—spectator in an "inhuman" theater that reveals or leads to a "virtual reality" (Artaud's words, not mine)—exists only as a "stripped, malleable and organic head, in which just enough formal matter would remain so that the principles might exert their effects within it in a completely physical way." The sound and light the spectators are immersed within produce a state that, while trancelike, nonetheless "addresses itself to the organism by precise instruments."[16]

Precision and control are key elements in Artaud's new language, as the intonations, the vibrations, movements, and gestures on the stage and of the actors are deployed "on condition that their meanings, their physiognomies, their combinations be carried to the point of becoming signs." The essential drama contains a kind of lexicon or a DNA for all possible dramatizations and consists of these contagious signs, collected and organized, which Artaud likens to hieroglyphs. Speech now appears "as the result of a series of compressions, collisions, scenic frictions, evolutions of all kinds" and within the phenomenality that such materiality bequeaths; it becomes a thing to be recorded, to be "written down, fixed in its least details, and recorded by new means of notation."[17] Artaud is unclear about the recording of this language—it could be accomplished through "musical transcription or by some kind of code," but hieroglyphics provides a model. He writes: "As for ordinary objects, or even the human body, raised to the dignity of signs, it is evident that one can draw one's inspiration from hieroglyphic characters, [which will allow one] to record these signs in a readable fashion that permits them to be reproduced at will." Warming to this, Artaud imagines that "the spectacle will be calculated from one end to the other, like a code. Thus there will be no lost movements, all movements will obey a rhythm, and each character merely a type, his gesticulation, physiognomy and costume will appear like so many rays of light." Hieroglyphics would operate vibrationally "on all organs" and metaphysically "on all levels." However, unlike the theater of cries, screams, gestures, matter, and things, hieroglyphic theater embraces the universe within the economy of the sign and uncovers a "passionate equation between Man, Society, Nature, and Objects." Here a primal law operates with the precision of a metaphysical, ethical, and aesthetic machine—a machine, incidentally, that Artaud has named the theater of cruelty. In this world of states reduced to symbols, phenomena such as sound and light, for

which linguistic representations are lacking, are coded and added to the world of objects. As contagion becomes transmission, matter is redefined in terms of the signal, and bodies turn into beams of light. Indeed, Artaud's hieroglyphics seem less imagistic than informatic, a goal he set out in the opening pages of "There Is No More Firmament," in which he very enigmatically proclaims that his sounds "will be to Morse code what the music of the spheres heard by Bach is to Massenet's *Clair de lune*."[18]

THE ASTRONOMER

As Artaud clothes and codes his hieroglyphic characters in "rays of light," fragments of his strange collaboration with Varèse begin to fall into place. In its incarnation as "The One-All-Alone," Varèse describes an astronomer who rakes the sky with his telescope "with such avidity that the stars grow progressively bigger and bigger and end up by absorbing him completely."[19] During this process he first becomes "a long ray of light" and then transmutes into a god figure as rays of light radiate in all directions from his body.[20] The astronomer reappears in "An Open Letter to Youth," which Stockhausen published in the *Journal musical français* in May 1968. In this article Varèse writes: "We are in a time when certain men of heightened consciousness are becoming so strong that they are approaching a higher form of life. Here on this earth."[21] In the vernacular of mysticism, the higher form of consciousness would be reached via a vibrational transformation, that is both material, intelligent, and cosmic. Varèse seemed happy with this kind of transcendence and had his astronomer volatilized into interstellar space. He was unhappy, however, with Artaud's protagonist, the Scientist, whose existence is bluntly terminated along with everything else.

Like Artaud, Varèse was concerned, perhaps obsessed, with the effect of sound on the audience, with its capacity for violence and control, and also with its objectlike projection in space. Describing *The Astronomer* as "an apocalyptic drama of hate and terror ending in an apotheosis of light," Louise Varèse writes of Varèse's desire to "make an audience feel the 'powerful joy' of an intense, terrifying, salutary emotion that would annihilate, at least momentarily, the personal ego."[22] In the final scene of Varèse's sketch, factory sirens and airplane propellers were to sound. Their "music" was to be as strident and unbearable as possible, so as to terrify the audience and render it groggy. At that moment "the powerful

spotlights supposedly raking the sky up on stage would be turned abruptly down into the auditorium blinding the audience and filling them with such panic that they would not even be able to run away."[23] "Made groggy" by sound before it is blinded by light, the earthly audience is finally paralyzed by panic—while in a biblical rendition of complete stasis, the mob on stage is turned to stone. The astronomer, on the other hand, is volatilized into interstellar space, embodying the composer's desire for "sound projection"—the fourth dimension in music, which Varèse explains as "that feeling that sound is leaving us with no hope of being reflected back, a feeling akin to that aroused by beams of light sent forth by a powerful searchlight—for the ear as for the eye, that sense of projection, of a journey into space." Similar to Varèse's scenario for *Espace*—which incorporated many of the ideas of *The Astronomer* and was also never produced, this space is not, however, soundless, for here there are: "Voices in the sky, as though magic, invisible hands were turning on and off the knobs of fantastic radios, filling all space, criss-crossing, overlapping, penetrating each other, splitting up, superimposing, repulsing each other, colliding, crashing. Phrases, slogans, utterances, chants, proclamations: China, Russia, Spain, the fascist states and the opposing democracies, all breaking their paralyzing crusts."[24] Becoming wireless, moving into an ether-eal ontology, Varèse, his astronomer and his sound, do not have to face the finality of nonexistence. Artaud's scientist, however, is denied this luxury. He cannot simply disappear into the futuristic, technospiritual space that Varèse imagined, because space is the place of matter, and matter is irrevocably meaningful, "carrion." The solution is the necessity—terrible though it might be—of cruelty. "We are not free," writes Artaud, "and the sky can still fall on our heads. And the theatre has been created to teach us that first of all."[25] As the sky falls, space is eradicated: the space between the human and the cosmos, between the spectator and the stage, between the word and the thing. Without space the sounds and noises, the onomatopoeic and glossolalist utterances that populate Artaud's universe, lose their echoic quality and are no longer a reflection or imitation of some thing or event. Without space there is no distance between the original and its reproduction, between being and representation, since materiality itself—even when it is as invisible, intangible, and ephemeral as sound—cannot take place.

A reading of "There Is No More Firmament" illuminates a series of processes in Artaud's hermeneutics, which repeat this antispatial logic. The first process has physical matter giving way to states, energies, and

forces, adopting the phenomenality and immateriality of sound, while sound itself becomes increasingly objectlike. Sound rushes forward. A second process transforms sound and light into code while developing a transmitted corporeality: the soul is reduced to a "skein of vibrations" that are like the pulses of a signal.[26] Everything stops and starts. A third process eradicates matter by dissolving the logical conditions for its existence—space and time—everything stops. The final process extinguishes existence altogether through an act of automatic cruelty: A cold light reigns. Similarly the first movement of "There Is No More Firmament" begins:

> Darkness. Explosions in the dark. Harmonies suddenly broken off.
> Harsh sounds.
> The music gives the impression of a far-off cataclysm; . . . Sounds fall as if
> from a great height, stop short and spread out in arcs, forming vaults
> and parasols.[27]

Here sound has a kind of materiality that allows it to fall and to form "vaults and parasols," creating an almost visible acoustic architecture. It is also individuated "when one sound stands out, the others fade into the background accordingly," which appears after the line "Street cries. Various voices. An infernal racket," giving the impression that the sounds are also acting like individuals on the stage, whereas the actors are a conglomerate mass. Having been produced as an object, sound then takes the form of communicative code transmitted over space: "The sounds and lights break up into fits and starts, jerkily, like magnified Morse." This pulse of sound and light becomes "the din and lights of a modern street intersection at dusk"—a site of continuous stopping and starting amid rapid movement, a site of strict observance of signals, a site where people become pedestrians, and there is a certain reciprocal automation between the car and the body. The actors on the stage cluster in groups, forming patterns with "varied and contradictory movements like an ant-hill seen from high up." The sounds of the city move rapidly from vocal "street cries" to "an infernal racket." The voices begin to indicate that something strange is happening to the sky, but their short exclamations are overtaken by "tornadoes of sound," heralding a prodigious, haunting voice from above, that blurts out the beginnings of an announcement. Like a recording, the announcement continually repeats, but never finishes its message; like a ghost it is heard "as in a dream."[28] The actors become deranged—reminiscent of scenes from the plague there is debauchery, a feeling of being on fire.

The intersection and all it contains become a single whirring machine—
it all stops and starts, goes on and off, and when it stops, it is as if the
flow of time itself ceases. So already we have a correspondence between
telegraphy, aurality, and human automation propelled by the reductive
formulae: on/off, stop/go. Automation is implicit in both Artaud's and
Varèse's desire for new (probably electronic) instruments that would
bypass musical or linguistic meaning.

In 1939 Varèse remarked that he wished for a musical instrument, a
sound producing machine that "will reach the listener unadulterated by
interpretation" and be able to read the new "seismographic symbols"
that the "living matter of sound" requires for its notation. Similarly,
Artaud's actors, as hieroglyphs, are "raised to the dignity of signs" and
therefore able to be recorded and then reproduced "at will."[29] Signs
also exist in the being of sound, as its objectification in space is realized
through the amplification, recording, and reproduction that would
accompany both Varèse's and Artaud's designs.

Throughout the second movement, news that the sky is falling is
relayed through news vendors, whose announcements are again incom-
plete, abrupt, repetitive, assuming the rhythm of Morse code—with
their distinct pauses signifying the stop often articulated during the nar-
ration of a telegraphic transmission. Gradually the full message is
revealed. A scientist has discovered "celestial telegraphy," which has
allowed him to establish "interplanetary language." As a result, the sky
has been physically abolished, and the earth is about to crash into the
planet Sirius. The crowd talks about energy, volatilization, and the end
of the world. In the third movement, the sound of matter in its death
throes occupies the stage. A woman with a huge belly enters while two
men beat alternate sides with drumsticks. The Internationale is sung in
the background reaching titanic pitch, the stage transforms into a "real
beggar's alley" with hideously deformed creatures rising from the
depths. "Every spasm, every belch of the dark chorus brings on a new
wave of faces." A character called the Great Pointer enters the stage and
makes a speech "but the end of each phrase echoes on, ending in cho-
ruses which themselves end in unbearable yelps." Sound falls and fades
into space, while speech degenerates into cacophony. All is reverbera-
tion and noise, space, corporeality, fetid matter. In the final movement,
speech becomes abstracted, initially through the ordering of music. A
lone scientist and his colleagues discuss the discovery (of celestial teleg-
raphy). We hear "intellectual castrati and scientific basses," and there is
a "different tone from one group to the next, fluctuating, changing

accentuation, pitch and speed, etc. etc."[30] Science and music join in
what is evidently a catastrophic union for the sound of matter—indeed
for matter itself. The scientist is approached by some of the scholars
who conduct a conversation in sign language. The discovery is declared
immoral by some, while others claim that science comes before every-
thing else. They mention instantaneous radiation and connect it with
the end of the universe. However, the scientist has no time for moral-
ity—he has already begun signaling:

> "There you are," he says.
> He rushes over to his apparatus.
> Night comes on as the curtain falls.
> Sounds rush forward, made up of the blast of several sirens at their highest
> point. Violent percussion intermingled.
> Cold light reigns everywhere.
> Everything stops.[31]

As mentioned, Varèse was not happy with this scenario, and the piece
was never produced. Perhaps it was the lack of overt romanticism and
idealism in Artaud's scenario that disappointed Varèse. Perhaps Artaud
simply went too far in articulating the devastating but logical outcome
his new mode of communication presupposed. Artaud's deployment of
sound parallels that of Varèse too closely for a kinship not to be
inferred. What happens to the body, and to sound, in the respective ver-
sions of the piece, provides a way of reading each through the other. Yet
although Varèse also entered a state of suicidal depression following the
failure of this piece and its progeny, *Espace,* to be realized, he was, at
this stage at least, reluctant to extinguish physicality and aurality in
order to close his mythic narrative. This is not to suggest that Varèse
objected to wirelessness—there are indications that telegraphy—or at
least the transmission of signals—was at work in Varèse's conception of
the piece. A sketch from 1928 includes the "discovery of instantaneous
radiation"—and the unexpected transmission of signals from Sirius.
The communication is via prime numbers—Sirius transmits 3, 5, 7; the
astronomer responds with 11, 13; Sirius answers with 17, 19. Sirius,
now aware of the earth's existence, threatens to destroy it. However, the
signals—sent as prime numbers—also come in musical waves. Varèse
writes: "Regular messages from Sirius. Mysterious—in musical waves
(supple, fluctuating). The Wise Men study them. Perhaps it is the
acoustical language of Sirius."[32]

These details reveal a marked difference in the way that Artaud and
Varèse regard telegraphy, transmission, and transmutation. In the causal

chain of this narrative, catastrophe occurs as the result of the aggressive inclinations of Sirius and is only incidentally linked to the act of transmission. For Artaud, it is transmission itself that annihilates not only the cosmos but, more profoundly, the conditions necessary for existence. In Varèse's sketch, sonority is maintained throughout the transmission, whereas for Artaud, the signal is not sonorous but electrical—it is a "celestial telegraphy" that extinguishes space and therefore sound. For Varèse, the astronomer is unjustly attacked by the mob and, as if by an act of grace, disappears into the ether. Artaud's scientist, on the other hand, is willingly suicidal. He acts with the kind of determination that Artaud associates with cruelty, and his actions embody the absolute necessity that cruelty demands: "Cruelty is above all lucid, and a kind of rigid control and submission to necessity. . . . In the practice of cruelty there is a kind of higher determinism, to which the executioner-tormenter himself is subjected and which he must be determined to endure when the time comes."[33]

In many ways Artaud's scientist simply taps out the final sequence of a series of instructions that have been fulminating in the writer's metaphysics. In company with the eviscerated head of the spectator that would view Artaud's virtual theater, and the hieroglyphic actor who would perform on its stage, the scientist executes the only operation left to a universe in which extension is ultimately rendered, not in the form of objects, or states, or even symbols, but as code. The necessity for this transformation from thing to sign to data is guaranteed by the actual annihilation of space and time, which, in an implosive and backwards slip, removes the conditions for the very possibility of matter. A quality of compulsive resignation contaminates the scientist—correlate to the contagion of matter—reducing his actions to those of an automaton, for whom consequence is not an issue. This resignation is made possible in the first instance by the automatic system, the automatic pulse of the on/off. The scientist must first of all submit to the language or code of the order, and the response that the order demands: yes/no/stop/start/ on/off. He must have resigned himself to accepting and understanding— to speaking and hearing—this language. And when this ordered sequence comes to represent not only things and individuals but states (like sound and space), then the conditions for life can be ordered and extinguished, in an act of metaphysical succinctness that bears the logic of a universal physics. The automatic act becomes, instead, a metaphysics of nihilism, that is, a metaphysics that can be resolved only through extinction.

INTERIOR BROADCASTS

Artaud's apocalyptic scenario, triggered by the rationalization and computation of space, could be read as a prescient dramatization of the automation and virtualization that would come to mark the postatomic era. The cruelty of Artaud's final scene is less the act of annihilation than the supreme resignation that would allow even the conditions of life to fit an equation: a simple on/off of transmission. This resignation, occurring via a series of blips, begins with the potential deceit of a voice as it travels through an encoding and decoding device and ends with the assimilation of a technologically defined presence that—like the vibration or the plague—transmits only itself, in the present, without mediation. Artaud's negotiation of the living spatiality of a phenomenon existing in the here and now is set against the notion of matter as data, creating what appears to be a duality. However, the a-topia of the transmissional pulse and the sonic vibration facilitates this move: belonging nowhere, these concepts are at home equally in the synapses of Artaud's electro-shocked brain as the cosmic tapping of a nervous scientist saying "hi!" to the end of the world. The metaphysical tension of the pulse or vibration is the nanosecond between external and internal, on and off, here and there. It is the shortest possible interval between "this and that" that allows difference to be maintained and the individual to remain cogent. Approaching zero space and zero time, it has a power for which the atomic explosion—"instantaneous radiation"—provides both a good metaphor, and a materiality that telegraphy exemplifies.[34]

While Artaud's text stops with an impossible signal twitching the fingers of a scientist with nowhere else to go, the sonic vibration and transmissional signal reappear throughout discussions of aurality, alterity, and audiophony, as a fused, conceptual substructure that new media would both inherit and exploit. A central component in this fusion is proximity: actual, inferred, and deferred. As mentioned, the telephone normalized the idea of telepresence, while radio created a protocyberspace. Like the trope of immersion used in new media, the radio spectrum provided both a concept and medium through which listeners could become enveloped, absorbed, and sometimes possessed. Unfortunately this was not to be for Artaud, whose engagement with radio left him silenced and earthbound. The censorship of his *To Have Done with the Judgement of God* from a radio broadcast confirmed his belief that the microphone, like the screen or the stage, is just another form of representation, sanitizing and paralyzing life. Again, presciently, he wrote: "There is nothing I abominate

and shit upon so much as this idea of representation, that is, of virtuality, of non-reality, attached to all that is produced and shown, . . . as if it were intended in this way to socialize and at the same time paralyze monsters, make the possibilities of explosive deflagration which are too dangerous for life pass instead by the channel of the stage, the screen or the microphone, and so turn them away from life."[35] Filtering the "explosive deflagrations" that might be noise (but might also be the noisy, "odious" texts of writers like Artaud), the "virtuality" of media representation is not only involved with socializing and paralyzing "monsters" but in producing the monstrous. The aural close-up in cinema, for instance, assumes a listener with enormous ears, while the audio recording, by automatically announcing that the voice heard is both absent and past, re-presents a phantom. The "haunted" nature of audio media (to borrow from Sconce) was not lost on writers who witnessed the birth of phonography and saw no contradiction in associating phonographs with both the "inscription of the soul" and the reanimation of the dead.[36] For instance, the Rev. Horatio Nelson Powers wrote "The Phonograph's Salutation" in which the phonograph itself narrates:

> I seize the palpitating air, I hoard
> Music and speech. All lips that breathe are mine
> I speak, the inviolable word,
> Authenticates its origin and sign . . .
> In me souls are embalmed. I am an ear,
> Flawless as truth, and truth's own tongue am I.
> I am a resurrection; men may hear
> The quick and dead converse, as I reply.[37]

For Hubert Greusel, a biographer of Edison, the phonograph articulated the promise of technology and spiritism alike: the conquest of mortality. By "imprison[ing] the human voice with all its infinite meaning," the phonograph has "taken the sting from death," for sound, music, and the voice: "dies only in the seeming . . . whatever sound ever was, still is; therefore may be, again; and once set up, goes on forever; just as, in another sense, man's deeds live after his body has turned to dust."[38] In listening to the recording, the auditor, it was assumed, would be transported to the time and the place of the original event. He/she would experience the reproduced voice in all its presence—almost as if it were there, in the middle of the living room. Given that the value of the phonograph was often tied to its ability to record people and events before they passed away, the recording became a testament to the past— always speaking the absence of the body that owned the voice coming

from the speakers. Beckoning presence from other times and other places into the ambience of the moment of hearing, merging that present ambience with the three-dimensional, existential, and what may appear to be the ontological presence of the voice or song it has so faithfully preserved, the record could take the sting out of death by emanating death; by re-presenting, in the present, the ceasing to be of voices and events. Such tributes reflect ways of thinking that locate the miracle of the phonograph in not only the materialization of sound but its new perdurability; recorded sound continued to exist through time, it could be stored and repeated infinitely, and, unlike its visual counterpart and predecessor, it reproduced the three-dimensionality of the original. While the photograph's relation to the real may have been in question, the recording seemed to evade the stigma of technical mediation. In 1878 Edison claimed that the stylus can "effect a restoration or reproduction of vocal or other sound waves, *without loss of any property essential to reproducing on the ear the same sensation* as if coming from the original source."[39] Some fifty years later, Harry F. Olson, the famous pioneer in sound recording and reproduction, defined the ideal of sound reproduction as "the elimination of distortion and the reproduction at the listener's ear of sound waves identical in structure with those given out at the source."[40] The immersiveness of sound, its three-dimensionality, set a precedent then for the evacuation of the technological apparatus in the production of audio, supporting the belief that three-dimensionality overrides the fact of mediation, and thereby creates a space that is beyond technology and culture.

Establishing a credible, though unobtrusive, interface between reality and artifice, the real and the reproduced, has been a constant preoccupation of media technology. Like the speaking tube of deific transmission, it has been necessary to construct and then deny a mechanism that channels, delimits, transduces, and sanitizes the materiality it transports. These interfaces are both technical and conceptual—consisting of wires, circuits, relays, etc., and transcendent spaces, such as the ether, the cosmos, or the irreducible vibration, to which the technical infrastructures are conceptually attached, and through which the presence of technology is masked. In the discourse of sound and audio, the technical/conceptual interface enabled a proximity between sound, auditor, and technology that fused the source and its technical reproduction. The construction of this proximity was aided by a rhetorical strategy that reanimated the "inner voice" of metaphysics, while anticipating the rhetoric of new media. We see this rhetoric in the descriptions of cyberspace

by the early cybertheorist Michael Benedikt, whose metaphorical palette is dominated by fluid and gaseous analogues for the immateriality that radio also shares. Cyberspace is "a soft hail of electrons" that "fills like a lake," while radio is a medium "not unlike the air itself— surrounding, permeating, cycling, invisible, without memory or the demand of it, conciliating otherwise disparate and perhaps antagonistic individuals and regional cultures."[41]

In the context of radio, this dynamic played out in the gradual elimination of physical space between the listener and the broadcast or recorded sound, and in its replacement by the inner sound and transcendent experience that ideal radio offered. In the same way that the telephone moved from multiline to one way, radio gradually became a one-way broadcast medium, used mainly for commercial purposes. Amateur or "ham" radio flourished in the United States, particularly among youth (mainly male) who were active in sending, intercepting, and receiving messages, forming clubs and associations, and contributing to the development of radio technology itself.[42] However, the participatory zeal of DXers, as they were known, their autonomy from government and their sometimes rebellious spirit, led to radio's fairly sudden domination by corporate and government interests. It was felt that the ether was becoming too crowded, too noisy, too overpopulated with inconsequential messages, and some amateurs refused to give precedence to the transmissions of government institutions. The interference during the *Titanic* disaster prompted the U.S. Congress to restrict the amateurs' transmissions to a small section of the spectrum— short waves—and to enforce licensing. Susan Douglas cites the response of a "ham" radio operator when asked to vacate the spectrum: "Say, you Navy people think you own the ether. Who ever heard of the Navy anyway? Beat it, you, beat it."[43]

Debates over who owned the ether were masked by the narratives of commercialism and patriotism: radio became the assumed catalyst whereby the increasing isolation experienced by individuals at the turn of the century would be transformed into one culture, one civilization, united through the single voice of a leader, radio star, program, or product. This would occur through the individual, separate, and private experience of listening to radio in the home.[44] While the "simultaneity" of broadcast helped establish a serial community listening, at the same time although not in the same place, this "community" was in fact highly regulated through programming schedules and the imposition of purely radiophonic rhythms that curtailed the flows of sound present in music,

voice, and ambient sound. As radio owners were persuaded to stop their eternal tinkering with the set and focus instead on the increasingly differentiated program schedule, radio became more and more associated with the consumption of media presence than with technical innovation and ethereal experimentation. Reaching less to the stars than to the nation, radio embarked upon a process of interiorization; it was no longer part of a communal achievement (to build and then tune a set), nor was it a gateway to the universal etheric "brotherhood," but was located first within the individual's family, and later within the listener's psyche.[45]

In a foretaste of the commercialization of the Internet, the increasing control of radio coincided with claims by prominent theorists of communications media regarding its utopian potential. Sound's ethereality and technology were brought together to provide a rationale for, and celebration of, the kind of material and spiritual transcendence that may have begun with radio but would blossom sixty years later into the trope of immersion specific to new media. Here, sound, united with the electronic broadcast of the voice, begins an epic journey: first projected into a transcendent and cosmic electronic ether, then received within the technologically enhanced, private space of the individual auditor. From here, and especially through headphones, sound enters and affects the individual's psyche, reconnecting the individual to a restored, enchanted community. This passage presumably neutralizes the cultural and machinic aspects of both language and technology, by attaching audio media to an Edenic past and projecting it into a technologically enhanced future. Sound and wireless are uniquely suited partners in this rhetorical enterprise, as evidenced by the frequency of their pairing and the breadth of their transformative and englobing purview. As early as 1936, Rudolph Arnheim emphasized the aurality of radio art: "This aural art reverts, so to speak, to those primitive ages . . . long before the invention of actual human speech. The pure sound in the word is the mother-earth from which the spoken work of art must never break loose."[46] In 1964 McLuhan wrote: "Radio affects most people intimately, person-to-person . . . [its] subliminal depths are charged with the resonating echoes of tribal horns and antique drums. This is inherent in the very nature of the medium, with its power to turn the psyche and society into a single echo chamber . . . of magical power to touch remote and forgotten chords."[47] For Gaston Bachelard:

> Radio uniquely presents the possibility for communication between the human psyche . . . the unconscious . . . [and] the foundations of human originality. . . . [Radio] is not merely a function transmitting truths or news.

It must have an autonomous life of its own in this logosphere, this universe
of speech, this cosmic conversation which is a new reality for man. . . . Radio
must find a way of bringing the "unconscious" into communication. It is
through them we will find a certain universality.[48]

In the same way that Freud linked the telephone to the process of psy-
choanalysis, writers such as Arnheim, McLuhan,[49] and Bachelard gave
radio the task of revealing the unconscious in the context of a shared
community of listeners. Radio broadcasts to the interior of the individ-
ual—the "house of our dreams," within the interior of their home—"the
seat of privacy and inwardness." This scenario is complemented by the
anonymity of the listener, opening an "axis of intimacy, the inward per-
spective."[50] Interiority, intimacy, a sense of shared listening, ancient
ritual (the "tribal drum"), the sacred, and sound are crucial rhetorical
elements in the developing conception of radio as an internalized, elec-
tronic *medium*—in both spiritist and communications senses of the term.

Prefiguring a common theme of new media, expressed by writers
including Howard Rheingold, Walter Ong emphasized radio's aura of
liveness and democratic participation and credited it with restoring
presence to the word and individual to community, through what he has
termed a "secondary orality": "This new orality has striking resem-
blances to the old in its participatory mystique, its fostering of a com-
munal sense, its concentration on the present moment, and even its use
of formulas. . . . Like primary orality, secondary orality has generated a
strong group sense, but [it] generates a sense for groups immeasurably
larger than those of a primary oral culture . . . we are group minded self
consciously and programmatically."[51] Like the idea of the noosphere, or
the more contemporary datasphere, notions of secondary orality were
situated within a larger ambivalence toward media and technology and
were expressed in popular culture during the nineteenth and twentieth
centuries.[52] Predating "cybergnosis," which, as Oliver Grau writes, is
"being invoked unconsciously" both as a panacea for the upheavals
wrought by rapid technological change and as an expression of "a
longed-for state of transcendence, a variant of gnosis,"[53] secondary
orality emerged as a way of bridging the gap between a lost nature and
an oppressive culture and offered a potential means of delivery: of infor-
mation and entertainment, and from the anxieties industrialism had
wrought. Couched in terms of a print/orality dichotomy, the latter rep-
resented the ideals of community, integration, and tradition found in
preliterate cultures, whose uniqueness and difference was rapidly disap-
pearing with the spread of communications.[54]

For Ong, this deliverance was almost biblical—radio and audio rean-
imated and resonorized the dead voice of print: "voice, muted by script
and print, has come newly alive," the "aliveness" being seen as congru-
ent with sound's "marketability" (records) and "recuperability" (record-
ings and tapes).[55] Because the "life" of electronic sound is intimately
connected to its reconfiguration of time, it also involves a refiguring of
mortality: "While the present age has in a new way validated the use of
sound and thereby in a new way validated time, since sound is time-
bound, existing only when it is passing out of existence in time, the
present age has also established man in a radically new relationship to
time. . . . Compared with that of earlier man, our sense of simultaneity
is supercharged, and our reflectiveness supercharges it even more."[56]
Offering a model of individual psychic development that parallels the
technological development of the twentieth century, Ong argued that
humanity has reached a level of "mature sociality" that is connected to
a sense of supra individuality created through the "omnipresence" of
instantaneous transmission.[57] By annihilating time, space, and (hence)
mortality, the electronic word maintains an original purity and divinity,
and again this is ensured by sound. "Sound," wrote Ong, "bound to the
present time, . . . advertises presentness." Here "the present" becomes
"presence" such that "even the voice of the dead, played from a record-
ing, envelops us with his presence."[58]
 Ong's theorization of secondary orality was based on a conception of
the electronic voice as "live," "spontaneous," and somehow inviolable.
Two rhetorics combine in this formulation. First, the phenomenon of
electricity, manifested by the reanimated (read "resonorized") broad-
cast voice, is represented as a third term through which the loss of face-
to-face presence that literacy inaugurated is recuperated. Electricity and
technology thus act as a conduit through which the presence of the
voice, in its metaphysical guise, can be reasserted. The characteristics of
inner speech: that it is silent, atopic, self-directed, and timeless can easily
be transferred to the perception of the electronic voice, since both occur
in the absence, the here-and-now embodiment of the speaker. Second,
the characteristics of aurality are represented as immanent to speech:
"The word is originally, and in the last analysis irretrievably, a sound
phenomenon . . . [it] cannot be seen, cannot be handed about, cannot
be 'broken' and reassembled."[59] Finally, sound and the act of speaking
are linked to an irreducible (and sacred) interiority: "The interiorizing
force of the oral word relates in a special way to the sacral, to the ultimate
concerns of existence."[60] This "special" way turns on the "eventfulness"

of the spoken word, which is a function of the temporal nature of sound, and on its ability to reveal "human beings to one another as conscious interiors."[61] Connected to the unconscious through the ears' labyrinth, to the heavens through the ether, and to the divine through the Word, radiophony becomes associated with a cosmic truth that is verified by notions of acoustic truth.[62] The broadcast of sound thus guarantees that the radio voice—moving both inside and outside the body at once, plundering the interior depths, and at the same time involving itself in a "logospheric" communication—will embody the truth of sound and the authority of the original, deific disembody.

One important technology in this context was the microphone—in particular, its ability to make audible sounds that are inaudible to the unaided ear. Operating along similar lines to the telephone, the term "microphone" arose from its similarity to the microscope in being able to discover very faint sounds. As Count Du Moncel commented in 1879, the microphone could amplify even a "fly's scream, especially at the moment of death."[63] For later writers, the microphone gave the listening experience a particular kind of authenticity, through its ability to close the physical gap between sound and listener. Arnheim believed that an intimate radio voice—enabled by the close-miked voice—is a physical fact of broadcast as much as a psychological ideal, and that it produces a spiritual proximity between speaker and listener: "The physical fact that the normal distance between sound-source and microphone is *inconsiderable,* implies as a normal condition of the art of broadcasting a *spiritual* and *atmospheric* nearness of broadcaster and listener." Because the "distance between the microphone and the source of sound is very small," Arnheim automatically assumes a recording perspective in which sound is amplified to a degree that the human ear, no matter how close it was to the sound source, could never hear.[64] This physical proximity is enhanced by a style of radio talk whose intimacy *corresponds* with the equipment.[65] The intimate voice creates, in Arnheim's words, a "Stimmung" or atmosphere, associated with "the cozy parlour," on the one hand, and the "Heavenly Father . . . unseen yet entirely earthy," on the other.[66] By eliding the distance between the source of the sound and its transmission, Arnheim denies any mediating or representational function the microphone might perform. But more than this, by describing the assumed proximity between broadcaster and listener as "atmospheric" and "spiritual," he connects the spiritist origins of radiophony with the broadcast apparatus, and with the listener—since there is no distance between these realms in his formulation. To be spiritually

proximate means to be "at one" (or in tune, or resonant) with the divine; to be atmospherically proximate is to be within the same time and space. In both cases, radio and the listener are joined to, indeed become, nature and the cosmos through the channels of the intimate voice.

A Renaissance perspective for the ear—one that situates the listener at the infinite, atopic coordinate of mind-to-mind reception, the audio recording dissimulates the presence of the technology, as Rick Altman has noted.[67] But technology is also strangely signified in this set-up. Ong's description of the electronic voice as "reanimated," for instance, reveals a perception of the broadcast voice as sonically and electronically charged, and endowed with imaginary characteristics. Listened to through headphones, in the dark, quiet intimacy of the living room, this already "stratospherized" voice becomes a screen for the projection of listeners' fantasies, its *significance* (Barthes) being overdetermined to the extent that the actual voice of the speaker becomes a phantom, enfolding the sound of transmission and amplification within its very timbre. By amplifying the volume of the voice at close range, rendering inaudible any extraneous sound, and concealing as much as possible the presence of the technology, the broadcast voice echoes the autoaffective circuit of its metaphysical corollary. As Ihde notes, the notion of an authentic voice "is at base a concern with a single voice . . . [it] harbours a secret metaphysical desire for eternity and timelessness."[68] While still aural, this voice has been evacuated of sound in the world, becoming something of a sound effect. Its authenticity is based on processes that eviscerate the embodied sociality, the necessary noise, of the voice, without which it speaks in silence. Solipsism, reflected in the concept of the "inner voice" in Western metaphysics, is an attempt to shut out the corporeal or phenomenal exterior, to close the gap between the mind and its thinking. The eradication of time and space is also the *raison d'être* of audio technologies; it is the attempt to install an anechoic vacuum, a space without distance, an absolute space that bodies, being voluminous things, cannot occupy, but through which voices—infused with electricity, defused of breath—can travel. The space of the broadcast network, the "ground" of the telephone system, is mapped again, by a reified and closed circuit, transmitting from mind to mind, without any airborne or corporeal externalization.

CHAPTER 3

Aural Objects, Recording Devices, and the Proximate Apparatus

Arnheim's prescriptions for the art of radio ca. 1936 were soon to move beyond the confines of the radio feature broadcast (the *Hörspiel* or radio play in Europe), as sound became a compositional material rather than a support for the spoken word. The microphone and magnetic tape were essential technologies in this development, and both were surrounded by, and indeed produced, certain narratives about the meaning and being of sound that far exceeded the technological frame that was their foundational support. Within these narratives, the three-dimensionality of the audio recording seems to absorb the presence of the technological interface, disappearing into a pseudo-animistic and spiritually inclined phenomenology. At the same time, sound becomes fettered to a notion of the "sound object" through the dual imperatives to first—find a way of discussing and representing sound unhinged from the visual object, second, find a device (the tape recorder) that will somehow enable such a representation, and finally, mask the mediation of that device by arguing for an ontological equivalence between the reproduced sound and the original sonic source. In the following I will discuss the key technologies, practices, and philosophical ideas associated with the microphone and magnetic tape, and the role these technologies played in creating both the discursive sound object and the transcendental "audio object." While the notion of the aural object has been critical for the development of sound theory, by being knowable only through audio, the sound (read "audio") object set a precedent for

"unmediated" media. This concept would reappear in new media theory, initially through the development of three-dimensional visual simulations that became known as "immersive" and were, like the audio recording, represented as unmediated by technology. Three highly influential composers/sound theorists: John Cage, Pierre Schaeffer, and R. Murray Schafer were, with their respective philosophical methods of "non-intentionality," "acousmatic listening," and "clairaudience," central to the developing phenomenology of sound, and they initiated discussions of the relationship between the visual object, the sound object, and audio technology. However, their involvement with technology also follows a familiar pattern, one that recurs in the theorization of new media, in which we find the phenomenality of aurality, and the visuality of Western culture combining in a variety of ways to suspend the instrumentality of audio, projecting it beyond the determinations of technology and media culture into a peculiarly transcendent space—surrounded by sound, but ultimately—as I will discuss—resting in an irreconcilable silence.

MUSIQUE CONCRÈTE: SCHAEFFER

Pierre Schaeffer was one of the first sound practitioners to theorize the notion of the aural object in relation to recording technologies. After various collaborations with Pierre Henry and decades of research, Schaeffer published his *Treatise on Musical Objects* in 1965–66 accompanied by a phonograph record ("Solfège de l'objet Sonore") of sonic experiments he had undertaken with the assistance of Guy Reibel, Beatriz Ferreyra, and Henri Chiarucci, who formed the Groupe Solfège (Music Theory Group). In the text, Schaeffer grapples with some of the most difficult musicological debates that audio art and electronic composition in particular had ignited, concerning the meaning of music, its system of referentiality, its status as a language, and the possibility of hearing sounds in themselves. While Schaeffer drew various parallels between music and language, "acoustics" and "acoulogy" (*tonic solfa*), "musical theory and rules of composition," his project for a "sound morphology and musical typology" via his concept of "objets sonores" stops short of reducing music to language: "Music cannot be boiled down to a well-defined language, nor can it thus be coded merely by usage. Music is always in the making, always groping its way through some frail and mysterious passage—and a very strange one it is—between nature and culture."[1]

Regarding the perception of sounds in themselves, Schaeffer devised a method of training the ear in order to escape "conventional listening habits," and, faced with the impossibility of describing sounds in themselves using text, he appended the recording with intricate textual notes, so that a sound heard is immediately followed by analysis. Schaeffer's "Theory of the Sound Object" proceeds by an analysis of musical and perceptual parameters (the correlation between frequency and pitch, the enigma of timbre, thresholds of listening, the relationship between the duration of sounds and their perception), employing a methodology based on his phenomenological approach of "reduced hearing." He discusses music in physical/acoustic and psychological terms, and the sound object as a composite of the various correlations between "sound, which is the physical vehicle of music, and pertains to nature, and the sum of psychological phenomena of perception which constitute the sound object." Together, the physical and psychological form part of a "sound morphology and musical typology."[2]

However, when Schaeffer approaches a pivotal section of the *Treatise,* entitled the "morphology of the sound object," his comments become more discursive and allude to the breakdown of distinctions between sound and music, composer and engineer, studio workshop and performance stage. The audio examples chosen are excerpted from *Three Dances* for two prepared pianos, by John Cage ("a famous tinkerer combined with musician—sometimes of genius"), followed by *Bidule en ut* (thingamabob), which Schaeffer created with Pierre Henry. In this piece Schaeffer produced "unorthodox fugato scales on record-players" in the workshop, while Pierre Henry played the prepared piano in the studio; and in the *Treatise* Schaeffer uses the partition between the performer and the workshop as a metaphor for the dissolutions between music, and what would become known as sound art: "Music could therefore be attempted on both sides of the partition, but also on the threshold of a door through which noises had apparently never been allowed to pass. In order to achieve the status of music. This was no stage door but at most the tradesman's entrance. . . . That is how noise knocked at music's door and made it creak and groan." But the creaks and groans were never deafening. Amid the noisification of music, or the musicalization of sound, Schaeffer imposed limits: not anyone or anything could produce music because "a sound extracted at random from its causal context cannot be so easily incorporated into a musical pattern whose principles have been evolved over centuries." His solution was to open music to particular sounds—sounds he called "objets sonores."[3]

These were distinguished by being independent of context, devoid of "extramusical information," and could not be confused with the sounding body that produced them. These criteria effectively eliminate acoustic instruments, or material objects, from the repertoire of possible sources for *objets sonores,* as they are too recognizable. If, argued Schaeffer, "our aim is to forget about origins, [then] the most effective tool will be anonymous magnetic tape." Tape, however, was also beset with problems, for it encouraged a misrecognition of the recording itself as an object, when in fact a detail like tape speed, for instance, will completely change the sound produced.[4] In search of a definition for authentic *objets sonores,* Schaeffer also dismissed the practices of editing and transposition because of their fragmenting effect on the "causal coherence" of a sound that "coincides with the fleeting history of an acoustic event." The experimental practice of tape cut up—forerunner to sampling—was considered to be particularly dangerous in this regard: "Just as a magnet can be broken into several smaller magnets, so a sound object, when cut into three segments, gives three new objects each with a beginning, body and decay."[5] Caught in the dilemma of seeking an origin without recognition, and a history that is silent to the perceiver yet authenticates the sound like a watermark does paper, Schaeffer turned to the objectivity or reality of a sound guaranteed by the recognition of the same sound by several listeners. But how does the listener recognize or even describe a sound without recourse to its material and visible source, or some form of measurement such as frequency, pitch, and so on? Here the tape recorder is a double-edged sword. As he writes in *Treatise on Musical Objects,* the tape recorder allows sound to be isolated, analyzed in detail, and repeated, thereby bringing "the sonorous object to the fore as a perception worthy of being observed for itself . . . [and] progressively reveal[ing] the richness of this perception."[6] But at the same time, it creates something of an aural chimera whose meaning (and being) depends on the auditor—for recognition of the same sound can only occur intentionally, inducing a "will to comparison" that modifies the sound, rendering it unknowable, in the phenomenological sense, despite the support and theoretical articulation that audio technology provides.[7]

Schaeffer is well aware of the contradiction inherent in his attempt to devise a typology of *objets sonores.* In order to be analyzed, sound must be extracted from its environment, bracketed, and heard in itself, yet at the same time, a sound object "is always determined by the structures to which it belongs."[8] Even if such sounds could be produced by

anonymous magnetic tape "that musical version of Pythagoras' screen which used to veil the speaker . . . allowing only the meaning to emerge," they would lack an auditor; for what kind of ear—extracted from consciousness—could hear them? Schaeffer's conclusion in *Treatise* is to propose a new subjectivity, formed through the practice of acousmatic listening, of "hear[ing] with another ear." This new listening arises from the "operative technique" provided by the tape recorder "which, if it creates new phenomena to observe, it creates above all *new conditions of observation.*"[9]

Despite Schaeffer's desultory estimation of his project some years later, there remains within his text the residual promise of not human but technological perception, which not only provides a context, or mediation, between the sound-in-itself and its perception, but creates new *forms* of perception and indeed new acoustic phenomena.[10] In this context his opening remarks in *Solfège* are instructive. Following a sample of electronic sound (bell-like dongs and electronic tones), he writes: "Such, at the dawn of a new, electronic, age is the chant of the Cologne studio. A strange pilgrimage into the past. . . . But does not the spirit of music, like the spirit of sound, pervade all of nature? A sounding body, when touched mechanically, comes to life and reveals its existence or rather its structure, and thus enters our field of knowledge." Like Varèse and Cage, Schaeffer unites nature and technology in an electronically geared vitalism. But more importantly, he reaches into aurality and the unknowable reality it represents and transforms it into a phenomenon that can be known through a prosthetic ear. Although this transformation occurs through technology, its real import is metaphysical: new, strictly audiophonic phenomena are created, having the same ontological status as nonrecorded acoustic sounds, and these sounds are perceived through a new acousmatic listening, which in turn creates new epistemic conditions. Being, hearing, and knowing move beyond the simply natural and simply human, and yet this movement is grounded in tautological iterations of the aural object and circulates through the dark abyss of music "always groping its way through some frail and mysterious passage . . . between nature and culture."[11] The alterity of aurality, in other words, provides a passage, a route, for a technologically defined subjectivity—one equipped with new modes of perception, knowledge, and self-knowledge, able to resolve issues of language and representation and to hear without the influence of habit or culture, and without distortions and degeneration of technological reproduction.

SONIC CYBERSPACE: CAGE

The persistent connection between "new" and "technology" in the section above reminds us that a significant component of the rhetoric of virtuality originated in the 1960s and 1970s, through the developing sound-art world and the ideas and technologies associated with it. In this context the influence of John Cage cannot be overstated. Best known for his desideratum "let sounds be themselves," Cage's work and writings stand at the forefront of the emerging field of sound theory and sound art. His unique, and at the time radical, methods of composition, together with his equally radical philosophy of sound, opened the musical establishment to sound while at the same time interrogating the very notion of music itself. Unlike Pierre Schaeffer, Cage was not interested in musicalizing sound; rather, like Murray Schafer (discussed later in this chapter), he became increasingly interested in sonic atmospheres and ephemeral environments rather than sonic objects. This interest was complemented by his increasing use of technology as an organizing compositional system, rather than simply one instrument among others. Sound in itself, "sounds pure and simple" became less of a concern than the metaphysical and social promise that self-generating, sonic, and technologically configured environments offered.[12] The various projects, happenings, performances, and collaborations Cage was involved with were notable in their diversity—of participants, technologies, and art forms—and utopian in their aims. For Cage, they embodied the utopic promise he associated with electronics, both for elevating the social good, and more personally for warding off the existential fear that his own philosophy of nonintentionality provoked. There are many key moments in this progression, which I have discussed at length elsewhere.[13] But in the following I will focus on particular works and ideas that are key to both Cage's rhetoric and the post-Cagean aesthetics that would become so influential in the art and technology movement of the 1960s, and in the discourse of cyberculture and virtuality that emerged during the 1990s.

Cage's dissolution of the distinction between music and sound began when he introduced silence as a compositional device. This occurs in three stages: first, he abandons the primary principle of Western tonality, that is, pitch as a means of structuring compositions, replacing pitch relations with rhythmic articulation, and using silence "to separate one section of a composition from another."[14] Duration, substituting for pitch, then becomes the "correct" structuring principle for composition: "Sound has four characteristics: pitch, timbre, loudness, and duration.

Of the four characteristics of sound, only duration involves both sound and silence. Therefore, a structure based on durations (rhythmic: phrase, time lengths) is correct (corresponds with the nature of the material), whereas harmonic structure is incorrect (derived from pitch), which has no being in silence."[15] Written in 1949, this formulation ties the materiality of sound to logical oppositions (sound and silence), on the one hand, and the implication that musical composition should correspond to the nature of sound, on the other. Bringing together the phenomenal and the purely symbolic, music and sound, presence and absence, was, initially at least, a way of destabilizing and then demolishing music as a category. However, as Cage was later to learn, such an equivalence would be flawed by the realization that silence, as such, does not exist.

In the second stage Cage includes the metaphor and materiality of noise. In his hands noise becomes a polysemic lever suitable for inching open the closure that tonality and serialism presented, and a palimpsest for the deeper ontological regions he was now exploring. The latter included a degree of sonic animism that Cage attributed to the views of the abstract filmmaker Oscar Fischinger, whom he met in 1932:

> When I was introduced to him, he began to talk with me about the spirit which is inside each of the objects of this world. So, he told me, all we need to do to liberate that spirit is to brush past the object, and to draw forth its sound. That's the idea which led me to percussion. In all the many years which followed up to the war, I never stopped touching things, making them sound and resound, to discover what sounds they could produce. Wherever I went, I always listened to objects.[16]

By 1936 Cage was experimenting with percussion, melding sound, object, and spirit in a material unity, the unity of the object, which had its formal correlate in the unity of his new rhythmic structure.[17] He explained: "The whole has as many parts as each unit has parts, and these, large and small, are in the same proportion."[18] With silence, sound, spirit, object, and organic rhythmic structure in hand, Cage confronted not only the structural mechanisms but the very *space* and instrumentation of tonality. This confrontation occurred by accident, a pure exigency that, in true Cagean style, substituted for an already established methodology and yet became central to his aleatory philosophy. Finding himself in a hall that simply could not hold all his percussion instruments, Cage created his infamous prepared piano, parting and muting the piano strings, first with a pie plate and more successfully with screws. In this simple tinkerer's act, the crowning technology of

tonality, the virtuosic instrument *par excellence* became a hybrid—a noise machine. While the symbolic end of the piano would later be enacted through its literal destruction by members of the avant-garde; at present it was enough that its performance yield a different spirit; not the spirit of the Romantics, for whom music served as a vehicle for the expression of their emotionally charged intentions, but the more subdued and modest "spirit" of the objects placed within the piano's frame. Substituting "spirit" for affect, Cage succeeded, in muting the strings, to de-mute the object, and at the same time he gave voice to his broader philosophical aim: "What we were looking for was in a way more humble: sounds, quite simply. Sounds, pure and simple."[19]

In the third phase, heralded by *Imaginary Landscape No. 1*, Cage redefines the object, both aural and material, to include the sphere of electronic sounds and devices. The sounding object becomes for Cage an "aural object" whose essence is intricately connected to amplification and transmission. Cage's use of the microphone coincided with a series of compositions—*Imaginary Landscapes,* which he produced "when [he] was using electric or electronic technology." The first of these (*Imaginary Landscape No. 1*) developed from an opportunity that brought him in close contact with not only a large collection of percussion instruments but a radio station able to broadcast "small sounds that required amplification" to an adjacent theater in The Cornish School (Seattle).[20] *Imaginary Landscape No. 1* is a score for two phonographs, one Chinese cymbal, and piano. The piano is played by "sweeping the bass strings with a gong beater," at times muting the strings with the palm of the hand; the speed of the turntables—test tone records (Victor Frequency and Constant Note records)—changes from 33 1/3 to 78 rpm depending on the score's instructions; and the styluses are raised or lowered to produce a sense of elongated rhythm.[21] Cage's foray into the sound and space of transmission was literally to set the tone for his developing philosophy, for as an instrument, the radio studio ironically produced not only sound but the "presence" of the radiophonic apparatus itself. The test tone, as the frequency used to standardize both broadcast equipment and the on-air signal, is considered a standard or measurement more than a sound by radio technicians and producers. Heard only in the inner sanctum of the studio, employed only to assist the interfacing of technology, when broadcast, the test tone in its sound becomes paradoxical: audible yet at the same time placeless, a sound without origin, seemingly abstracted from all material existence and flowing unimpeded by matter, as pure signal through the airwaves.

In the new space of the studio, Cage's understanding of sound changes. Still connected to the object, still evoking a spirit, sound nonetheless is abstracted; its sonic and metaphorical envelope adjusts to the shape and meaning of the broadcast signal. This change is evident in Cage's response to the inaugural performance of *Imaginary Landscape No. 4* (1951), an indeterminate score for twelve radios and twelve performers. Because of its late scheduling on the night of the performance, very little radio signal could be received and the piece was considered by some to be a failure. However, for Cage "the radios did their job that evening quite satisfactorily."[22] By functioning as instruments that were determined (by the radio station) in sonority, they were yet indeterminate in actual audition. In contrast to the percussive object that, once struck, could remain silent only in a vacuum, the broadcast signal, dependent on the workings of an already existing technology, can remain silent in the living silence of the yet-to-be-tuned airwaves. As Cage declared: "listening to this music one takes as a spring board the first sound that comes along; the first something springs us into nothing and out of that nothing a-rises the next something; etc. like an al-ternating current."[23] The "alternating current" can now be seen in the fullness of its electro/metaphysical ambiguity. For the electronic airwaves allow the possibility for a silence that is not dead, a silence re-presenting a presence whose essence is actualized even when its sonorous potential is not. In the imaginary of *Imaginary Landscapes,* sound thus occupies the nonspace of electronics and releases the spirit, not of objects, but of the quasi-objects that constitute technology and are permeated by the animating force or "spirit" of electricity.[24]

Entering the radio studio, Cage leaves behind the everyday notion of objects and locales, positioning the aural within a continually shifting "field" where sound fluctuates between the acoustic and the electronic, the object and the meta-object, the produced and the reproduced.[25] However, within the scope of this oscillation a new unity is provided by technology's ability to "liberate" sounds from objects, in the same way perhaps that sound liberates the "spirit" of the object, therefore providing a neutral avenue toward the essence of the sound itself. Amplification, for instance, allows sounds, which otherwise would remain silent, to be heard via the action of electronic ears, ears that Cage never suggests might have their own modes of constructing sound. Live and improvised radiophonic transmission liberates sound from the objectification recording imposes: "The phonograph . . . is a thing—not a musical instrument. A thing leads to other things."[26] And radiophony,

even when silent, provides technical assistance in the transformation of "our contemporary awareness of nature's manner of operation into art," allowing the art object (and the object of art) to recoup the flux of life: "the radios did their job that evening quite satisfactorily. So you see, I sometimes manage to bring about pure processes."[27] In this way technology becomes a process within the overall metamorphosis of the cultural into the natural, the entelechy of the "natural" and sounds in themselves, becoming dependent upon and almost overshadowed by technology's "liberating" force.

Substituting the "process" for the "thing," Cage seems to be abandoning the object in favor of the medium; a record is a "thing" while a radio transmission is not. At the same time, the concept of process becomes a rubric for ideal artistic practice, integrating the artist with *sounds in-themselves* in a continuum of creativity and creation. The materiality of sound is abstracted through the various equivalences Cage draws between aurality and his developing artistic method. For instance, sound's ephemerality represents for Cage a material equivalent to the concepts of "interpenetration," "unimpededness," and "non-obstruction"—active processes that ensure the indeterminacy and hence freedom of performance when adopted as a creative strategy.[28] Similarly, sound's ambiguous ontology becomes a trope for the "letting go" inherent to the process: "A sound possesses nothing, no more than I possess it. A sound doesn't have a being, it can't be sure of existing in the following second. What's strange is that it came to be there, this very second. And that it goes away. The riddle is the process." Working with concepts such as "interpenetration" and "nonintentionality," the "hitherto unimaginable"—sound in its semantic and referential ambiguity becomes for Cage an aesthetic and ethical template, giving his Zen-influenced prescriptions for the conduct of life a nonphilosophical, material, and uniquely sonic grip on reality. Through the metaphor of sound, being emerges from nonbeing, and subjectivity is formed through the withdrawal of the intentions, judgments, and the self-consciousness of the auditor-artist.[29] To see this more clearly it is helpful to note the allegory of Zen enlightenment Cage applies to music, substituting "music" for "Zen" and "sounds" for "mountains," and concluding that like enlightenment the realization that "men are men and sounds are sounds" comes only after "one's feet are a little off the ground," that is, after one has gone through a process of estrangement from the naive perception (sounds are sounds) to abstract intellection (sounds are tones), in order to see the original perception in its complexity.[30]

Artistic pursuit, "letting be," can now be defined as "bring[ing] into co-being elements paradoxical by nature . . . the whole forming thereby an organic entity." As such, the "organic entity" is able to penetrate contradictions, both musical and epistemic. Yet Cage's organicism is primarily centered in electronic transmission, as he writes: "Urgent, unique, uninformed about history and theory . . . central to a sphere, without surface, its [sound's] becoming is unimpeded, energetically broadcast. . . . It does not exist as one of a series of discrete steps, but as transmission in all directions from the fields center."[31]

Cage confirms the obvious influence of the radio studio and notes that composition—structured according to an organic rhythm and embracing any and all sounds including silence, is also the domain of sound engineers, who "seemingly by accident" meet the artist: "by intersection, becoming aware of the otherwise unknowable (conjunction of the in and the out) imagining brightly a common goal in the world and in the quietness within each human being."[32]

CAGE MEETS SCHAEFFER:
TECHNOLOGY AND PHENOMENA

In the space and metaphor of the studio, Cage's phenomenology meets Schaeffer's *acousmatics,* with similar rhetorical results. Between 1952 and 1965 Cage produced five major pieces using magnetic tape and four works for radio, adding to his "electronic" ensemble microphones, loudspeakers, and tape loops, plus the curious "percussive" device of the phonograph cartridge, which appears in *Cartridge Music* (1960), scored in part for "amplified small sounds."[33] These experiences led him to claim in 1957 that technics, in this case magnetic tape, could not only alter but generate a "total sound-space . . . the limits of which are ear-determined only."[34] Like Arnheim, Cage finds in audio technology a correspondence that both honors the nature of the material and provides an avenue to a spiritual/existential mode of (ideal) being. The vicissitudes of the equipment (the lack of synchronization in tape machines for instance) encourages an acceptance of indeterminacy in performance and composition, which also parallels the multiplicity found in nature.[35] But while the performance may be indeterminate for Cage, the sonic metaphor remains stubbornly object oriented. The materiality of tape supported Cage's "art into life" philosophy, yet it also reaffirmed his already established views of sound as some kind of object, the being or "center" of which could be released through the

incisions of razor blade. Commenting on *Williams Mix* in 1958, Cage advocated the method of splicing tape used in its construction as a means for "heighten[ing] the unique element of individual sounds, releasing their delicacy, strength, and special characteristics."[36] Similarly, Cage saw the use of amplification as a means of projecting sound outward from an inaudible center toward the human ear. This radiant movement included objects and bodies, as evident in *0'00"* (or *4'33"* No. 2), Cage's electronic "silent piece," in which the body and its actions constitute the instrument, and the performance is intended to be merely "the continuation of one's daily work." Like his first silent piece, *0'00"* transforms everyday phenomena into an art form. But whereas in *4'33"* sound was "musicalized" through the visible presence of the piano, in this piece, everyday action is "musicalized" by the audible amplification of the microphone. As Cage suggests, "everything we do . . . can become music through the use of microphones." The amplification system acts as a transducer in this context, as James Pritchett remarks, turning the intentional actions of the performer into "a non-stop stream of minute, unintended acts."[37]

With his body now an instrument, Cage is able to externalize an experience that he recounted as life changing, demonstrating the logical outcome of his sound as life, life as art philosophy, through an immersive experience that had striking parallels with later interpretations of VR and cyberspace. Isolated in an anechoic chamber in 1952, Cage was able to hear the sounds of his nervous system working and his blood circulating instead of the silence he had anticipated. From this experience he concluded that silence—the concept that had initiated his departure from music—was an illusion.[38] As Cage's ear turned inward to hear the sounds of his body, so his concept of silence turned outward; silence is now "the aspect of sound that can be either expressed by sound or by its absence." Silence is desonorized for Cage, transformed into process or action (as the score for *0'00"* dictates) rather than thing, while nonintentional action or inaction becomes a correlate to silence, which in *4'33"* Cage had aligned with unintended sound. Given its new latitude, silence has an entirely different structural role in the formation of Cagean subjectivity: silence, as absence, as the possibility of death, no longer exists—there is *only* sound and noise, and nothing is always something. A comforting thought, and for Cage a cushion against the demands his rhetoric of selfless existence might make. Just as there is no absolute silence, there is no absolute death. At the same time, there is no causality, no meaning, no possible

narrative, only undifferentiated being known through the simple fact of noise—the body's continuous hum, which, when potentially audible, guarantees that one is alive, but when impossible to hear, signals the collapse of hearing, of the body itself. For Cage, the noise of the body now represents both life and the *arche* of unintentionality, since "no one *means* to circulate his blood."[39]

But like Schaeffer, Cage requires a new ear to hear this *arche* of unintentionality—the basis of authentic existence, and the guarantor of enduring presence, of both sound and life. He finds this ear in technology and, like Schaeffer, believes it to be both a neutral anonymous instrument to hear sounds in themselves (even the barely audible and unheard sounds of the body's autonomic processes) and an agent in itself, returning the past and revealing the future. The operations of this ear are complemented by another technology—chance operations— that ensure that the work's production originates from a detached subject who is therefore not responsible for the meaning or intention of its actions. Through these surrogates the composer inherits not only neutrality but all that "neuter" encompasses: neither body nor mind, neither mortal nor immortal, but infinitely present in the infinite permutations of aleatory and electronic transmissions. There is now no need to fear the silence, for, as Cage realized late at night with the help of twelve radios, an electronic silence ensures that Silence as such, Silence as death, will remain only a convenient metaphor. Cage's animation of technology resolves the problems of both representation and mediation and allows the auditor direct access to sounds in themselves and the vibratory cosmos alike. But more than this—by refusing the separation between life, his own existence and technology, Cage avoids the possibility that nonintentionality implies in its impossible neutrality: the possibility of human nonexistence, of silence and nothingness *as such*. As Cage divined from the anechoic chamber and the circumstances surrounding the performance of *Imaginary Landscape No. 4*, a meeting with either of these states could occur only at death. But whereas death is a human inevitability, it makes no sense to speak of the finitude of the airwaves, or the mortality of the automata, or for that matter of the perceptual limitations of a cyborg, which, like the electronic ether, is always potentially capable of being there—either in and with the "sound itself," or on the radio station ever ready to be tuned.

The necessity of these metaphysical concepts and their techno/tropic foundations is evident in the essay *Rhythm Etc.* (1962), which, in contrast to *4′33″*, reveals nostalgia for nominalism:

There was a time [when] . . . in Music, there was a glimmer of perfection—a relationship between the unit and the whole, down to the last detail: so elegant. How did that come about (it was an object)? It was an icon. It was an illustration of belief. Now do you see why what we do now is not at all what it was then? Everything now is in a state of confusing us, for, for one thing, we're not certain of the names of things that we see directly in front of us. . . .

. . . When we say as one artist to another, "The unit and its relationship to the whole," we speak of an object, and it is well to remember that the only time the idea of movement on the part of an object entered his head, except as farfetched analogy to music of previous times, was when he was forced to accept errors in his calculations.[40]

Cage is probably referring here to the miscalculations Lou Harrison made with regard to tape measurements in *Williams Mix*. However, it was through such "mistakes" that Cage developed his theory of indeterminacy. Like chance operations, the "bugs" in electronic systems also lessen the control and intentionality of the composer; but unlike "measurements" and calculations, electronics systems do not, for Cage, imply the kind of instructive, circumscriptive organization that "instruments" embody:

He had not made mistakes: it was just that circumstances were overwhelmingly different than the idea with which he was attempting to cloak them. And his idea, actually, he said, was a tool, an instrument—not an object. But it had all the elements (present only as measurements) that the object, once made, was to have. Thus it was not a tool . . . but an instrument, like the piano, which, used, leaves its notes scattered all over the music that was played. . . .

. . . The problem is more serious: we must dispense with instruments altogether and get used to working with tools. . . . It can be put this way too: find ways of using instruments as though they were tools, i.e., so that they leave no traces. That's precisely what our tape-recorders, amplifiers, microphones, loud-speakers, photo-electric cells, etc., are: things to be used which don't necessarily determine the nature of what is done.[41]

It is possible to discern a certain resignation in this quotation. Music, once so elegant, has been transformed by representation into an object, cluttered and confused by not only notation and tonality, its once accepted discourse, but the words and the theories used to prescribe its very being. And these prescriptions are themselves shrouded in a language that, being disconnected from the world as it is, is no longer useful. To recapture that connection it is necessary to find and use a "tool" that will "leave no traces," which, in other words, will allow an unmediated relationship with the thing-in-itself. For Cage, that "tool" is first and foremost a system, embodied initially in the *I Ching*, and

later in electronics, which represents a means of organization whereby
the absence of the composer's intention can be conceived as the corol-
lary of technology's neutrality and thus be absorbed within its traceless
configurations. Once the subject has been diffused in the simultaneous
and insubstantial sphere of electronic circuitry, the gap between subject
and object, or word and thing, no longer matters, since everything and
everyone are everywhere all at once. Within this sublime sphere, free
from material commitments and unfettered by signification, sound
becomes for Cage what music once was: a thing that represents only
itself, of which nothing can be said with any certainty, which, as
Schopenhauer insisted of music, "never expresses the phenomenon, but
only the inner nature, the in-itself of all phenomena, the will itself."[42]

It could be argued that Cage's critique of tonality was motivated in
part by the fact that its discourse—musicology—confers meaning upon
music in the same way that tonality itself confers meaning upon sounds.
Thus tonality now speaks, ceasing to represent only itself, referring to
things outside itself (emotions, intentions, histories, intellectual
schemas), and becoming an object of interpretation. As such, it can no
longer serve the rhetorics of either pure or absolute music or "sounds
in-themselves": for not only does music lack the silence Cage is looking
for—the silence of sound in its a-significatory, nondiscursive muteness—
but it cannot guarantee the detachment of the observer from the sub-
lime object of contemplation, since both object and observer are now
involved in language and representation.[43] Indeed, after confinement in
the anechoic chamber, Cage discovers that the possibilities for transcen-
dence that sounds-without-meaning present can be expressed only
through the paradox that his definition of silence implies. In Cage's
hands, silence is an extremely full metaphor of lack, not of material
sound but of intention/mind/discourse/culture/meaning, and this lack
has resonance only through the equally enigmatic concept of nothing-
ness: "No thing in life requires a symbol since it is clearly what it is: a
visible manifestation of an invisible nothing."[44] With this concept
Cage's relationship to the sublime assumes added significance, for the
problem of meaning and reference, of representation as such, is inti-
mately connected to the paradox of the unrepresentable in its extreme
form—death—which both unintentionality and the notion of "sound-in-
itself" embody. The perspective from which one could *speak* of the sounds
of one's body—a perspective Cage regards as the *arche* of unintentional-
ity—is necessarily detached from life. At the same time, the representa-
tion of these sounds is essential to Cage's philosophy; he must speak

them, yet at the moment they are spoken Cage himself becomes disembodied. As Daniel Charles remarks with some anguish:

> DC: But there's nothing more to say about it. . . . We are always led back to this: there is nothing to say.
>
> JC: That is, to silence—to the world of sounds. If I had something to say, I would say it with words.[45]

The problem is, however, that Cage does "say it with words" and in so doing hubristically occupies the space of his own nonexistence: the sublime, the unrepresentable. It seems that the ear Cage is looking for is the ear that could hear the sound of its bodily existence, but this hearing is possible only in a space of no sound, a space very close to death. The only way to redeem this space for the living is to describe it in terms of a pseudo-void, a void that is not nothing, which shares the essential divinity of the sublime yet can be inhabited by mortals. The Cagean subject is one who can occupy and internalize this space. By inhabiting the netherworld of electronics, on the one hand, and the metaphorical/paradoxical interstices of language, the very limits of representation, on the other, this subject is able to represent both the Ur-silence—the sound of unintentionality—and the sound-in-itself, as it represents only itself, from a still living but also detached perspective. Through a Cagean silence and the concept of sound-in-itself, the Cagean subject is able to speak its death. For it, there is "no more discourse. Instead . . . electronics." In 1962 Cage is ready to identify the "traces" that electronics do not leave: "We live in a global village (Buckminster Fuller, H. Marshall McLuhan). . . . One of the things we nowadays know is that something that happens (anything) can be experienced by means of technique (electronic) as some other (any other) thing (happening)."[46] In 1965 Cage relates this simultaneity and lack of differentiation to the archaic elegance that music was before words got in the way: "All technology must move toward [the] way things were before man began changing them: identification with nature in the manner of operation, complete mystery. . . . Science and technology . . . lead to many more ways so that we become Imagination personified."[47] And in 1966 he concludes that "nowadays everything happens at once and our souls are conveniently electronic."[48]

This maturation coincided with, or was perhaps influenced by, Cage's involvement with 9 Evenings: Theatre and Engineering, New York, 1966.[49] Begun as a series of planning sessions for what was known as the "Stockholm Festival," 9 Evenings was organized by engineer Billy

Klüver and artist Robert Rauschenberg. Although the Stockholm festival failed to eventuate, Klüver and Rauschenberg decided to go forward regardless, and they used many submissions by artists for the festival to form 9 *Evenings*. The experience of the event led Klüver and Rauschenberg, along with Cage, to establish Experiments in Art and Technology, Inc. (E.A.T.) one year later. Cage saw 9 *Evenings* as liberating for both sound and artist: freeing sound from the aesthetic structures of music, which belongs to the individual artwork (the object), and freeing the artists from oppressive social structures, by integrating the structurelessness of sound with a collaborative process. Cage described his piece for the event, *Variations VII*, as: "Indeterminate in form and detail, making use of the sound system which has been devised collectively for this festival, . . . using as sound sources only those sounds which are in the air at the moment of performance, picked up via the communication bands, telephone lines, microphones, together with, instead of musical instruments, a variety of household appliances and frequency generators."[50]

It has been said that in the performance of *Variations VII* Cage gave up more control than in any other composition. Again, it is difficult to tell whether this was a result of accident or intention. The setting was perfect for Cage. The venue for 9 *Evenings,* the 69th Regiment Armory, was acoustically very live with its six- to seven-second reverberation span that ensured the entire space was filled with cathedral-like ambience. This acoustic space presented a nightmare for the technicians—as Robby commented after visiting the building five days before the first performance: "How in Christ's name were we ever going to produce any coherent sounds in an environment like this? Would all of these little black boxes be swallowed up and shrink to insignificance? I swore I could count a seven-second echo constant each time I placed my foot on the floor."[51] Although this attribute greatly concerned the engineers, Cage and David Tudor thought it was wonderful. Using the building itself as an instrument, sound was made present in ways that went far beyond performance or aesthetics, transforming the Armory into a pan-aural center from which sounds poured in and were processed: "[Cage] . . . wanted sounds from all over the city—and if possible all over the world. We had 15 telephone lines to restaurants, an aviary, a dog hospital, a street, etc. He also made use of radio receivers covering all the wavelengths. [He] also wanted to pick up sounds from outer space . . . [and] suggested picking up and amplifying the multitude of sounds around us that we cannot normally hear."[52]

The primary aim in collecting this wide range and variety of sounds was not so much to present them in themselves, which had been Cage's overriding philosophy, but to use them as a source to *sound* technology. Cage's prior focus on *process* had already expunged music of its structure by inserting—indeed scoring—the substrate of nothingness in *4'33"* and replacing the author/composer with the protointeractivity of chance operations. In the more socially oriented context of 9 *Evenings* and E.A.T., his concept of process expanded: acoustic, aesthetic, technological, and social processes merged, winding their way through the various external sites, the telephone lines, the acoustic architecture of the Armory, the hubbub of the (often restless and raucous) audience, and the intricate patch bay of the central control unit, TEEM. Given that the sounds, fed into the system via radio and telephone lines, were already modified—made telephonic—before even reaching the Armory, and given the degree of processing that occurred at the Armory site, any sense of the original sound was lost amid what was, in effect, a mix of electronic systems rather than sounds themselves. Recordings from the performance reflect this orientation—the sound mix is dominated by deep tones that sound suspiciously like a mix between an oscillator and a siren, interrupted by explosive static interference, with vague vocal sounds in the background fading in and out.[53]

It was through this mix, and the philosophy of the mix, that multiples were formed and borders broken. Cage's emphasis on the liberatory and social aspects of artists working with science and technology could be seen as an application of his project to liberate sound from the structures of Western art music. As he commented to Alfon Schilling after 9 *Evenings:* "You see what we're involved in here is so interesting in terms of change. [It's] not work which involves one person but work which involves many . . . and this is what makes that experience and subsequent experiences that are related to it because it has a social character."[54] In the 9 *Evenings* catalogue, Cage set this democratic process within the revolutionary character of working with technology:

> Perhaps the central fact of Renaissance art was that the work of art sprang from a single individual's imagination. Now we have another way of making art that is less individual and more social. . . . Art instead of being an object made by one person becomes a process set in motion by a group of people, in this case artists and engineers. It is not someone saying something, but people doing things that give everyone (including those involved) the opportunity to have experiences they would not otherwise have had.[55]

While Cage was not yet ready to articulate the social anarchy that his aural aesthetics represented,[56] he did subscribe to the widespread belief that technology has a democratizing and civilizing effect. This effect was noted at the time by David Antin, who included "Klüver and Rauschenberg's EAT" with Art Nouveau theoretics, Bauhaus, and "the theme of the democracy of technology."[57]

FROM ACOUSTIC ECOLOGY TO INTERIOR SOUND: MURRAY SCHAFER

The "all sound is music" axiom of Cage and the *musique concrète* of Pierre Schaeffer were extremely influential in the development of a genre of sound art known as "soundscape" and its associated philosophy known as "acoustic ecology." The latter was founded by R. Murray Schafer, whose World Soundscape project developed in the 1980s and 1990s with the first International Conference on Acoustic Ecology, held in Banff, Canada, 1993. Acoustic ecology situates sound *in* the environment as part of the natural ecology and also as musical material. As Schafer writes in the introduction to his best-known text, *The Tuning of the World*: "Today all sounds belong to a continuous field of possibilities lying within the comprehensive dominion of music. Behold the new orchestra: the sonic universe!"[58] However, Schafer's interest is not limited to music or aesthetics—his theory of sound connects to a larger critique of modernity, and the individual's alienation within it. Like Pierre Schaeffer, Murray Schafer developed a notion of reduced listening that he called "clairaudience—clean listening," and, like Marshall McLuhan, Walter Ong, and Rudolph Arnheim, he believed that electronic culture would once again counter the visualism of culture by revitalizing the sense of hearing.[59] Schafer's project has involved analyzing and categorizing sounds within their natural habitat—so to speak—and by so doing to discover the most important, dominant, or significant sounds of that environ.

In *The Tuning of the World*, Schafer arrived at four categories, which he named: keynote sounds—sounds that are not listened to consciously and are inherent to the geography and ecology they are situated within; signals, which are listened to consciously and often demand attention—for example, sirens, whistles, alarms, etc.; sonic archetypes, which, like the horn used in the hunt, are both semantically and symbolically rich; and soundmarks, which like landmarks, are unique to a community and "deserve to be protected."[60] The sounds of the

environment—the sounds of birds, insects, fish, whales, animals, and finally humans—are analyzed within a historic-cultural, acoustic, musical, and, in the case of humans, linguistic framework to demonstrate their inherent or primordial correspondences through sound.[61]

Just as there is a natural link between the sounds of nature and the sounds of culture, sound and hearing integrate the senses. For Schafer, hearing is a "special sense" because its vibrational spectrum includes lower frequencies that are felt as well as heard: "hearing is a way of touching at a distance and the intimacy of [this] first sense is fused with sociability." According to Schafer, modernity has broken this continuum, masking the discrete sounds of the hi-fi rural soundscape with the broadband noise lo-fi cityscape. This transformation began with the Industrial Revolution, which created "sound congestion," and was multiplied by the "Electronic Revolution," which caused sonic "overpopulation," and, through recording and transmission, introduced "schizophonia." Like Cage, Schafer has an organicist understanding of sound: "we may speak of natural sounds as having biological existences . . . they are born, they flourish and they die." Unlike Cage, however, Schafer distinguishes between natural and artificial sounds: the lo-fi soundscape of modern urban existence is populated by sounds that are "suprabiological . . . the generator or the air conditioner do not die; they receive transplants and live forever."[62] Duration is an important component in the latter: the time between impulses is so shortened that they are heard as continuous. Schafer relates this speeding up of sound impulses to the need for greater efficiency, which, like the acceptance of industrial noise, was a consequence of the overriding technological determinism of the twentieth century. As the noise of the machine becomes "a narcotic to the brain" so too it disturbs the psychic equilibrium of sounds, producing "schizophonia." He explains:

> Schizophonia refers to the split between an original sound and its electro-acoustic transmission or reproduction. . . . Originally all sounds were originals. They occurred at one time and in one place only. Sounds were then indissolubly tied to the mechanisms that produced them. . . . Every sound was uncounterfeitable, unique. [Since recording and transmission] we have split the sound from the maker of the sound . . . in time as well as in space. A record collection may contain items from widely diverse cultures and historical periods.[63]

Schafer's argument is aimed at industrialization; however, his reasoning involves the assumption that sounds are actually split, that some ontic identity persists in sound's reproduction and transmission, such

that it *can* be severed from time, history, culture, and environment. This assumption has been critiqued by Jonathan Sterne, who emphasizes the inherently cultural nature of hearing and the dangers of sonic essentialism and argues against the distinction between sound *in situ* and its audiophonic reproduction that schizophonia represents:

> Acousmatic or schizophonic definitions of sound reproduction . . . assume that sound-reproduction technologies can function as neutral conduits, as instrumental rather than substantive parts of social relationships, and that sound-reproduction technologies are ontologically separate from a "source" that exists prior to and outside its affiliation with the technology. Attending to differences between "sources" and "copies" diverts our attention from processes to products; technology vanishes, leaving its by-product a source and a sound that is separated from it.[64]

The conflict between Schafer and Sterne can be understood as an aural version of a much broader debate (mentioned briefly in chapter 1) that has occupied theorists of technology and culture and is centered around the critique of the "original." Unlike the distinction between the photograph and its copy, the distinction between the aural original and its reproduction has always been more difficult to establish. The argument that because, unlike the image, sound suffers no loss of dimensionality in its reproduction then the sound recording is ontologically identical to the original sound has been dubbed "the ontological fallacy" by film-sound theorist Rick Altman. As Altman wrote in the early 1990s: "Revealing its mandate to represent sound events rather than to reproduce them, recorded sound creates an illusion of presence while constituting a new version of the sound events that actually transpired."[65] Some ten years earlier, Alan Williams had emphasized the effect of the audio playback system, which would in effect produce only a *simulation* of the original sound. First, the recording mechanism, along with the perspective it reflects, filters and transforms the sound; second, the playback mechanism projects the sound into an entirely different acoustic environment; and third, there is a spatio-temporal difference between the original and the reproduction. Williams surmises that if sound is understood as vibrating air, then reproduced sound is in effect an ontologically different sound.[66] Although it seems counterintuitive, this new version bears no ontological relation to the original sonic event.

Because sound's ontological status is problematic at the outset, the status of the recording as a representation seems to vanish in the aural presence that the audio recording invokes. This slippage between the

source and reproduction presents theories of aurality with a number of difficulties. While the technologically inscribed sound can be considered a continuation of the cultural mediation that occurs in the perception of sound, the use of technology does introduce fundamental distinctions between prerecorded and recorded sound, with the recording process or event itself being the point at which this distinction begins to operate, altering forever the experience and meaning of aural perception. As mentioned, the act of recording sound immediately introduces a perspective formed by the properties of the recording apparatus. No longer bound to the here and now of lived experience, able to be heard at any time, in any place, by any listener, recorded sound becomes a pseudo object, both phenomenal and epistemic—able to be collected and stored, transported and transmitted great distances and infinitely repeated, such that one can finally talk of "a" sound, and say of sound, "there is." But while audiophony does not *reproduce* as much as *represent* sound as the product of a series of technological mediations, it is still very difficult to differentiate the recording from acoustic sound without using terms that imply an original, identifiable, and thus *singular* sonic event, an event that conforms to the visually based ontology, that sound theory is attempting to escape.

The concept of the sound object develops from the common association of seeing with being that has not only shaped Western thought, but prescribed the kinds of objects that are knowable. Heidegger (discussed in detail in the next chapter) identifies this object-centeredness of metaphysics with the "monstrous transformation" whereby Being is thought in terms of "beings" and Becoming is banished to the realm of nothingness. As a result of this reduction "modern philosophy experiences beings as objects," and "reality becomes objectivity."[67] The existence of objects or "entities," as he calls them, their appearance in the concrete reality of the world, in short their presencing, is forgotten. Modern metaphysics is gripped by "representational thinking" that cannot, but also prefers not to, accommodate sound. The privilege accorded to permanent, material, and visual objects also enables their theorization. Heidegger points to the Latin transformation of *theoria* as *contemplatio,* which encompasses the dual notions of partitioning phenomena into separate parts or categories in order to be viewed more closely: "In theoria transformed into contemplatio there comes to the fore the impulse, already prepared in Greek thinking, of a looking-at that sunders and compartmentalizes. A type of encroaching advance by successive interrelated steps toward that which is to be grasped by the eye

makes itself normative in knowing."[68] Contemplation is influenced by the Latin *templum,* meaning both a sacred edifice (cf. temple) and the "temple" of the head, and it is associated with Latin *tempus*—time divided into periods—as well as the idea of a delimited space partitioned off into a separate sector.[69]

Even though there is neither a moment in time for sound nor a dissectible materiality, and the closest sound comes to being "in the head" is the absurdity of the inner voice, the idea of the sound object has inherited many of these associations. Sound is always a polyphony, as Don Ihde pointed out many years ago: "When I use a pen to strike the water pitcher, you hear both the sound of the glass and of the plastic, simultaneously in a duet of voices of things."[70] To isolate a particular sound within that polyphony a reduction must occur: the object (the pitcher or the pen) must become the center of focus, and the sound mix (described perhaps as a muted "ting") is represented as an attribute of that object. Once isolated and named, the sound mix is referred to as the sound of that object; no longer a multiplicity, its characteristics are described in terms of the material characteristics of the object, it is "delicate" like the glass, or "hollow" like the urn. In his seminal text "Aural Objects," the film theorist Christian Metz pointed to the peculiarity of onomatopoeic words referring to sounds, such as "lapping," "buzzing," "crash," "thump," "hiss," etc., which function ideologically as adjectives, despite their linguistic status as nouns. Metz attributes this inconsistency to the cultural habit of identifying sounds by reference to their source, a source that is always embodied in an object: "As soon as the source of the sound is recognized (jet plane), the taxonomies of the sound itself (buzzing, whispering etc.) can only provide, at least in our era and geographic location, supplementary precisions . . . of a basically adjectival nature."[71] Being adjectival, sound is clearly a characteristic of objects, rather than an object in itself. In reference to the visual, then, the "aural object" appears as an "infra-object, an object that is only aural."[72]

This difficulty is addressed by film theorist Michel Chion in his analysis of the sound object. Like Altman, Chion decries the way theorists refer to film as a visual medium, with sound considered a "plus," and an add-on: "the screen remains the focus of attention. Under the effect of this copious sound it is always the screen that radiates power and spectacle, and it is always the image, the gathering place and magnet for auditory impressions, that sound decorates with its unbridled splendor."[73] The screen, then the image, and finally the object absorb sounds' ephemerality and dimensionality, tying sound to the visual object, and

predisposing analysis toward an aural correlate in the aural object. As Chion writes, the concept of a sound object "evokes this object as if it were a ball that hearing grasps so to speak in the blink of an ear, when actually sound unscrolls itself, manifests itself within time, and is *a living process, energy in action.*"[74] Although influenced by Pierre Schaeffer's acousmatics, Chion recognizes that "reduced listening requires the fixing of sounds, which thereby acquire the status of veritable objects."[75] At the same time, however, through acousmatic listening "participants quickly realize that in speaking about sounds they shuttle constantly between a sound's actual content, its source, and its meaning. They find out that it is no mean task to speak about sounds in themselves."[76] Chion reconciles the conflicting representations of sound as object or event by incorporating a sense of organic process, of movement, change and complexity, while maintaining a sense of identity and individuality. As I will discuss in later chapters, a similar strategy has appeared in new media theory, where the organic and the vibrational appear again as unifying forces, through which the nagging question of representation, technological mediation, and the distinction between the real and the copy is resolved.

SCHIZOPHONICS, TYMPAN, AND VIBRATION

In many ways, the question of sound's schizophonia, as well as the conflict between Schafer and Sterne mentioned above, is pivotal to the fallacies that would result from adopting either position. While Schafer commits sound to a materialist metaphysics, Sterne denies the transformative effects—both material and cultural—of audio technology. The denial of difference between the source and the reproduced sound is an ontological claim, an assertion of ontological similitude, which has enabled audiophony to avert the kinds of discursive discriminations that are fundamental to media analysis. Similar ontological claims have been made regarding new media: there is no difference between, for instance, virtual space and real space, artificial life and real life, digital being and organic being. Although Sterne's argument must be separated from this larger claim, his focus on the vibrational qualities of sound reframes audio as acoustic; aurality as sound, removing audio from its media and cultural context, and placing it within the phenomenality that, as I have argued, is already working within an epistemic system that defines "being" in the first place. Sterne seems to confirm this when he writes that "the tympanic mechanism—that mechanical function

that lies at the heart of all sound reproduction devices—points to the resolutely embodied character of sound's reproducibility."[77] Because sound is vibration, and because the mechanical devices associated with sound reproduction use a vibrating diaphragm to transduce sound, Sterne declares the sound to be "embodied." But in what sense embodied? And if so, does this extend to the reproduced sound's ontological identity, discounting its status as a representation, like any other media product? It is true that, as Sterne argues, "the history of sound reproduction is the history of the transformation of the human body as object of knowledge and practice."[78] However, by securing his theorization of sound in vibration and, following Hemholtz, treating sound as an "effect" ("frequencies are frequencies"), Sterne removes the cause—the source—of the sound from consideration: "Since sound is an effect indifferent to its cause, the various processes of hearing can be simulated (and, later, reproduced) through mechanical means."[79] Placing sound within these acoustic and physical parameters ignores both the importance of locational hearing and (relatedly) the signifying aspects of sound. Since the specific character of an acoustic environment is integral to any embodied hearing, then, according to Williams and Chion, there will always be a difference between the source—or cause—and its reproduction.

Sterne's argument relies on two assumptions: first, that vibration is the correct figure for reading sound; second, that the "tympanic construct" is the correct figure for reading or theorizing hearing. While acknowledging that the "the tympanic is not an 'ideal' type, it is not a fixed thing existing outside, above, or prior to the history of sound reproduction," Sterne offers the "tympanic function" as a way to "move away from presuming and then attempting to adjudicate the widely variable relations among different sounds (original/copy; reality/representation) to a consideration of the social, cultural and technical mechanisms that open up the questions of those relations in the first place."[80] Yet it is these same relations that are obscured by Sterne's choice of vibration as a central figure.[81] Notions of acoustic truth and their passage through telephony, phonography, and audio generally are caught first and foremost in the vibrating voice: culturally, the tone of the voice is thought to be indicative of one's mood or emotional state; a voice speaking the truth is said to resonate with the listener like a sympathetic vibration, metaphorically uniting the acoustic properties of the voice with the authority of science, the transcendence of music, and the mysticism of cosmic vibration. Interiority, presented through aurality,

signals presence and truth: the veracity of the here and now and the depths of individual being act as a shield against absence, representation, and simulation. For while words and visual images are open to deception, the tone of the voice, united with the natural vibrations of sound, is thought to be indubitable—as Edison's biographer Hubert Greusel exclaimed so many years ago: "Behind all music is vibration, the law that compels like to fly to like, impinging on the same harmonic and sweetening as it dies. But herein lies the miracle: that it dies only in the seeming; with Edison, whatever the sound was, still is."[82] In the discourse of sound, the vibratory resonance of the reproduced voice adopts a similar role to that of the ether.

In the previous chapter I briefly mentioned the importance of vibration in the phenomenology of Bergson and his influence on the avant-garde. As a logic, Bergson's concept of the "numberless vibration"—the interval between matter and our conscious perception of matter, between object and subject that defeats or resolves duality—can easily be transferred to the interval between the original sound and its audiophonic reproduction, and in that transference, the "problem" of technology disappears. Telephony, phonography, and radio created a spatio-temporal, disembodied relation between sound and auditor, which could now be enveloped by a concept—vibration—which fluctuates between particle and wave, object and event, being and becoming. As Artaud's use of the figure suggests, vibration unites matter and form via a kind of organicism, it defies or subtends representation, it transmits itself in the present, yet provides an irreducible interval or pulse within which alterity can rest. The concept will appear in the vitalism of artificial life and in the argument for the autoaffectivity of virtual reality and new media, and it is intricately connected to the mutually reinforcing influences of sound technology and the interests of early sound composers including Varèse, who wanted "to be in the material, part of the acoustical vibration so to speak."[83]

My argument here is that figures like the tympana and vibration unsettle, rather than resolve, the approach to sound studies that Sterne endorses. Because aurality problematizes the very concepts of the "original" and the "recorded" sound it may be that these need to be thought not in terms of original/copy, or as object/event, but as the secondary products of a metaphysics operating on the axis of singular/multiplicity. The split voice of "schizophonics" and the ontological difference between sound and source presume a singularity, an already internalized materialist ontology that gathers together in one sweep the

metaphysics of aurality that I outlined previously. It bears repeating that "a" sound can only exist within stasis, and thus the notion of "disembodied" sound, like the disembodied voice, or more recently, the disembodied user of new media, is a fiction requiring singularity and stasis where none exists; sounds and the bodies they emanate from surround, immerse, and belong to, as Michel Serres would say, the multiple.

While Schafer may be guilty of confusing, and thereby defusing, the difference between sound and audio, his notion of "split" sound and "schizophonia" also reveals a deeper fissure, one where sound, technology, and subjectivity meet in an anxious alliance. His anxiety about technology and audiophony can be read two ways. First, as a collection of fears that were common at the time: a fear of urban overcrowding, and relatedly, of global overpopulation, intermingled with the growing awareness of the homogenizing and corrosive effects of mass media. Second, and more important, it can be read as a reaction to the contradictory conceptual frame required to accommodate this human and sonic proliferation. The very first division of the soundscape into lo-fi and hi-fi suggests that Schafer is already thinking about sound in terms of technology before embarking on his clairaudient analysis, thus ceding to technology the powers that Greusel imagined, yet doing so critically. Sound's splitting is a product of technology, and the colonization of the natural soundscape by noise is associated with the "cry" of the radio and the blasts of Hitler's loudspeakers. Noise is not just unwanted, but deformed physically, through its unnatural a-periodicity and its suprabiological longevity, and psychically, through its schizophonic reconstitution. Here the link between sounds and humans, between noise and modernity, manifests as a deep anxiety about (dis)embodiment and psychic derangement, leading us to ask: could what is happening to sound also be happening to the individual, and the culture at large?

Schafer is caught in a paradox here—for his clairaudient listener cannot fulfill the project of analysis if he or she is already hybridized, and living in the lo-fi environment automatically guarantees that condition. Indeed with already muddied ears, how would the listener recognize the four categories of sound that Schafer has identified? His way of dealing with this problem is, like Pierre Schaeffer before him, to find new ears. While the tape recorder assists here, allowing sounds to be recorded and analyzed, the most productive tool is "the recovery of positive silence"—the precondition for the kind of concentrated listening Schafer's project demands. In this regard, it is not the soundscape that is too noisy, but the mind: "Still the noise in the mind: that is the

first task—then everything else will follow in time."[84] "Noise" in this quotation stands for both the scattered thoughts proliferating in the psychic clamor of modernity and the mechanical sounds associated with modern urban life. The mind requires other, "proper" sounds to inhabit it. To this end Schafer recommends augmenting the ears with headphones, as these produce authentic, originary sounds, unsevered from their environment, their maker, or their history, since they resound within the head and redeem their original nature as pure vibration:

> In the head space of ear-phone listening, the sounds not only circulate around the listener, they literally seem to emanate from points in the cranium itself, as if the archetypes of the unconscious were in conversation. There is a clear resemblance here to Nada Yoga in which interiorized sound (vibration) removes the individual from this world and elevates him towards higher spheres of existence. . . . Similarly, when sound is conducted directly through the head phone, the listener is no longer regarding events on the acoustic horizon; he is no longer surrounded by a sphere of moving elements. He is the sphere. He is the universe. While most twentieth-century developments in sound production tend to fragment the listening experience and break up concentration, headphone listening directs the listener towards a new integrity with himself.[85]

Interiorized sound operates for Schafer in a similar fashion to Arnheim. As interior, it can be "in conversation" with the unconscious and thereby integrate the fragmented individual through something like the reverie that Bachelard attributed to radio. Here Schafer offers the receiving end, so to speak, of Arnheim's argument for interiority: the proximity of the sound source to the recording apparatus (the microphone) provides an atmospheric and spiritual closeness for Arnheim, but for Schafer the proximity of the receiving or transmitting apparatus to the ear creates an interior sound that is vibratory, integrative, restorative, and immersive. ("He is the sphere.") Proximity then serves two purposes: first, it suggests that a simple positioning of audio technologies, in terms of the physical closeness between the microphone and/or mouth, headphone, and ear during the process of recording and transmission, can somehow transform a potentially fragmenting and alienating experience into an experience of the sublime. Second, this transformation—from the mundane to the sacred, from the outside and external world of noise to the inner sanctum of the unconscious—occurs through the representation of sound as vibration: the removal of its sonic aspects (there can be no sound in the head) and its replacement by a force (vibration) that is independent and, as we have seen, associated with transcendence. As the contours of this vibration are determined by

the shape of the skull, the meaning of the sound (its sociality) is secondary to the physical (or vibrational) and psychic integrity that technology provides. It is difficult not to hear in Schafer's sudden reversal regarding reproduced sound the longing for the transcendent and impossible silence that headphones represent. Not only is the sound contained within the ear of the listener, but the listener's relationship to the world is virtually eliminated: sound is desocialized, and the threat of an overcrowded mind, or the din of the social, is temporarily reduced. In such a move, the schizophonic disembodiment of sound is resolved through the technological interface. Once again, the audio technology disappears through the subsonic indeterminacy of the figure of vibration, while the power of technology is registered individually, as a spiritual and evolutionary force.

Death, Silence, and the Tape Recorder

The experience of immersion relies upon stereoscopy to create a sense of depth and body monitoring to create a feeling of interactivity. These technologically aided sensory illusions extend the cultural phenomenon of what I am calling "apparatus proximity," by projecting physical/ spatial characteristics beyond the particular technologies with which they are associated, into a cosmic, metaphysical, or transcendent domain. The proximity between voice and body, headphone and ears, stereoscopic screens and eyes, or computer interface and body, acts as another version of the "presence" that Derrida critiques vis-à-vis the autoaffectivity of the voice and becomes the ground for technognosti- cally inclined theorizations. But while the 3-D "eyephones" of VR sys- tems might be seen as an obvious correlate to the intracranial sound of Murray Schafer's earphones, this technical coincidence between audio and immersive media is less interesting than the complex cultural asso- ciations that proximity forces us to consider. As mentioned in the previ- ous chapter, the claims made about telephony, radio, and recording bear a striking resemblance to the myths surrounding cyberspace and VR. Such is the force of these myths and the difficulty of thinking sound that we find a conceptual correlation between the two: sound, difference, audio, and transcendence converge, occupying a liminal zone that resembles Artaud's pile-driven sounds in its ferocious resistance to the- orization. For Schafer, Cage, et al., proximity offered the opportunity to envisage a new, technically augmented embodiment, one that could

occupy transcendent space. In each instance, a technical contingency (the distance between headphones and ear, or mouth and microphone, for instance) was interpreted within a larger techno/metaphysical cosmology. A similar trajectory has occurred with new media and its popular theorizations, often leading to the obliteration of the distinction between the body and technology. This distinction is not my concern here. Rather, the belief in technology as a force for such dissolutions and the rhetorical strategies used to justify this belief will be the focus of the present discussion.

As mentioned in the previous chapter, Cage provides a glimpse into what would later become a major theme in the popular discourse of Artificial Intelligence (AI) and the digital revolution—the quest for immortality via a technologized embodiment. Throughout the long process of attributing agency to technology, Cage establishes a conceptual (or quite possibly rhetorical—with Cage it is often difficult to tell the difference) mediator for this attribution, through the ephemerality of sound, now captured by recording. But while ephemerality allows him to immerse sound in life, and life in process (and finally art), ephemerality also raises the questions of being and nothingness that he continually struggles with. Cage's elaborate reworking of silence reflects his problem with nonbeing, and it also, ironically, points to his great difficulty in thinking sound. Regardless of the clarity of his aesthetic appreciation or musical intuition, he seems incapable of articulating these existential questions, and his various attempts to do so create further conundrums from which he cannot escape. Cage's meditations on sound, noise, silence, life, art, ephemerality, and technics exemplify the potency of sound—as material and metaphor—for rethinking philosophy and aesthetics, and they bear a striking resemblance to existential phenomenologists—in particular Merleau-Ponty and Heidegger. Indeed, later critical theorist Derrida would ponder the questions of death, silence, and the tape recorder, while Deleuze and Guattari would draw on Cage's aesthetic to formulate their theory of avant-garde and electronic music as an exemplary deterritorializing force. The often contradictory thinking about sound that these artists and philosophers demonstrate emanates from aurality itself: that is, from the conceptual lacuna that remains when sound not only is theorized but, crucially, is party to a negotiation between embodiment, technology, and modernity.

If any singular figure emerges from the various philosophies of sound congealing between art and theory, it is the figure of silence. Both Cage and Heidegger adopt silence as a prime metaphor and charge it with the

task of restoring the inwardness and repose needed for existential understanding. For both writers, silence suggests the possibility of experiencing authentic being, and indeed comes to represent Being itself. In his major treatise *Being and Time* (which I will discuss later in this chapter), Heidegger institutes silence by eliminating noise: first from hearing (because "what we 'first' hear is never noises or complexes of sounds, but the creaking wagon"), and then from language (which Heidegger defines as authentic only insofar as it is not contaminated by the "noise" of the "they" [*Gerede*]) in order to retrieve the experience of authentic being. By entering the silence of the self and, in that silence and stillness, coming face-to-face with Being, it is possible for *Dasein* to approach death as the possibility of nonexistence.[1] Cage's redefinition of silence renders this question inconceivable, by situating noise within the overarching concept of a "soundful" silence—the silence of the void, the nothingness out of which everything comes and unto which it returns, the nothingness that, paradoxically, is full of sound as it is of life. But despite the similarities, there is one crucial difference between the composer and the philosopher. Because, for Heidegger, death is approached through the construct of a *silent* call, while "pure sound" represents the fall of *Dasein,* its severance from the world. This difference is important in understanding the link between Heidegger's early phenomenology and his later writings on technology, which have so influenced new media art and theory. Heidegger's near obsession with sound and silence, I suggest, provides a link to his later critique of technology and his eventual recourse to art as a way of reconciling—however awkwardly—the challenge technology presents. For Heidegger, "silence" is both a phenomenal and existential vehicle for retrieving metaphysics from the "monstrous transformation" that occurred when Being came to be thought in terms of "beings," and modern metaphysics was gripped by "representational thinking."[2] One would think then that his critique naturally leads us toward sound and listening and away from vision as a way to shift philosophy from its representationalist bent, and as much has been suggested by sound theorist/philosopher David Levin, who has convincingly argued that when Heidegger uses visual metaphors he is referring to a particular kind of vision, one that involves: "a radically different figure-ground structure for perception in terms of an 'attitude' of *Stimmung* that he calls *Gelassenheit,* letting-be."[3] Certainly, Heidegger critiques a particular kind of vision that has occupied modern philosophy and the imperative toward enframing that characterizes the era of modern technology. Without wishing to detract

from this important critique—one that has informed new media artists such as Char Davies (whose work I discuss in chapter 5), Heidegger's use of the aural metaphor is, however, paradigmatic.

Perhaps the most salient example of Heidegger's aural-rhetorical strategy lies in his use of attunement or *Stimmung* in *Being and Time*, as a way of formulating and eventually reconciling his concept of *Dasein*—or "being-there," through which human existence is always already in the world. For Heidegger: "Dasein's openness to the world is constituted existentially by the attunement of a state-of-mind."[4] Although often translated as mood, *Stimmung* runs deep, connected to a much more profound self-understanding than mood—as a feeling or surface play of emotion—might suggest. Reading Heidegger through sound, *Stimmung* begins to reverberate: as a "state-of-mind" (*Befindlichkeit*) it has the connotation of finding oneself; like the notion of resonance, it is self-reflexive; and, like a well-tuned instrument, it enables *Dasein* to understand and articulate its being with clarity and depth. Based on vibration, as in sympathetic vibration (essential to the concept of tuning), *Stimmung* aligns with Platonic notions of a cosmic harmony that, according to Leo Spitzer, is thought to be universal, ideal, and prior to individual existence.[5] Spitzer stresses the connections *Stimmung* also has with *gestimmt sein*—"to be tuned," which has a sense of stability, as in the "tunedness of the soul."[6] These meanings could be associated with the idea of tuning the radio, or world harmony through the ethereal hum of telecommunications, or the "atmosphere" (atmos) created by mixing a variety of sounds used in film—all tropes circulating in the first part of the twentieth century and connected to a general fascination with, and mystification of, technology. In the same way that Arnheim uses *Stimmung* to evoke the idea of a unity or harmony between "the Heavenly Father" and the individual soul "tuned" to its spiritual mission, Heidegger uses *Stimmung* to forge a direct, unmediated relationship between *Dasein*, self-knowledge, and authentic being.

However, since "ontologically mood is a primordial kind of Being for Dasein, by which Dasein is disclosed to itself *prior* to all cognition and volition, and *beyond* their range of disclosure," *Stimmung* seems to present a departure from the being-in-the-world that Heidegger wants to establish as the existential condition of *Dasein*. First, being precognitive, its "worldliness" is difficult to explain; second, as mood it could be confused with one's interior or psychological states.[7] To avoid this connection, Heidegger establishes a teleology of self-knowledge: from attunement to understanding to the self-reflexive knowledge unique to

discourse, and he processes this teleology through a shift in metaphors—from the aural to the visual—wrapping them in the primordial being-in-the-world of *Dasein*. For instance, "understanding," which is already mood-laden, has the character of "projection" and makes up *Dasein*'s "sight." By way of having a mood, *Dasein* "sees" its existential possibilities, and through this seeing (or "projective disclosure") understanding leads to interpretation. Meaning involves the articulation of a foreknowledge, involving a "fore-sight," the "seeing" of interpretation, and the "transparency" of self-reflexivity. Heidegger does warn against "a misunderstanding of the expression 'sight,'"[8] and he qualifies "seeing" as being more than "just perceiving with the bodily eyes." But these caveats are also motivated by another desire:

> In giving existential signification to "sight," we have merely drawn upon the peculiar feature of seeing, that it lets entities which are accessible to be encountered unconcealedly in themselves. Of course, every "sense" does this. . . . But from the beginning onwards the tradition of philosophy has been oriented primarily towards "seeing" as a way of access to entities and to Being. To keep the connection with this tradition, we may formalize "sight" and "seeing" enough to obtain therewith a universal term for characterizing any access to entities or to Being, as access in general.[9]

This is the other connection that the metaphor of sight produces—the connection with the tradition of philosophy, supposedly the object of Heidegger's critique. At the point where the primordial access to the world, which attunement bestows, becomes fully fledged, reflexive, and representable knowledge, Heidegger shifts his metaphoric base from the aural to the visual. This allows him to "keep the connection going" with the tradition of philosophy, while apparently avoiding the dichotomy between essence and relational structure, interior and exterior, nature and culture—or in his terminology, between the "in itself," or present-at-hand, and the "for others," or ready-to-hand, that has so corrupted modern metaphysics. Further, being always already cultural, attunement is therefore free from the uncritical metaphysical connotations of intuition or feeling.[10]

Yet, as a primordial state, being-attuned must be reconciled with being-in-the world, which involves *Dasein* in meaning and discourse (*Rede*),[11] and by which the "there" of Being-there (*Dasein*), first apprehended through primordial attunement, is articulated. Mood might be ontologically prior, but it is also plagued with ambiguity; it "brings Dasein before the 'that-it-is' of its 'there,'" but in doing so "stares it in the face with the inexorability of an enigma." This enigma rests on the

question of representation, which poses considerable obstacles in *Dasein*'s journey to self-understanding and knowledge. Because attunement "arises out of being-in-the-world," it lacks the distance or projection required for the act of reflection. Being unreflexive, unable to represent itself, attunement falls within the unrepresentable, which Heidegger calls "unmeaning."[12] However, since it is less contaminated by representation, which always involves the possibility of deceit, attunement can seem closer to the "truth" of the real, the "there" of Being-there. Heidegger's enigma revolves around the alterity of aurality and is bound by the metaphysical conundrum that (particularly aural) representation involves and Heidegger's choice of metaphors inevitably invokes. For how can *Stimmung* avoid the fate of the unrepresentable that it shares with the sonic and vibratory meanings of attunement? This connection is not spurious, nor is the dilemma it poses Heidegger's alone. The question of musical meaning has plagued musicologists for centuries, and many have been content to secure musical meaning in the (equally enigmatic) field of emotion. Heidegger, however, has chosen to free this quintessentially aural term from the aspect of mood or emotion, from the cultural association of music with emotion, and align it instead with the spirito-acoustic trope of vibration—which is the essence of being tuned.

DISCOURSE, NOISE, AND AUTHENTIC BEING

A good metaphor, but difficult, for without some kind of externality, Heidegger is trapped by a *Stimmung* that can only be activated through a relationship with a tuneable entity, and this inevitably involves him in the materiality of sound and voice. Heidegger's next task is to explain how discourse as "the Articulation of the intelligibility of the 'there,' [and] constitutive for Dasein's existence" involves voice, and therefore sound, without the interference of sound in itself, which for Heidegger is meaningless. This dilemma motivates him to establish yet another teleology, this time in order to sever the connections with mood (intuition, emotion, feeling, harmony, and thence possibly music) that the sonorous voice might have, and to ensure that discourse has the unfettered existential connection to *Dasein* that he wants to establish without the encumbrance of "unmeaning" sound. In an inverse operation of extending sight to go beyond "just perceiving with the bodily eyes," Heidegger constricts and reformulates hearing—hearing isn't really concerned with hearing sound as such but only "significant sound": "What

we 'first' hear [are] never noises or complexes of sounds, but the creak-ing wagon, the motor-cycle. . . . Even in cases where the speech is indis-tinct or in a foreign language, what we proximally hear is unintelligible words, and not a multiplicity of tone-data." Being in the world, sound is heard in terms of objects (the wagon) or words—it is only when sound is "unnaturally" removed from the world that it is heard as noise: "It requires a very artificial and complicated frame of mind to 'hear' a 'pure noise.' The fact that motor-cycles and wagons are what we proximally hear is the phenomenal evidence that in every case Dasein, as Being-in-the-world, already dwells alongside what is ready-to-hand within-the-world." Hearing only wagons and words rather than noises and tone-data is proof that *Dasein* is always already in the world, and that its hearing is authentic rather than artificial. But hearing noise in speech removes *Dasein* from the world, first, by imposing an "unnatural disre-gard"; second, and especially, by transforming the communicative func-tion of discourse: from "Being-with" the other (*Mitsein*), discourse degenerates into *Gerede;* "idle talk." Here, Heidegger switches from the acoustic—the "mere vibration"—to the cultural connotations of noise as rumor. As "gossip" and "passing the word along," *Gerede* approaches the archaic sense of rumor: a continuous, confused noise, clamor, or din. Like *Stimme*, the root of attunement, translated as voice and voic-ing (in the sense of giving one's opinion), "noise" also has a vocal origin. Coming from Greek *nautic* and Latin *nausea*, it carries the archaic con-notation of the cries and groans (noise) made by seasick (nauseous) pas-sengers on ancient ships.[13]

Noise, as sonorous, is indeed all around: unbordered, open to any-thing, apposite to truth, busily heard but not necessarily precipitating understanding. It does not make sense to talk of meaningful noise; and for Heidegger, noise says nothing to *Dasein* and does not resonate with *Dasein*'s being as being-attuned. As *Gerede* falls into the delirium of the crowd, it "de-tunes" attunement in a way that reveals a remarkable similarity between Heidegger's attitude toward the voice and that of Western metaphysics in general. Aristotle believed that the "cough or clicking of the tongue" contaminates speech.[14] Heidegger worries that the listener might hear the vocal sounds of language as *sounds* rather than words and thus fail to hear the meaning and intention that define his concept of discourse. Hearing mere sounds would mean *Dasein* was severed from itself: overtaken by an artificial and "complicated frame of mind," the same frame of mind perhaps that issues from *Dasein*'s immersion in *Gerede*, where the noise of idle talk, passing the word

along, rumor and hear/say continually interrupts its recognition of its "being-in." To escape the consequences of mere sound, rumor, noise, and the abstraction of vibration within the worldliness of discourse, Heidegger proposes another mode of hearing, which he calls "hearkening," and he complements this with another mode of "speech." Hearkening is distinguished from hearing as "more primordial than what is defined 'in the first instance' as 'hearing' in psychology—the sensing of tones and the perception of sounds," and it is grounded in the prior attunement of *Dasein*, which in turn develops from *Dasein*'s ability to listen to its own authentic being.[15] But since attunement and hearkening are always prior to and grounded in themselves, it is difficult to know just how *Dasein* establishes its authenticity. If the world is populated by noise and rumor, and *Dasein* is always already in the world, from what space can *Dasein* hearken and thereby become attuned? What does hearkening hear in its understanding?

Strung between these impossible choices, Heidegger chooses the best metaphor available—silence.[16] Through silence *Dasein* becomes aware of its primordial mood—anxiety—which is experienced as an "uncanniness," a feeling of "not-being-at-home," of the collapse of everyday familiarity that *Dasein*'s flight to the "they"—the public world—is intended to ward off. Silence "speaks" now through the "voice" and "call" of the conscience, which summons the individual from their lostness in the "they." "Conscience gives us 'something' to understand; it discloses. . . . If we analyze conscience more penetratingly, it is revealed as a call [*Ruf*]. Calling is a mode of discourse. The call of the conscience has the character of an appeal to Dasein by calling it to its ownmost potentiality-for-Being-its-Self." Emitted as a call, it "speaks" from somewhere other than the world of the "they" and is heard, not through the sensory apparatus of the ears, but more directly, from within *Dasein* itself.[17] Faced with its Self, *Dasein* recognizes the "they" for what it is, and the flight toward inauthenticity—falling—as a part of its Being. To arrest that falling, *Dasein* itself calls "in its uncanniness: primordial, thrown Being-in-the-world as the 'not-at-home,'" prompting a discourse of the conscience that, attuned by anxiety, "comes from the soundlessness of uncanniness," and "never comes to utterance."[18]

As Heidegger continues this process of desonorization, the refinement of his aural metaphors begins to match the poeticism of his analysis. In *What Is Called Thinking* (1968), for instance, he warns again that: "In order to hear the pure resonance of a mere sound, we must first remove ourselves from the sphere where speech meets with understanding."[19]

By now the "sphere where speech meets with understanding" has become existentially dense. It houses *Dasein*'s self-consciousness, which operates within the space of understanding, a space that connects the subject to the primordiality of attunement while propelling it toward meaning and self-knowledge. At the same time, it threatens an abyss: "Between the unintelligible word and the mere sound grasped in acoustic abstraction, lies an abyss of difference in essence. . . . The supposedly purely sensual aspect of the word-sound, conceived as mere resonance, is an abstraction. The mere vibration is always picked out only by an intermediate step—by that almost unnatural disregard."[20] When Heidegger refers to the abyss of "difference in essence" that lies between the unintelligible word and "mere sound," he articulates the difficulties that the "there" and "nowhere" of sound presents. Indeed, the philosophical gymnastics required to get from "the unintelligible word" to "acoustic abstraction" stretches as far as the abyss that their separation supposedly reveals. One suspects that the creak of the door that, for Pierre Henry and Pierre Schaeffer, was an instance of *musique concrète* is, for Heidegger, literal—the sign of a break or fracture, a crack that exposes the ultimate muteness of language. This caesura is recovered to some extent by the term "tone-data," which, combined with "acoustic abstraction," "resonance," and "vibration," situates the aural/metaphysical within the relative sobriety of science, and wards off the fear of "unmeaning," which onomatopoeic words—by referring to "nonthings" and to sounds—present. Heidegger's use of the more technical (and modern) jargon of acoustics is mirrored, rather strangely, by the increasingly spiritual or cosmic terms he uses to describe the state of attunement. His retranslation of ancient pre-Socratic philosophers—in particular Heraclitus—continues his previous work of eliminating sound from speech and hearing from understanding, but adds a spiritual dimension to hearkening. In *Early Greek Thinking*, he writes: "What is heard comes to presence in hearkening. We hear when we are 'all ears.' But 'ear' does not here mean the acoustical sense apparatus . . . hearing in the sense of hearkening and heeding is supposed to be a transposition of hearing proper into the realm of the *spiritual* [*das Geistige*]."[21]

Heidegger's use of "attunement" in *Being and Time* may have already been influenced by the Heraclitean dictum: "The hidden attunement of the Universe is better than the open."[22] However, Heraclitus's dictum "Listening to the logos it is wise to acknowledge that all is One" once again introduces the possibility of sound and voice, for the "logos"

to which Heraclitus refers is inseparable from the *hearing and saying* of what is said, whereas for Heidegger "mere" hearing and saying are literally "hearsay"; the idle talk of the "they" that represents the fall of *Dasein*.[23] In order to appropriate the Heraclitean concept of the logos, Heidegger has to show that the hearing and saying it elicits does not involve sound and therefore is absolutely distinct from the noise of the "they." He does this through a simple act of translation: "saying also means what our similarly sounding *legen* means: to lay down and lay before." Heidegger interprets this laying as a "fore-gathering" (*Vor-lese*), which "unconceals"—allowing what is hidden to come to presence, *without* necessarily involving voice or sound: "The essential speaking of language, ["saying"] as laying, is determined neither by vocalization nor by signifying [it is neither Voice nor Meaning]. . . . As 'laying,' speaking is not characterized as a reverberation which expresses meaning." This retranslation allows Heidegger to reinterpret the logos as a silent laying and to confer a spiritual meaning upon the concept of attunement and hearkening that he introduced some fifty years earlier.[24] With hearing now detached from the voice or ear, Heidegger enters an abyssal paradox within which "proper" hearing and belonging to the logos presuppose one another. Whereas for Heraclitus "listening to the logos" is understanding the attunement of the universe, for Heidegger listening, or rather hearkening, is its own end, since it automatically involves attunement. Thus he conflates the two, and the Heraclitean fragment becomes: "When you have listened, not merely to me (the speaker), but rather when you maintain yourselves in hearkening attunement [*Gehoren*], then there is proper hearing." But attunement is not something that one listens to, rather it is a state in which one dwells in order to hear and understand existence itself, and what characterizes that state is silence: "Laying, thought as a letting-lie in the widest sense, relates to what in the widest sense lies before us, and *speaks without a sound: there is*" (my emphasis).[25]

As Heidegger progressively evacuates sonority from the process of signification, from meaning in language, from discourse and self-knowledge, and finally from the concept of Being itself, he inserts silence—the silence of the "self," of authenticity, *Stimmung*, logos, Being. At each step in this process, the being-in of *Dasein* is reduced: Heidegger's hearkening subject hears only the silence of the call—it hears an absence, it hears nothing. The closer *Dasein* gets to the imagined silence of Being, the further it moves from the world. Its Being is now ultimately circumscribed by "language [that] speaks as the peal of stillness."[26]

But the questions this silent call raises are both clamorous and demanding. Is the call of the conscience an activator in the process of *Dasein*'s self understanding—from which the discourse of the conscience proceeds? Does the "soundlessness of uncanniness" mean that, therefore, the voice must always be silent, or are these silences independent? Is this silence a catalyst that, like the vibration, transforms as it rattles? Is it a signal, or some primordial tone—ever-present and waiting to be decoded, sonorized, and given form? What produces the signal—what attunes prior to *Dasein*'s attunement? How does this new voice become tuned in the first place, and tuned to what? Attunement is always relational; it makes no sense for an instrument, for instance, to be tuned to itself. Similarly, silence—even given its abstraction—can only be imagined as a potentiality out of which something emerges. Like Arnheim, Heidegger needs a microphone, and in this context perhaps a telephone, to support the "afar" from which the call comes.

At this juncture it is worth asking what, if any, influences audio technologies had on Heidegger's analytic. In 1927, when *Being and Time* was published, the new technologies of sound transmission and reproduction were at the forefront of technological invention and had already normalized the seemingly disembodied, telepresent voice. Although predating his critique of modern technology, one can suppose that the introduction of audiophony to the domestic sphere may have seemed to Heidegger as the apotheosis of the subject's severance from the world and its Self as experienced in the world. Certainly his use of acoustic terminology and his near obsession with sound suggest that audio had some kind of impact. The phonograph, for instance, allowed speech to be objectified or "enframed" (*gestell*)—that is, assembled, ordered, transported, manipulated, and stored as a "standing-reserve." Similarly, radio transmitted the disembodied voices of *Gerede,* the "they," into the living rooms of the emerging consumer class, filling the air with noise and chatter. Such incursions were not missed by writers at the time: in 1930 M. M. Gehrke and Rudolph Arnheim published a dialogue concerning the merits of radio—synecdoche for technology—in "The End of the Private Sphere," in which Gehrke situates radio and the gramophone within the rise of mass culture, the "technologization of life," and the penetration of sound and noise into the home:

> The neighbor down the street has a radio, and the one across the hall, the one below, above, and next door. All of them have speakers [which] . . . penetrate the walls of old and new buildings alike into the home that was once my castle. . . . Is it an accident that everyone today expects the

understanding participation of the whole street in the sounds of his enter-tainment, and that in such streets there no longer exists the odd individual who takes the speakers and grammophones, the barking of a dog and the clatter of a running engine for an invasion of the private sphere?[27]

These technological incursions seem also to have entered Heidegger's vocabulary, as his use of the term "tone-data" in *Being and Time* sug-gests, and they resonated with the increasing noise of his environment (note that Heidegger follows "tone-data" with the mention of a motor-cycle). The kind of mind that would hear pure sound or sound in-itself is a mind in an artificial frame, that, by the time of *What Is Called Thinking,* has an almost unnatural disregard. But what effect does this process of unnatural disregard have on the listener? And what kind of sound can be associated with "tone-data"? Doesn't the term evoke the test tone used in tests of the emergency broadcast system, or the tone used to calibrate signals of different amplitudes? Hearing this tone, wouldn't the subject be hearing a substratum of sound—the sound that identifies the correctness of transmission—and if one were hearing this instead of ordinary speech, wouldn't that indicate problems with the filter or decoding device that normally hears vocal sound as speech? If the subject hears "tone-data" then its hearing cannot be distinguished from the "hearing" of the telephone or recording device, which receive and filter sound mechanically or electronically, regulating it according to purely technical, rather than cultural, criteria. Hearing tone-data, then, is evidence of a subjectivity that has become "instrumental," which has internalized modern technology's drive toward viewing nature as mathematical, matter as data, and ultimately humans as sophisticated input/output devices. Similarly, Heidegger's later belief that technology had come to rule the understanding of Being also res-onates in his notions of "attunement" and "the voice of conscience"—concepts that are related, in a most uncanny way, to sound and audio.

Avital Ronell has presented a convincing case for interpreting Heidegger's "call of the conscience" as a telephone call, the connection originating in the "being-guilty" that Heidegger felt for accepting a call from the Storm Trooper University Bureau, and his later engagements with the Nazis.[28] The telephone does share with the voice of conscience a unique disembodiment, and Heidegger underscores this similarity by describing the caller as the "not-at-home"—the bare "that-it-is" in the "nothing" of the world. When the subject is in a state of unauthenticity, like the telephone it cannot distinguish between authentic speech and the noise; it cannot filter out the noise of the transmitting device, nor

can it distinguish between calls—the call of the conscience, on the one hand, and the noisy calls of *Gerede,* on the other. Given that *Being and Time* was written sometime before that call was placed, and given Heidegger's choice of words, how the chatter on the phone lines may have contributed to his concept of *Gerede* is a matter of speculation. Perhaps, in his obfuscating way, Heidegger was questioning the easy forgetting of the *phōnē* in telephony—the voice concealed by the non-status of sound and tarred with the illegitimacy of rumor? Certainly, the cultural amnesia regarding the impact of this "disembodied" technology parallels his warnings regarding the danger of technology as a danger associated with the *thinking* (or not) of technology. Taking the analogy further, if the call of the conscience comes from afar—if it "discourses in the mode of being silent," if it does not speak, if, in fact, it is not voice but transmission, signal, the nonsonorous silence of data, then "it" discourses as a mode of revealing the nature of technology *as* an index of human, cultural denial—in other words, as a failure to recognize just what the "silence" that constitutes this "call" actually is.

DERRIDA AND THE TAPE RECORDER

As composers philosophized about new technologies, so philosophers entertained—consciously or not—audio in their theories of modernity and technology. Like Heidegger, Jacques Derrida critiques metaphysics by invoking metaphors of silence and departs from the absolute silence of Heidegger's "voice of being" to the "almost" silence of a redefined "writing before speech." And like Cage, Derrida presents this "almost" silence as the index of a refigured being, one that can be experienced only via a technologized subjectivity. Derrida's interest in sound technology originates from his critique of the "phonocentrism" of Western culture: the common belief that there is an immediate and unmediated relationship between the mind, the voice, language, and the nature of the world. Phonocentrism, the "absolute proximity of voice and being, of voice and the meaning of being, of voice and the ideality of meaning," provides metaphysics with an origin myth, which acts as the founding metaphor of notions of a *prima causa,* absolute truth or ultimate creator—a "transcendental signified."[29] Traditionally, the voice grounds the subject in presence, and here "presence" signifies both the temporal present and the "presentation to the senses," which Western ontology demands to attribute existence. Projected from the inside to the outside, heard at the moment of utterance, the voice establishes a

circuit between perception and intellection, between the thinking mind and the speaking body, between the interior and the exterior, and between the subject and the object. Descartes' *cogito* is modeled on this circuit and provides a logical foundation for "truth" due to the impossibility of thinking in the absence of being.[30]

Against the absolute silence of the inner, metaphysical voice, Derrida poses his core concepts of *différance* and the trace: the trace reveals and is revealed by the space, or spacing, of writing; be it the gap between letters on the page or the silence that differentiates (and constitutes) phonemes in speech.[31] Writing allows the difference, the absence, the Other inherent in discourse, to appear.[32] The difference that such spacing allows to be heard is captured in Derrida's concept of *différance*. Meaning both to differ and to defer, *différance* constitutes the structure of presence as intersected by the spatial and temporal difference in language, the production of which writing—*ecriture*—reveals. Because in French, the *a* of *différance* can be seen inscribed on the page, but not heard in speech, *différance* is constituted by silence, but it is a silence formed from the oscillation between hearing and seeing, speech and writing, that is revealed through an absence or gap: the "silence" of the trace. According to Derrida, this oscillation provides a way of both articulating the mechanisms or logics that constitute metaphysical presence and *interrupting* those mechanisms. For instance, the *a* of *différance* interrupts the metaphysical distinction between writing and speech, where writing is seen as secondary and supplementary. In eradicating the difference that writing has traditionally represented, *différance* also dissolves the opposition between writing and speech, and oppositional thinking itself. In this way "differance . . . opens up the very space in which onto-theology—philosophy—produces its system and its history," since the temporalizing, which the deferring of *différance* reveals, suspends the possibility of full presence, just as the spacing or interval that the movement of *différance* inserts, interrupts the continuity of the present: "With its *a*, différance . . . refers to what in classical language would be called the origin or production of differences and the differences between différences, the play [*jeu*] of differences. . . . This différance belongs neither to the voice or to writing in the ordinary sense, and it takes place . . . between speech and writing."[33]

The silences, spaces, and gaps that circulate through Derridean deconstruction are defined within an overarching "science": the "science of writing," which Derrida designates "grammatology." Like *différance*, grammatology contains within it the deliberate contradiction

between the "gramme," the graphic sign, and "ology" as logos, which for Derrida means voice or *phōnē*. This "science" reveals, however, a certain deafness in his thinking, for in the grammatological construction, logos is conflated with *phōnē*, and *phōnē* is assumed to represent both the technology of the voice-speaking-language and the sonority of the voice: "*What is said of sound in general is* a fortiori *valid for the phōnē* by which, by virtue of hearing (understanding)—oneself-speak—an indissociable system—the subject affects itself and is related to itself in the element of ideality." Jean-François Lyotard makes the point that the *phōnē* is what Aristotle called "the voice as timbre," which can be contrasted to "*lexis*," which he defines as "the articulated voice."[34] The difference between the two, he suggests, comes down to *noise*—the sounds of the body, of timbre and "grain," which interrupt "meaningful" speech: "With the *phōnē* [humans] show [affect]; with the *lexis* they communicate, reply, debate, conclude, decide. They can tell tales."[35] *Lexis* is a derivative of the Greek *legein*, which, as mentioned, was interpreted by Heidegger as the "letting-lie-before" of logos, to avoid the consequences of aurality, but which is also akin to the Latin *legere*: to gather, to form an impression, to read, to find written, to count; hence to recount, say or speak.[36] By conflating sound and voice in this way and absorbing both within the silence of *ecriture* and the trace, Derrida's deconstruction is always veering toward the inner and silent voice of metaphysics—the Husserlian voice he critiques in *Speech and Phenomena*.[37] As Giorgio Agamben comments:

> Philosophy responds to the question, "What is in the voice?" as follows: Nothing is in the voice, the voice is the place of the negative, it is Voice— that is, pure temporality. . . . From this point of view it is possible to measure the acuteness of Derrida's critique of the metaphysical tradition and also the distance that remains to be covered. [Derrida] believed he had opened a way to surpassing metaphysics, while in truth he merely brought the fundamental problems of metaphysics to light. For metaphysics is not simply the primacy of the voice over the *gramma*. If metaphysics is that reflection that places the voice as origin, it is also true that this voice is, from the beginning, conceived as removed, as Voice. To identify the horizon of metaphysics simply in that supremacy of the *phōnē* and then to believe in one's power to overcome this horizon through the *gramma*, is to conceive of metaphysics without coexistent negativity.[38]

It is this split between voice and Voice, between the ideality and materiality of the voice, that possibly led Derrida to audiophony, to, in a sense, re-embody his inscriptive, and perhaps too silent, schematic—his "science of writing."

THE "PHONOGRAPHIC ACT"

Initially Derrida finds in the audio recording a technological embodi-
ment of *ecriture,* since it oscillates between speech and writing, reading
the recorded (phonographed) voice as a form of writing (phonographic
inscription) and deconstructing phonocentrism in the process. At the
same time, he sees in what he calls "the phonographic act" possibilities
for a nonphilosophy, or philosophy of difference. Through the metaphoric
movements of various forms of audio technology, Derrida reworks his
rhetorical repertoire, beginning with the trace, which he renames as the
"cinder." This occurs in *Cinders,* and in its *Prologue* he writes that for
some ten years he had been thinking about the sentence "cinders there
are (*il y a là cendre*)."[39] Like the *a* of *différance,* the accent on the *là* of
il y a là cendre is silent. The silent accent marks a tension between writ-
ing and speech that is reflected in the text of *Cinders,* itself a polylogue
woven from a variety of Derrida's other writings and constituted, as he
says, by "an indeterminate number of voices." Derrida describes the
polylogue as a "writing apparatus," which "calls" to the unheard
voice/s rumbling through the authorial text of metaphysics. In some
ways responding to the silent call of the conscience that Heidegger for-
mulated to ground—however tautologically—*Dasein*'s self-under-
standing, Derrida raises the metaphysical stakes, by asking "how can
this fatally silent call that speaks before its own voice be made audi-
ble?" That is, how can the call that precedes the voice, which is only
emitted through writing, and the silence of which the accent on *là* speaks,
be made to sound? Derrida acknowledges that since the polylogue is
written and therefore is "destined for the eye," it "corresponds only to
an interior voice, an absolutely low voice." So how can it be amplified?
He finds the answer in sound technology—"Then one day came the pos-
sibility, I should say the chance of making a tape-recording of this."[40]

Through the tape recorder the "voices" in the text will have their
"*specific* volume," and the previously heterogeneous mediums of text
and sound recording will be "reinvented by the other," providing "a
studio of vocal writing." The polylogue will become a polyphony; like
the mixing of voices in a recording the other voices, other readings,
within the text will become audible. The "phonographic act" effects
this polyphony and dissemination by amplifying the inaudible, or in
Derrida's tropology, through the "pyrification of what does not remain and
returns to no one."[41] Here Derrida invokes the vitalism of (an originary)
fire of which the cinder is a residue, merging sound, fire, ephemerality, and

recording in a formulation that approaches the poeticism that Heidegger—writing his major opus—was forced to avoid.[42] Strewn with multiple references, the cinder combines a pre-Socratic, Heraclitean understanding of being as flux (one that Heidegger both appropriated and reworked to avoid the problems of sound and hearing that language involved) with a reinterpretation of Heidegger's critique of modern metaphysics ("the setting of the sun").[43] It is from this fusion of Heideggerian Being, (an unacknowledged) Heraclitean fire, and Derrida's own "trace" that the concept of the cinder arises:

> The all-burning is an essenceless by-play, pure accessory of the substance that rises without ever setting . . . without becoming a subject, and without consolidating through the self (Selbst) its differences. . . . The all-burning . . . resembles the pure difference of an absolute accident. . . . As soon as it appears, as soon as the fire shows itself, it remains, it keeps hold of itself, it loses itself as fire. . . . That is the origin of history, the beginning of the going down, the setting of the sun, the passage to occidental subjectivity. Fire becomes for-(it)self and is lost.
>
> No cinder without fire. . . . The sentence ["cinders there are"] avows only the ongoing incineration, of which it remains the almost silent monument: this can be "there," *là*—.[44]

In the context of audio recording, the sentence "cinders there are," *can* be an almost silent monument to Being (as Becoming) only through the amplification that recording provides. Like vibration, amplification is culturally connected to notions of synesthesia, of transforming the sensorium so that hearing becomes feeling and feeling is experienced as the cosmic vibration of life emitted from all things both animate and inanimate. Amplification both detects and transmits this vibration, supplying the listener with a prosthetically induced access to the plenitude of an otherwise inaudible phenomenal life and metaphysical being. Recording captures this life, puts it "on record," endows it with an objectivity and representational status. While Derrida's cinder is a residue, a remainder, a still-glowing index of fire that both repeats and makes possible difference, at the same time it is waiting to be amplified, broadcast, transmitted by the prosthesis of the stylus: the phonograph needle, the recording head of the tape recorder, or the nib of the pen.[45]

As a recording, as audio, the word self-destructs in the temporality of voice, consuming itself as a cinder, a trace that names Being. The *phōnē*, which for Derrida also represents "sound in general," becomes literally a trace—the phonograph's grooves, the tape's magnetic configurations, the cipher of the "impossible emission." Thus, it is the *sound* of the

recording that connects it to the cinder, by creating an "aural-trace," a vocal writing that represents the always already inscribed, but also always potentially audible nature of the cinder. Through the operations of technology, pure difference—Being itself—can finally be made to sound. "By entangling itself in impossible choices, the spoken 'recorded' voice makes a reservoir of writing readable, its tonal and phonic drives, the waves (neither cry nor speech) which are knotted or unknotted in the unique vociferation, the singular range of another voice. This voice . . . is then left to pass away, it has passed away in advance, doubly present memory or doubly divided presence."[46]

THE TELEGRAMOPHONIC SUBJECT

Technology amplifies writing at the same time that it sonorizes the "interior voice," the "absolutely low voice" that, as Derrida says, is "destined for the eye."[47] But how does the interior voice reach its ocular destination? Appropriating this transmissional technology, he now supplements gramophony with the spatiality and movement of telephony. Gramophony becomes "telegramophony": a concept that also hinges on a barely audible, barely legible "silence." In *Ulysses Gramophone*, Derrida invokes the telephonic metaphor anecdotally, as an occasion that prompted a chance decision concerning the title of the talk he would give on James Joyce at the Ninth International James Joyce Symposium in Frankfurt in 1984. Glancing at a page of notes, Derrida reads "*hear say yes in Joyce* [*l'oui dire de Joyce*]" as a kind of "telegraphic" order, irresistible in its brevity:

> So, you are receiving me, Joyce's saying *yes* but also the saying or the *yes* that is heard, the *saying yes* that travels round like a quotation or a rumor circulating, circumnavigating via the ear's labyrinth, that which we know only by hearsay [*ouï-dire*]. The play on "hear say yes," *l'oui-dire* and *l'ouï-dire,* can be fully effective only in French . . . the untranslatable homonym can be heard (by hearsay, that is) rather than read *with the eyes*—the last word, *eyes,* let us note in passing, giving itself to a reading of the grapheme *yes* rather than a hearing of it. *Yes* in *Ulysses* can only be a mark at once written and spoken, vocalized as a grapheme and written as a phoneme, yes, *in a word, gramophoned.*[48]

While "hearsay" opens the possibility of a philosophy of difference embracing flux, aurality, and alterity, a philosophy generated through listening (to rumor, noise, the sound of the other), for Derrida, this listening is *electronically* aided. At the very beginning of the text, he translates

entendre, meaning to hear/understand, as "receiving": "*oui, oui,* you are receiving me, these are French words," thus situating hearsay and "yes" within the trope of telephony. The first phone call in *Ulysses,* which Derrida reads as a call to Israel from God, takes place "in the offices of *The Telegraph* newspaper (and not *The Tetragram*)."[49] In the context of telegramophony, the tension between writing and speech, and on a deeper level, between presence and absence, begins to resonate and resolve into audibility. For Derrida, writing is now "a telegramophonic obsession," concerned with receiving a certain call; the call "between God . . . and Israel," which occurs in the mode of a recording. The prayer is now a telephone call—or the call is a prayer—caught in the grooves of a phonograph. But the obsession is also with receiving (*entendre*) the untranslatable. Mixing metaphors, he acknowledges that: "This *remote control* technology, as we say of television, is not an external element of the context; it affects *the inside of meaning* in the most elementary sense, even so far as the statement or the inscription of practically the shortest word, the gramophony of *yes.*"[50]

This voice or sound of technology eventually transforms the "yes" in *Ulysses Gramophone* into laughter, a "yes-laughter" (*oui-rire*), which for Derrida occupies and "re-marks" all spaces, acting both as a supplement and a "quasi-transcendental remainder." As such it is "a *Stimmung* or a *pathos,* [a] tone which re-traverses all the others since it re-marks all of them," a tone "haunted by a completely different music." The telegramophony of *différance* now represents an attunement not unlike Heidegger's: in order to hear this tone, the subject shifts from the anechoic space of metaphysics to the Derridean ("quasi-transcendental") space of the cipher, the signal, the electrical impulse, the cinder, the latter-day tongue of fire.[51] But while it may seem that Derrida is substituting technological operations for Heidegger's call of the conscience, he is also simultaneously describing the prior instrumentality of the voice that metaphysics relies on to establish self-presence.[52] Yet, when mixed with audio technology, the priority of the voice, its metaphysical privilege, becomes diluted: it becomes quasi-transcendental; it "works" like an instrument. As Derrida writes: "So, a telephonic interiority: for before any appliance bearing the name 'telephone' in modern times, the telephonic techne is at work within the voice, multiplying the writing of voices without any instruments . . . a mental telephony, which, inscribing remoteness, distance, différance, and spacing in the *phōnē,* at the same time institutes, forbids, and interferes with the so-called monologue."[53]

Derrida's recourse to technology could be interpreted as supporting his claim, made in *Speech and Phenomena*, that deconstruction critiques metaphysics only *within* metaphysical boundaries: "To think through the ontological difference doubtless remains a difficult task, a task whose statement has remained nearly inaudible."[54] Inaudibility describes both a perceptual shortcoming (one cannot hear) and a phenomenal circumstance (there is no sound). Silence—or for Derrida perhaps—a *petit* silence, a soft sound, a semi-dysfunctional ear creates a dynamic that opens metaphysics to *différance* and interferes with its solipsistic circuitry. But this positive diminution—of sound and hearing—occurs, ironically, through the actual attenuations of audio. Whether by tape or telephone, amplification or distorting transmission, the voice becomes resistive; it becomes an interior writing machine, only via another set of dynamics that, perhaps, are equally metaphysical. Although the texts cited above do not imply a parallel deconstruction of technology, it may be that, like Heidegger, the combination of sound, voice, and audio was sufficiently explosive to provoke something of a reconstitution of the trace as "event."

A decade and a half later Derrida returns to the aural metaphor and the phonographic trace in a discussion of the media "event" and the simulation of "liveness"—media's version of presence—in order to distinguish the two along metaphysical lines. This distinction occurs in a conversation with Bernard Stiegler in *Echographies of Television* in relation to what Derrida calls "teletechnologies"—in which he includes both old media, such as television and radio, and new media, cyberspace, and "the new topology of the 'virtual.'" These technologies incorporate the trace and *différance* in the delay or gap *not* between the original event and its recording, but between the singular event and what is reproduced as "live, such that . . . a maximum of 'tele,' that is to say, of distance, lag or delay, will convey what will continue to stay alive, or rather, the immediate image, the living image of the living: the timbre of our voices, our appearance, our gaze, the movement of our hands. . . . The greatest intensity of 'live' life is captured from as close as possible in order to be borne as far as possible away. . . . We should never forget that this 'live' is not an absolute 'live,' but only a live effect, an allegation of 'live.'"[55] Of importance here is Derrida's emphasis on the epistemological consequences of the transformation brought about by such technologies. It is not that the delay or gap hasn't existed in earlier technologies—the difference isn't ontological— but rather that liveness affects belief and knowledge: "as soon as we

know, 'believe we know,' or quite simply *believe* that the alleged 'live' or 'direct' is possible, . . . the field of perception and of experience in general is profoundly transformed."[56] While such transformations—and in particular, the degree of apparatus proximity mentioned earlier—have been attributed with triggering an evolutionary leap, a new mode of consciousness, an amplification of human intelligence or, as Bernard Stiegler comments in the same text, a "new intelligibility," Derrida severs the tie between experience, knowledge, and technology by situating the latter within the impossibility of thinking technology *as such:* "That which bears intelligibility, that which increases intelligibility, is not intelligible—by definition, by virtue of its topological structure. From this standpoint, technics is not intelligible." With this, Derrida returns to Heidegger's project to "think a thought of technics that would not be technical" pointing out that such a thought, or thinking, is impossible, as it requires a "purification of the thinkable," a thinking that is free from "philosophical, scientific or technical contamination."

By focusing on the beliefs that attend to the broadcast image or sound, Derrida lodges an intractable gap between discursive rather than technical categories, beliefs rather than actualities. This epistemological orientation carries over into a related and equally important differentiation: for by encapsulating technology within metaphysics, Derrida denies a commensurability between the two: placing technology outside of the category of meaning and sense, and consequently, outside of the appropriating or incorporating practices that would allow technology or technics to "seamlessly" blend with existence. The apprehension and appropriation of Schafer's "new ears," for instance, only occurs within a circuit already infused with "spiritual" (techno-gnostic) beliefs about technology. And these already powerful constructions prevent actual technologies to be thought outside of the field of "technology" as such. By stressing the logical impossibility of thinking "a question that does not belong to the field of the questioned," and the unappropriable alterity of technology (which is not necessarily a positive thing), Derrida puts a brake on the versions of posthumanism favoring total absorption between human and machine.

WHY SILENCE?

As we have learned from Cage, silence infers a subject that, in a trivial sense, exists outside or beyond the world (since the world is all sound and noise), but more significantly it is able to conceive itself *in*

absentia, as the kind of abstract entity that Heidegger argues against with respect to hearing "pure sound." Like the aural metaphor generally, silence is a wonderful compositional device: moving across metaphysics, music, and phenomena, its abstract yet paradoxical permutations create a space that can remain transcendental and absolute while still be very much "in the world." The anechoic atopia of Cage's chamber, or Heidegger's calling conscience, represent in both instances a space from which "silence" can be "filled" and the metaphor can be set in motion. Heidegger's "difference in essence," like the "enigma" of attunement, perfectly articulates the dramatic shift in registers that philosophy must execute in order to deal with sound and still be itself. Giorgio Agamben describes the kind of limit this shift reveals: "Having reached the limit, in its anxiety, of the experience of its being thrown, without a voice in the place of language, Dasein finds *another Voice,* even if this is a voice that calls only in the mode of silence. . . . Here the theme of the Voice demonstrates its inextricable connection to that of death. . . . if [*Dasein*] finds a Voice, then it can rise up to its insuperable possibility and *think death:* it can *die (sterben)* and not simply *cease (ableben)*."[57] In order to hear its self as silent, *Dasein* must not only be without the body, space, and movement that makes "being-in" possible, it must also conceive itself in absentia, as the kind of abstract entity Heidegger argues against with respect to hearing "pure sound." Silence can be imagined only in the context of the interiority of the subject, reflecting in the quietude of the mind. In this respect, how different is Heidegger's *Dasein* to Descartes' *cogito?* In the same vein, why does Derrida choose to shift his rhetorical base from metaphors of inscription (*ecriture* and the trace) to metaphors of the ephemeral—fire and sound—that are underwritten by a primordial "tone"?

What is this relationship between making audible and technology—not just concerning sound, but more generally, concerning the ephemeral, the extinguishable, the mortal? If the tape recording preserves the voice, if the telephone transmits the body, if sound thus transfigured establishes an architecture whereby subjects can be preserved in vinyl and spectralized through the wires, then isn't existence itself in a sense bracketed and placed within another abyss: *between* materiality and what we might call a "technologized immateriality"? And in this strictly metaphysical relation, isn't it the latter that speaks? Not *who* speaks, but this curious "thing" that on a very trivial level is anthropomorphized, or associated with "forces" like progress and evolution, but

more substantially, reconfigures ephemerality and immateriality as states represented and known *only* through technological bracketing. This is perhaps part of what Heidegger is referring to when he pries apart "technology" from "technological."[58] Arthur Kroker suggests that the metaphors Heidegger used to analyze technology were prescient given the current form of digital media.[59] It may be that Heidegger's earlier thesis on "attunement" is similarly revealing in its tortuous circumnavigation of sound. Pulled toward and repulsed by sonority, his refusal to just "let sound be" might also be read as a latent analysis of the deaf ear that culture turns toward the impact of telecommunications—specifically the telephone—as a force of and for technology. As Kroker insists:

> Make no mistake. Heidegger does not "think" technology within its own terms. Quite the contrary. Repeatedly he insists that technology cannot be understood technologically because, in opening ourselves up to the question of technology, we are suddenly brought into the presence of that which has always been allowed to lie silent because it is the overshadowing *default condition* of our technical existence. Heidegger is relentless in making visible that which would prefer to remain in the shadows as the regulating architecture of contemporary existence.[60]

It is worth pausing for a moment to reflect on "the *default condition* of our technical existence." What is it to default—what does one default to? "Default" has the connotation of both a failing, a deficiency, a lacuna or lapse, and deceit. As a failure to show, to repay, to act, or to think, and also as a condition, the defaulting here can be interpreted as a state that allows thinking to fall away—or fail—at the moment that technology appears, falling in this case into silence, into the gasp that technology often elicits. The gasp occurs when there is a momentary vacuum, when one is left speechless, when rhetoric cannot reconcile the lie that is unfolding. Engulfing both the highly utopian and darkly dystopian promises of technology, the gasp also creates an opening, a deregulated space for colonization by rationalist propaganda. It is both from and within this "silence" of the gasp that Heidegger's call of the conscience has contradictory implications. Silence can be read as a refusal of the technologically situated, and especially wireless, individual to be constantly appropriated by technoculture, who prefers instead to ignore the beeps and just be left alone and "unplugged." Silence, on the other hand, is the space of nonthinking, that lacuna that slips between the default articulation of technology (as a rhetoric of progress, civilization, evolution, and, more recently, posthumanism) and the

gasp—silent and breathless—that this rhetoric elicits. Caught between silence and sound, between nonthinking and avoiding data-assault, could the call of the conscience be thought of as the momentary pause during which a convocation of guilt, questioning, curiosity, and estrangement is fleetingly engaged and the fear of falling into an abyss is swiftly put aside? That moment before we reconnect, in transforming the silent gasp, into the brief, somewhat mechanical response: "Hello, I'm here"?

Immersion

Always what was important to me was the notion of being
immersed in enveloping space, and the sensation that you're
fully enveloped, . . . it's not about interactivity but the fact
that you are spatially encompassed and spatially
surrounded—it's all around—and that's what sound is.

<div style="text-align: right">Char Davies, 10 September 2006</div>

As a prologue to discussing Char Davies's work, I begin this chapter
retrospectively, from the position of one who has followed Davies's
work for over a decade, to establish a context through which the cas-
cading repercussions of a very simple event—walking and talking on
Reverie—will manifest in my reading of her work. I am making tea in
Davies's cabin, on her land—*Reverie*—in southern Quebec. We have
just returned from a long walk, and still a little breathless (Davies has a
fast clip), I am astonished to realize that during my short time in the
kitchen she had already sketched our "route." Although it seemed to
me that we were going nowhere in particular, and certainly there were
no paths, tracks, or markers of any kind, Davies walked me through
notable landmarks of her new work-in-progress: her land. This seems at
first to be a dramatic departure from her highly acclaimed VR works
Osmose and *Ephémère,* but in a very relaxed and matter-of-fact way,
Davies responds to my obviously puzzled expression: "For me the pro-
gression feels very natural—meandering through the land, the sensation
is one of being spatially enveloped, where the horizon and trees are all
around you, and everything is engaged in these transformations and
fluxes. So I see my current work as an expansion from what I was
attempting to enable other people to experience [in my immersive works].
This land for me is both a medium and an environment."[1] The sketch
Davies has drawn fills another page in her working notebook, already
brimming with handwritten entries, outlines of routes, and drawings—a

set of schematics by which she graphically maps the land, as she physically inscribes it through walking. Her sketches are less about depicting the two-dimensional space of conventional drawing, than showing "how a boulder may warp all the space that revolves around it, how the trees may have a certain rhythm depending on their place in the land." Where this will lead is still emerging, but themes that inhabited her entire oeuvre are palpable here also. Ephemerality, existence, becoming— themes that were evident in *Ephémère*—have now become integrated in what can only be described as a deep personal exploration—one that places Davies *within* what she had previously attempted to evoke through VR technology. This "within" is profoundly ethical, in the sense of *ethos,* as disposition, and also as comportment: a way of being in the land that makes walking the land such an essential component of Davies's current artistic process. There is an interiority to Davies's immersion in *Reverie*—placing one foot in front of the other is a movement both into the external environment and toward a sensibility that she describes as "being-among."[2]

In the field of her awareness, in the fields of her land, Davies is engaged in an ongoing reclamation that is as much physical (planting trees, restoring stone walls) as it is philosophical. In terms of new media, Davies is also reclaiming and reworking the aesthetic and philosophical principles that have always informed her work: her critique of ocular-centrism, dualism, and instrumentality through an investigation of perception that is itself grounded in her own "soft-sight." In so doing, she challenges many of the fantasies that have framed her work, since there is not much to say about virtual space and embodied awareness when it is resituated within the land itself. But this is not a repudiation of VR technology. Rather, by reclaiming terms originally used to signify (pretechnological) virtuality and (pretechnological) immersion—terms appropriated to support the particular technological configurations that emerged during the 1990s—Davies is clearing the ground; reinscribing her philosophical influences, while resituating embodiment, her here-and-now presence on the land, beyond the frame of technology. Unplugged perhaps, but then Davies has no particular loyalty to any one medium: while VR enabled her to realize one artistic goal—shifting the habituated, object-centered, perception of the "immersant" (the term Davies coined for the viewer or participant)—like Cage, she finds her aesthetic naturally leading to a perceptual/conceptual/ethical comportment—a "letting be," which is more than simply seeing, hearing, or touching, more than the material substrate of perception, more

even than the synesthetic perception and spatial simultaneity that she
explored in her immersive works. Like Cage also, Davies has found that
while sound (or visual transparency, spatial simultaneity, interactivity)
might help the user or viewer to "see freshly," ethics becomes enfolded
within aesthetics. My concern here is to address the phenomenological
inspiration underlying her work, which has been realized in particular
through the breath and balance interface and pertains directly to sound.
The neglect—or miscontrual—of this component of Davies's work is an
example of the way new media theory, by ignoring the field of aurality
(breath, in particular) and concentrating instead on three-dimensional-
ity and interactivity, has retraced and reinvigorated a techno-Romantic
impulse associated with early audio.

In order to understand this process, we should return to the rhetorics
of immersion that surrounded the premiere of *Osmose* in 1995 at the
Musée d'Art Contemporain, Montreal. The opening itself was quite an
experience, as expectant viewers, excited and nervous as they waited
their turn, gathered in the foyer, while others drank champagne and
watched the navigation of the immersants via a large-scale projection
screen, or gazed quizzically at a translucent scrim where the shadowed
silhouettes of the immersant could be seen swaying and bending as they
navigated the "worlds" of this virtual environment. People emerged
from the immersion chamber white and shaking, smiling, or speechless,
and seeing their reactions made sense of the somewhat intimidating dis-
claimer that the viewer had to sign before being led into the chamber
and carefully fitted with the breath and balance vest, before donning the
helmet and being told to relax. This disclaimer, mounted on a podium,
was a legal document, which freed both artist and sponsor from any
responsibility for the surprisingly long list of medical conditions that
experiencing *Osmose* might activate or upset. Although necessary, it
seemed an odd intrusion, interrupting the buzz about this piece in par-
ticular and VR in general. Here we were, about to engage with this
strange new technology, to enter this realm called "virtual reality" and,
if the hype was right, experience something entirely new; yet we were
presented with a medical disclaimer reminding us not only of our always
vulnerable bodies but of our judicial body, the body that can sign its
name, that is fully, legally committed to its one and only identity. Within
the rhetoric of cyberspace and VR, identity was supposedly fluid and
mutable—to the extent that one could feel like, indeed "be" a lobster, or
a crow, but this document gave pause to such flights of fancy. Directly
opposite, at the other end of the foyer, was another podium—supporting

a large comments book to which the immersant, still shaking from the VR experience, was asked to contribute. In contrast to the absolutism of the medical disclaimer, the pages of this book held together expressions of uncertainty, of not quite being able to gather oneself in order to speak or write. For people like myself, who could barely walk, let alone put two words together, the musings of previous contributors were there as both a guide and a record—and, incidentally, made for a surprisingly good read. Thrown by the complete ocular engulfment of the experience and still twitching from "virtual lag," reportees understandably would exude a state of excitement. But what caught my attention among the iterations of unbridled enthusiasm were the more serious pleas for technology and art to provide a reconciliation between nature, spirit, body, and culture and, in so doing, to capture again the *Wanderlust* that twentieth-century living has destroyed.

These documents could also act as bookends to the sphere in which VR and new media have been produced and received. At one extreme, there is the intense, entirely rational and legalistic tracking of the body, executed by the computer and the medical and legal establishments, at the other, a ponderous nebula of recounted experience, part mystical, part sublime. At the entry is the apex of Western systems of representation and knowledge, contained in the binary code that computes the vicissitudes of matter to suit the Cartesian architecture of the virtual, and at the exit, garbled messages about irrational unions and impossible transcendence. How could these polarities exist in the same room, the same cultural milieu? How could the paradoxes that flow between them be reconciled without triggering aphasia? The visual content of *Osmose*—which consists of nature imagery—didn't help, offering those who were willing to suspend disbelief the lure of an Edenic possibility: perhaps "the clearing" and "the deep sea abyss" were manifestations of a new technologically "tuned" nature, enabling a state of unmediated innocence to be rediscovered? Perhaps, as one immersant commented: "*Osmose* is a reconciliation with nature through technology, a reconciliation with technology also contrary to what we're used to, gentle and peaceful."[3] These entirely unscripted entries suggest that between the entry and the exit of *Osmose* lay a field of possibility that had already been sown with the unrequited desires of twentieth-century technoculture. Despite Davies's cautions, *Osmose* had previously already been invested with the hype of *new* technology and, paradoxically, nostalgic yearnings for some kind of closure to the blend of new age and technophilic attitudes formed in the 1960s counterculture. If *Osmose*

was "a good step toward a successful marriage between art and new technology," it also reinvigorated a union formalized by Experiments in Art and Technology in the mid-1960s, as the following comment suggests.[4]

> All the rhetoric about "VR" can be dissolved by this work to produce a new ground for discourse—gentle and magical—I never have felt so elevated before by an immersive work, only by the actual experience as nature or dream. As Gene Youngblood hoped, here is a work wherein we, as a culture, had been able to create at the level which we destroy, that is, this technology, so often used for the extrapolation of the banal and the exploitation of violence and fear has been turned to the creation and experience of wonder![5]

In the art-to-life ethos of the time, industry often blurred the boundaries between art and commerce by appropriating the mystique of the artist—it was, for instance, no coincidence that Pepsi-Cola became involved with E.A.T.'s *Pavilion* project in the 1970s in order to extend its market to youth culture in Japan.[6] In the late 1990s, youth culture, cyberpunk, and geekdom-as-style helped create markets for once-nerdy computers and IT. In both cases, artists played an important although unacknowledged role at the time in forging, through their own labor and through the historical and cultural weight of "Art," the rhetoric required to sell a product, a culture, and—in the postmillennial globalized world of outsourcing—a new regime of work and life.[7] Indeed, the axioms that Billy Klüver (cofounder and spokesperson for E.A.T.) formulated to encourage partnerships between artists and engineers not only laid the foundations of the rhetoric in the 1960s, but gave license to the modes of address and rhetorical styles that launched a similar movement in the 1990s.[8] Five years before the turn of the millennium, it is no wonder that *Osmose* became a fulcrum for unresolved and rapidly mutating attitudes toward technology and inherited many of the beliefs, conflicts, and ambiguities of prior decades.

So much has been written about *Osmose* that I will not repeat the various interpretations here, except to offer readers unfamiliar with the work a brief description and to mention some of the main criticisms. *Osmose* is described by Davies in 1994 as:

> An immersive interactive virtual-reality environment installation with 3D computer graphics and interactive 3D sound, a stereoscopic head-mounted display and real-time motion tracking based on breathing and balance. There are nearly a dozen "realms" in *Osmose*, metaphorical reconstructions of "nature" as well as philosophical texts and software code. The visual elements within these realms are semitransparent and translucent.

Osmose is a space for exploring the perceptual interplay between self and world, i.e., a place for facilitating awareness of one's own self as consciousness embodied in enveloping space.[9]

The enormous attention *Osmose* has received is largely due to four distinct but related factors: first, technically the unique interface she and her team developed, together with the visually sophisticated images, and their multilayered transparency, remains at the forefront of innovation in the area. Second, the use of breath and balance as a navigational device has challenged the traditional VR interface, by offering a critique of VR as a medium based on Cartesian coordinates, one that reenacts the privileging of the eye and the mind over the body. Davies is well aware of the origins of VR in the "western-scientific-military-industrial-patriarchal paradigm," which she connects strongly with the Western philosophical tradition.[10] This paradigm has a physical correlate in the dominance of the visual, which in VR is hyper-attenuated through the use of all-encompassing stereoscopic screens in the HMD (through which the wearer is "cloistered from external distractions"), and the close association between the hand and eye in most VR navigational systems. The metaphysical and the perceptual (sight and touch) thus blend in a culturally proscribed, virtually "embodied" experience that—in traditional VR—reinforces visualism while adding the powerful element of interactivity. Third, the use of semi-transparent images critiques the photorealist bias of computer graphics, presenting a series of simulated environments or "worlds" devoid, for the most part, of solid objects. In doing so, the work evokes an alternate metaphysics in which materiality no longer governs ontology, and "perception," or rather proprioception, is governed less by sight than through the boundary disturbing operations of breath and balance. Finally, Davies's use of nature imagery is highly confronting, since it begs the *arche* question of VR: why attempt to create "virtual" realities in the first place—and what, politically and culturally, lies behind such a motivation? In the following I will deal specifically with the critique of visualism that Davies engages in her work, which provides an opening to her broader aesthetic, a context for her recent land-based project, and an answer to the most troubling question her work has generated—why VR?

Although some have responded to the ocularcentric basis of VR by extending the means for sensory interactivity (based on the assumption that once all senses are represented then immersion will be more realistic—so realistic in fact that the *experience* becomes "real" rather than "virtual"), Davies has attempted to move away from the visual by

incorporating the breath and body balance into the navigational system, rather than relying on the relatively crude interface of the data glove. The breath functions as a metaphor, signifying the fluidity between inside and outside the body, and as a navigational device that encourages deep breathing, "bring[ing] us closer to the connectedness of all things and reaffirming the physical world and the interior spiritual space of self."[11] The focus here is on embodiment—seen as the total body, rather than the body as a point of view determined by the eye/hand and head. Using breath to move up and down in the virtual environment, and balance to move left and right, the design of *Osmose* was intended to counter the frontality of vision with a sense of movement within enveloping space. This shift in perception, Davies hoped, would effect a shift in habitual modes of organizing the world—from hand-eye coordination (pointing to, naming, categorizing, etc.) to a focus on being-in, from the desire for forward movement, which in "looking ahead" sets in motion the ethos of modernity as futurity, to an appreciation of being grounded in the here and now of experience.[12] Breath, like sound and the voice, is constantly moving from interior to exterior, but as mentioned, this superfluity has been circumscribed throughout philosophy to produce the transcendent idealized voice. As mentioned in chapter 1, St. Thomas Aquinas relegated air to the voice's instrument, itself an instrument of the soul, while Aristotle quarantined speech from breathing.[13] If air and sound have historically been so reduced, an interface based on breathing would seem to restore some primacy to this most vital flow. But less abstractly perhaps, breath—as the first and last sign of life—is a constant reminder of mortality. While controlling one's breath might be important for the practice of meditation, generally in Western culture the obvious inhalation and exhalation of the breath signifies shock: "I gasped"; or fear: "I held my breath." Metaphors for breath describe moments of wonder and terror, moments when one is lost for words, when a state (terror, anguish, or joy) can be expressed only through a nonlinguistic, nonvocal exhalation.

Davies's choice of balance as the second component in the navigational interface was informed by David Michael Levin, who describes balance in terms of centering and suggests that "balance concerns our vertical alignment, our standing in relation to vertical axis. The two poles of this axis are the earth and the sky, the element of our grounding and the element that teaches us spaciousness."[14] In *Osmose* and *Ephémère,* the vertical axis of the immersant's body—as subjectively experienced through actual contact with the floor, and the sense of

ascending or descending in virtual space—is mirrored in the spatial structure of both works, with their emphasis on "above" and "below." Yet ironically, in *Ephémère*, the vertical and horizontal axes that the interface controls is subdued by Davies's larger focus on the liminal zone *between* life and death; *between* up and down. Occupying this liminal space depends on attaining not only a mental but a bodily, proprioceptively skilled "stillness" on the part of the immersant so that certain features of the work become responsive.[15]

The breath and balance interface has been interpreted by critics as an attempt to "reembody" the virtual within a new "reality, involving the artist in the seeming contradiction," as Steve Deitz puts it, "of attempting to create completely non-technical feeling spaces and experiences with some of the highest technology available."[16] This common criticism forms a substantial component of Oliver Grau's extended reading of *Osmose* in his book *Virtual Art* (which offers the reader more detail than I can provide here). Grau aligns *Osmose* with the attempt to "develop a natural interface" that eradicates the necessary distance for a work of art to be appreciated, or even exist *as such*:

> *Osmose* offers a totally new reality, a cascade of alternative realities that, through physical and mental presence in the image world, effect a fusion and a moment of transcendence. . . . The body is addressed polysensually and immersion is produced with the techniques of illusion. This full-body inclusion demands . . . that the observer relinquish distant and reserved experience of art and, instead, embrace eccentric, mind-expanding—or mind-assailing—experience of images. . . . The more intensely a participant is involved, interactively and emotionally, . . . the less the computer-generated world appears as a construction: rather it is construed as a personal experience.[17]

Grau's concern regarding the eradication of aesthetic distance that "total immersion" encourages is understandable. The lack of distance from an artwork, or the inability to view it as an object, is heightened in immersive media—which are unfamiliar (we haven't learned how to "read" them yet) while their illusionism is extremely seductive.[18] The danger lies not only in an obliteration of the very possibility of aesthetic appreciation, but in potential changes to human perception brought about by "the serious contradiction between corporeal reality and artificial image illusion [that] is likely to be at a level that almost precludes rational access."[19] For Grau, virtual reality departs from the long tradition of interactive art (as art that challenged the authority of the work of art and that often made use of technology) formed by the avant-garde; this departure is ontological, since the virtual image is not an

"image" as such—it has no separate existence outside of its realization in the cerebral cortex.[20] The immateriality of the image, the fact that it has no objective existence, means that it becomes essentially a private perception, and therefore, ontologically, it cannot be considered a work of art—as, for instance, Heidegger and others would consider it. All the attributes for which *Osmose* is praised (the sense of floating, of being enveloped, of moving through translucent objects and worlds) become, for Grau, mechanisms for psychosis—of being unable to differentiate between the virtual and the real. As we have seen with audio, in terms of "apparatus proximity," the danger with what Grau calls the "natural interface" is that it leaves no sense untouched—all the better to hide the technological apparatus while diminishing the possibility for critical and aesthetic reflection. The ideology of the natural interface then is bound by a certain formula: the more proximate and sophisticated the technology, the easier it becomes to dissimulate the apparatus, and thereby disavow the technological basis of the medium.

POORLY EQUIPPED BODIES

Even though stillness is an essential feature of Davies's intent, the irony of being still while using a highly interactive medium has featured in representations of her work (often as a criticism).[21] Richard Coyne, for instance, remarks that while *Osmose*

> provides freedom of movement through a "virtual space" [it] is a space in which there is nothing to do except contemplate, look, listen, and "float around." For all its qualities as an artwork, it is difficult to see how this work presents as a spatial environment beyond its immediate fascination, because there is nothing to do. From a Heideggerian perspective, space builds on spatiality, which operates in a field of praxis, and if there is nothing to do that draws you in, then you become aware of other sources of breakdown extraneous to the focus of the system: the heavy headset, the low image resolution, the noises in the museum, the time constraint, and so on.[22]

Here Coyne is describing the experience of one who has failed to become immersed, and such failure may have been more common than reported. The idealized experience of immersion that Davies wants visitors to share is one that, after all, developed from her hours of experimenting with the medium. Rather than presenting a universally understood medium, Davies instead created an apparatus that only she perhaps could "see through" with, and via, her uncorrected vision (to be discussed later) and her long history as an artist. This odd combination of skill and disability, translated into an art piece whose novelty at

the time defied comprehension, often meant that the deliberate
(con)fusions underlying Davies's conceptual schema were felt as the
intrusion of "extraneous" sources upon what was ostensibly a total
(although undefined and then unknowable) immersive experience. As
the world encroached upon this already mythologized virtual reality,
Davies's aesthetic of flow, impermanence, transparency, and ephemeral-
ity was, ironically, quarantined to the space of the HMD, and all that
her aesthetic represented was "captured" within that technical/rhetorical
frame.

But while the VR apparatus—like the camera in mainstream film—
might be beyond the visual frame, it does not follow the same logic of
the disappearing interface that Grau and others contend. Yes, it is true
that there is little distance between the "immersants" and the virtual
environment they navigate, and this lack of distance has been used to
argue a lack of difference between the viewers and what they see.
However, in almost every media representation of VR the HMD is pres-
ent, even fetishized, as a signifier of the possibilities that VR represents.
In the popular imagination these representations take a variety of forms,
from the data glove and transparent touch screens of *Minority Report*,
to the grimy "dentist's chair" simulator in *The Matrix*. Indeed, the pre-
ponderance of grime and the frequency and consistency of a "metal and
dirt" futuristic aesthetic (from *Brazil, Max Headroom, 1984, Johnny
Mnemonic* to *Paranoia 1.0*) may not be a coincidence. Theorist
Margaret Morse suggests that the desire for "incorporation, identifica-
tion, and symbolization" that immersion in the datasphere represents
(which, she argues, follows an oral logic) must be seen in the context of
the body-horror genre of science fiction film: "fragmented, dismem-
bered, or, for that matter, mismatched, multiple or decaying bodies and
lost parts (namely the cannibalistic fantasy of the body treated as food)
suggests that something fundamental is 'eating' our culture. . . . How
can the body be resurrected when it is so loathed?"[23] With this cultural
subtext, the immersant "enters" a virtual world with, at best, the faint
possibility of, as Morse suggests, "eras[ing] the organic from aware-
ness, if only partly and just for a while," but in *Osmose's* spectacular
staging, the messy and fragmented organic was reinforced by the sil-
houettes of the immersant making very odd movements as they tried to
balance their way through the environment. As Morse has suggested,
for the spectator, it appears that the immersant is reduced to the semi-
locomotive state of infancy—a shadow on the screen negotiating the
transparent and ambiguous spaces of a "nature" that is bordered by

code, constituted by code, and already culturally coded.[24] Morse recounts her own experience of *Osmose* as near to terrifying. Being an asthmatic, she found herself "instantly afraid" of even the symbolic association of being underwater, while her "math phobia" was triggered by the world of code that "scrolled upward faster than I could escape it by breathing in more and more."[25] My first experience of *Osmose* also provoked a variety of panic that would be familiar to those who are spatially challenged. As anyone who has traveled with me knows, left and right, let alone up and down, can be difficult coordinates to keep "in the right place"—and *Osmose* demanded that I remember which was where. My experience then was not of a disappearing but an all too present interface, one that foregrounded the skill of navigation (or lack thereof) as much as the worlds to be navigated. This disassembly was repeated recently, although for different reasons, when I attempted to "go through" *Osmose* and *Ephémère* in Davies's Montreal studio. Because the chest expansion belt was ill suited to my small dimensions, I was unable to navigate up or down and found myself on several occasions simply sinking. Expanding the chest belt by hand proved to require more physical force than I was able to muster, and so, reluctantly, my journeying was both limited in scope and scattered to the point of becoming literally dizzying. It is unfortunate that anecdotal testimonies like my own and Morse's were probably not recorded in the comments book placed on the podium at the exit of *Osmose*'s premiere, since the abject failure of virtual embodiment of which they speak may have muted some of the more wildly mystical comments that came to represent Davies's work.

As anyone who has ever engaged with this kind of technology knows, there are *multitudes* of technical and circumstantial impediments to forgetting the presence of the apparatus. But these pale in comparison to Davies's intentional, although latent, insistence on the "poorly equipped" body rupturing the fiction of the perfect body that virtual embodiment implies. For the kind of body that navigates Davies's virtual worlds is culturally and metaphysically challenged: not only do the immersants not get to "do this to that" via the data glove, not only is their virtual zoom constrained in order to encourage a stillness in *Osmose,* and a particular approach to objects in *Ephémère,* but the visual world they survey is composed of objects that aren't really "objects" at all. This liminality is matched by a primary source of Davies's aesthetic—her own "poorly equipped" eyes. Davies often cites her work in other media to discourage a techno-oriented reading of her

work, and while this seems at first absurd—given the sheer size, sophis-
tication (at the time), and expense of the technical apparatus—when she
details the actuality of her own uncorrected vision, her detachment from
the apparatus is more understandable. Davies's "sight" and her aesthetic/
philosophical vision are two sides of the same coin, intertwining the
physical, perceptual, and very material basis of her work with what oth-
erwise might be considered a fairly abstract, conceptual predilection.

Reminiscent of the way Cage turned to sound because he "had no ear
for music," Davies's attraction to ephemerality and flux, and thence to
phenomenology, can in part be understood as providing an intellectual
ground for her astonishing physical (in)capacity, which became the
source of her lifelong aesthetic and artistic practice. Not only did her
childhood myopia (developed at age eight) give Davies the experience of
a certain blindness or lack of visual acuity, but it demanded from her an
uncertain and questioning approach—a stumbling that was both serene
and alarming.[26] In her twenties, Davies was told by her eye doctor that
she would have to take out her contact lenses for a week to do some
tests, and it was during that time that she actually became interested in
her uncorrected sight. From then on she began working with what she
refers to as her "soft-vision" and developing a technique of painting
using half-glasses: "I learned that if I took away my corrected vision,
which is very frontal and whereby objects are hard-edged, it radically
changed my sense of my own body. . . . Space was no longer empty,
filled with solid objects, but rather felt like it was *all around* me and my
body was moving *through* it."[27] Thereafter, Davies made what was
essentially an aesthetic decision, to choose to (de)focus her vision, not
so much as an exercise in developing a new perceptual modality, but in
understanding the new sense of space her soft vision revealed. Davies
attributes the transparency in her work to this investigation of space as
objectless, enveloping, and full rather than "empty."[28] She was initially
reticent to attribute her aesthetics to her myopia.[29] Davies began to see
the relevance in her uncorrected sight, through which "the circles of
confusion, to use that optical term, were like huge spheres of confusion,
semi-transparent, luminous and overlapping."[30]

PHILOSOPHICAL INFLUENCES

Con-fusing objects, ontologies, and identities, Davies's body—or at
least her eyesight—might provide a view of the world that is nondualist,
a view that David Michael Levin, whom she cites, describes as the

"pre-ontological understanding of Being [which] is the precious gift the lived body can give to thinking."[31] But what is it to ground this idealized view, and all that it stands for, in an embodiment that is impossible to inhabit within the world of objects? Davies is caught between dual visions: the actual vision she has, and the philosophical vision she is trying to communicate. There is no doubt that her understanding of space, perception, materiality, and embodiment has been greatly influenced by Merleau-Ponty; she often sums up her ethical approach via Heidegger's concept of *Gelassenheit* and her critique of technology via his concept of "enframing," while environmental philosophy and Buddhist influences (in particular Nishitani) literalize these philosophical concepts in her physical engagement with her land.[32] It is no coincidence that many of the philosophers Davies mentions pose a subjectivity and metaphysics that are as much aural as visual. Merleau-Ponty, for instance, provides an avenue for thinking about the translucent, immaterial "objects" or flows that populate Davies's VR works, through his critique of traditional philosophy, which he refers to as "specular" philosophy, or the philosophy of reflection.[33] Very briefly, specular philosophy, in uniting perceptual "anomalies" (phantasms, illusions) via a transcendental rather than incarnate subject, creates an idealized perspective or "ideality," through which reflection approaches the phenomenal world by way of the ideal "essences" of its elements, thereby reducing the multiplicity of phenomena to the sedimented edifices of scientific objects. However, since "the reflection recuperates everything except itself as an effort of recuperation, it clarifies everything except its own role," there will always be a "blind spot"—a distance between the perceiving subject and the object, and the latter will always be constituted in the light of an already preconstituted world, an already given analytic. Traditional philosophy can therefore never restore to us the "there is" of the world; indeed, it "replaces our belongingness to the world with a view of the world from above."[34]

For Merleau-Ponty, the pervasiveness of this view is anchored in the perceptual experience itself, from which a relation of identity is established between, for instance, the object viewed from a distance and the object viewed close at hand. What establishes this "sameness" of the object is the "seeing apparatus" of the body, which constructs a "point of view" and inserts the object within the field of significations (language) that refer not to the objects themselves, but to the object as "object-thought"—as meaning. Within language the object is constituted, almost as an "artifact," and circulates through the "coherent

system of appearances," which indeed makes possible any relation to an object. But this constitution is not after the fact of perception; citing Jacques Lacan, Merleau-Ponty stresses that perception itself is already structured "as a language." Because the very act of perception forecloses the possibility of apprehending the thing in itself, the notion of complete certainty implies the evacuation of embodied subjectivity: "in the measure that the thing is approached, I cease to be; in the measure that I am, there is no thing, but only a double of it in my 'camera obscura.' "[35]

This dilemma cannot be resolved within philosophical discourse.[36] Merleau-Ponty urges that it can be mediated through the praxis of a "hyper-reflection"—a reflection that is simultaneously aware of itself and engaged with the horizon of the world—found within experiences that have not yet been "worked over," do not yet enforce the subject/object distinction. The example he gives is the perception of color, which begins as atmospheric until it is "fixed" into an entirely relational structure.[37] Rather than an "atom" that could be identified as "the same red," color is instead "a punctuation in the field of red things." He concludes: "a naked color, and *in general a visible,* is not a chunk of absolutely hard, indivisible being . . . [but rather is] an ephemeral *modulation* of the world."[38] If the visible is a modulation, the visual perception is less a "look" than a "palpatation": undivided, ephemeral, and not at all "thing-like." Perception and being are structured by a continuous movement or flux between subject and object, continuum and discrete series, sense and sensation.[39] For Merleau-Ponty, the body is no longer *in front of* the world: "Being [is] no longer *before me,* but surrounding me and in a sense traversing me." The "thing" becomes a field, horizon, or dimension, and the subject is no longer distinguished, though is distinguishable from, the object, which is no longer an "object" as such.

Merleau-Ponty's subject may as well be a listener. Like color, the field of sound is not a chunk of divisible being, but is more like a state or quality, surrounding the listener, who is simultaneously hearing and being touched by the vibrating, engulfing, sonic atmosphere. Referring to this synergy, in a seemingly tangential note, he writes: "What are these adhesions compared with those of the voice and hearing?"[40] Later in the text, he concludes that the voice and hearing belong to "other fields . . . beyond the circle of the visible."[41] These fields lead at once to interiority—"I hear my own vibration from within . . . I hear myself with my throat"—and to abstraction. Uniting voice, body, vibration, and the autoaffectivity of hearing oneself speak, Merleau-Ponty situates their intersection within the body, beyond the visible, at the threshold of alterity. As he writes, the

"expression" of the flesh is precisely "the point of insertion of speaking and thinking in the world of silence." What is inserted between the interior (flesh) and the abstract (thought), between sound and meaning, speech and "what it means to say" is a gap or delay—a pulsation. It is the dehiscence of the voice—the gap or delay produced by the subject hearing himself or herself speak, which forms a circuit between the felt voice (as flesh) and the heard echo (as exterior perceptions and abstract language), a circuit connecting matter and mind via a movement that both is and expresses "one sole contraction of Being."[42]

The sensorium sketched by Merleau-Ponty is not unique to his philosophy, but can be found in pre-Socratic thought—in particular the writings of Heraclitus, whom Davies cites and often echoes in her use of the term "flux." Heraclitus offers a cosmology radically different from the dominant understanding of Being as static, rational, and dualistic. Describing existence, knowledge, subjectivity, and the cosmos in terms of a perpetual Becoming, he represents this Becoming via a number of metaphors and symbols that Davies also incorporates—especially in *Ephémère*—based on their ephemerality, their ambiguous existence, their "flux." The flowing river, for instance, which is never the same as itself: "Into the same river we step and we do not step." Or fire, which is always either kindling or diminishing, simultaneously seen and felt, exterior and interior.[43] As Heraclitus writes: "Everything flows and nothing abides; everything gives way and nothing stays fixed." This mutability prevents the "thing" from being objectified. Even the soul—Aristotle's *prima causa* of the proper voice—loses its "the" and is described instead as "the vaporization out of which everything else is derived" and "in ceaseless flux."[44] These characteristics also apply to sound: like the fire, sound is always coming into and going out of existence, evading the continuous presence that metaphysics requires; like the fire also, sound is heard and felt simultaneously, dissolving subject and object, interior and exterior. Like the river, sound cannot be called "the same" since it changes at every point in its movement through a space; yet like "Soul," it does not strictly belong to the object. Nor can sound's source and ending be defined, for it originates as already multiple, a "mix," which makes it impossible to speak of "a" sound without endangering the structure of Western thought itself.

Bringing these writers and philosophies into the context of Davies's literal sight and aesthetic vision, one can sense a history to her VR works that has a multitude of correspondences with aurality. These are by no means accidental: Davies's breath and balance interface in *Osmose* and

Ephémère, together with her use of semitransparent luminosity, can be read as a primarily aural approach, eliciting perceptual and philosophical modalities based on sound and listening more than materiality and sight. Although rarely addressed by commentators, sound is one of the most important elements in Davies's VR works—literally (sonically) as much as metaphorically, and this aural influence can be interpreted as integral to the formation of her aesthetic and philosophy.[45] By reading Davies through aurality, common elements, characteristics, descriptions, associations, and embedded epistemologies emerge. The "coming into being, lingering and passing away" that propel her aesthetic are all terms that signal movement from one state, one ontology, one tense, to another. All the material and technological elements that Davies brings into play seem designed to capture the moment(s) prior to the becoming-object of being, to capture the virtual (in the sense of the "not quite"—as Bergson describes it). The concept of flux is the driving "narrative" of *Ephémère,* where each element, each "scene" undergoes—both internally and as a reaction to the immersant's navigation—a dissolution: from visibility through semitransparency, to invisibility, enacting a visual allegory of the rhythms of existence, within the multiplicity that composes the scene. This focus on "coming-into-being" creates the often uncomfortable contrast with digital technology, wherein "being"—even only as nominal code—is articulated at the minute level, and if there is any "in-between" it is not brought into whatever approximations are made in producing the digital sound or image, and therefore, not brought into the field of perception, which as Brian Massumi points out is always analog.[46]

 This constant movement is, however, anchored by a certain stillness— a "space" from which "objects" emerge. The stillness resonates with Davies's understanding of *Gelassenheit*—itself informed by her experience of "hovering" in oceanic space—and manifests in the work as a surrendering of volition (of "doing this to that"), which is required of the immersant in order to experience both floating sensations and the opening or "presencing" of the boulders and seeds in *Ephémère.* By tracking the direction of the head, Davies uses the immersant's gaze to determine their approach toward the seeds and the subsequent activation of the seed's blooming.[47] This "approach" is analogous to the way that the head turns toward a sound source and requires the same degree of focused stillness.[48] Listening demands the kind of passivity that has been associated with the nonaggressive, mythologized innocence of sound within certain quarters. However, such an attribute is entirely misplaced—credible only within a metaphysics and culture that privileges action. In the context of

Ephémère, being still, poised, so to speak, in order to approach the other is, from the point of view of the other, a simulation, a pose, a comportment that draws attention to the necessary hybridity of apparatus and wearer. "The body" as such does not exist in *Osmose,* rather it transforms into an immersant, leaves behind the ethical approach that Davies is trying to install, and adopts instead the ethical or ideological apparatus of the interactive, computer driven, digital simulation that *is* VR. The fact that the body is still in this moment of suspended interactivity only serves to highlight the unnaturalness of this construct, and to suggest perhaps that stillness, or inactivity, is the perfect stance for approaching the simulated image. Which is to say that the phenomenological body of Davies's intent can never correspond with the immersant in the same way that the soft vision that drives her aesthetic must necessarily remain within the frame of her VR works and not be applied to everyday life.

VIRTUALIZING THE BODY

Technology interferes while enabling the phenomenological basis of Davies's work by enforcing a frame that transforms the body into an "immersant." At the same time, it is only through this frame that the ephemeral can be artistically realized. One frame enables and subverts the other. Similarly the sound in *Ephémère* has no resolution through the "music" representing flux. Unlike *Osmose,* the sound in *Ephémère* is continuously, relentlessly minor and discordant, with the only major chord appearing when the seed "blooms" after the immersant has paused for a moment. If flux—the flux and flow that Davies is evoking with *Ephémère*—has an aural correlate, it would be the kind of cacophony that Davies wanted to represent through a variety of sounds.[49] The origin of these sounds was disguised because as composer/producer Rick Bidlack noted, "sounds are as recognizable as words, and carry with them all kinds of emotional and contextual baggage which we did not want to impose on the world of *Ephémère.*"[50] In describing the spatialized and interactive sound, Bidlack gives as an example the "ethereal, shimmering, high pitched sound which accompanies the immersant as he/she is drifting through the above-ground forest. This sound is what we called in general a 'body' sound—it is intimately connected to the movements of the immersant."[51]

Bidlack raises the interesting question of whether or not the apparatus (the vest, helmet, and sensors) could be considered an instrument that the user plays. While he answers in the negative, "instruments require time on the order of years to attain proficiency," the parallels

with playing a musical instrument and the sonic interactivity of VR are revealing. As sound is the most "immersive" medium, so too playing a musical instrument is a very apt example of "interactivity." Musicians often speak of feeling "one" with their instruments and involuntarily move muscles when hearing their instrument played. Audiences commonly respond emotionally to certain chord sequences (national anthems are built on this), and sound is notorious for creating the suspense factor in films. However, musicians don't generally refer to their instrument as embodied; audiences—no matter how enchanted—don't regard the film or concert as a reality: a distinction is made between the body and instrument, the sound and the reality of the environment, the emotional experience and emotion in general. As Bidlack points out, sound carries its emotional baggage—it is always discursive. However, affect and interactivity—for so long associated with hearing and playing music—have appeared in recent theorizations of new media without so much as a nod to their aural, and still preeminent, exemplars.

This disregard is most obvious and potent in Mark Hansen's reading of *Osmose,* in which he champions the role of self-movement and touch while dismissing Davies's emphasis on stillness that Coyne has criticized. Like Coyne, Hansen sees movement as integral to the immersive, interactive experience: "whatever effect of presence the installations produce must stem not from a withdrawal from the activity of movement and the contact with the 'force-experience' . . . but rather from a heightening of self-movement and the proprioceptive in internal kinesthetic senses of the 'immersants.'"[52] In his recent book *Bodies in Code,* Hansen devotes a chapter to Davies's work, through which he elaborates an argument he has been developing for some time, namely that new media art is a unique vehicle for both the virtualization of the body and the recovery, or manifestation, of an originary technicity. *Osmose* and *Ephémère* are, he argues, exemplary instances of what he calls "one kind of 'body-in-code': an experience of embodiment that is specifically engineered to breathe life into the immaterial."[53] It is worthwhile pursuing Hansen's argument here, since it relates directly to the current discussion of Davies's work and also to larger theorizations of virtuality, technology, and questions of embodiment to be explored in the next chapter. Unlike Grau, Hansen regards the lack of aesthetic and proximal distance between the interface and the artwork not as a potential danger but as an aesthetic process in itself. Situating the proximity of the VR interface within an overall theorization of the medium in general and *Osmose* in particular, Hansen describes *Osmose*

as "restor[ing] virtuality as a dimension of embodied life, as a technicity within the living rather than a (mere) technical artifact that affects life from the outside."[54] Hansen's reading of *Osmose* is based in part on the phenomenological analysis of new media that he has been developing through his three books, *Embodying Technesis, New Philosophy for New Media,* and *Bodies in Code,* in which, roughly put, he outlines a theory of immersion in space as a dissolution between self and environment, a body/world blend, that is specific to digital media, and virtual environments (VEs) in particular. Hansen's reading of *Osmose* is part of this overall thesis and is based largely on a reading of Hans Jonas's essay "The Nobility of Sight," which he uses to critique the ocularcentrism of traditional VE (virtual environment) design. Jonas's central thesis is that sight depends on all the other senses, but especially touch, in order to produce its "noble" vision—a vision that, unlike the other senses, is not affected by temporality: "All other senses construct their perceptual 'unities of a manifold' out of a temporal sequence of sensations which are in themselves time-bound and nonspatial. . . .Thus the content is never simultaneously present as a whole, but always in the making, always partial and incomplete."[55] However, the persistence of vision—required for the ideality of the object to be established—comes at a cost:

> Vision secures that standing back from the aggressiveness of the world which frees for observation and opens a horizon for elective attention. But it does so at the price of offering a becalmed abstract of reality denuded of its raw power. . . . It is but the basic freedom of vision, and the element of abstraction inherent in it, which are carried further in conceptual thought; and from visual perception, concept and idea inherit that ontological pattern of objectivity which vision has first created. . . . Thus in speaking of the advantage of the casual detachment of sight, it must be born in mind that this results also in the casual muteness of its objects.[56]

Vision, for Jonas, must be supplemented by touch, "the true test of reality" (one can grasp an object), which moreover involves intentionality and is therefore not simply "mere sensation." Involving purposeful motion, touch is integrated with movement, becoming "self-movement," which Jonas argues is the "spatial organizer in each sense-species, and the synthesizer of the several senses toward one common objectivity."[57] Jonas's conclusion will sound familiar to critics of ocularcentrism: "Without this background of nonvisual, corporeal feeling and the accumulated experience of performed motion, the eyes alone would not supply the knowledge of space."[58] However, there is more to ocularcentrism than simply the idealization of sight; materiality is equally important in

establishing an object-centered ontology that, coupled with vision, creates a circuit between this and that, allowing, as Davies suggests, an aggressivity toward the world that the transitory, transforming, and semitransparent images in her VR worlds are designed to subvert. Without wishing to deny the critique of vision that Jonas establishes, it does seem strange that—given the interface and visual content of Davies's work, particularly her deliberate avoidance of manual grasping at objects— Hansen would embrace the priority that Jonas affords touch, without questioning the sonophobia latent in Jonas's analysis. I discuss it briefly here to emphasize the denial of sound and aurality that persists in both philosophy and (some) new media theory and that has also contributed to the awkward and fantastic readings of Davies's oeuvre.

Jonas does not like sound and hearing. Sound's temporality, its inability to "give . . . static reality" bars it from contributing to knowledge, and this deficiency—although an aspect of Jonas's critique of *theoria*— implies other negative qualities. Sound's perception and object are coincident: it "has no reference to the world of things and therefore no cognitive function"; it occupies the negative side of a set of dualities: between the static and dynamic, the temporal and the omnipresent, the partial and the complete, the persistent and the transitory.[59] While Jonas's ultimate aim is to show that sight is integrated with and depends on the proprioceptivity of the body in conjunction with the other senses, on the way to getting there he repeats many of the dictums that have, through the centuries, obscured the analysis of sound and marginalized it within a sphere of incomprehension. For instance, sound doesn't "refer" to anything except itself; being only itself, having no "representative function," sound, like music (perhaps *as* music), has meaning only via the memory of its sequential ordering.[60] This very traditional approach to sound ignores the events of 1966, when Jonas's essay was published. David Tudor, for instance, was performing his *Bandoneon!*— presenting for the listener a wall of sound wherein temporality was lost to simultaneity and the sequential, tonal system of music was replaced by white noise. Similarly, Cage's *HPSCHD*, or Varèse's *Ionization* for that matter, creates a simultaneity of tone and a synesthetic experience that parallels Davies's attempts, through visual transparency, to create what she refers to as "spatial simultaneity."

For Jonas, such a juxtaposition produces only noise, another "unmeaningful" aural event that, paradoxically, robs sound of its representational function of representing only itself: "Even so the limits for a simultaneous manifold allowing integrity to its members are narrow

in the world of sounds . . . to relate more than a few at a time to different source-loci in space becomes difficult, and beyond a limited number any multiplicity of sounds merges into a compound noise."[61] For Jonas, sound must both be and represent itself—and only itself—within a sphere delimited by noise: that is, it must be and represent itself through a meaning that cannot be named (the ambiguous or nonmeaning of sounds) circumscribed by a meaning that must be rejected (the "unmeaning" of noise). Unmeaning has for Jonas the same attributes that "mere sound" or "tone data" has for Heidegger and, like *Gerede*, is intimately related to the rumor and contamination of the multiple: "there is no 'keeping to one's place' in the community of acoustic individuals."[62] Whereas sight is selective and controllable, hearing is the opposite—rendering the listener a passive recipient of whatever sounds surround them: sound trespasses, it "intrudes upon a passive subject."[63] This "disability" has an ontological basis, since hearing is "related to event and not to existence, to becoming and not to being."[64] We could say, in paraphrasing, that sound and listening belong to the noisy and clamoring "outside" of metaphysics. Touch, on the other hand, is reified, it has a "mental" side "that transcends all mere sentience, and it is this mental use which brings touch within the dimension of the achievements of sight."[65] Coupled with sight, touch now has the status of materiality and immateriality at the same time—the ground of knowledge and the facility for transcendence—the phenomenal, material, and transcendental all at once. Touch is thus brought into the ideality of sight. Committing to an ontology of the material object, Jonas's analysis has no room for the kind of spatiality that Davies is attempting to evoke—if, in Davies's aesthetic, the transparency of images is intended to evoke a sense of sheer existence in objects—these objects are, like Cage's ashtray, both vital and vibrating. Viewing objects through a *lack* of sight—through the myopia that Davies has lived with for much of her life—is the act of viewing them in a vibratory sense. And indeed Davies describes the luminosities she sees in her field of (myopic) vision as "flowing" and "pulsing." So when Jonas writes that "things are not by their own nature audible as they are visible," he is ascribing to the nature of things what is indeed a shortfall in their (human) perception.[66] As a process of reasoning, "the nature of things" is referenced in order to build this hierarchy of the senses; and from this hierarchy, the nature of thought is established.

This reasoning continues in Hansen's analysis of *Osmose* and *Ephémère*. Following a narrative remarkably similar to early film

theorists' notion that sound could "breathe life" into the two-dimensional image, and with the same ontological implications, Hansen argues that touch synthesizes all other senses, transforming the interface from predominantly visual to primordially affective, and thereby embodying or materializing the immaterial in the process of vitualizing the body. Quite rightly, Hansen argues that the visual focus of VE design ignores "the grounding role played by the body and by experiential modalities—touch, proprioception, internal kinesthesia—proper to it."[67] Emphasizing "touch" as a "reality-generating" element (to use Jonas's term), Hansen argues that the success of generating compelling virtual experiences comes not by simulating visual images, but by simulating tactile, proprioceptive, and kinesthetic sense modalities. However, in equating Jonas's theory of perception in "real" environments to those of VEs, Hansen not only eliminates their difference, but, more important, he constructs a very individualistic and ideal notion of reality as only sensorially perceived, rather than socially shared. Hansen then couples touch with movement and "reality," or a sense of reality, with the perception of spatial depth—a theme he addressed in *New Philosophy for New Media*. By including action, Hansen (quoting Jonas) finds the element required to "synthesize" (according to Jonas) the other senses. Tactility here is understood as movement (qua "bodily performance"), which transforms perception into experience. From this purely phenomenological account of the body moving (touching) in an environment, Hansen infers the following conclusion: "On Jonas's account, then, VE's generate an effect of presence or 'reality' because they correlate a 'virtual' perceptual stimulus with a 'real' motor response."[68] Drawing on Bergson's account of the passage from virtual action to real action, which occurs through affection (the coincidence of the object perceived with the body itself—a correspondence not dissimilar to Merleau-Ponty's *chiasm,* which Bergson theorizes in terms of actual proximity), Hansen interprets affection as touch. In a prior essay, "affection approximates touch since in both cases what is at stake is some kind of 'force-experience.' "[69] In *Bodies in Code* this rationale is reduced to a correspondence between Bergson's "virtual" and vision, "real action" and touch, which, combined with self-movement (per Jonas), demonstrates for Hansen that all perception not only "must lead back to an action of the body on itself (self-movement) [but must clarify] how the reality-generating potential (or virtuality) of embodied self-movement can be lent to the most schematic artificial environments."[70] These cascading equivalences (between Bergson's "virtual" and VR, between Jonas's "reality-effect" of a nontechnologized touch

and the effect of presence, or "reality" that VEs generate, between the predigital understanding of environment and embodiment that Bergson and Merleau-Ponty shared and its digitally informed adaptations) are then applied to Davies's work: "We can now specify precisely what constitutes the uniqueness of Char Davies's deployment of virtual reality technology to create a body-in-code. *Osmose* and *Ephémère* are designed expressly to catalyze a shift, as well as to compel the self-reflexive recognition of the shift, from a predominantly visual sensory interface to a predominantly bodily or affective interface."[71] Grounding Davies's interface in touch and self-movement departs quite radically from the concept of ephemerality governing her aesthetic, which is itself tied to her ethics of stillness.

Amid abundant praise, Davies's critique of Cartesianism (interpreted, it seems, as a critique of ocularcentrism) is understood via her myopia, which is cited as a way of understanding her work in the context of "this private experience." Critiquing vision through poor vision is, however, only one reading of Davies's intent. As she mentions repeatedly, her use of semitransparency is a visual expression of a philosophically informed notion of being: "[my vision] has to do with things not being solid, not being separate, and being in a state of constant flux and flow."[72] Instead of seeking to extend sight as a sense dependent on the body, to reinvigorate "that most disembodied sense" that in a move similar to Heidegger Hansen asserts will stand for all other senses, a more productive approach might be to look at breath and balance from the perspective of listening.[73] The inner ear is after all the seat of balance, while the breath incorporates and is incorporated by that most affective, most troubling bodily production—the voice.[74]

Ephémère is an example of the maturity of Davies's work; her willingness to risk the conventions of VR and interactive media works, in order to place the immersant in a state of stasis, is, rather than a withdrawal, an openness that encourages the "other" to come forward.[75] In the context of diving, stillness requires balance and poise: that one subtly contain the movements of one's own body so as to engage the other. In the context of listening, it requires the listener first to quiet the sounds of the body brushing against objects. In the context of simulated computer-generated environments, poise might also be an ability to straddle the difference between the media-simulated images and the shift in perceptual habits they might provoke, without collapsing the two in an impossible and implosive ontology—one that leads to the infinite regress of positing multiple bodies and equal yet different realities.

And here we find that the metaphysical movement from aurality to audiophony provides an important and cautionary precedent for the movement between virtuality and VR. For while the metaphysics of aurality is transported through sound, it also opens up to epistemic fields *beyond* sound. No medium, technology, or sense can effect the shift of which Davies speaks, nor do aurality or virtuality adequately address the alterity they gesture toward. The idea that the technology acts as a form of *poiesis*—manifesting the latent virtuality of human embodiment—has been made for all media and in the case of audio has struck a particularly cosmic, evolutionary chord, with the activation of individual and interior capacities paralleling the activation of hitherto inert objects. These activations contribute to the attribution of agency to technology, through technical devices like amplifiers, microphones, and headphones (in the case of audio) or computer interfaces and eye-phones (in the contemporary context). However, headphones augment by delimiting or filtering sounds in the environment, and VR eyephones augment the illusion of immersion through imposing a physical blindfold; and with every delimitation, a degree of control is exercised. The head-phones can create their cosmic, ethereal inwardness only by collapsing the space between the ear and the audio device; just as the eyephones col-lapse the space between the eyes and the digital image. The proximity of the interface "immerses" through filtering, and, as the history of audio reveals, such filtering is never neutral. What sounds are amplified? What range of the voice is dominant? What perspective or frame is put in place? What kind of eyes and ears are being constructed here?[76]

Filtering out noise of course is a cultural conceit and has been used literally to silence voices, sounds, and noises that the idealized listener does not want to hear, or that the producer doesn't want them to hear. In VR, the actual space of the room in which the immersant stands, including the technical infrastructure, is blocked out visually, but as anyone who has worn an HMD knows, this context weighs heavily on the experience. The same question then applies to VR: what kind of proprioceptivity, or tactility, or "self-sensing affectivity" is augmented, and what is filtered? And isn't this a crucial question when it comes to utopic or dystopic readings of media? By internalizing virtuality, Hansen effectively erases any hard distinction—however dubious—between the body and technology. This occurs via the proximity of the stereoscopic apparatus (the HMD) to the eyes of the user, which in the context of the immersive artwork "places the body into interactive cou-pling with technically expanded virtual domains."[77] My focus here is on

the rhetorical mechanisms that inform interpretations of prosthetic augmentation. In "catalyz[ing] the production of new affects," new media artworks create, according to Hansen, experiences that are integral to the development of a newly virtualized subjectivity. As technology enhances and catalyses perception, so the user is transformed, since these new affects are unique to the new media apparatus and artwork:

> New media artworks facilitate interaction with virtual dimensions of the technosphere precisely in order to stimulate a virtualization of the body. By placing the body into interactive coupling with technically expanded virtual domains, such works not only extend perception . . . they catalyze the production of new affects—or better, new affective relations—that virtualize contracted habits and rhythms of the body. For this reason, virtualization can be said to specify the virtual dimension of human experience.[78]

In a broad rhetorical sense, Hansen's virtualized body may be understood as part of a larger project to confer an evolutionary agency on technology (discussed in the next chapter). The latter is particularly significant in the theorization of so-called embodied technologies— exemplified by the wearable devices and affective computer systems that involve the attribution of life or being or intelligence to the technologies themselves, making them coextensive with human experience and perception and rendering their output (data, information, or actions) originary. Again, there is no question of representation here because representation is replaced by the "perceptions" of the technologies: the question of source and copy does not arise. Embodiment is deferred onto a transcendental subjectivity that in turn defers to technology.

Arthur Kroker writes of new media art:

> New media art? That would be Heidegger's concept of the "turning" as a way of opening up being to the incommensurability of the digital nerve, learning, that is, a "comportment towards technology" that begins with the premise that the saving-power is also harbored within the danger. . . . *For Heidegger, the special purchase of art, understood as a poetics of listening to that "which withdraws," is that the artistic imagination recovers thinking in a time of thoughtlessness.* . . . Against the current of speed culture, the essence of new media art lies in reversing the technological field: an art of (electronic) slowness, and art of digital dirt, an art of boredom.[79]

In many ways Davies's aesthetic and philosophy resonate with Kroker's questioning of new media art. The schematics that Davies has built over time give her work a coherence that, in tying everything together, also tends to fold in on itself, and on the discursively ambiguous domain of cyberspace and new media phenomenology. The actual dirt, or the lack of

a frame, complicates the appreciation of her land-based work as "art," while the presence of the VR interface hides her aesthetics of being, or "letting be," from view. The trajectory of Davies's oeuvre can be read as a continued questioning of the frame—ironically, via a perceived absence of the frame—the disappearance of the apparatus that she allows into her work as an element that oscillates and wavers, like sound/noise, between being acknowledged and being ignored. Situated in the duplicitous context of incorrect sound and uncorrected sight, Davies's work offers both more and less than the many readings of her work suggest. More, because the elements of Davies's work, the breath and balance interface, the semitransparent images and the spatialized sound are not, as some have suggested, simply destined to critique ocularcentrism, or subvert the dominant visual emphasis of VR, or "reembody" the user in VR, or, alternatively, reembody VR. Less, because the interface does not in itself dissolve the essential mediation that so many writers and theorists of new media have hoped it would: it does not create a new space, a new mode of perception, or a new body. Nor are Davies's references to nature a covert statement about the possibility of healing the rift between technology and nature.

FINE LINES

According to Timothy Morton, the fantasy and rhetoric of experiencing a surrounding, all-enveloping world or atmosphere—a fantasy he names "ecomimesis"—is established through a poetics that itself "interferes with attempts to set up a unified, transcendent nature that could become a symptomatic fantasy thing."[80] "Soundscape" writing is a perfect example of this, and Morton refers to ambient sound frequently to elaborate his notion of ambient poetics. For instance, the concept of "schizophonia" put forward by R. Murray Schafer is here interpreted as "sounds without a source" that stand for "disembodiment as a feature of modern alienation." Commenting on the uncanniness of "disembodied" sound, Morton introduces an important distinction that pertains in particular to Davies's recent work. Regarding sound, he writes: "If, however, there is no source at all, the phenomenon does not reside in our world. It radically bisects it. . . . We thus face a choice between a transcendental experience and a psychotic one. Most ecomimesis wants to reassure us that the source is merely obscure—we should just open our ears and eyes *more*. But this obscurity is always underwritten by a more threatening void, since this very void is what gives ecomimesis its divine intensity, its admonishing tone of 'Shh! Listen!' "[81]

Figure 1. Char Davies, *Among the Myriads (@ Reverie), no. 25p*, 2007. Pencil on paper, 40″ × 26″.

Figure 2. Char Davies, *Among the Myriads (@ Reverie), no. 26p*, 2007. Pencil on paper, 40″ × 26″.

The pressure of the void that underlies the more Romantic interpretations of Davies's work, as well as her possible leanings toward a Romantic pseudo-material flux that could be apprehended if only we saw differently, is again interrupted by her own eyesight, which has become a component in her most recent series of artworks, which consists, at the time of writing, mainly of pencil drawings. These develop as a series, at first engulfing the viewer in a multiperspectival, abstract, and moving mass of lines and shapes that, to some extent, are reminiscent of both the three-dimensional spaces in her VR works and the boulders, streams, gorges, on *Reverie*. However, toward the end of the series the lines have lost all reference to any object or space and seem to be disappearing into the paper to the point that they become almost invisible (see figs. 1 and 2). Davies is drawing the kind of fine lines that are impossible to see with the naked eye—and especially impossible for her—with her eyesight—to see. If these lines and shapes represent the flux she is attempting to evoke, they are also pointing to the void that flux necessarily belongs to. And if this void is an atmosphere, an ambiance, an environment, it is one Davies is familiar with—she returns to it every time she takes out her contact lenses. The distinction Morton refers to—between a transcendental and psychotic experience—is extremely present in Davies's recent work, and it also haunts *Ephémère*. Often interpreted as transcendental, the atmospheres she visually inhabits out of choice and necessity are, like Heidegger's *Stimmung*, fraught with a danger both physical and metaphysical. "What is that object?" is a constant question in both the world of the visually impaired and the ambiance, atmosphere, and environments of sound. It elicits a thinking that is itself traumatic, and these traumas can be seen in the very faint lines Davies takes pleasure in not quite being able to see. If the void is present in Heidegger's embrace and his refusal of sound as a marker of a thinking that itself draws and repulses him, similarly, the fine lines of Davies's drawings are a marker of a state of unknowing that she is attracted to. The oscillatory, turbulent presence of sound—materially and figuratively—functions in an analogous way to the breath and balance interface she uses, to her insistence on stasis, and finally to her exploration of vision's fine lines in her most recent work.

Embodying Technology

From Sound Effect to Body Effect

Sonic signs flourish in the contemporary acoustic landscape: beeps remind you to charge, answer, or read your cell phone, louder beeps warn you that either your house is on fire or the smoke detector needs a battery change; sonic commands flood the acoustic field, saying as much about the technology from which they issue, as the aural messages they transmit. As mentioned, through audiophony—whether analog or digital—sound can be heard at any time, in any place, by any listener. Divorced from any phenomenal relation to the forms and flows of sounds occurring in the environment, no longer bound to the here and now of lived experience, sound becomes a pseudo-object. Like the visual object, it can be collected and stored, transported and transmitted great distances, and infinitely repeated; like the image, it can function as an icon, an aural logo, *read* by culture as much as it is heard by a listener.

Contemporary culture has developed a high degree of media literacy, which includes reading sounds as signs, as *effects*. These skills, more than anything intrinsic to the medium itself, have enabled the stylized sounds and idealized ears of the VR interface to fulfill its immersive function. While sound in the head has been spatialized through virtual audio, and sound in the body has been hypostasized through the impossibly intimate sounds of the big screen, this sonic projection is also a kind of evisceration. The whisper in the ear, the guttural laugh, the close-miked voice with a touch of reverb, represent a voice too large for any body, and a hearing too acute to be human.

The voice has long since surrendered any bodily commensurability, as it has been used as sonic material in experimental music and sound for many years: from F. T. Marinetti's sound poem *Zang Tumb Tumb* (1914), Kurt Schwitters's famous *Ur Sonata* in the 1920s, the intricate vocal manipulations in Pierre Henry's *Vocalises* and *Astrologie* in the early 1950s, to tape "cut-up" works of William Burroughs and countless other artists, to scratch and the plethora of contemporary musical and media genres that use vocal manipulation. With digital audio, the range of this manipulation is increased dramatically, creating a vibrant sphere of sound/musical expression that consists of nothing other than sound bytes or interesting aural glitches. In this context, sound is presented as being tied more closely to the technology than to the object, place, or body. Being remoored, so to speak, sound-as-sign no longer provides an escape, a field of alterity, a sonic wilderness yet to be developed, marketed, and consumed. Sound, or rather audio, surrenders its intimate relationship to the body, its unquestioned access to interiority and truth, its camaraderie with the unrepresentable, the emotional, the mystical—for the jurisdiction of the identifiable, divisible, packageable, and contestable object. This departure is no simple leave-taking, given the enormous investment media culture has made in sonic authenticity. Sound's perceived attachment to the non or even "pretechnological"— to the body, to space, and to the environment—no longer provides a defense against what could be called "the recording effect": the accumulated impact of sound's recording and transmission, which manifests today as the proliferation of beeping machines issuing orders, circulating samples, and reading various forms of static, not as messages from the ether but as one of the many genres of sound art. With the stylized sound effect, the "there" of sound, its here-and-now presence, its otherness to the voraciously visual drive of contemporary, externalized culture, evaporates. Like Cage's *Variations VII*, the system itself sounds, and as listeners become aware of the ironic, humorous, and sometimes tragic vocal traces emerging through these scattered signals, they understand a voice that is both destabilized and brought together by a technological apparatus that also, incidentally, has a sound.

The recording effect is particularly forceful in digital audio, which, in producing sound as an effect, becomes another form of writing, like word processing or the notational systems of music. While digital audio implicitly defines sound in terms of a "thing," that "thing" is no longer an object (of the concrete kind) but a stream of information constituted by zeros and ones that are approximations of discrete samples

of audio waves. These approximations simulate the analog sound wave, reproducing characteristics that the listener will perceive to be "true" of the sound rather than the actual characteristics of the sound itself.[1] Representing the sound wave as a series of discrete units that can be infinitely divided, arranged, and combined, digital audio transforms sound into a nano-object—an object capable of being manipulated at subsonic, inaudible durations, whose manipulation is therefore undetectable. Sound is thought of as "signal," a term that connotes movement only in terms of its input and output from the computer onto some other storage device, and once in the computer it is referred to as "data." As if rearticulating the history of metaphysics, the digital processor additionally represents sound as an image. As Brenda Laurel notes, "even though we don't see sound, virtual reality researchers commonly speak as though we do. For example, sound is 'displayed' with audio displays. We don't know where this tendency to use visual metaphors for aural experiences started, but it was long before virtual reality."[2]

The development of virtual audio (or "spatialized" sound) radically extends these tendencies. Moored in the floating spaces of telephony and radio, enveloped by the neo-organic and neo-Romantic discourse of the "global village," mapped by the stylus of phonography and tape recording, and now ejected into the semiotic ocean of digital sampling, virtual audio incorporates multiple dimensions. But it does so in a way that is by far an advance of other audio media because, in the pursuit of immersion and embodiment that is VR's stated goal, virtual audio actually takes the body into account. In fact, virtual audio acknowledges and technologizes the presence of the body and the environment in a manner that the visual aspect of VR is only just beginning to encompass. Like the visual component of VR, virtual audio technology creates an interactive aural space or "sound field," in which sounds are heard as if they occurred in the lived environment. If digital audio transforms the ear of the listener into *a hearing eye*, virtual audio threatens to shift this visual orientation. It does this through two mechanisms. First, unlike previous audio technologies that offer at best a stereophonic perspective, a "hearing ahead," virtual audio offers a 360-degree aural space. Second, this three-dimensional space simulates the actual movement of sound in an environment, mapping sound's passage from a virtual source through a particular acoustic environment to the ear, which, it must be stressed, is no longer abstracted as a hearing eye but represented in its full fleshy uniqueness. For computer technology to admit

the listening body into the interface is quite radical; to admit the sound source as an independent, autonomous identity is even more so.[3]

These acknowledgments might reflect a pragmatic rather than a metaphysical shift; nonetheless their effect is to reconfigure the parameters of listening. The kind of mapping necessary to locate sounds in space and to replicate the physiology of auditive processes is immense. The virtual sound source must be described according to its distance, elevation, azimuth, and environmental context (the effect of the room on the sounding source). This perspective must then be calculated for each and every sound in the sound environment and has to accompany each sound as it moves or transmutes over distances and through space. If static, the sound source must be perceived as remaining constant despite movement of the user's head. Reverb (for the room environment) must be calculated for its crucial role as a cue for the localization of sound, which means calculating reflections from walls and every other structure in the environment for each sound.[4] These factors are extremely important in simulating an immersive space, since the "there" of an environment is registered in minute detail by the ears. With sound there is no "nothing"—no empty space—between objects, no volume that can be ignored. Every object, every form, affects the resulting sound; every surface becomes a topology that yields reflections and, by registering the sound absorbency of the materials, reveals a depth. In the virtual environment, sound both travels through and bounces off objects. In doing so it marks materiality and immateriality at the same time, representing the world as matter, on the one hand, and as a continuum of differing pulses and transient formations, on the other.

Enveloped by this perspective, the ear, or rather the body, of the listener, together with the mechanics of hearing, undergoes a similar redefinition. First, the "interaural-amplitude differences and interaural-time differences" produced by having two ears separated by some distance have to be calculated to simulate binaurality.[5] Second, and far more complex, the "head-related transfer function" (HRTF), that is, the individual formations of the ear, the head, and the torso must be computed, since differences will change the way sound enters the ear.[6] The HRTF measurement represents a major change in the understanding of hearing. Philosophically, it realigns the ears with the body rather than the head, dispersing audition through regions of the body, such as the paunch, that have been regarded as irrelevant to sensory perception or the formation of knowledge. Culturally, it introduces a degree of technological intervention in the listening space that, since the time of

phonography, has been considered private, intimate, and individual. This intervention takes the form of a measurement standard that idealizes certain ear shapes; thus researchers will talk of good or bad pinna with reference to the pinna's ability to localize virtual sound. As Durand Begault writes: "In the future, in fact, I think we'll see musicians and recording engineers carrying around special sets of data for ears, the same way keyboard players carry around synthesizer patches now. . . . On the backs of CD packages you'll see credits like, 'This CD was recorded with Michael Jackson's ears.'"[7]

Nonetheless, the problem of "bad pinna" persists and cannot be overcome simply by transplanting Michael Jackson's ears (for example) onto the average audiophile. "Reading" virtual audio is an acquired skill; it must be learned in the same way that audiophiles have learned to "read" telephonic, radiophonic, phonographic, and cinematic sound. The localization of virtual audio thus begs the question of what kinds of sounds were actually audible in previous media, and what kinds of ears were listening. It is important to note for instance that the HRTF "earprint" represents the journey of sonic signals as they are transmitted through loudspeakers in an anechoic chamber. An anechoic chamber is of course devoid of any sound, so the original sonic event, the event that in analog recording may have been in the field, is already at one remove. This map is then reproduced through headphones, which detach it even more from the "there" of the world. Indeed, one of the problems associated with localization is that of hearing sound "inside" the head rather than to the right, left, or back. Hearing sound inside the head defeats the purpose of sound spatialization. This technically abstracted, anechoically derived sound is then placed within an audiovisual context, the closest analog for which is realist cinema. It is fairly well recognized that, as in cinema, the use of sound increases the realism or, rather, the "suspension of disbelief" in the virtual environment.[8] Also, high-quality audio encourages viewers to perceive visual displays as having higher resolution, while the converse is not true.[9] However, as John Belton has pointed out, cinema sound is more hyper-real than real: "The soundtrack corresponds not, like the image track, directly to 'objective reality,' but rather to a secondary representation of it. That is, to the images that, in turn, guarantee the objectivity of the sounds. What the soundtrack seeks to duplicate is the sound of an image, not that of the world."[10] By representing the sound of an image rather than the thing or event, film sound's long history of devising strange percussion instruments to simulate banging doors or opening windows, not to mention the impossible and imaginary

sounds associated with science fiction, has also reduced sounds to easily recognizable "sound effects." Virtual audio has inherited this use of a fairly standard taxonomy of sound effects. Because, as researchers point out, it is easier to localize the sound of a plane overhead than the sound of a piano flying overhead, sounds have to be both recognizable and in their right place, so to speak.

If the identity and trajectory of the virtual sound must be regulated, so too must the involvement of the listener. Linda Jacobson claims that "all the [three-dimensional audio] systems work in different ways but share a goal: to trick the brain. They fool us into perceiving that the sound is coming somewhere other than the speakers (or headphones)."[11] Extending the cinematic practice of placing speakers behind the screen, simulating the unity of sound and image with their respective and often opposing epistemologies, sound and vision seem, if not unified in an object, at least to belong to the same virtual environment. But there is another correspondence operating here, for the virtual environment, it should be stressed, has no cultural or indexical relationship to realism, in the same way that sound has no loyalty to the object being represented: after all, where there is no "thing" to represent, there can be no "misrepresentation." Similarly, VR, as a computer-generated simulation, renders irrelevant questions of verisimilitude, realism, and authenticity. Without the anchor of realism, a continuing tension develops between the necessity of the body (materiality) and the arbitrariness of the signal (virtuality), between two-dimensional images and three-dimensional sound, between embodiment and the virtual experience. For what kind of space can be entered if it is designed—like the sound effect—to maximize resolution through familiarity, but is also set adrift from the familiar scenes that make up our real world perceptions? On the other hand, what is the point of creating realistic virtual environments?

These contradictions are the logical outcome of the persistent attempt to represent VR as a "space" one inhabits rather than a scene one watches, a space that by definition is different from the real world, but that requires a degree of media familiarity to supplement the lack of realism it necessarily presents. It is easy to understand the genesis and meaning of sound and visual effects, yet contemporary culture is only just coming to terms with spatial effects (via, for instance, gaming), and this familiarity works against the mythos of space and embodiment by reminding the viewer of its mediamatic origins. As Anna Munster points out:

> Much of VR is described in terms of spatial perception. . . . But the full VR perceptual experience gained by wearing a head mounted display is in fact

generated by temporal manipulation. The effect of feeling immersed in a computer-generated 3-D graphic world is produced by alternating the left and right eye views of the small monitors mounted in front of the immersant's eyes. This process, known as "time multiplexing," literally shuffles alternating images every one-thirtieth of a second or even faster to produce the illusion of stereoscopy. . . . Although the subjective experience of VR is filtered by a representational image layer . . . and accompanied by action modes such as navigation that utilize the everyday metaphors of space, it is digitally realized virtuality breaking time down into discrete states and quantities.[12]

Of course, this play between realism, special effects, and the suspension of disbelief is everywhere and untroubled in cinema, possibly because no filmmaker has ever claimed his or her film to be a "reality." Related, cinema has been spared the contradictions involved in VR's attempt to develop a digital, immaterial venue that requires an enduring, material body, without either involving "old" media literacies or acknowledging the ontological differences between the viewer and the viewed. And here is where the difference between the mechanics and the experience of VR becomes apparent: for while the immersant shares with the listener an undecided, disembodied subjectivity—a roving kinesthesia and an overlapping sensorium—although she or he exists in a place, like sound, where "the whole world is your body—equally—and everybody shares the same body," every point in this fluid, polymorphous space is precisely mapped, both technologically, through computation processes, and culturally, through processes of signification.[13] Although the addition of sound may increase the realism of the virtual event, this "realism" is born not from "the real," that is, the here and now central to the immersive experience, but from "the real" as constructed by other media, chiefly cinema and television. If one cannot tell the difference between the original and the copy, or between the copy and a computer-synthesized version, that may be because the original has been so abstracted. Similarly, the terms that describe space, perspective, and reality have meaning only through recourse to the "ground" of an increasingly abstracted corporeality. As Slavoj Žižek writes: "The ultimate lesson of the 'Virtual reality' is the virtualization of the very 'true' reality: by the mirage of 'Virtual reality,' the 'true' reality itself is posited as a semblance of itself, as a pure symbolic construct."[14] Far more than cinema or television, VR transforms its user, and, as virtual audio makes clear, this transformation involves mapping and computing the body in a manner that heralds a liberation from the dominance of vision, yet also threatens to colonize the other senses with the same processes that produced post-Enlightenment vision in the first place.

BODY EFFECTS

Measuring the skin between the body and its environment, representing the body's proprioceptivity by numbers and figures, mapping the minute while invoking the cosmic—all these operations involve reconceiving space that paradoxically renders terms like "inside" and "outside" meaningless. What would it be like to enter and interact with a "space" of numbers? Could you call it a "space"? Could you call a constellation of data an object or even an image? Could you call a bionic interface manipulating numbers an artist, or would "writer" be a more appropriate description? The practice of "writing with sound," enabling the aural to be played backward, slowed down, cut up, spliced together, and reassembled has, since the time of phonography, problematized audio's status as a *nonmediated* medium. As mentioned, recorded sound cannot claim the so-called authenticity of direct, live transmission, since the recording is no longer tied to the here and now of the sonic event. The inscription of sound thus presents a troubling moment in the discourse of audiophony. As aurality, or the organic whole it once represented, is replaced by the recording, the possibility of a "source" beyond the field of inscription fades in the twilight of the last century, and a similar trajectory in the field of virtual embodiment takes its place at the dawn of this one. Despite the construction of three-dimensional, interactive "space," these renderings also presage the kinds of informatic processes that so-called embodied technologies might employ, and the kinds of subjects they might produce. Just as sound—as audio—is heard as an effect, so embodied technologies may also produce a "body effect" as audio's correlate. Indeed, it could be argued that the body has provided a similar defense against the recording effect, and that in this context the stakes are just as high.

If sound's integrity is eviscerated through recording, sound's materiality however, provides a firewall against complete atomization. This occurs, once again, through the figure of vibration, which is not confined to sound, but rather opens an expanded phenomenal field, wherein sound and the body can recover ground lost to reproduction, simulation, and mediatization. As Cage demonstrated so well, the aural metaphor conceals by amplifying technological mediations, and is often used to situate the particular technics used within an almost spiritual domain. In this context, the full rhetorical force of Cage's comments regarding an ashtray can be understood retrospectively to contain a number of tropes that have shaped the discourse of cyberspace and virtuality:

> Look at this ashtray. It's in a state of vibration. . . . But we can't hear those
> vibrations. . . . I want to listen to this ashtray. But I won't strike it as I
> would a percussion instrument. I'm going to listen to its inner life, thanks
> to suitable technology . . . at the same time I'll be enhancing that technol-
> ogy since I'll be recognizing its full freedom to express itself, to develop its
> possibilities. . . . It would be extremely interesting to place [the ashtray]
> in a little anechoic chamber and to listen to it through a suitable sound
> system. Object would become process; we would discover, thanks to a
> procedure borrowed from science, the meaning of nature through the
> music of objects.[15]

Deconstructing this quote, we find a number of implicit assertions that
have since matured. Inanimate matter (the ashtray) is attributed with an
"inner life" dissolving a distinction that has prevailed since the Socratics via
the figure of vibration. The "life" of this object is revealed through tech-
nology, through what would normally be thought of as an instrument—
like the microphone—that aids audition, but in Cage's mindset,
technology "hears" the ashtray with a degree of agency that implies not
only sentience but desire. Interacting with humans in the revelation of
an otherwise unheard and hitherto unthought "life," technology is given
the freedom to "express itself." In technology's self-actualization via its
human interaction, nature (read alterity) becomes knowable, and
objects become musical. Music, nature, and an augmented, cyborgian
hearing are united via technology in a cosmology that is both predual-
istic and knowable. In what retrospectively appears as a classic move in
the rhetoric of the digital sublime, Cage appeals to a vibrational essence
that subtends the dualisms of appearance, while bringing the object,
technology, art, nature, and life into the same existential orbit.

If the vibrational essence of the ashtray gave objects, once amplified,
another kind of life, Cage and his primary collaborator, David Tudor,
also developed protoimmersive, interactive, immersive, and "smart"
environments. In particular *Pavilion,* a well-known project organized
by E.A.T. and sponsored by Pepsi-Cola for the Osaka World Fair
(1970), became a symbol of "new techno-organic" environments serv-
ing the needs and interests of the electronic age.[16] Like *9 Evenings,*
sound became the main cohesive force in *Pavilion.* A later press state-
ment jointly released by E.A.T. and Pepsi-Cola entitled "An Artists
View" attributes the final coming together of divergent ideas for the
project to Robert Rauschenberg's suggestion to use sound as the main
element.[17] This led to David Tudor's remarkable sound loop system that
was built into the floor to create an immersive, interactive environment.
In designing the acoustic architecture, Tudor emphasized the physicality

of sound and its movement through space as a way of altering the sound itself: "My interest is in going beyond that point and seeing what speed itself will create; to see what kinds of sound material will not require faithful reproduction or will act as a new sound generator."[18] For Tudor, the physicality of sound with its rapid movement through space was a way to fundamentally alter the sound itself. In this respect Tudor's use of movement anticipates virtual audio and spatialized sound; however, unlike the latter, his lack of interest in referentiality of sound, in seeing "what kinds of sound material will not require faithful reproduction," departs from the virtual realism that many VR artists have aspired to.

The art critic Barbara Rose wrote in 1970 of *Pavilion*'s evolutionary character: "symbolic of an organism constantly in a state of subtle change."[19] Her comments are indicative of the tendency for interactive technological environments to be endowed with a protean agency. For Rose, this agency was linked to the consciousness of the time: from these values and this new aesthetic, the building that housed the art transformed into an organic structure. At the same time, the division between artist and spectator, between artwork and audience, between art and life was eliminated, calling into question the very possibility of the category "art" itself. Such dissolutions were also described by Gene Youngblood in 1970, in an article inspired by his experience of the *Pavilion* that was notable for its use of many tropes that would feature in contemporary discourse. In "The Open Empire of the Cybernetic Age," he writes:

> Through aesthetic decisions as to the uses of technology, the differences between art and life, the real and the unreal, are being utterly and finally obscured. The Cybernetic Age is the new Romantic Age. Nature once again has become an open empire as it was in the days when man thought of the earth as flat and extending on to infinity. When science revealed the earth as spherical, and thus a closed system, we were able to speak of parameters and romance was demystified into existentialism. But we've escaped the boundaries of earth and again have entered an open empire in which all manner of mysteries are possible. We are children embarking on a journey of discovery.[20]

In the same vein, Rose framed the *Pavilion* in terms of community, organism, and life itself. Within this amalgam of rhetorics, technology was represented as the "natural," if not historical, trajectory of Western art, culminating at the time in the merging of the category of "art" with that of "art-as-life." The latter, realized through technology, became a component in the overall ideal of democracy and equality. However, it also begged the question of whose art, whose life was to be equated,

interchanged, reconciled, and merged in this movement? Whose strug-
gles with technology—specifically automation—were appropriated as
an element of the "life" to which art both aspires and is? And what was,
and is, the particular role of the artist in this immersion?[21]

These questions reemerged during the 1990s, as artists were urged to
acquiesce to new definitions of art as "data," placing the artists in an
extremely difficult—some would say unviable—position, since the
vision of technoevolution proffered by some and internalized perhaps
by many strikes at the heart of artistic identity. Ideas and indeed cre-
ativity itself were subject to this force, which dissolved the distinction
between art and artist as creativity itself was absorbed within the grand
thematic of digital immateriality, reducing artistic production in some
cases to patterns of information capable of being decoded and artifi-
cially generated. Writing in the mid 1990s, German art critic and theo-
rist Heimo Ranzenbacher, for instance, argued that in the age of
"informatization" art can only survive its absorption as "mere data" by
becoming a "technology for the perception of the program of culture."[22]
In other words, art acts as a "cognitive pixel" in maintaining its dis-
tinction from advertising, from "mediatization" (from all other media),
and from data, by becoming a kind of meta-information system—a pro-
gram about a program; a "cultural technology."[23] Here the digital
becomes the new environment for techno-evolution—both a habitable
space for on-line communities and a space for the generation of life
itself, both an organism and an architecture, a structure and its content.
Repeating early technocultural themes, the power of natural forces
(such as electricity and electromagnetism), combined with technological
invention, become common referents in the associations among art, life,
and technology. Sound and audio have been integral to this develop-
ment: the telephone and, later, radio had enculturated ideas of fluidity,
spontaneity, liveness, transparency, intimacy, and immersion, and these
technologies were themselves nuanced by the residues of prior move-
ments such as Futurism and the works and writings of early sound com-
posers such as Varèse and Stockhausen.

Operating under the radar, so to speak, experimental music and
audio art often express the techno-utopic and dystopic narratives rum-
bling beneath the sheen of modernity and have often been associated
with both the posthuman, and the inhuman. Stockhausen, for instance,
situated his creative process within the context of electroacoustics,
which he likened to the "synthetic industry," and the process of molec-
ular manipulation.[24] Stockhausen saw no difference between his body,

the sounds he composed, their inner nature, the organization of the universe, and the "electric" force unifying all: "We are all transistors in the literal sense . . . a human being is always bombarded with cosmic rays which have a very specific rhythm and structure, and they transform his atomic structure and by that his whole system—let's forget about our always dying bodies, so to speak, in order to be reborn in a different form."[25] This "rebirth" is electronic, technological, and atomic all at once, and it configures a unity that, driven by evolution, enables being to occur equally in real or virtual space. The adoption of evolution has conferred a certain amount of not just agency, but primordial, originary agency, operating in and through areas previously considered cultural, and therefore within human control. Exploring this primordiality, we find again metaphors associated with the aural: vibration, linked to an archaic existential moment, something akin to the big bang; and flux, linked to a chaotic state of continuous becoming. The guru of Artificial Life (A-life), Louis Bec, who founded the Scientific Institute for Paranatural Research in 1972, describes A-life as autonomous, "near-living," and in fact stymied by the mimetic impulses of artists and the "animate schema of the living."[26] A-life needs, he argues, a new form and a new environment in which to develop: that form is essentially modeled on culture rather than nature, it is "semaphoric," acting as a "transducer/translator between signal and sign," and its environment is the infosphere of cyberspace—which creates the "conditions for bringing about technological biodiversity; for the creation of unknown forms of life and post-biological virtual worlds."[27] For Bec, A-life represents a chaotic "mutagenic agent" that disrupts artistic, scientific, and epistemological conceits. The products of such disruption, and their manifestation via A-life, seem to have little to do with technology, nor even evolution, but "are based on a primeval tremor . . . an imperceptible tremor of the living, a vibration going back to time immemorial."[28] Simultaneously primordial, natural, human, and artificial—productive of evolution but also "technozoosemiotic"—Bec's understanding of A-life reflects aspects of techno-mysticism that Cage and others articulated, while it also prefigures the semiotic, poststructuralist approach that media artists and cultural theorists would adopt in the 1980s and 1990s.

A product of the failed Artificial Intelligence program, which was widely criticized for using a "top-down" approach to creating intelligent machines through extensive but ultimately inadequate programming, A-life, on the other hand, aims to "evolve" intelligence through a

"bottom-up" approach, where the computer gradually acquires intelligence through heuristic systems. Conceptually, A-life is grounded by the theory of "emergence," which postulates a process or phenomenon whereby rule-governed objects within a system interact to the extent that new levels of unexpected complexity, leading to new behavior, "emerge." Rhetorically, emergence—the concept if not the reality—provides a means whereby dueling agendas, conflicting desires, and impossible tropes can be reconciled through a process both rational (it happens within a computer/scientific system) and magical (it is life-generating, self-organizing, autopoietic.) As Sarah Kember points out, "emergence" has allowed A-life researchers to "secure a form of digital naturalism in the face of the evident constructivism."[29] As a field, A-life has been variously interpreted as offering a viable alternative to biological life and habitation in a physical space, as proof of an equivalence between computer-mediated experience and computer-mediated existence, and as a reduction of life to an essentially mechanistic paradigm.

This translation between the old mechanical order and the biotech future, between carbon-based life forms and silicon (artificial) life forms, or, to use Kevin Kelly's quaint distinction, between the "born" and the "made" has been propelled by two interrelated, though seemingly opposed, beliefs: progress is defined by and dependent upon technological development within free-market capitalism; and such mergers, being evolutionary, are beyond human regulation. Kelly, coeditor of the journal *CoEvolution Quarterly* in the early days of the WELL, developed these ideas and to some extent helped set the discursive agenda during the dot.com boom of the 1990s. This decade saw the cybertheorist Douglas Rushkoff apply the catchphrase "information wants to be free" to the "free marketplace of ideas," thus merging both within the evolution of natural systems.[30] Like many writers at the time, Kelly saw cyberspace, A-life, and biotech as the revelation of what had always been true or real, but could only be manifest through technology: "The apparent veil between the organic and the manufactured has crumpled to reveal that the two really are, and have always been, one being. What should we call that common soul between the organic communities we know as organisms and ecologies, and their manufactured counterparts of robots, corporations, economies, and computer circuits?"[31] In Kelly's text, as mechanical systems become more "organic," nature dematerializes, becoming an "idea factory."[32] The virtual and the real, the conceptual and the material, the future and the present, the artificial and the natural, the human and the machinic, the biological and

the informational, the sensory and the mathematical—all become inter-changeable. More recently, Stuart Kauffman, in his book *At Home in the Universe: The Search for the Laws of Self-Organization,* folds tech-nology, evolution, and economics into a modern version of natural law and argues that technological and cultural systems are like communities of species and subject to similar evolutionary patterns of growth and extinc-tion.[33] Linked to a suprasystem that is simultaneously self-correcting, chaotic, and universal, biological evolution and "technological evolu-tion" "may even provide a deep new understanding of the logic of democ-racy," which, like the "evolution of complex organisms and the evolution of complex artifacts," operates according to design criteria under the "selective pressure of market forces."[34] Despite its eschatological scope, Kauffman's techno-cosmology is replete with sets of equations that direct the heterogeneity of the world toward a new instrumentalist and scientistic paradigm. Kauffman is explicit on this point: "We seek reduc-tionist explanations. Economic and social phenomena are to be explained in terms of human behavior. In turn, that behavior is to be explained in terms of biological processes, which are in turn to be explained by chemical processes, and then in turn by physical ones."[35]

If these reductions seem collectively to resemble an abstract, univer-sal explanation that bears no relationship to real, living systems, they are not devoid of actual, albeit experimental and artificial, models. Through a range of projects, architectural forms have been created to house virtual communities in cyberspace, and these are not limited to human habitation, but include artificial entities. Kelly and others describe the latter as "breeding," evolving, and exhibiting traits of con-sciousness. Or to cite Kelly's prologue to *Out of Control,* entities show signs of "self-replication, self-governance, limited self-repair, mild evo-lution and partial learning."[36] That Kelly can use such metaphors to describe what are essentially computer programs is a testament to the endurance of habitation, civilization, and evolution as key themes in the twentieth-century narrative of progress, and the power of cyber-rhetoric to appropriate these themes.[37] The latter is aided by the physical existence of sites that, like the E.A.T. *Pavilion,* could be described as protovirtual.[38]

A number of artists adopted the dual tropes of habitation and evolu-tion, lodged somewhat awkwardly between the tribalism of the past and the distributed being of the future. One such project, *Telegarden* was a prime example. An "art installation" launched on the Internet in 1995; it offered telepresent gardening where World Wide Webbers could

manipulate a robotic arm in order to plant, water, and weed a living garden.[39] According to its creators, the *Telegarden* was designed to promote "postnomadic" behavior favoring collaboration.[40] The term "postnomadic" includes hunting and gathering, activities that, coincidentally, "characterize existing Internet protocols," while "collaboration" involves sharing e-mail addresses with other members of the community. Enforcing an equivalence between organic cultivation and electronic communication, the privilege of planting seeds was granted only after members registered a certain number of visits or "hits" to the site. Complaints that "the garden is too slow"—because transmission time from the United States to the installation's home in Linz, Austria, took longer than its previous station in California—further emphasized this equivalence, as if plant growth is the same as data transmission, or, more ethereally, plant growth *is* transmission, with some kind of life force sent down the wire.[41] Using the narrative of the "evolution of man," the *Telegarden* represented itself as both a living laboratory and an anthropological site for the study of human/computer interfaces and the development of virtual communities. However, testing the success of the interface entirely overshadowed any concerns about the actual garden, which often suffered from overwatering. In this regard, the often naive but enthusiastic comments by members about the joys of gardening and kinship through community stood in stark contrast to the highly organized and detailed monitoring for which the site provided an occasion. As if to dispel any illusions that this project was a "work of art in the interplay of natural beauty and technology" or even a "place where surfers can slow down their 'site skipping' and rest," the study titled "Virtual Community in a Telepresent Environment" succinctly stated the project's goals. "The *Telegarden* was created to provide a test bed for a new generation of low-cost 'point and click' devices for control of a robotic apparatus over wide area networks, to explore the ability of networked telerobotics to create a sense of telepresence . . . and to provide a laboratory for the study of emerging on-line communities."[42] Such "art" in the service of evolution shows exactly where "evolution" actually occurred: the *Telegarden*'s blandness and functionality are examples of just how far the metaphors of habitation, civilization, community, and evolution can be stretched yet still elicit joyous protestations about the unity of nature (even in miniature), the body (even if remote, harnessed, and tracked), and technology. Like many of the other digital or virtual "garden" projects at the time, the *Telegarden* demonstrated a desire to translate communication spaces, including the

Internet, into pseudobiological entities, and in so doing, model evolution while also providing a protean space for the construction—or rather self-generation—of all kinds of social and biological worlds.

The survival of actual communities, of remote places and fragile ecologies, has reverberated through cyberculture in a manner not unlike audio and telephony: as an uncomfortable reminder, and remainder, of once-vibrant and independent communities. Many artists have, however, questioned the foundations of this biotechnological juggernaut and the tacit denial it demands. Australian digital media artist Jon McCormack, for instance, makes the fundamental point that "nature is boundless while the artificial requires a container," and he cautions against replacing biological evolution with technological evolution, as this involves a redefinition of life in terms of the product of mechanisms rather than any particular materializations, and in that respect is synthetic and reductionist.[43] Crucially, McCormack notes the anthropomorphism that is integral to A-life rhetoric. While it is common to project biological behaviors such as mating, or eating, or dying onto A-life "creatures" on the screen, he stresses that we're looking only at pixels, representations rather than organisms. Like the Canadian artist Catherine Richards, discussed in the next chapter, and Char Davies discussed previously, McCormack engages the limit point of representation, epistemology, and art, by using images of nature, within the context of artificial systems that mimic biological and ecological systems. Like Richards and Davies also, McCormack—a computer scientist by training—is deeply engaged with science and technology but maintains a critical distance from it.[44] By combining that which exceeds representation (nature) with that which attempts to represent nature (A-life ecologies) within the context of environmental degradation, on the one hand, and the art gallery, on the other, McCormack's own interrogation of containment and the epistemic/aesthetic frame carries with it a sense of enclosure and a realistic assessment of new media: "The frame poses a number of problems that operate simultaneously on a number of levels. . . . It represents a type of control, [that] is not limited to fine art images or cinema screens. Bounding a concept, image or entity implies both security and understanding. . . . Screen based media . . . are in essence future screens—for while they do reinterpret the issue of the visual frame, the ontological and epistemological questions around framing remain."[45]

McCormack's own A-life work, *Eden* (first exhibited at *Cybercultures,* Casula Powerhouse, Sydney, 2000), displays the frankness and genuine

concern about the implications of A-life peculiar to much Australian work in this area. McCormack describes *Eden* as an interactive, self-generating, artificial ecosystem, exhibited as an installation that features multichannel video and audio and uses fog to create a 3-D projection. The "creatures" in *Eden* evolve to fit their landscape, which consists of three basic types of matter: rocks, biomass, and sonic creatures that "move about the environment, making and listening to sounds, foraging for food, encountering predators and possibly mating with each other."[46] If they learn behavior conducive to mating, they may pass on "genetic" material to their offspring: "*Eden* uses Lamarckian evolution"; however, for McCormack, "evolve" requires a caveat:

> [While it's true that in *Eden*] each cell has a rule that says what it does and it's based on what's happening around it . . . whether you say it "evolves" really depends on your perspective. But that's the whole thing about A-life isn't it? The idea that life is more defined in terms of process rather than any particular physical instantiation. In the strong A-life view a computer program that has either statistical or behavioral qualities common to natural processes is likely to be called "alive." . . . If you talk to people like Tom Ray he'd say that yes these (A-life) systems are alive and evolving . . . if you talk to people in computing most would say that genetic algorithms (which is basically what evolution is) are what you use if you can't find any other way of doing it.[47]

Sound is central to the being and the evolution of the creatures in *Eden*. Indeed, McCormack registers the lack of attentions given to sound—especially spatialized sound—despite the fact that sound-based virtual environments are easier to produce.[48] *Eden* could be seen as an experiment in using sound to create experiences that are not cinematically derived and therefore "subservient to the image."[49] And in fact the work is described by A-life researcher Jon Bird as "a music composition system [in which] there is an evolution from an initial cacophony to more structured sounds."[50] The creatures hear and make sound to locate other creatures, to mate, or to find food. Additionally, they use sound to attract an audience for the installation space, which has sensors to detect movement—which is then "mapped to the food supply for the creatures. If there are no people, the food supply dries up and the creatures starve to death."[51] Reminiscent of early experiments with genetic algorithms in computer music, *Eden* doubles as a compositional system driven by the presence and musical sensibilities of the audience. Not just sounds, but meaningful sounds—those that form a progression,

or a musical narrative, and hence encourage the viewer to linger—are an evolutionary adaptation among agents in this system.[52] *Eden* differs, however, from the earlier approaches, in that a pleasurable polyphony must emerge for the compositional process to occur and for the system itself (thought of as an elaborate computer program) to function. At the same time, the piece is situated well within the parameters of virtuality and evolution (albeit artificial): "In summary, a system has been produced that attempts to integrate the open-ended nature of synthetic evolutionary systems into a reactive virtual space."[53]

Ironically, the phenomenality of sound—its lack of containment within the atmospheric space of the gallery and its physical interaction with the presence of the viewer—"re-frames" *Eden* within art rather than science. Jon Bird comments: "As the primary purpose of *Eden* is to generate interesting sonic behaviours and not to investigate hypotheses about natural phenomena, the aspects of the exhibition environment measured by the motion sensors are not observables in the scientific sense."[54] Yet it is precisely this interaction, together with the atmospheric movement of sounds in *Eden*—around the gallery, through the listener, among the ambience of the space—that, in its very unscientific way, escapes the containments of technoscience that McCormack critiques, while at the same time engaging the audience in the actual environment that their listening selves are embodied within. The "creatures'" sonic drives are multiple: linked to the environment that is within the work (as code), and the acoustic environment of the work's exhibition—the art gallery—over which there is little control. The presence and/or evidence of artificial life paradoxically terminates when the sounds begin to mingle—when they escape the epistemological screen, frame, or discipline that confers the identity of "A-life" in the first place. The viewer/listener is not only incorporated within the overall logic of the piece as a determinant factor, but listens to the sounds that their presence provokes within a multiplied context: the gallery, the artistic field of A-life, the cultural field of Art and Technology and actual fields of the fragile Australian environment, represented by landscape images overlain with cryptic comments such as "ALL THE WORLD IS WATERED WITH THE DREGS OF EDEN." If the use of sound in *Eden* predisposes the piece to move beyond the gallery: socially, ethically, and ecologically, it also interrupts what might be an otherwise smooth flow between art, science, and technology, between the artificial and the natural, between the atmospheric and the (necessarily framed) aesthetic. This movement beyond the work and toward the unrepresentable excess

of nature points to a concern about the natural environment that McCormack shares with other artists dealing with biotech issues, who also find it ironic, if not dangerous, to be invoking biological and ecological metaphors at this particular point in the history of the earth. In an uncanny mirroring, it seems that where A-life activates, biological life becomes inert, where A-life colonizes hitherto unheard of territories, biological life withers away; where A-life increases its hubris, biological life develops an insecurity.

THEORIZING POSTHUMANISM

McCormack's concerns resonate with feminist and other critiques of technology that emphasize the importance of the body and the environment as the primary source of knowledge, and this critique has also encouraged a rethinking of posthumanism within evolution and artificial life. The new kind of being that cyber-rhetoric introduces—part digital, part organic, extremely versatile, and poised to reconcile whatever cultural and intellectual anxieties that arise from technoposthumanism—has been critiqued by theorists like Paul Virilio.[55] It produces an ever-expanding, continuously on-call individual, who becomes another kind of interface, while the strength of the hyper-individuated subject—to borrow from Cubitt—collapses under the unbearable lightness of computer ergonomics and the minute bodily movements necessary for computer work.[56] As if dealing with a prescient form of mimicry, one discovers that computing—far from being external and "objective"—renders the body a thing to be computed, by reducing its movements to those necessary to operate the keyboard.[57] Attached to the wires of VR systems, with hand and head, or breath and body position monitored, the analogy of life support becomes irresistible: gesture is eventually reduced to the steady rhythm of the respirator, the eyes blinking once for "yes," twice for "no," in a total economy of movement. In as much as there is a link between the body as text and nature as code, there is also a relationship between what artist Tom Sherman identifies as the "extreme, tragic irony (of) fleshing out the cultural ecology (of memes) during an era of catastrophic biological collapse" and the creation of virtual spaces where that cultural ecology can thrive while the physical environment becomes uninhabitable.[58] Like the transmissional elsewhere of the ether—retained and yet unacknowledged as a foundational and still operative spatial metaphor—the concepts of virtual reality, cyberspace, and A-life become rhetorically bonded with a concept of the

posthuman—one that simultaneously maintains and reconfigures the foundational metaphor of embodiment. The introduction of evolution here, together with the shift to posthumanism, occurs *by necessity*, since evolution—the concepts if not the reality—provides an outside, an exteriority, that offers the possibility of intervention in what would otherwise be a solipsistic, implosive, and ultimately useless enterprise.

The postmodern self disintegrates into the discursive mélange provoked by texts like Donna Haraway's—"A Manifesto for Cyborgs," wherein "we are all chimeras, theorized and fabricated hybrids of machine and organism; in short, we are cyborgs . . . [and] cyborgs are ether, quintessence."[59] The posthuman moves within and beyond various historical binaries—between human and machine, brain and computer, form and matter, often appealing to a neo-organicism that gives information the status of an entity (that, as Philip Mirowski comments, is ontologically coherent and stable) while reducing organic life to the interplay of code.[60] A living code, or an entirely coded living, might offer relief from the normative regimes of modernism—accelerating the deconstruction of dominant culture and introducing the new posthuman subject. However, the problem of how to think about this subject has by and large been ignored. In Hayles's groundbreaking book *How We Became Posthuman,* the question of materiality and embodiment is inseparable from what she describes as the "postmodern orthodoxy that the body is primarily if not entirely, a linguistic and discursive construction." Asserting the primacy of embodiment, Hayles draws a distinction between "the body" and embodiment and stresses the situatedness of the latter. Embodiment is always "tied to the circumstances of the occasion and the person" and resists abstraction through processes of inscription: "Whereas the body is an idealized form that gestures toward a Platonic reality, embodiment is the specific instantiation generated from the noise of difference."[61] Hayles uses the term "incorporation" to express this difference: "As the body is to embodiment, so inscription is to incorporation . . . [whereas] incorporating practices perform the bodily content; inscribing practices correct and modulate the performance. . . . Incorporating practices leave the situatedness of experience in tact, or rather, are translated into knowledge with a residue of their embodied origin." As an example of this process, she looks at tape recording, at the period when "one's voice could be taken out of the body and put into a machine," contrasts audio and phonography with telephony and radio, and argues that the latter, by "participating in the phenomenology of presence" through simultaneity

(that is, transmission), preserves the situatedness, the embodiment crucial to her rethinking of the posthuman via practices of incorporation rather than inscription.[62] Audiotape was inaugural for Hayles, because once the editing possibilities of tape were discovered, "the body metonymically participated in the transformations that voice underwent. . . . For certain texts after 1950, the body became a tape recorder." Hayles's analysis of tape and its relation to the posthuman occurs through a reading of William Burroughs's *The Ticket That Exploded,* in which Burroughs introduces randomness through a "third tape recorder" that records random sounds, thus breaking the infinite loop of the infinitely prerecorded that Baudrillard famously surmised in his description of the real as that which is always already reproduced, parlayed into *The Matrix*'s "welcome to the desert of the real" via Cronenberg's more corporeal rendition in *Videodrome.* The interplay or infusions between technology and text, body and machine, in these and countless other sci-fi films, provides an example of just how intertwined body, machine, and thinking are (or might become); yet the context of this interplay here is still literary and remains so until the closing pages of the book.[63] Here we get a glimpse of what Hayles means by the term "posthuman." Whereas in the (traditional) posthuman view, "there are no essential differences or absolute demarcations between bodily existence and computer simulation, cybernetic mechanism and biological organism, robot teleology and human goals,"[64] Hayles's ambition is to find a posthumanism that resists the denial of embodiment (articulated by artists like Stelarc and scientists like Hans Moravec) without resorting to the (equally dualistic and ultimately disembodied) concept of the liberal autonomous subject—the product of humanism. Posthumanism presents for Hayles the possibility of going beyond a metaphysics of presence (including the critique of deconstruction) to a new dialectic—pattern/randomness where "the origin does not act to ground signification" but rather complex systems evolve "toward an open future marked by contingency and unpredictability." Meaning is not guaranteed by a coherent origin: rather it is made possible "by the blind force of evolution finding workable solutions within given parameters."[65]

Three factors are dominant and, for the purposes of this discussion, telling in Hayles's theorization. First, while the tape recorder is, for her, inscriptive rather than incorporative, the ephemerality of sound links it to more incorporating technologies such as the telephone and radio, while embodiment (required for audition) resists inscription—absolute

individuation or coding——because it arises from "the heterogeneous flux of perception" (which, through cultural processes, stabilizes into objects and identities) and is generated from "noise," used here as a metaphor for alterity or difference.[66] Second, this resistance follows a dynamic of "pattern/randomness" that is itself grounded (or acquires meaning) via "the blind force of evolution." Third, the transducer between noise and evolution in this particular narrative is the tape recorder——Burroughs's tape recorder no less, which like Cage's microphone, or Schafer's headphones, is something of an icon in the cybercultural semiotic that audio, and before it telephony, helped construct. The tape recorder's as yet uncritical associations with viral and other genres of posthumanism are markers of the persistence of the kind of cultural denial that conceals the audio apparatus within the alterity of sound, while fashioning a new kind of (technologically enhanced) listener who can interact with this technology. As mentioned at the beginning of this chapter, audio editing and sampling produce sound as an effect, and with virtual audio's incorporation of the physiology of the listener, the body is also produced as an effect. In this respect, the tape recorder is certainly the "harbinger of the posthuman." However, if tape editing brought the body into the cut and mix, this fragmentation and recombination must be attributed less to the technologies themselves than to the peculiar detachment of the voice, which, as I have discussed, underwent a series of "disembodiments" in its passage through metaphysical, rather than technological, systems. Similarly, just as the tape recorder has disappeared in the mythology of audio, the tropes of noise and evolution ("blind" in this instance) hover on the edges of a transformative technology, which is itself best known for reproducing not the voice but the "presence" of the voice. If, as Hayles argues, incorporating practices are formative with regard to embodiment, and "embodiment mediates between technology and discourse by creating new experiential frameworks," we must look to metaphysics itself as a prior technology. But, then, to what extent can metaphysics accommodate terms like flux and noise? Doesn't the use of these terms resolve one problematic—the dualism of traditional posthumanism—by resurrecting another—the metaphysical (non)status of sound and the voice?[67]

Atmospheres

The signal claps like a flash of lightning, rumor rushes forth.

Michel Serres

At this point it is important to return to the dual movements of contraction (interiorization) and expansion (etherealization) that permeate media technology, allowing it to constantly mold the cultural, technological, and discursive horizon to accommodate new and often very enchanting vistas. In the discussions of posthumanism thus far, two rhetorical threads stand out: the first focuses on the transcendent private space of virtual or immersive environments; the second expands this space of "being-in" to theorize artificial life and "digital being" in general. Uniting these two is the overarching conceit of evolution, the enabler of partnerships between humans and machines, and the means by which the lofty (but commercially untenable) heights of VR, or the democratic (but too idealistic) potentials of cyberspace, could be conceptually transduced into the more mundane (but commercially viable) reality of wearable and wireless devices at the forefront of "embodied" technologies. The body is pivotal here: faced with the arbitrariness of the signal, some theorists have sought to replace the indexical trace anchoring analog media in the real, with the body as a new correlate, grounding the digital once again in a transformed 'reality' wherein the distinction between machine and human cognition is irrelevant. Mark Hansen, for instance, argues that "technology is an 'agent' of evolution, having a 'supplemental exocultural' dimension."[1] This extra, anterior dimension forces us to abandon those notions of cognition and embodiment that privilege human, as opposed to technological, agency.

He writes: "If we can learn from AL research efforts . . . we may come to understand how our nervous systems can adapt to material changes that exceed their inscriptional capacities and how we can stimulate our nervous systems to 'learn' in an emergent and completely practical way—one that would forever lack a representational correlate. [In this context cognition is] the operation not of disembodied logical operations but of massively distributed nervous systems."[2] Here the concept of "distributed cognition" performs a number of functions. First, it creates a bridge between the computer-based and generally inaccessible systems of A-life and everyday interactions with technology. Second, it provides a coherent challenge to the notion of the autonomous liberal subject (the object of poststructuralist critique). Third, by situating technology within the embodied reality of lived experience, it challenges the hard version of posthumanism that, as Hayles argues, "constructs embodiment as the instantiation of thought/information."[3] Replacing the dualistic "mind/body" with a more integrative "mindbody" (Hansen) and focusing on interactivity rather than implants, reciprocity rather than augmentation, the posthuman is refigured not as an entity, such as a cyborg, but as a field of relations.

As mentioned in the previous chapter, new media artworks are, for Hansen, a privileged site for the transmission and manifestation of these relations. Embodiment is central to this rethinking, and often it seems that the perceived need to prioritize—that is, to situate as *a priori*—the virtual and the body is interpreted as a need to situate the virtual *within* the body. As Timothy Lenoir summarizes: "From Hansen's perspective, technologies alter the very basis of our sensory experience and drastically affect what it means to live as embodied human agents. They accomplish this by reconfiguring the senses at a precognitional or even paracognitional level (not to privilege one level over the other), prior to conscious perception and assimilation to language."[4]

Important here is how the interface with its proximity to the user is seamlessly integrated with philosophical concepts such as affectivity, and rhetorical figures such as technological agency.[5] If technology produces a reality that "exceeds the onto-hermeneutical grasp of language," that is enmeshed in our perceptual system, that produces knowledge yet is precultural, one might look to code—as raw data rather than information—for a suitably ambiguous signifier of something that informs and affects human embodiment while distinct from it.[6] True, data is meaningless in the absence of interpretation, and code maintains a connection to semiosis; however, the interplay between

these two systems suggests the possibility of a transmissional space not bound by the technologies or practices of inscription, a space that offers some resistance to the otherwise authoritarian logic of representation, quantification, and codification (a logic that manifests equally in the specter of Orwellian states and disembodied individuals). Such a space reveals a materiality that, as Hayles writes, "thoroughly interpenetrates the represented world."[7] It is a signal that—like the electromagnetic pulsations of the human heart—is below the threshold of knowledge, although not necessarily below the level of cognition.

Like "vibration," or "pulse," the metaphors "signal" and "code" often connote an *Ur* state, which supposedly resists theorization, yet also acts as a ground. Hayles interrogates this assumption by returning to Derridean *ecriture* and argues that just as writing exceeds speech, computer code "exceeds both writing and speech, having characteristics that appear in neither of these legacy systems." The difference between writing and speech can be summarized by its infinite deferment (mnemonically contained in the fusion of "difference" with "defer") such that writing "is not confined to the event of its making." Code not only shares this characteristic, but can be distinguished from speech and writing, formally (it consists of only two symbols) and functionally (it can be read by both humans and machines). Pairing Derrida's concept of *différance*—which avoids any origin, any claim to the "thing-in-itself" through the endless movement of the trace, with the concept of computational complexity, Hayles makes the further distinction: "For code, complexity inheres neither in the origin nor in the operation of difference as such but in the labor of computation that again and again calculates differences to create complexity as an emergent property of computation." In distinguishing code from writing and speech, Hayles articulates a particular worldview—what she refers to as "the Regime of Computation"—noting that it has the advantage of enabling emergence to be "studied as a knowable and quantifiable phenomena, freed from the mysteries of the logos and the complexities of discursive explanations dense with ambiguities." While seemingly precise (and correspondingly limited), the calculation of difference in the computational worldview is also infiltrated by noise, not the noise of redundancy and ambiguity that characterizes "physically embodied system[s]," but the "noise" that enters the system through slight differences and ambiguities in the electrical signal that are rounded up, so to speak, to become zeros and ones.[8]

While this ambiguity might give code a degree of materiality that could be likened to the excess and alterity that *ecriture* generates, Hayles

takes great pains to emphasize that prior to any perceptible manifestation of code "before (or after) any human interpretation of [machine] messages" this material, voltage-based ambiguity must be removed. Hence, "although the computational worldview is similar to grammatology in not presuming the transcendental signified . . . it also does not tolerate the slippage Derrida sees as intrinsic to grammatology. Nor does code allow the infinite iterability and citation that Derrida associates with inscriptions." These essential differences between writing and code are important, given the early application of Derridean concepts to hypertext and digital media and the belief that code is somehow outside of both metaphysics and culture. As Hayles comments: "Although code may inherit little or no baggage from classical metaphysics, it is permeated throughout with the politics and economics of capitalism, along with the embedded assumptions, resistant practices and hegemonic reinscriptions associated with them." In emphasizing the cultural aspect of code, Hayles dampens the enthusiasm for locating an organic materiality within code that would allow a seamless transition from speech to writing, to code as a higher level human language, within an overall worldview of human evolution as teleologically driven to understanding the "computational nature of reality."[9] This teleology depends, as I have mentioned, upon the prior acceptance of digital space as equivalent to physical space and digital presence to actual presence, and the use of evolution as an overarching concept, one that presents change as massive but comprehensible, beyond prediction but also safely held within the realm of the imaginable. As such, evolution is contained within human technocultural ambition, and with it, the possibilities for chaos, for random, unmediated, and uncontrollable events are suspended.

THE BODY DISASSEMBLED: CATHERINE RICHARDS

Yet the appeal to evolution as an exterior, validating force—as a generator of the noise necessary to open the system to change—is itself subject to chaos of another order, as Thomas Ray—a key figure in A-life—discovered while giving his remote presentation "A Wildlife Reserve in Cyberspace" at Cyber Futures in 2000 (Sydney, Australia). The first part of Ray's talk concerned the absolute immateriality of cyberspace and virtual being; the second, in seeming contradiction, described his project to develop an artificial "wilderness" in cyberspace. With great enthusiasm Ray demonstrated how the different "species" would "breed," how their DNA would couple and multiply, how

evolution would work its way through this global artificial system. In response to the audience's heavy criticism that he was too liberally borrowing metaphors from the biological sciences to represent his computer simulations, Ray answered that he "was interested in evolution— be it digital or biological." But although evolution might at the time have been the new progress, it was not apparently a welcome word in the state of Oklahoma—the origin of Ray's presentation. For when Ray mentioned the term, coincidentally, his telecast was interrupted by a hurricane warning, identifying his physical presence in one of the extreme-weather prone, evangelical states that now favors "Intelligent Design" over evolution. If Ray's presentation showed how close fundamentalism—either Christian or techno—is to this area, it also reminded the audience of another nonlinear system—climate change—that, ever more vociferous, is shaping the discourse in entirely unexpected, non-rational, emergent, but scarcely artificial ways. As Ray's voice was reduced to static, then overridden by an emergency broadcast, the paradoxical materiality of his telepresence was all too evident. In that brief, disturbing moment, the audience heard the background noise of transmission: a signal interrupted by the voice of state and national authorities, triggered by other atmospheric signals that are read by meteorologists as a warning. Who, or what, was speaking here? And if it was an earthly semaphore that raised the red flag, then what kind of signal is that?

These questions concern Canadian artist Catherine Richards, who, in a series of works dating from the early 1990s, has investigated the signal as a central node in materializing the immaterial and interrogated the constellation of rhetorics, representations, materialities, and technologies that constitute the contested sphere of digital media and posthumanism. Richards likens her work to the "philosophical machines" that appeared in nineteenth-century advertisements for scientific apparatuses, which were valued as much for their ability to conceptualize the forces of nature as for their practical application.[10] Throughout her oeuvre, Richards brings together radically different spheres of culture and knowledge—from the extremes of the nonrepresentable body to scientific visualization and representation—using the invisible and the immaterial as metaphysical transducers, while also questioning our understanding of such concepts as they are parlayed through technology. From *Spectral Bodies* (1991) to *Shroud II* (2005), Richards channels ideas about embodiment, the senses, and notions of the self through her own "philosophical," or rather "aesthetic machines."

These function simultaneously as scientific devices and art objects and are equally at home in the science museum and the gallery. In her investigation of the field of technology and culture, Richards introduces the non-, or barely discursive field of phenomena of forces, materials, and elements, which are opposed, twinned, combined, set in motion, and then filtered through contemporary theories of technology (and in particular posthumanism), on the one hand, and the viewer's actual engagement with the work, on the other.

In this engagement, the viewer's body and attendant sense of embodiment and their identity coalesce in an experience that is paradoxically site-specific (the gallery or the museum) but also spans an odd mix of historical moments and futuristic scenarios. These scenarios are matched by the combination of hi- and lo-tech equipment that—sculpted and modulated—also happens to be "art." Caught between a past that technoculture generally wants to forget and a future that it can never occupy, the actual historical time of the viewer's engagement becomes another element in the piece, which situates him or her at a transit point, between the period known as humanism, from which the viewer has come, to the posthuman, into which the viewer—supposedly—will enter. This is the moment of transit, like the periods of scientific discovery when knowledge was less congealed, that Richards constantly probes or orders to think through notions of the "virtual." As she comments:

> A strange occlusion happened with VR where all the thinking that came out of the 60's and 70's about the dematerialization of the art object suddenly linked up with this new technology—and the new technology seemed to be a device for materializing that thinking. So I began asking "what is actually virtualized about this and what is actually dematerialized"? We have to have some form of materialization to actually engage with a work—even if it's in code, and code is still a representation.[11]

If Richards goes to the "stuff" of technology, she also draws viewers into the actuality of their embodiment, uncomfortably situated within the frame of the gallery, the contours of technoutopian rhetoric, and that ambiguous sphere where body and world exchange silent and invisible currents. Her early investigations prefigure contemporary theorizations of autoaffectivity in VR, and in the early 1990s she was experimenting with creating an experience of embodiment that was less dominated by vision.[12] Perhaps the most striking example of the viewer's engagement occurs in her early works *Spectral Bodies* (1991) and *The Virtual Body* (1993), which began as experiments with early VR. *Spectral Bodies* consists of a videotape of various experiments that explore the limits of

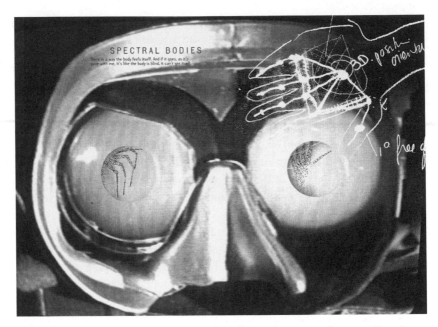

Figure 3. Catherine Richards, *Spectral Bodies*, video artwork, 1991. Interior of the virtual environment "eyephones" used in the artwork experiments in the VR research lab, composited with a working drawing of the data glove and generated hand images.

proprioception not as a medical or scientific actuality, but as a fiction that forms narratives, which themselves spread across personal histories and scientific research. VR in this context acts as an instrument for both creating and representing these narratives and in Richards's hands becomes a means for questioning the tight intertwining between our instruments, realities, sense(s), and fictions of self.[13] As a sense other than and possibly prior to the dominant sense of sight, an exemplar of "body knowledge," and a primary source of the fluidity of self-identity, proprioception features in the emerging philosophical rationale for both the neurophysiological mapping of the body that has so engaged affective computing research and the long overdue assault on the body-as-text dominance of poststructuralism. For Richards, however, proprioception is a way to interrogate not just the limits of our body boundaries, but the way those limits are metadiscursively established or transgressed through technoculture at particular historical moments. As she rather enigmatically states: "The *Spectral Bodies* narratives can be seen as equally fictional and 'real' testimonies *to how we think we know where our senses and body boundaries begin and end.*"[14]

Knowledge is never given in Richards's works, but always in question. Moments of epistemic uncertainty, like the moments of fluidity in the history of science, do not lie dormant, so to speak, but are translated into code and visualized in a rudimentary VR environment. Showing that the boundaries of the body are permeable, that the unified autonomous subject is a myth, Richards also explains how challenging this myth can inadvertently spawn yet another—now transferred onto the "knowledge" systems, the representationalist modes, the visualizations, of technology:

> After destabilization, "bodies" are ready to be re-mapped. A segment of interactive work then begins the process of re-representing the body as a virtual body. . . . A spectral hand and arm are portrayed as spectral dots and skeletal lines in a virtual environment. The VR participant recognizes this as a conventional schematic representation of his or her arm and hand. However, these initial representations of hand/arm begin to transform. The spectral arm and fingers lengthen, the palm spreads open and so on. Combined with body illusions, the participant's limb is mapped into an insect-like thing. As this mapping takes place there seems to be a physiological sense that this transformed virtual body is oneself.[15]

Drawing attention to the technological representations and the mediated images of a reconfigured embodiment, Richards situates technology within culture, as a schematic that, reminiscent of Heidegger's *enframing,* both contains and reveals the values of modernity. In her second proprioceptive work, *Virtual Body,* Richards contextualizes the illusion of disembodiment within the illusionism and protosimulated architectures of the Baroque—a period when the desire for total immersion in a space was also evident. The piece is in fact a miniature replica of a Rococo room in Antwerp that she photographed and scanned onto a glass box. This image then becomes the ceiling of the small glass "room" into which the viewer looked while placing the arm within an opening in the box and concentrating on the "floor"—a series of moving patterns designed to trigger a proprioceptive illusion. Disoriented by the already illusionistic "ceiling" the viewer looks onto, the proprioceptive illusion forces the viewer to "make this strange psychic decision—which is an impossible decision"—to reown the hand that "is floating away" or to repress the desire "for my body to float with it." The need to reconsolidate the body within the illusionistic space of both *Virtual Body* and *Spectral Bodies* (one woman in *Spectral Bodies* asked Richards if she could "please put her body back to the way it was before") suggests that the notion of a newly acquired "liquid identity" is desirable perhaps only in the abstract. While engaged with the piece

the viewer necessarily enacts the reintegration of the body, which occurs within a recollection of prior artistic attempts at simulated, immersive spaces and reminds the viewer that he or she is still within an artistic and conceptual schema. Being in a gallery, gazing at the Rococo ceiling, perhaps making parallels between the many examples of *trompe l'oeil* and the theistic and Cartesian quest to enter the heavenly sphere and leave the body behind, the viewer reads "old" artistic conceits through "new" media and is unnerved by both the similarities in their respective agendas and the contradictions their close proximity reveals.[16]

ELECTROMAGNETIC IMMERSION

These contradictions are articulated through another of Richards's aesthetic/scientific devices, *The Curiosity Cabinet at the End of the Millennium* (1995, hereafter *Cabinet*). The work consists of a wooden box large enough to seat one or two people, encased by copper wire screens that block electromagnetic radiation, and literally earthed by a huge copper coil that sends the electromagnetic charge gathered by the screens back to the ground. Richards named this piece in reference to the curiosity cabinets of the 1800s that displayed the collected treasures during the period of colonial expansion and the emergence of "new worlds." While the wood, the carpentry, and the Zen-like simplicity of the piece is reminiscent of a meditation room, the beauty of the copper screens and coil is beguiling, for the cabinet also resembles a cage and the person inside, a specimen, like a fly in amber. Just as a feeling of immanent energy resides in amber, so too the shimmering, conductive properties of copper, which feature in many of her works, alert our attention to the existence and intricacies of the electromagnetic spectrum, enabling us to see the sheen as perhaps another luminescent illusion. Unlike *Spectral Bodies* and *The Virtual Body*, where the exploration of machine/body interface is intended to blur the boundaries of the self, forcing the participant to experience on a very physical level the kind of disorientation, dislocation, and identity shifts that the reality of virtual life promises, *Cabinet* deals less with the experience of the virtual self than with the *impossibility* of that self. The sitter in this piece is on view—not only as part of an artwork in the gallery but also as a negative coordinate in electronic surveillance and tracking systems and a black hole in telecommunications culture. Such is the magnitude of electronic traffic that being "unplugged" is tantamount to becoming a quaint curiosity, a monkish recluse, or a caged exoticism. This would

include not only the individual who desires a "room of one's own" unplugged from the cultural grid, but the majority of the world's cultures. According to Richards: "The cabinet was in part a deliberate conceptual protest against the notion of the cyborg as being a wired-up, plugged-in thing that new technology is leading us to. But we've been cyborgs since the second world war, because of all the electromagnetic fields we're immersed in . . . and so I thought I'd make a piece that doesn't have any plugs and shows you exactly how plugged in you are."

Viewing the work, one has a sense of the fragility of the human body, exposed to the glaring rays of absolute media saturation, reflected in the bright copper screens that cast a golden shadow on the sitter, who appears to be glittering but distorted to the viewer outside. Images of too much fusion suggest liquidation rather than liquid identity—a population of withered rather than enhanced individuals, occupying other gleaming, shining boxes that already exist with the aluminum "safe" houses designed for sufferers of environmental illness.[17] Dispersal into an electromagnetically charged atmosphere may produce economic, cultural, ecological, and spiritual mutations, not prosthetically enhanced bodies and psyches. As both haven and cage, art object and instrument, *Cabinet* evokes a sense of retreat amid the terminal connectivity of technoculture, an awkward but necessary move in an empty space that is teeming with forces—vibrational, electromagnetic, and gravitational.

The electromagnetic spectrum has a history folded into its present. Like the air itself, it both surrounds and moves; ceaselessly reconfiguring, surging, penetrating, and enabling. What we hear of this spectrum are the radio and television waves associated with media—Western culture's talking cure—but what we feel is another matter. Richards remarks that "we don't have a language for articulating that sense of being in an electromagnetic field. Obviously some people can feel it, so that like proprioception, we're wordless." The senses—or at least those other than sight—are, like the invisible electromagnetic sphere, barely acknowledged in Western culture, and in Richards's work they act in the same way—becoming vehicles for reflecting on the "objects" or "devices" that mediate between social and bodily knowledge. For Richards, "immersion" rather than "penetration" is the metaphor of choice here, because "natural" electricity permeates the atmosphere and courses through our cells, annihilating the difference and distance, which we like to imagine between human-made electricity and the natural world, and uniting satellites of culture with the rapid firings of global electromagnetic phenomena in one huge continuum.[18] Yet our understanding, even our

perception, of this spectrum is coupled and twinned with the technologies that register it; insofar as human and machine are doubled, there can be no relationship, no between, for the autonomy of the autonomous subject to occur. In her long-term study of this technotwinning, Richards unearths, in a sense amplifies, these issues as the contrast between being rapt with and wrapped by technology continues to fade.

As we know, enthusiasts have tried to hear voices from the future, the past, and the extraterrestrial, by supposedly infiltrating different and unknown parts of the ether. These historical antecedents evoke themes that are with us today: the desire for and the fear of the power associated with invisible energies. Attraction and repulsion may be the poles of a force within which humans oscillate—and these operate aesthetically and conceptually, in Richards's work and, one might suggest, in the culture at large. In *Charged Hearts* (1997) Richards draws an association between the electromagnetic field of the heart, the magnetic fields of the earth, and the electromagnetic fields of media immersion. The piece is an elaborate construction using glass-blown, anatomically correct models of the human heart placed inside glass bell jars and positioned on either side of a large glass platform. In the middle of the platform sits a terrella modeled on the natural electromagnetic orb that surrounds the earth, and the artificial electromagnetic system of the cathode ray tube that fronts our television and computer screens.[19] Participants step onto either side of this platform and lift the encased hearts, which are fitted with sensors that read their heartbeat and send a signal of its pulse across the platform to the other heart. Picking up the hearts triggers the "excitation" of gases within the hearts and the terrella, which then become phosphorescent. While referencing the cathode ray tube that delivers television, Richards's medium here is electrically charged gas, which, when excited by electromagnetic forces, produces a milky light materializing the virtual environment and registering the participants' interaction.[20] Once thought to be "plasma"—a universal substance that revealed the equally nebulous, material/spiritual atmospheric force known as the ether—this light, when coupled with the electromagnetic pulse of the heart, manifests the barely understood fields of the emotions, the signals of the body, the signals of the earth, within what looks like the kind of nineteenth-century scientific experiment that would have preceded the transmissions of radio, television, and contemporary wireless. (See fig. 4.)

Richards describes *Charged Hearts* as "an external re-creation of this situation of which we are all a part. In *Charged Hearts* we can hold the

Figure 4. Catherine Richards, *Charged Hearts,* detail of the cabinets. From Catherine Richards: Charged Hearts, in the National Gallery of Canada, Ottawa, 1997.

image of this condition in our hands."[21] The situation she is referring to is the total immersion of the individual in electromagnetic signals. Like *Cabinet,* Richards produces an "object" that the viewer can interact with, but the object here is not a signal-free space but a "condition": created through a combination of forces (somatic, atmospheric, and mediamatic) that circulate within and without the individual in a field where electromagnetic immersion is coequal with the heart's natural rhythms. By situating her work in the gallery and engaging the participant in the work's realization, she blocks the easy transference that might allow questions of representation to be superseded by the seeming neutrality and otherness of the technological apparatus. Simulation is limited here, as literal frames and literal screens also form barriers to what would be an easy dissolution and impose instead memories of the critiques (of media and art world institutions) too easily abandoned in contemporary discourse. The viewer/participant engages in the works in a variety of ways: whether embarrassed about being an object in "show" (e.g., *Cabinet*), or part of a performance (e.g., the wrapping in *Shroud*), or cautiously stepping on the glass to engage with *Charged Hearts,* or lying on the glass table in *Shroud* to be wrapped, or touching

the glass tubes in *I was scared to death/I could have died of joy*, the viewer
is caught in the same fragile union of materiality, identity, cultural
expectation, and the technological and elemental forces that drive the
aesthetic devices Richards has created. Fragility, pressure, containment,
and power are at once material elements and social forces that culture
often prefers not to see or to view through a suitably concealing
medium.[22] This fragility and ambiguity are literalized in the materials
used to create the works. Wood, glass, copper, gas, electricity, and elec-
tromagnetic forces are recurring elements in almost all of her works,
and each have their particular material and conceptual valence. The
fragility of glass, for instance, is used to increase the viewer's sense of
vulnerability (as a surface upon which the viewer stands or lays), while
its transparency allows the otherwise invisible gases—charged by elec-
trical pulses—to be seen. Glass is also very malleable: it becomes a
brain, a heart, a test tube and throughout its various transformations
retains both the fragility and strength that define its material and con-
ceptual function. Copper is transductive. A vehicle for electricity, lumi-
nescent and malleable, it functions as a conductor, a shield, a literal
screen, and a fabric wrap. For Richards, gas is "a way to materialize
electromagnetics"; it is also a transducer, a medium that is volatile, that
reacts to different material in unknown ways, that volatilizes—to
borrow from Artaud—any universal substance or state—be it the
Urstoff of early Greek philosophy or the ether of the nineteenth century.
This point brings us to the core element in Richards's constructions: the
electromagnetic spectrum, the ontology of the signals therein, and the
devices—both technological and cultural—used to contain and reveal
them. In materializing these immaterial substrates of technology,
Richards is also interrogating some of the contradictory desires that per-
meate technoculture, for example, being wholly immersed in technology
while remaining an individual, or believing that the virtual originates in
some magical elsewhere, devoid of any physical manifestation.[23]

AFFECT PULSES

The duplicity of these materials is again brought into play as a way of
exploring the "excitable tissues" and the signals they emit and respond to
within the brain. Just as the heart informs thought, or electro/magnetic
signals course through body and atmosphere alike, the electronic signal
itself oscillates with a certain amount of statistical and thermal random-
ness, thus ensuring that its status as signal—as thing to be interpreted—is

Figure 5. Catherine Richards, *I was scared to death/I could have died of joy*, detail of glass brain and spinal cord in tube (pulsating). From Catherine Richards: Excitable Tissues, Ottawa Art Gallery, 2000.

always a matter of estimates rather than certainties. It is fitting, then, that the oscillations in Richards's *I was scared to death/I could have died of joy* begin at the entry to the exhibit, in the title itself. In the eleven words that name this piece, catastrophic fear and joy meet and are divided, only by a thin mark—a slight interruption in what could be a continuum between a fear and a joy that happen to culminate in death. The typographical slash that unites these emotional extremities is materialized in the space of the gallery. As viewers enter, they notice two large glass tubes placed on stainless steel tables at opposite ends of the room. Each tube encloses a delicate, glass model of the right and left lobes of a brain with a trailing "spinal column" that tapers to an ambiguous, reptilian tail. The glass tubes are filled with a gas that, when excited by electrons, produces ringed columns of plasma: one white-mauve, the other maroon-red. When touched, the columns of light glow and pulse: one arcs as if responding to the viewer's hand; the other, ringed like a translucent larva, flashes more insistently. (See figs. 5 and 6.)

The rhythmic pulsing of the brains is neither random nor accidental. According to Richards, both are modeled on the patterns of brain activity that neurotheologians and some neuroscientists claim will produce a feeling of benign enlightenment—of being occupied by a godlike

Figure 6. Catherine Richards, *I was scared to death/I could have died of joy*, detail of spectator's hand touching the tube at the spinal cord (pulsating). From Catherine Richards: Excitable Tissues, Ottawa Art Gallery, 2000.

presence—or trigger the abject fear of being possessed by a demonic presence.[24] In particular, Michael Persinger, a professor of neuroscience at Laurentian University in Sudbury, Canada, has developed a series of electromagnetic wavelength patterns premised on the belief that the left hemisphere maintains our sense of self, and if that region of the brain is stimulated while the right hemisphere remains quiet, the left makes sense of this by inducing a presence of an Other.[25] Persinger has developed a series of pulses that induces sensations of haunting and paresthesia: the "Thomas Pulse," for instance, stimulates the "sensed presence" while "Burst X" induces sensations of relaxation.[26] The brain's haunting can also be understood as a mechanism for maintaining a sense not only of self but of the world, existence, and the presence

of others. This need to make sense of a cerebral silence is manifested in Richards's piece through the flickering of the twinned brains. As the mauve-white brain surges enlightenment and the maroon/red brain flashes terror, the self-contained image of the brain-in-a-vat, or consciousness downloaded onto a hard drive, comes to mind, yet at the same time, according to Persinger at least, these brains are desperately trying to evoke the other in order to retrieve their sense of self.

But where would the sense of another presence register? While the emotional sense (or neurobiological profile) of being haunted might be contained within, and confined to, the vacuum sealed glass tubes, the actual, material presence of an Other is provided by the viewer, who, by touching the glass tubes, becomes part of an electrical circuit, literally grounding the work as they themselves are literally and figuratively, grounded by the gallery.[27] It is on this solid ground, and via this bodily presence, that the viewer is able to experience the fractures—both emotional and intellectual—created by the piece. The glowing, pulsing brains seem to be alive: they move, they respond to touch, and in the darkened space of the gallery they appear to be communicating, bringing to mind countless scenarios of consciousness disembodied, or, more recently, downloaded. Collectively these visions have shaped speculations about the development of intelligent machines that are distributed, responsive to the environment, and "embodied." At the same time (and not necessarily in contradiction), with its finely crafted glass, interior fluorescence, and otherworldly plasmic pulsing, *I was scared to death/I could have died of joy* recomposes an older and more mystical vision: the beauty, simplicity, and elegance of human consciousness unfettered by the paraphernalia of flesh, communicating the highest joys, the deepest fears, the full spectrum of emotional existence via the perfect medium: a light emanating from within that both embodies and transmits unfathomable experience in a mathematically precise manner, communicating across a darkened space through a transparent medium to other "like minds."

This particular interpretation underscores the impossibility—rather than potential—of engagement. The light's constitutive matter—plasma—cannot exist outside the vacuum provided by the glass tube, which both incarcerates the brain and allows the viewer a form of contact that can only ever be spectatorial. Such an electrical and aesthetic circuitry reveals an often overlooked fact: that the fantasy of a disembodied, telepresent posthuman existence—a fantasy most often destined for the future—depends for its coherence on the body of the spectator existing in the present, and situated in the rarefied "look but don't touch" atmosphere

of the gallery. Similarly, the belief that the spectrum of human emotional experience can be separated into poles, designated as fear or joy, represented by numeric frequencies, and assigned to a brain that has been split from itself, its body, and its environment, depends for its hubristic reach on the current errant and immeasurable nature of emotions. If emotion is deracinated, contained, and made dependent upon a system of intellectual abstraction and material fragility, how can haunting occur? The only diversity, redundancy, or fullness of presence here is that provided by the nuances of the spectator's flesh, the lay of the gallery's ground, and the purely speculative possibility of an Other—deific or demonic—intersecting the brain's perfect rationality. A slight, typographical disturbance separates the duality of the title *I was scared to death/I could have died of joy.* Yet just a small slash, an accidental mark, a pen slipping somewhere, and the separation is undone, the emotional extremes blended. A slight disturbance in the gallery floor, and these beautiful, delicate, glass-blown objects shatter in an instant. A surge in the electro-pulsations, a shift in the frequency, and the patterns that separate the emotions collapse. Like Ray's remote presentation on the potentials for A-life, the possibility that the self is, as Persinger's coresearcher Todd Murphy declares, nothing more than "a characteristic readout on an EEG" depends on the absolute stability and certainty of human architectures—both physical and epistemic.[28]

Fragility, ambiguity, paradox—these characterize both the postmodern and posthuman: on this shifting ground the "hard" science of brain mapping produces its disenchanting, but all too believable, results. If, as science might claim, fear and joy are measurable events that can be managed, balanced, and set within a normative neurological range, this possibility is contained within, and only possible through, a particular social, material, and technological architecture, one that in Richards's piece is chillingly unstable and ultimately unsustainable. Joy animates its fantasy of an enlightenment sealed off from the world; fear hovers at the edges of its fine glass tubes, anticipating the next hurricane perhaps; the material present breathes life into an immaterial, projected future. The glass becomes a fishbowl, a bubble inflated through decades of electromagnetic thickening and the high maintenance investments of a highly speculative technoculture, blown by desire and the rhetorical baggage of prior body/machine fusions. Like all bubbles, it is destined to burst.[29]

After years of domesticating the body-as-machine analogy within popular culture, reorienting this analogy to accommodate a less problematic fusion is a difficult task. It is important to remember that these

reorientations presuppose rather than supplant commonplace analogies. Talk of "hard-wired" behavior, of overloaded "memory banks" of being "plugged in" or "off-line" is so habitual that the movement from the body as machine, to the mind as computer, to the body as text, and finally as code is a process that has been so internalized that it seems like a natural progression. But if the slide from solid machinic metaphors into ideas of fluidity, multiplicity, and emergence creaks with remnants of modernity, it is also lubricated by the resurrection of an ancient and enduring belief that all matter is simply a manifestation of some kind of universal deep structure. The body, once objectified, once excluded from reason, easily shifts from machine to meat. However, the shift is never complete, the body-in-transformation always carrying traces of its past as a constant source of anxiety. Ironically, one of the heaviest traces is the twentieth century's idea of the future: 'posthumanism,' like postmodernism, bears the weight of a 'retro-futurism'—a nostalgic yearning for the future promised in the early twentieth century and particularly emphasized in the aftermath of World War II blended with a cynical acknowledgment that technology has not overridden human greed or brutality. Not only have machines failed to deliver, but the future is always "not-me-now" and "not-me-here," and this very negative constellation is shadowed by the cumulative history of our experience with machines that are always in the process of becoming obsolete.

Even in its early stages, the adoption of machine metaphors to explain the universe incorporated the knowledge that no engine could operate forever. As the electrical enthusiast Thomas Mackintosh lamented in the 1830s: "The river flows because it is running down; the clock moves because it is running down; the planetary system moves because it is running down; every system, every motion, every process, is progressing towards a point in which it will terminate; and life is a process which only exists by a continual approach towards death. Eternal life and perpetual motion are almost, or altogether, synonymous."[30] The torpid and repetitious references to a slow winding down of everything and the downward modulation of the voice required even to speak Mackintosh's lament are almost physically enacted in *Shroud/Chrysalis* (hereafter *Shroud*) through the careful wrapping of the viewer in a fabric woven from very fine copper thread. Swathed in the datasphere, the desires to gather oneself together and to hide from view, but at the same time to interact and participate, coexist in a set of contradictory desires that *Shroud* articulates, again through the questions

posed by the title and the literal materiality of the work. A development on *Cabinet, Shroud* exists as both an installation and a performance. The latter begins with a white, brightly lit vacant room and a rectangular glass table with the copper fabric folded and neatly placed on top, ready to wrap the first participant. Like *Cabinet*, the fabric acts as a material shield from electromagnetic radiation. However, this time the viewer is wrapped, the shield has become a shroud, or, depending on your view, the skin of a chrysalis. The title—*Shroud/Chrysalis*—places this materiality within the deeply symbolic act of wrapping the dead or shielding the newborn. We can know the subject within only by the name of the material: "shroud" evokes decay and death—while "chrysalis" suggests emergence and life. According to one vision of posthumanism, the fabric is itself only a transitory "skin" soon to be outgrown as its contents "evolve" into something else. This process is necessarily situated in the future, since the larval stage is, by definition, only temporary. The skin sheds as the interior of the being develops, presumably through technological enhancement: implants, increased neural activity due to connectivity, biotech manipulations, etc. But another narrative may be forming here, in which the chrysalis is twinned not by a shroud but by a body bag used to conceal and contain a body that may have been too punctured, or violated, which could be in any kind of state. Here the skin loses the volition of the concept "shed": it peels or is peeled, it erupts, it leaks. In the dystopic narrative that has sometimes been attributed to Richards's oeuvre, the being inside the body bag, like the viewer in *Cabinet*, is the victim of too much communication, electro/magnetic radiation, or an excess of technology and its invasive, invisible actions.

Returning again to the materiality of *Shroud*, one might ask what is the material shielding the body from? In the context of the work's premiere—the art gallery—the future chrysalis could be shielded from its past, which is the present of the participant who is wrapped in this space. If *Chrysalis* implies a better future for whatever is inside, even if it implies a necessary, biologically ordained development, then, as mentioned, the participant is engaged in a deeply nihilistic exercise, as the future is always only before one, imaginary and speculative, and the past overflows with rituals for wrapping the dead, preparing the body for decomposition and the soul for entry into an afterlife modernity has denied. In this light, the shroud brings to mind the long history of the body, its decomposition into earth, and, as Hayles writes, the "sedimented history [that is] incarnated within the body," a body

"whose constraints and possibilities have been formed by an evolutionary history that intelligent machines do not share."[31] In its second iteration, *Shroud II* (2005)—a "body" flattened and girdled, uniting both shroud and chrysalis—is situated as both pre- and post- all other containers, filters, and devices that have held Richards's subjects in the work. As if to reiterate the present, the future, and the past of the body viewed through technological devices, *Shroud II* presents a three-dimensional print of a body wrapped in the original *Shroud,* lying on the same glass table, and viewable as an image only through a very old-fashioned, cumbersome stereoscope, mounted on a stand that forces the viewer into an awkward posture to see what the shroud—or chrysalis—once was. But in this context, the viewer stoops over and adjusts the face and eyes to see what is obviously an illusion of depth, an imagistic mummy, as if looking back to a time in history where illusive dimensionality was literally and figuratively wrapped in the body. Straining to see through this awkward "old" technology, the viewer also recognizes that the fascination it held also obscured the fact that there really is only a large sheet of paper on the table. And with this realization the viewer becomes aware that the stereoscopic apparatus is very uncomfortable, while the room itself is cold and faintly smells of concrete. (See figs. 7 and 8.)

RESONANCE

From *Cabinet* to *Shroud/Chrysalis,* materiality moves from wood to screen to fabric wrap: the increasing intimacy of the enclosure mirrors the trajectory of liberal human to posthuman subject. But as the latter increasingly occupies an ambiguous, postethereal space, the profound questions raised by Richards's work—concerning life or death, freedom or imprisonment, connectivity or containment—also shed their gravitas. Crossing the material and the immaterial, acting as a conduit for communications, telepresence, and unpredictable, natural phenomena, the electromagnetic sphere that Richards invokes functions as a no-frills version of the ether—a transmissive space stripped of the cosmic connotations, the benign attributes, the sense of plenitude that ether once enjoyed. As a metaphor, it incorporates all the failures of technoevolution: the physically finite atmosphere now harbors industrial toxins, ozone holes, erratic weather patterns, and foreboding indicators of irreversible climate change. These betray both the myth of continuous growth and the perpetual motion that, as Mackintosh

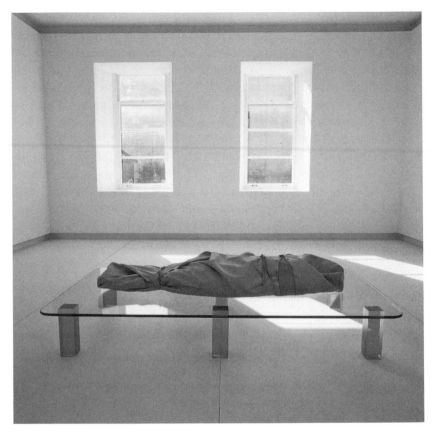

Figure 7. Catherine Richards, *Shroud/Chrysalis I*. From Catherine Richards:
Excitable Tissues, Ottawa Art Gallery, 2000.

understood in the mid-nineteenth century, is a necessary equivalent to
eternal life. The decade following the exhibition of *Cabinet* saw
increasingly sophisticated theories of posthuman subjectivity emerge,
and according to some theories Richards's work represents a conser-
vative desire to shore up the fiction of the self. When she writes that
Cabinet displays the autonomous self as an endangered species, she
seems to be reiterating the dystopian themes of many science-fiction
narratives where the human is overtaken by technology. These narra-
tives have been cast as a fear of invasion and often culturally relate to
white, Western, and usually masculine fears of the Other. Yet when
"penetration" is replaced not by "immersion," as Richards suggests,
but by the concept of *resonance,* an entirely different reading of the
"shroud" is produced. For, as she demonstrates, the body is already a

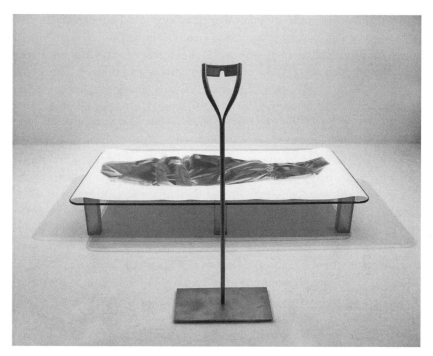

Figure 8. Catherine Richards, *Shroud/Chrysalis II*. From Catherine Richards: Excitable Tissues, Ottawa Art Gallery, 2005.

pulsating reservoir of signals; the emotions—hallmark of humanism—literally oscillate between frequencies we like to call "fear" or "joy"; the sense of self is malleable and will easily accommodate deific or malevolent phantoms. In short, the posthuman subject is not so much disembodied by technology—projected from the physical self in a telepresent experience—as simultaneously etherealized and "retuned." With its social, fiscal, political, and consumer profile spread across the vast systems of communications culture, and its internal rhythms humming along to heart rates and electromagnetic pulses alike, the figure of the shroud/chrysalis is already forming itself around atmospheres no longer separate and distinct. These are, to return to Heidegger, properly mood-laden—creating a latter-day *Stimmung*. However, this would be a *Stimmung* not grounded in the silence of Heidegger's call of the conscience, but formed from all that the concept of silence excludes: the noise, chatter, oscillations, and tone-data that spread across and move amid the human, technological, and cosmic spectrum.

The excitable tissues of the beating heart provide a counter to the dissociative tendencies of technoculture: the "body as meat" leanings of Artificial Intelligence, or the refusal to see technology within a larger field of influences that are—literally—infused with power. Inasmuch as it is laden with signals, pulses, and waves, this electromagnetic, discursive, and political atmosphere is also thick with conceptual ambiguity, irreconcilable agendas, false starts, and baseless suppositions. There is no ground in this atmosphere; it is, like Artaud's "celestial telegraphy," or Richards's *Shroud,* a space of both liberation and death and cannot easily be contained by conceptual structures looking for an anchor—in either the body or technology. In this dynamic, the (conceptual) resistance offered by materiality—posed as a counter to immateriality—operates in much the same way that Cage's aural/philosophical mechanisms harnessed sound to counter the abstract silence of Western tonality. Unfortunately for Cage, his opposition, sound/silence, would have to be abandoned for the all-encompassing unity of a "(nothing but) sound" doctrine, in order to fill the theoretical sinkholes that sound/silence generated. Similarly, the material/immaterial dyad, as Hayles points out, is a humanist fiction. But more than this, it tends toward the proliferation of bodies and states that require the overarching unity of an all-encompassing evolution for their accommodation. While Richards's aesthetic machines deal in pairs, dualities, and opposites, their junctures cannot be mapped upon a set of binaries (attraction/repulsion, presence or absence), since the pulsations, vibrations, and interferences that direct their electromagnetic energies our way situate such conceits within a metaphysical dynamo that the artwork puts into play. Because the technology that produces her work is also immanent in it, there is no massive but invisible system upon which the work relies though of which it never speaks.

Reading Richards's work through the metaphor of the pulse and the notion of sympathetic resonance complicates the very question of a relationship between human and machine that is not so much seamless, as mute. Crucial to this problematization is the difference between the signal as information and the signal as pulse. The latter is not essentially communicative; it often requires a form of technological mediation to be perceived, is without agency, and relies upon some kind of system of representation, which, in Richards's work, is often also the device. Yet this system is not inscriptive, in the sense of offering a surface that is bounded by either flesh or medium, a surface upon which culture is written or projected, a body that is penetrated by technologies as

implants, prostheses, enhancements, or wearable devices. Rather, it is transmissive and presents a field of "excitability" that is triggered, charged, and set in motion through an indissociable mix of fantasy, corporeality, and the chattering atmosphere. As Richards comments: "If you are immersed in a signal, you start to resonate, in a way, to the system. So for me the question is: 'who has the power of the pulse—whose pulse is everybody syncing to?'"[32]

Conclusion

Music and Noise

Hayles's correlation between technology as an agent of incorporation, which produces the interactions between humans and machines that she endorses, and her initial analysis of audiophony is not at all without precedent. Whereas the samplings of audio artists may suggest the eclipse of body and space in favor of the culturally saturated signal, the "new" of new media depends on redefining embodiment, space, reality, and experience in ways remarkably similar to notions of immersion and transcendence associated with audiophony. This "elsewhere" beyond media, and sometimes beyond culture itself, enabled early sound theorists to retrieve audio from the stain of reproduction and either restore or omit from consideration the integrity of the aural object. As discussed in chapter 3, Pierre Schaeffer invested the tape recorder with almost mystical capabilities, allowing sound objects "when touched mechanically" to reveal their existence.[1] Murray Schafer connected earphone listening with an unmediated interior listening, wherein "the archetypes of the unconscious were in conversation."[2] The magic of the "mechanical touch" has been a constant companion to phenomenological approaches such as Pierre Schaeffer's and appears in new media theory under various guises as a transparent, unmediated avenue to the thing-in-itself as a site of excess and alterity. Indeed a harbinger of the posthuman, as Hayles suggests, the tape recorder, rather than obscuring the perception of sonorous objects by imposing its own associations, could act as an agent of change that

would activate new perceptive capacities and create both new sounds and new bodies in the process.

A more contemporary version of this argument is presented in Michel Gaillot's extended essay on the phenomena of "techno" and "raves."[3] In this essay the combined musical, rhythmic, dance, and audio technologies are initially brought together to define a new social phenomenon, but rapidly become the ground for a new metaphysics of being. This transformation follows a familiar path: the participatory nature of raves, the involvement of the body in dance, and the unique properties of the audio mix and sampling herald a new form of sociality, a new "being-in-the-world and being-in-the-body" that in challenging the "old socio-historic figures of meaning" re-fuses the political and ethnic divisions in the world.[4] Technology is central in this emergence, and the coincidence between technoartists and machines like the sampler evidences a far more significant "cosmological revolution" brought about by technology itself. Not only is it "through the technological that the tendency to transgression—to phenomena of trance and ecstasy—survives and revives."[5] But technology is central to the essence of human existence *qua* lack: "Technics is proper to man to the extent that he is without essence. Unlike any other existent, man is not, nor does he become, automatically—instinctually—himself; he also has to make himself into man. In this sense, technics . . . is the means through which man becomes a work of his own. . . . What is so frightening about technics is nothing more than the angst man feels before, and in, the exposure of his existence to the abyss of his lack of essence."[6]

As "techno," the musical genre becomes a metonym for technology per se; the engagement of the body in dance becomes an instance of the "new forms of sensibility and thought" that technology inaugurates. At the same time, the unique nature of music (read sound) is intrinsically related to the technologies that produce this particular form of audio art. With a nod to the prior work of Pierre Schaeffer, Pierre Henry, John Cage, Terry Riley, Steve Reich, and *Kraftwerk,* Gaillot nonetheless distinguishes techno from audio art because of techno's emphasis on dance and therefore the involvement of the body. But the engagement of the body in music is a very difficult criterion to maintain, and we find, later in the text, that it is not so much the body but the instruments that transform, first, music and, then, the body, which interest the author. In this respect, Gaillot takes a lead from Deleuze and Guattari by using the radically deterritorializing force of music to declare that "we are at the dawn of the new cosmology, about to enter what might be called

'techno-cosmology'" and ending this declaration with the rather despondent claim that "in the end, nothing but techniques come . . . to our lack of being. Instead of reinforcing the confinements and enclosure of identity, it pushes identities to open up and experience alterity." Here technology is an avenue to alterity itself, the experience of which is necessarily associated with the bypassing of representation to experience the real *in itself*. This occurs through music—which, despite the best efforts of many musicologists (including Pierre Schaeffer), is still considered to be quintessentially nonrepresentational. As Gaillot reinforces, music "communicates itself all by itself as meaning, communicating without the mediation of language," and he cites Deleuze and Guattari in the declaration that music provokes "the most extreme deterritorialization, beginning with that most intimate and special one, that of 'self.'"[7]

At this point it is worthwhile to consider Deleuze and Guattari's treatise on music in greater depth—particularly as these philosophers so often feature in theories of new media. Of note is the inclusion at the very beginning of their influential book *A Thousand Plateaus* of a brief segment of Sylvano Bussotti's score *XIV Piano Piece for David Tudor*.[8] It is offered as the musical/textual equivalent of a selected quotation, followed in close proximity by the words: "The two of us wrote Anti-Oedipus together. Since each of us was several, there was already quite a crowd." If not a close paraphrase, this sentiment is also expressed, in interviews and various writings, by John Cage, who collaborated closely with Tudor—referenced in the scribble of lines that make up the score of the opening citation in *A Thousand Plateaus*.[9] Music is central to Deleuze and Guattari's concept of the rhizome and is introduced early in the book: "Music has always sent out lines of flight, like so many transformational multiplicities, even overturning the very codes that structure or arborify it, that is why musical form, right down to its ruptures and proliferations, is comparable to a weed, a rhizome." Direct reference to Cage (via Pierre Boulez) occurs much later, in reference to "the plane of consistency" (as opposed to the plane[s] of organization or development) that are understood through temporality and movement in the musical plane:

> It is a question of a freeing of time, Aeon, a nonpulsed time for a floating music, as Boulez says, an electronic music in which forms are replaced by pure modifications of speed. It is undoubtedly John Cage who first and most perfectly deployed this fixed sound plane, which affirms a process against all structure and genesis, a floating time against pulsed time or tempo, experimentation against any kind of interpretation, and in which silence as sonorous rest also marked the absolute state of movement.[10]

However, not all of Cage's compositions are so perfect. In "Refrain" Deleuze and Guattari caution against the synthesis of too many elements, of producing a "jumble," of lapsing back into a "machine of reproduction": "The claim is that one is opening music to all events, all irruptions, but one ends up reproducing a scramble effacing all sounds" citing, in parentheses, Cage's prepared piano as an example of "a material that is too rich, [remaining] too territorialized: on noise sources, on the nature of objects."[11] It seems that the prepared piano does not produce a "cosmic machine" (such as the "sound machine" that Varèse creates), "which molecularizes and atomizes, ionizes sound matter, and harnesses a cosmic energy" through the "assemblage" of the synthesizer. Although Varèse didn't use the synthesizer, for Deleuze and Guattari it nonetheless has an intrinsic relationship to the nature of sound and seems to have more importance in this context than any criterion that would differentiate the perfect from the not so perfect deployment of sound in the cause of music's cosmic potential. Indeed, it has metaphysical implications: "The synthesizer, with its operation of consistency, has taken the place of the ground in *a priori* synthetic judgement: its synthesis is of the molecular and the cosmic, material force, not form and matter, *Grund* and territory. Philosophy is no longer synthetic judgement; it is like a thought synthesizer functioning to make thought travel, make it mobile, make it a force of the Cosmos (in the same way that one makes sound travel)."[12]

Cage's prepared piano was definitely not an electronic piece, but used nuts and bolts, pie plates, screws, and other everyday materials to transform the piano effectively into a percussive instrument. As such it did not fulfill a lurking criterion for the kind of molecularization that Deleuze and Guattari desired—the transformation of sound through speed, becoming a material force through, we might add, a technological instrument. If Cage failed to produce a "cosmic machine capable of 'rendering sonorous'" by using the prepared piano, what of his more important, philosophical claim to be "opening music to all events" within the larger discourse of sonic democracy and democracy in general? How does Deleuze and Guattari's critique affect the belief in multiplicity contained in the first sentence of *A Thousand Plateaus*—the reference to "we are many" and the score that prefaces its introduction? In "Refrain" the liberation of "music's language" and its reassignment to a machinic assemblage occur through both the materiality of sound (timbre) and chromatics that they identify with glissando.[13] The temporal blurring of tonality caused by the incremental accumulation of

frequencies turns music—once a system—into a force, an intensity, "irreducible" to the one.[14]

This democratic sentiment has resounded throughout the twentieth century: Luigi Russolo's "Intonarumori" was not only a machine, but it represented a philosophy in which technology acted as an agent within a field of possibilities; Varèse's and later Cage's liberation of sound was deeply tied to technology. However, the conjunction of Cage, Deleuze, and Guattari is more than aural. The invocation of "I" as "we"—of the multitude, the crowd, democracy as multiplicity and minority, leaning toward "cosmic creation" (Deleuze and Guattari) or the transcendent conjunction of art, technics, and nature (Cage)—reveals a cultural predilection for erasing power relations through an appeal to the mass, to dis-individuated participation.[15] The aural equivalent for this is "noise," while its sanctified, meaningful progeny are certain kinds of music. Thus although Bussotti's score *XIV Piano Piece for David Tudor* looks at first glance like a mass of lines and scribbles, beneath the visual cacophony one can glimpse the faint intensities of traditional musical notation. The palimpsest indicates a necessary substratum of both order (pitch) and tradition (notation), in the same way that the variability, deterritorialization, and rhizomic representation of aurality extends to music (even Beethoven) but doesn't extend to noise—or the complete absence of form.

Did Cage himself make a distinction between synthesized and non-synthesized sound, and if so, did his distinction articulate the same kind of metaphysical claims embedded in Deleuze and Guattari's reading of modern music? The replacement of pulsation with a kind of pure speed, the dissolution of temporal intervals, is the mark of electronic sound manipulation and a form or genre of sound art that Cage developed and later popularized—the mix. Indeed *Variations VII*, Cage's piece for *9 Evenings*, not only combined all kinds of sonic material, but was set within an extended series of performances that were also a mix: an installation, performance, convergence, multiplicity, "happening." It was through the philosophy of the mix that multiples were formed, that literally and metaphorically the one became many. However, temporality was not entirely lost. And it could be argued that, if *9 Evenings* was exemplary of the dialectic between experimentation and tradition, demonstrating an entirely new instance of the former, and if Cage, as Deleuze and Guattari argue, "most perfectly deployed this fixed sound plane," then *Variations VII* demonstrates a preference for a certain narrativity—a temporal

form—not the all-at-onceness that his colleague and friend David Tudor demonstrated with *Bandoneón!* The use of narrative is important for a number of reasons. First, it attaches to a sense of causality; second, it allows for sounds to be deployed in time; third, and most important, it creates "space" within the piece—allowing different sounds their difference, a degree of identity, a certain differentiation. This narrativity is also necessarily mapped upon the embodiment of the listener, for whom sounds must be audible, must presence for a certain amount of time, must be contiguous (etymologically akin to *contigere*: to touch on all sides). Thus while Deleuze and Guattari refer to the "soundblock" as an instance of deterritorialization because of its "nonpulsed" time, they invoke the presencing of sound as if its nontemporality, or nonlinearity, were sufficient to absent it from (musical) meaning or significance, thereby denying it the quality of transcendence or organization that is the hallmark of the Western musical tradition.

A similar rhetorical path is taken by Gaillot, who very quickly moves from the circumstances surrounding techno as art to the intrinsic role technology has to play in the realization of human essence: "our existences have been displaced and transported from the horizon of metaphysics or ontology (that of 'being') to that of the possible or the virtual."[16] This shift occurs via the negation of representation: "With the virtual image one no longer finds one's self frontally across from a wall, but in the presence of new horizons which one can enter and experience singly and collectively. We are no longer dealing with a copy of the real world, with this representation, but rather with its extension. This gives rise to new sensibilities, as well as to a new mode of being-in-the-world."[17] I cite Gaillot at length because his argument offers a stark insight into the rhetorical maneuvers wrapping sound, music, technology, popular culture, and metaphysics into a formula that reaches out to the very depths of human existence and its role within the cosmos yet finds its solution in the historically specific, narrowly defined sphere of new media—specifically, the virtual image. While this particular narrative might be considered an enormous stretch—both logically and figuratively—it parallels, albeit on a much grander scale, similar arguments locating the virtual (as both media and metaphysical concept) within the body and beyond or outside of representation.

This intertwining or interpenetration is seen to bypass representation, for even if digital media reduce, through computation, the visual and aural to humanly unperceivable code, the body, with its perceptual

apparatus, reembodies such data via the digital interface, in much the same way as its predecessors (the analog interface of radio or television). However, if the body and materiality per se are resistive to inscription, they also establish limits. With respect to digital media, a limit is imposed by what the human perceptual system can see or hear, which means that the body cannot account for the signal or pulse in its entirety.[18] There are certain frequencies in the auditory spectrum that may mean a lot to crickets but are beyond my hearing range. There are electro/magnetic frequencies that can be "heard" only through some kind of technology, and these signals are never discrete, but composed of pulses, which require a periodicity and a degree of filtering to become "signal" at all. The meaning that a signal might convey results from its serialization and periodicity—something that is heard and felt in rhythm—but what lies between signals, what in fact defines the signal (Derrida's cinder, Cage's silence) is an aesthetic, technological, and metaphysical process that both filters and is constituted by noise. While noise—like flux, vibration, pulse, or signal—is indeed a good metaphor, its ceaseless movement between signal, music, rumor, and language unhinges any dialectic with which it is engaged, or to which it is applied. Here the words of Michel Serres are instructive: "There is noise in the subject, there is noise in the object. Meddling in the phenomenon, the receiver introduces or produces a certain noise there, his own, for no-one can live without noise. . . . There is noise in the observed, there is noise in the observer. In the transmitter and in the receiver, in the entire space of the channel. There is noise in being and appearing, . . . in being and knowing, in the real and in the sign, already."[19]

Noise annoys—it lacks the neutrality of flux, the plenitude of excess, the resistive connotations of difference, the positivity of incorporation. The a-periodicity of noise—its randomness—is not simply a metaphysical irritant waiting for clarification; nor does it have an essential relationship with order and singularity, as if, as Cage said of silence, it were an opposite and necessary coexistent. In fact, noise breaks the conceptual levees that establish it as a unity to battle with other unities, as a third term to reinvigorate an old dialectic. Lying beneath representation, noise lurks in the vibrations and waves that disjoin any attempt at unification, including at any attempt to think technology through the body or embodiment. The usual question that hovers around noise is not what it is, but how can we "not" hear it? What kind of filter can we put in place to protect our ears, our speech, and our various containers from the interruptions that, like Ray's encounter with hurricane

emergency alert, dissolve our speech into static? The dynamic therefore is not so much between what the body can or cannot perceive, but what and how it wants to hear or see.

Noise has and sets its limits: for Heidegger, that limit became apparent when the sound of objects ("tone-data") and the noise of the masses (rumor) prevented *Dasein* from hearing itself and becoming attuned, which led him to filter sound from almost everything. For Cage, the sound of his circulating blood forced him to break with first "silence" and then "sound" and refigure music as noise and art as life. In the context of surveillance, the inscrutability of the "chatter" that surrounds, like a fog, various exchanges within the data-sphere has spawned a variety of devices to delimit and therefore identify suspicious behavior, while individuals aware of these devices impose their own boundaries on bodily emanations in order to operate "below the radar." In the field of discourse, the limit of noise is its oscillation between singularity and plurality: the difference between "a noise" and "a sound" and "Noise" and "Sound." This difference designates a filter, what is in fact a noise filter, in the form of a capitalized "N" that enables certain insights but obscures others. In this respect, noise operates like vibration, as a reoccurring figure, uniting aurality, technology, and mythology in a single but ineffable term that is shared by all fields, and surfaces as a *prima causa*. As previously suggested with regard to the use of the aural metaphor, the absence of the possibility of the question "*what is* sound?" leaves aurality, ephemerality, and immateriality as fathomless tropes to be deployed in new discursive fields unabated. But thinking of sound—as vibration, voice, breath, ephemerality, immateriality, and metaphor—through Noise is at least a sobering exercise, as "Noise" cannot be thought without some kind of guttural and cognitive flinch.

Notes

INTRODUCTION

1. As early as 1991, a phenomenological approach to understanding immersive space was articulated by Michael Benedikt in his groundbreaking edition *Cyberspace: First Steps*—one of the first anthologies to seriously engage with the field. Benedikt begins his own essay by posing the question: "What is space? . . . Is space a physical phenomenon, an object in some sense? Insubstantial and invisible, space is yet somehow there, and here, penetrating, and all around us. Space, for most of us, hovers between ordinary, physical existence and something other. Thus it alternates in our minds between the analyzable and the absolutely given." Michael Benedikt, *Cyberspace: First Steps,* ed. Michael Benedikt (Cambridge, MA: MIT Press, 1991), 126.

2. *Der Prix Ars Electronica* catalog (Linz: Veritas, 1992), 104.

3. As media theorist Margaret Morse has written: "Immersion is associated with a variety of media and cultural forms, [and is used] as a metaphor for a state of mind, as a descriptor for historical and cultural forms and techniques thought to induce that state, and finally, as a tool of aesthetic reflection." Margaret Morse, "Aesthetics and Immersion: Reflections on Martin Jay's Essay 'Diving into the Wreck,'" Asthetik-Colloquim vom 27.02. bis 01.03.03 in Berlin, October 2003.

4. As Sean Cubitt writes: "It is impossible to distinguish between the vibrations of the air, the vibration of the eardrum and the bones . . . and the neurobiological events which, in consort, provide us with the mental event of sound perception, sound events create a space with no respect for the sacrosanctity of the epidermis in Western philosophy." Sean Cubitt, *Digital Aesthetics, Theory, Culture and Society,* ed. Mike Featherstone (London: Sage, 1998), 95.

5. See Richard Coyne, *Technoromanticism: Digital Narrative, Holism, and the Romance of the Real* (Cambridge, MA.: MIT Press, 1999).

6. See N. Katherine Hayles, *My Mother Was a Computer* (Chicago: University of Chicago Press, 2005), 21.

7. Mladen Dolar, *A Voice and Nothing More*. Short Circuits, ed. Slavoj Žižek (Cambridge: MIT Press, 2006), 15.

8. For an account, see Tom Levin, "The Acoustic Dimension," *Screen* 25, no. 3 (May–June 1984): 55–68; and Rick Altman, "Introduction," *Yale French Studies* 60 (1980): 14, 15.

9. Michel Chion, *Audio Vision: Sound on Screen*, trans. Claudia Gorbman (New York: Columbia University Press, 1990), 29. Chion also adds: "At the same time, however, through acousmatic listening, participants quickly realize that in speaking about sounds they shuttle constantly between a sound's actual content, its source, and its meaning. They find out that it is no mean task to speak about sounds in themselves." Ibid.

10. The appropriation of aurality through the use of silence as a key structuring term is not unlike the process of "technesis" that new media theorist Mark Hansen elaborates. However, rather than the "putting-into-discourse of technology" and the latter's subsequent reduction to the field of representation, here we find the use of the aural metaphor—*in absentia*, as silence—in order to critique technology (at least, in the case of Heidegger), or theorize its alterity. See Mark Hansen, *Embodying Technesis* (Ann Arbor: University of Michigan Press, 2000).

11. See Jay David Bolter and Richard Grusin, *Remediation: Understanding New Media* (Cambridge, MA: MIT Press, 2000).

12. Eric Partridge, *Origins: A Short Etymological Dictionary of Modern English* (New York: Macmillan, 1966), 636.

CHAPTER 1

1. Roland Barthes, "The Grain of the Voice," in *The Responsibility of Forms*, trans. Richard Howard (New York: Hill and Wang, 1985), 274. For Barthes: "Music is both what is expressed and what is implicit in the text: what is pronounced . . . but is not articulated, what is at once outside meaning and non-meaning." See "Music, Voice, Language," ibid., 284.

2. Barthes, "Music, Voice, Language," in *The Responsibility of Forms*, 283. The grain of the voice is described in Barthes's essay *The Pleasure of the Text*, as "the articulation of the body, of the tongue, not that of meaning, of language." Barthes, *The Pleasure of the Text* (New York: Hill and Wang, 1975), 66–67.

3. "Music, Voice, Language," 280.

4. Barthes, "The Grain of the Voice," 272.

5. Barthes, *The Pleasure of the Text*, 66–67.

6. Barthes, *The Responsibility of Forms*, 251.

7. For a lengthy and erudite analysis of this myth, see "The Madonna's Conception Through the Ear," in Ernest Jones, *Essays in Applied Psychoanalysis* (New York: International Universities Press, 1964), 266–357.

8. Cited in Frederick Copleston, *A History of Philosophy*, vol. 1 (Westminster: Newman Bookshop, 1946), 463.

9. Much later, this association would appear in the context of the electrical impulses representing the nervous system.

10. Cited in Copleston, *A History of Philosophy,* 1:47. Philip Wheelwright notes that Heraclitus's writings may well have postdated those of Parmenides by two decades, and that his theory of flux may in fact be a reaction against the view of Parmenides that change is unreal, which he thought to be unworkable. Wheelwright, *Heraclitus* (New York: Atheneum, 1964), 9–10.

11. Copleston, *A History of Philosophy,* 1: 144, 196. The so-called proofs of Zeno (ca. 489 BC), a disciple of Parmenides, again attempted to deny the possibility of change and motion by debating the concept of the unit of time, the instant, and the point in space. Ibid., 1:54.

12. See Don Ihde, *Listening and Voice: A Phenomenology of Sound* (Athens: Ohio University Press, 1976), 10. Ihde adds "intuition" from the Latin "in-tueri": "to look at something." Ibid., 8.

13. Plotinus, cited in Copleston, *A History of Philosophy,* 1:463. The notion of ascension is identified with knowledge. Plato credits sight with indicating the upward movement or telos of "his" soul, while also distinguishing "him" from animals: "the word 'man' implies that other animals never examine, or consider, or look up at what they see, but that man not only sees but considers and looks up at that which he sees, and hence he alone of all animals is rightly called." Plato, "Cratylus," in *The Dialogues of Plato,* vol. 3, trans. B. Jowett (Oxford: Clarendon Press, 1953), par. 399/c–414.

14. To begin, Plato assumes that both things and actions "have their own proper and permanent essence [which is] prescribed by nature" (*Dialogues of Plato,* 386/e). Knowledge of this essence comes through naming, for while "a name is, it seems, a vocal imitation of any object," it is a very special imitation. For Plato, names originate from the "legislators" of language, who invented words that would phonetically correspond to the nature of the thing, the "letters" (phonemes) in a word expressing certain states of the thing, such as motion, or shock. For instance, Plato believed that "the legislators" created letters that were "adapted to express size, length, roundness, inwardness, rush or roar." Plato, cited by Jowett, in the introduction to *The Dialogues of Plato,* 30.

15. Unlike the graphic symbol, the drawing, or the sign, for Plato the voiced name does not insert a gap between being and knowing, since it re-presents the thing itself: "[A name is] not a musical imitation, although that is also vocal; nor, again, an imitation of what music imitates." Ibid., par. 423/b.

16. Ibid., 440/b.

17. Thanks go to Noel Sanders for pointing this out.

18. Antonin Artaud, *The Theatre and Its Double,* trans. Mary Caroline Richards (New York: Grove Press, 1958), 52.

19. "Striking by the soul (in these parts) upon air inhaled through the windpipe is voice." Aristotle, *De Anima, in the Version of William of Moerbeke and the Commentary of Thomas Aquinas,* trans. Kenelm Foster and Silvester Humphries (New Haven: Yale University Press, 1954), par. 466–77.

20. "The principal cause of the production of voice is the soul, using this air, i.e., air inhaled, to force against the windpipe the air within it." Ibid.

21. As David Appelbaum points out, "making voice immune to the cough, means leaving voice mute . . . in terms of sound, the mute is the immutable."

David Appelbaum, *Voice* (Albany: State University of New York Press, 1990), 8.

22. Aristotle, par. 478.

23. As Derrida elaborates: "Between the phonic element (in the phenomenological sense and not that of a real sound) and expression, taken as the logical character of a signifier that is animated in view of the ideal presence of a Bedeutung [meaning] (itself related to an object) there must be a necessary bond." Jacques Derrida, *Speech and Phenomena* (Evanston: Northwestern University Press, 1973), 76.

24. Giorgio Agamben, *Language and Death: The Place of Negativity,* trans. Karen E. Pinkus with Michael Hardt, Theory and History of Literature, ed. Wlad Godzich and Jochen Schulte-Sasse, vol. 78 (Minneapolis: University of Minnesota Press, 1991), 35.

25. For instance, "by actualizing the virtual dimensions of the artwork, the viewer-participant simultaneously triggers a virtualization of her body, and opening onto her own 'virtual dimension.'" See Hansen, *New Philosophy for New Media* (Cambridge, MA: MIT Press, 2006), 140–41.

26. Jonathan Sterne, *The Audible Past: Cultural Origins of Sound Reproduction* (Durham: Duke University Press, 2003), 1. As there was an Enlightenment, Sterne proposes, "so too was there an 'Ensoniment': During the Enlightenment and afterward, the sense of hearing became an object of contemplation. It was measured, objectified, isolated and simulated. . . . These facts trouble the cliché that modern science and rationality were outgrowths of visual culture and visual thinking" (2–3).

27. "By this emphasis on [audible] technique I mean to denote a concrete set of limited and related practices of listening and practical orientations toward listening." Ibid., 91.

28. As Janet Oppenheim writes: "'Techno-spiritualism' conflated technological and spiritual immortality within the concept of the ether: thought of as the cohesive force of the universe; the vehicle of transmission of all energies; and the sphere within which both telephonic, telegraphic and later wireless communications, together with messages from the 'other side,' could occur." For a detailed account, see Janet Oppenheim, *The Other World: Spiritualism and Psychical Research in England, 1850–1914* (New York: Cambridge University Press, 1985), 18.

29. Richard Pioli, *Stung by Salt and War: Creative Texts of the Italian Avant-Gardist F. T. Marinetti* (New York: Peter Lang, 1987), 45.

30. Daniel Czitrom, *Media and the American Mind* (Chapel Hill: University of North Carolina Press, 1982), 65.

31. See Thomas A. Edison, *The Diary and Sundry Observations of Thomas A. Edison,* ed. Dagobert D. Runes (New York: Philosophical Library, 1948). Various devices invented to capture roving spirit voices, and meetings of the fledgling theosophical society were common, while early experimenters like Thomas Watson were interested in messages from extraterrestrial sources and would attend nightly séances in Salem—a town, as Avital Ronell points out, known for its witch burning in the seventeenth century. Ronell describes Watson's experiments with the telephone as "electronic" witchery: a substitute for the "mediumship," which was held to be a feminine ability at the time,

taking place in the symbolic town of Salem. See Avital Ronell, *The Telephone Book* (Lincoln: University of Nebraska Press, 1989), 247n16.

32. Hubert Greusel, *Hours with Famous Americans: Thomas A. Edison* (n.p.: Greusel, 1913), 84–87.

33. Carolyn Marvin notes that electricity was linked to religious beliefs through the idea of the Spirit and cites the Bishop of Aix, for whom electricity "is as the invisible soul of the material world." Marvin, *When Old Technologies Were New* (Oxford: Oxford University Press, 1988), 126–27.

34. Sigmund Freud, *The Standard Edition of the Complete Psychological Works,* ed. James Strachey (London: The Hogarth Press, 1964), 22:54.

35. Freud writes: "Do not forget that it was only analysis that created the occult fact—uncovered it when it lay distorted to the point of being unrecognizable. And further: [telepathy] is a kind of psychical counterpart to wireless telegraphy—The telepathic process is supposed to consist in a mental act in one person instigating the same mental act in another person. What lies between these two mental acts may easily be a physical process into which the mental one is transformed at one end and which is transformed back once more into the same mental one at the other end. The analogy with other transformations, such as occur as in speaking and hearing by telephone, would then be unmistakable. . . . It would seem to me that psychoanalysis, by inserting the unconscious between what is physical and what was previously called psychical, has paved the way for the assumption of such processes as telepathy." Cited in Laurence Rickels, "Warm Brothers," in *Aberrations of Mourning* (Detroit: Wayne State University Press, 1988), 28.

36. Jean-François Lyotard makes the point that the narrative of Freudian psychoanalysis is based on "the ideology [that] there is a voice, it belongs to someone; which is to say that this someone knows what he or she says by means of this voice; and this voice is addressed to someone . . . [and] that someone who has a voice also has a life which is recountered in that voice." In order to locate the "real voice" of the analysand, Lyotard argues that "a supplementary witness would be needed, an extra voice [which] can only be found in an absolute subject." Jean-François Lyotard, "Voices of a Voice," trans. Georges Van Den Abbeele, *Discourse* 14, no. 1 (Winter 1991–92): 127. I suggest here that the "absolute subject" is provided in the form of the recording or transmitting device.

37. Freud, *The Standard Edition,* 54. This new role was no doubt amplified by reports of psychic disorders of the time in which patients discover "telephones in the head," and analysts such as Tausk developed theories of "the influencing machine" to explain electrical currents, waves, rays, and forces reported by schizophrenics. Victor Tausk, "On the Origin of the 'Influencing Machine' in Schizophrenia," *Psychoanalytic Quarterly* 2 (1933): 521. See also Marvin, *When Old Technologies Were New,* 133. On this topic, Ronell cites a patient of Jung, who retained, alongside her cryptic discourse, a coherently critical agency she called the "telephone." Only by taking the place of the telephone was Jung able to engage in analysis, a procedure that led him to describe her schizophrenia as "eroding the covering of consciousness . . . so that one could now see from all sides the automatic machinery of the unconscious complexes." Ronell, *The Telephone Book,* 132. See also Friedrich Kittler, *Discourse Networks,* trans. Michael Metteer, with Chris Cullins (Stanford: Stanford University Press, 1990), 280.

38. See Kittler, *Discourse Networks*, 285.

39. See "radio" in *Webster's New Universal Dictionary* and "ray" in Eric Partridge, *Origins: A Short Etymological Dictionary of Modern English* (New York: Macmillan, 1966), 552. See Tom Lewis, *Empire of the Air*, PBS documentary, September 1991, KAET television.

40. As Susan Douglas writes: "News of [Marconi's] achievements inspired awe and wonder; to people still getting accustomed to the telegraph, cables, and the telephone, signaling without any wires—without any tangible connection at all—was fantastic and incredible." Douglas, "Amateur Operators and American Broadcasting: Shaping the Future of Radio," in *Imagining Tomorrow*, ed. Joseph J. Corn (Cambridge, MA: MIT Press, 1987), 37.

41. Ibid., 55.

42. According to Czitrom, the relation between the wireless and ether stirred anew the old dream of "universal communication, a dream expressed in religious terms by the early commentator on the telegraph. But with the wireless, the discussion drew its metaphors and vocabulary from physics and biology." Czitrom, *Media and the American Mind*, 65.

43. As Czitrom notes, radio advertising later capitalized on this sense of isolation: "In its mature state, radio succeeded not in fulfilling the utopian visions first aroused by wireless technology, but in appropriating those urges for advertising interests. The ideology of consumption reiterated a basic message that what one had was never enough. It created a need for products largely through an appeal to a mythical past—lost community, lost intimacy, lost self-assurance." Czitrom, *Media and the American Mind*, 88.

CHAPTER 2

Parts of this chapter were first published in Edward Scheer, ed., *100 Years of Cruelty* (Sydney: Power Institute, 2000).

1. Marinetti, for instance, wrote "War, the worlds only Hygiene" (1915), a poem in which the sounds of combat are depicted by syllables, vowels, and consonants.

2. Luigi Russolo, *The Art of Noises* (New York: Pendragon Press, 1986).

3. Ferdinand Ouellette, *Edgard Varèse*, trans. Derek Coltman (New York: Orion, 1968), 52.

4. Newspaper interview, *New York Telegraph*, March 1916, cited in Jonathan W. Bernard, *The Music of Edgard Varèse* (New Haven: Yale University Press, 1987), 1.

5. "When these sound masses collide the phenomena of penetration or repulsion will seem to occur. Certain transmutations taking place on certain planes will seem to be projected onto other planes, moving at different speeds and at different angles. . . . In the moving masses you would be conscious of their transmutations when they pass over different layers, when they penetrate certain opacities, or are dilated in certain rarefactions." Ibid.

6. Varèse, "The Liberation of Sound," in *Contemporary Composers on Contemporary Music*, ed. Elliott Schwartz and Barney Childs (New York: Holt, Rinehart and Winston, 1967), 197.

7. Antonin Artaud, "There Is No More Firmament," in *Collected Works,* vol. 2, trans. Victor Corti (London: Calder and Boyars, 1971), 92.

8. Ibid., 13: 258–59. Cited in Stephen Barber, *Antonin Artaud: Blows and Bombs* (Boston: Faber and Faber, 1993), 151.

9. Antonin Artaud, *The Theatre and Its Double,* 89.

10. Ibid., 7, 24, 30, 37, 38. "I am well aware that words too have possibilities as sound, different ways of being projected into space, which are called *intonations*" (89). Ibid., 91. For Artaud, "to make metaphysics out of spoken language" is to make "the language express what it does not ordinarily express . . . to reveal its possibilities for producing physical shock; to divide and distribute it actively in space; to deal with intonations in an absolutely concrete manner, restoring their power to shatter as well as really to manifest something . . . and finally, to consider language in the form of *Incantation*." *Theatre and Its Double,* 46.

11. Ibid., 47.

12. Ibid., 51, 51–52. For in-depth analyses of Artaud's glossolalia, see Allen Weiss, "Radio Death and the Devil," in *Wireless Imagination: Sound, Radio and the Avant-Garde,* ed. Douglas Kahn and Gregory Whitehead (Cambridge, MA: MIT Press, 1993), 269–308.

13. Henri Bergson, *Matter and Memory* (New York: Zone Books, 1988), 208.

14. "It is useless to give precise reasons for this contagious delirium. It would be like trying to find reasons why our nervous system after a certain period responds to the vibrations of the subtlest music and is eventually somehow modified by them in a lasting way. First of all we must recognize that the theatre, like the plague, is a delirium and is communicative." Artaud, *Theatre and Its Double,* 26.

15. Ibid., 111. "The sonorisation is constant: sounds, noises, cries are chosen first for their vibratory quality, then for what they represent." Ibid., 81.

16. For in-text quotes, see 31, 42, 91, 81, 49, 81. Suggesting traces of techno-spiritualism and neo-Platonism, Artaud adds: "The composition, the creation, instead of being made in the brain of an author, will be made in nature itself, in real space, and the final result will be as strict and as calculated as that of any written work whatsoever, with an immense objective richness as well" (111).

17. Olivia Mattis, "Edgard Varèse and the Visual Arts" (PhD diss., Stanford University, 1992), 178. Other in-text quotes in this paragraph are from Artaud, *Theatre and Its Double,* 89.

18. Artaud, *Collected Works,* 2:79.

19. Mattis, "Edgard Varèse," 180–81, from the typescript scenario of *The One-All-Alone, A Miracle,* in Louise Varèse, *Varèse: A Looking Glass Diary* (New York, W. W. Norton, 1972), 260. According to Mattis, this scenario "was fundamentally autobiographical, and so it is of utmost importance that one of the protagonist's facets was pure light, while the antagonist's tool is an arrow that becomes a beam of light when fused with the light of The-One-All-Alone. Here is alchemy at work in Varèse's oeuvre: the transmutation of man into Godhead from whose body 'rays of light radiate in all directions.'"

20. Ibid. Mattis cites Antony Beaumont, who notes that "the figure which Varèse called the Astronomer can be traced back to Busoni's Faust." See Antony Beaumont, *Busoni: The Composer* (Bloomington: Indiana University Press, 1985), 35–36n49.

21. From "Statements by Edgard Varèse," assembled by Louise Varèse, in *Soundings* no. 10 (1976).

22. Mattis, "Edgard Varèse and the Visual Arts," 178.

23. Varèse, Santa Fe lecture, 23 August 1936. Cited in Mattis, "Edgard Varèse and the Visual Arts," 8.

24. Cited in Henry Miller, "With Edgar Varèse in the Gobi Desert," in *The Air-Conditioned Nightmare* (New York: New Directions, 1945), 163–78.

25. Artaud, *Theatre and Its Double,* 78.

26. Ibid., 135.

27. Artaud, *Collected Works,* 2: 79.

28. Ibid., 2: 79, 80.

29. Mattis, "Edgard Varèse and the Visual Arts," 128. Artaud, *Theatre and Its Double,* 89.

30. Artaud, *Collected Works,* 2: 83, 87, 88, 90.

31. Artaud, "There Is No More Firmament," 92.

32. Olivia Mattis, "Varèse's Multimedia Conception of Déserts," *Musical Quarterly* 76, no. 4 (Winter 1992): 570. Mattis notes that these messages from Sirius were to be represented by that "otherworldly" electronic instrument, the ondes Martenot.

33. Artaud, *Theatre and Its Double,* 102.

34. This coincidence was not lost on composers and critics of electronic music. For critic Herbert Russcoll, it is no surprise that the era of electronic music should coincide with the atomic age: "Is [electronic music] this 'controlled chaos,' this 'wild clumps of jagged sound, blips, squeals,' 'tonal ruptures and utter boredom,' 'this aural nightmare,' to use the words of various outraged critics, really here to stay? It seems to me that the answer is emphatically yes. . . . The aural nightmare, the abyss of total freedom, is upon us, just like the Bomb. Neither is simply going to go away." Russcol, *The Liberation of Sound* (New York: Prentice-Hall, 1972), xxiv.

35. Artaud, *Collected Works,* 13: 258–59. Cited in Barber, *Antonin Artaud: Blows and Bombs,* 151.

36. For instance, the trademarks of early phonographs featured logos such as the "angel with a pen" of "the Recording Angel" fame, produced as part of the Victor Monarch series in 1903–04. See Daniel Marty, *The Illustrated History of Phonographs* (New York: Dorsett Press, 1981), 42, 46.

37. Cited in W. K. Dickson and Antonia Dickson, *The Life and Inventions of Thomas Alva Edison* (London: Chatto and Windus, 1894), 135.

38. Greusel continues: "Musical voices drawn magically from choirs invisible peopling the eternal silences, the dead spaces of the air, where all these harmonic wonders had all unknown been slumbering, ready at the right moment to come forth at the master's sign, conjured into life by Edison's magical command of mind over matter." Hubert Greusel, *Hours with Famous Americans: Thomas A. Edison* (n.p.: John Hubert Greusel, 1913), 84–87.

39. Cited in Count Du Moncel, *The Telephone* (New York: Harper & Brothers, 1879), 255 (emphasis mine).

40. Cited in Rick Altman, "The Technology of the Voice," *Iris* 3, no. 1 (1985), 11.

41. Michael Benedikt, *Cyberspace: First Steps* (Cambridge, MA: MIT Press, 1991), 3. The full quote reads: "Cyberspace: The realm of pure information, filling like a lake, siphoning the jangle of messages transfiguring the physical world, decontaminating the natural and urban landscapes, saving them . . . [from all the] corruptions attendant to the process of moving information attached to things—from paper to brains—across, over, and under the vast and bumpy surface of the earth rather than letting it fly free in the soft hail of electrons that is cyberspace." Further, "What poured forth from every radio was the very sound of life itself. . . . Here are McLuhan's acoustically structured global villages . . . and support for the notion that the electronic media . . . provide a medium not unlike the air itself—surrounding, permeating, cycling, invisible, without memory or the demand of it, conciliating otherwise disparate and perhaps antagonistic individuals and regional cultures." Ibid., 10.

42. Ibid., 45, 49. See in particular Jeffrey Sconce, *Haunted Media: Electronic Presence from Telegraphy to Television* (Durham: Duke University Press, 2000), 59–91.

43. Robert A. Morton, "The Amateur Wireless Operator," cited in Susan Douglas, *Inventing American Broadcasting, 1899–1922* (Baltimore: John Hopkins University Press, 1987), 51.

44. However, as Shaun Moores and Lesley Johnson have noted, the acceptance of the radio within the home was not automatic. Initially the "set" had to be arduously tuned and, lacking a loudspeaker, could be heard by only one person at a time. It was with the modernization of the home, the switch from battery operated to electronically powered radio, with the introduction of the "home current," and the ideological dominance of the nuclear family that radio began to be thought of as a "product" like other household items, or as a piece of furniture with aesthetic and comforting properties. Shaun Moores, "'The Box on the Dresser': Memories of Early Radio and Everyday Life," in *Media Culture and Society*, 10, no. 1 (1988). See also Lesley Johnson, "Radio and Everyday Life: The Early Years of Broadcasting in Australia, 1922–45," in *Media Culture and Society* 3, no. 2 (1981): 12; and Douglas, *Inventing American Broadcasting*, 307.

45. As Carolyn Marvin writes: "[The] fantasia of expanded experience could be entertained within the steadily contracting circle of the physical, emotional, intellectual and moral fireside, [and] cultural difference itself could be regarded as illusory." Marvin, *When Old Technologies Were New*, 200.

46. Rudolph Arnheim, *Radio* (1936; repr. New York: Da Capo Press, 1972), 27–29.

47. Marshall McLuhan, *Understanding Media* (New York: Signet, 1964), 264.

48. Bachelard continues: "Radio is a total realization of the human psyche; it must find the times and the means of making all psychisms communicate in a philosophy of rest." Gaston Bachelard, "Reverie and Radio," in *The Right to Dream* (New York: Orion, 1971), 188–190.

49. Compare to McLuhan: "All those gestural qualities that the printed page strips from language come back in the dark and on the radio." McLuhan, *Understanding Media*, 264.

50. Bachelard, "Reverie and Radio," 188–91.

51. Walter Ong, *Orality and Literacy* (New York: Methuen, 1982), 136.

52. According to Eric Leed, during the nineteenth century the machine was no longer thought of as uniform but as composed of opposing parts that had to be balanced to transform raw energy into "work." At the same time, the psyche was conceived as a structure of entities in conflict that also had to be balanced: "the 'darker drives' had to be controlled, however their policing turned the subject into a piece of clockwork, a cog in the wheel." Eric Leed, "'Voice' and 'Print': Master Symbols in the History of Communication," in *The Myths of Information,* ed. Kathleen Woodward (Madison, WI: Coda Press, 1980), 41–61.

53. See Oliver Grau, *Virtual Art: From Illusion to Immersion,* trans. Gloria Custance, (Cambridge, MA: MIT Press, 2003), 284.

54. According to Leed, secondary orality "was fashioned by a literate intelligentsia, by men who had one foot in the republic of letters, the other in the 'popular' tradition. In the oral folk they created their own counter mentality, their own negation, and rooted this negation in the very medium of communication used by the people. Sound was regarded as redolent of affect, less distancing, rational and superficial than vision." Leed, "'Voice' and 'Print,'" 47.

55. Walter Ong, *The Presence of the Word* (Minneapolis: University of Minnesota Press, 1967), 88.

56. Ibid., 91.

57. Linking the age of electronic communication to the genital stage in Freud's chronology of the subject's psychosexual development (oral, anal, and genital) Ong notes their correspondences: both direct the individual out of himself or herself, both "orient man and woman toward each other and both toward children, who in turn [are] themselves orientated towards others." Ibid., 100. Freud's "mature subject" now represents a technologically oriented humanity; as the mature individual has transcended the oral and anal phases, arriving at the telos of his/her development in the genital phase, so too the culture has moved into the heightened sociality, the "genitality" of the electronic stage.

58. Ibid., 101.

59. Ibid., 18, 303, 200, 323.

60. Walter Ong, *Orality and Literacy,* 74.

61. Ibid., 32, 74.

62. Ong, for instance, holds greater faith in sound than vision, since it "unifies" and "harmonizes" rather than dissects, while "hearing can register interiority without violating it": And as this interiority is grounded "in the experience of one's own body," it is also an ideal for knowledge, "ultimately not a fractioning but a unifying phenomenon, a striving for harmony." The material conditions of aurality thus become congruent with and immanent to the psychosocial conditions of consciousness. Ong, *The Presence of the Word,* 72.

63. Count Du Moncel, *The Telephone,* 145–46.

64. Arnheim, *Radio,* 78 (emphasis mine): "[The close-up] is the normal position and historically the first. . . . This is a fact which fundamentally affects the whole attitude and conduct of wireless transmission." Ibid., 71.

65. "Anyone who does not possess this unaffected personal way of speaking suited to the short distance between the source of sound and the microphone, and to the isolated position of the individual listener, will never have his text understood . . . and anyone whose profession is speaking on the wireless will not be able to sin unpunished against the fundamental stipulations of wireless." Ibid., 74.

66. Arnheim, *Radio,* 76.

67. "The technology of sound contributes to the overall effect of dissimulating its very existence. . . . From 'normal' hearing to the 'facts of nature,' every device is used to make directional miking appear ineluctable—and with it a notion of sound perception assuming that sound sources can be split into important and incidental components." Altman, "The Technology of the Voice," 13, 15.

68. Don Ihde, *Listening and Voice: A Phenomenology of Sound* (Athens: Ohio University Press, 1976), 175.

CHAPTER 3

Parts of this and the following chapter were first published in Arthur Kroker and Marilouise Kroker, eds., *Critical Digital Studies: A Reader* (Toronto: University of Toronto Press, 2008).

1. Pierre Schaeffer, *Solfège de l'objet Sonore* (1967), trans. Livia Bellagamba, 2nd ed. (Paris: Institut National de l'Audiovisuel and Groupe de Recherches Musicales, 1998), 11.

2. Ibid., 11, 53, 11, 13.

3. Ibid., 53. "Musical criteria should be extended, subject, of course, to their being confined to what we shall call suitable objects" (55).

4. "The slightest variations of the playing speed or intensity will create new objects as different from the initial objects from the same sounding body can be." Ibid., 57.

5. Ibid., 59.

6. These quotations are from an excerpt in Pierre Schaeffer, *Traité des objets musicaux* (Paris: Éditions du Seuil, 1966) in *Audio Culture: Readings in Modern Music,* ed. Christoph Cox and Daniel Warner, trans. Daniel W. Smith (New York: Continuum, 2004), 76–81. "It becomes a vehicle, a 'sonorous support or an acoustic signal'" (78).

7. "Coming from a world in which we are able to intervene, the sonorous object is nonetheless contained *entirely in our perceptive consciousness.*" Ibid., 79.

8. *Solfège de l'objet Sonore,* 65. The final note in *Solfège* acknowledges the limitations of his theory, describing it as a tool—less adequate than language— for describing and labeling sonic objects. Ibid., 83.

9. Ibid., 57, 65, 81 (emphasis mine).

10. See Douglas Kahn, *Noise, Water, Meat* (Cambridge, MA: MIT Press, 1999), 111.

11. *Solfège de l'objet Sonore,* 15, 11.

12. Daniel Charles and John Cage, *For The Birds* (London: Marion Boyars, 1981), 74.

13. See my chapter "The Ear that Would Hear Sounds in Themselves," in *Wireless Imagination: Sound, Radio and the Avant-Garde*, ed. Douglas Kahn and Gregory Whitehead (Cambridge, MA: MIT Press, 1992).

14. Richard Kostelanetz, *Conversing with Cage* (New York: Limelight, 1988), 51.

15. See John Cage, "Forerunners of Modern Music" (1949), in *Silence* (Middletown, CT: Wesleyan University Press, 1961), 63n2.

16. *For The Birds*, 74.

17. *Trio* (1936) used skin and wood, *First Construction (in Metal)* (1937).

18. Cage, cited in *John Cage*, ed. Richard Kostelanetz (New York: Praeger, 1968), 127.

19. *For the Birds*, 74.

20. *Conversing with Cage*, 158.

21. John Cage, "Imaginary Landscape No. 1," in *25-Year Retrospective Concert of the Music of John Cage* (New York: Peters Edition, 1959) (Charles Amarkanian, sleeve notes cited).

22. *For the Birds*, 169.

23. *Silence*, 135.

24. As Kathleen Woodward writes: "Just as the technology of electronics transfigures the material world, so the metaphor of the invisible transforms our way of interpreting the world. . . . Thus for Cage electronics is much more than a concrete phenomenon. It is also a metaphor for what is also invisible and thus spiritual. . . . It is the wireless technology which can turn man towards his original harmony with nature." See Woodward's essay "Art and Technics: John Cage, Electronics and World Improvement," in *The Myths of Information*, ed. Kathleen Woodward (Madison, WI: Coda Press, 1980), 175, 184.

25. For Cage, the "field" acts as a potent metaphor for the continuum of life: "The difference is specifically the difference, say, between an ashtray and the whole room. Ashtray can be seen as having beginning and end. . . . But when you begin to experience the whole room—not object, but many things—then, where is the beginning? Where is the middle? . . . it is clearly a question not of an object but rather of a process." Cage, interview by Roger Reynolds, *25-Year Retrospective Concert*, 50.

26. Cage, *Silence*, 125. Similarly, in 1952, when Cage first worked with magnetic tape, he discovered that sounds could occupy determinate spaces, measured in lengths of tape that corresponded to specific durations, and this correspondence was interpreted as a technologically motivated synesthesia: "in the late forties and early fifties it became clear that there's a physical correspondence between time and space. And music is not isolated from painting because one second of sound is so many inches on tape. . . . Therefore, I began doing graphic notations." *Conversing with Cage*, 184.

27. *For the Birds*, 169.

28. Ibid. See "Lecture on Nothing" and "Lecture on Something" in *Silence*. "Unimpededness" appears again in "Juilliard Lecture," given in 1952 at the Juilliard School of Music, as an index of the development of Cage's ideas. Later, in conversation with Daniel Charles, Cage adds: "I like to think that each thing has not only its own life but also its center, and that its center is always the very center of the Universe . . . there are a plurality of centers, a

multiplicity of centers. And they are all interpenetrating and, as Zen would add, non-obstructing. . . . There must be nothing between the things which you have separated so they wouldn't obstruct each other. Well, that *nothing* is what permits all things to exist." *For the Birds,* 91.

29. *For the Birds,* 150. In 1945 his profound questioning of the purpose of writing music led him from a once only encounter with psychoanalysis to study the philosophy and classical music of India with Gita Sarabhai, and Zen Buddhism with Dr. Daisetz Suzuki.

30. The full passage runs as follows: "Before studying music, men are men and sounds are sounds. While studying music things aren't clear. After studying music men are men and sounds are sounds. That is to say: at the beginning one can hear a sound and tell immediately that it isn't a human being or something to look at. . . . While studying music things get a little confused. Sounds are no longer just sounds but are letters: A, B, C, D, E, F, G. . . . If a sound is unfortunate enough not to have a letter or if it seems too complex, it is tossed out of the system. [In composition] the sounds themselves are no longer of consequence; what 'count' are their relationships. [In understanding a musical idea] you think that a sound is not something to hear but rather something to look at. In the case of a musical feeling . . . [one] has to confuse himself to the final extent that the composer did and imagine that sounds are not sounds at all but are Beethoven and that men are not men but are sounds, . . . this is simply not the case. A man is a man and a sound is a sound. To realize this . . . one has to stop all the thinking that separates music from living. . . . Sounds are sounds and men are men, but now our feet are a little off the ground." Cage, "Juilliard Lecture," in *A Year from Monday* (Middletown, CT: Wesleyan University Press, 1967), 96.

31. *John Cage,* 84. *Silence,* 14.

32. *Silence,* 62.

33. His pieces using magnetic tape were: *Williams Mix* (1953), discussed in n. 36; *Fontana Mix* (1958), a score for the production of any number of tracks, performers, and instruments, and through the use of transparencies, indeterminate of its performance. Its tape realization was also used in subsequent works such as *Water Walk* and *Sounds of Venice* (1959) and *WBAI* (1960)—an auxiliary score for performance with lectures, parts of *Concert for Piano and Orchestra,* recordings and radios. Cage's works for radio included: *Imaginary Landscape No. 5* (1952), a score composed using the *I Ching* for the recording and mixing of various elements of forty-two phonograph records on tape; *Speech* (1955), an indeterminate score for five radios and news-reader; *Radio Music* (1956), for one to eight performers each at one radio; and *Music Walk* (1958). During this period Cage also composed for piano, prepared piano, toy piano, orchestra, voice, percussion instruments, and "any sound-producing means" (*Variations* 1–7). See *25-Year Retrospective Concert,* 33–41.

34. *Silence,* 9.

35. Despite the laborious editing involved in *Williams Mix,* magnetic tape nonetheless represented for Cage the continuum of life that tonality and thinking had divided into discrete units. This led him to "renounce the need to control durations at all" and from there to indeterminate works such as *Music For Piano* and *Variations,* which began anywhere and lasted any length of time,

were no longer "preconceived objects . . . [but] occasions for experience" (*Silence*, 31).

36. Cage, cited in *John Cage*, 127. *Williams Mix* (duration, approx. four minutes) took about one year to make, was produced on eight tracks, involved the recording of six hundred sounds divided into six categories (city, country, electronic, wind produced, manually produced, and small sounds requiring amplification), which are further catalogued in terms of pitch, timbre, and amplitude, and organized according to the *I Ching* (*John Cage*, 111, and *25-Year Retrospective Concert* [sleeve notes]). Speaking in a later publication, Cage expresses excitement over the fact that, with tape, time is measurable in inches, one second being equivalent to fifteen inches of tape. As a result, sound's temporal ephemerality is no longer a problem. With sound so easily manipulated, it is understandable that Cage would begin to consider it an object that could be "entered" in some way or another. See *Conversing with Cage*, 164.

37. *Conversing with Cage*, 70. See James Pritchett, "The Music of John Cage," in *Music in the Twentieth Century*, ed. Arnold Whittall (Cambridge: Cambridge University Press, 1993), 148.

38. *Silence*, 8. This happened fairly quickly. In "Lecture on Nothing" (1950), the argumentation remains dualistic—aligning the ear with noises and the possibility of hearing "fresh" sounds that had not yet been "intellectualized," and the mind with the suffocation or "wearing out" of sound ("Thinking had worn them out," Cage, *Silence*, 117); but in "Lecture on Something" (published in 1959 but "prepared some years earlier"), Cage positions the creativity of unthinking perception, the ear, within the now problematic (post-anechoic-chamber) notion of silence.

39. *Conversing with Cage*, 52; *Silence*, 80.

40. Cage, *A Year from Monday*, 123–24.

41. Ibid.

42. Arthur Schopenhauer, *The World as Will and Representation*, trans. E. F. J. Payne (New York: Dover Publications, 1969), 261.

43. According to Carl Dahlhaus, the paradigm of absolute music is music without words, free from "extramusical" associations, self-sufficient and providing a direct avenue to the true, the beautiful and the divine, whose contemplation alone allows one to escape the bounds of mortality in moments of self-forgetting. Carl Dahlhaus, *The Idea of Absolute Music*, trans. Roger Lustig (Chicago: University of Chicago Press, 1989), 7. Ernst Kurth characterizes the situation well: "Hence we can see clearly that the word 'absolute' has a double meaning. In a technical sense it means dissolved from song; in a spiritual sense, dissolved from man." Ernst Kurth, *Bruckner* (Berlin: Hesse, 1925), 1: 258; cited in Dahlhaus, *The Idea of Absolute Music*, 40.

44. Cage, *Silence*, 136. Thus, the opening comments of "Lecture on Something" (129) are devoted to: "The unity of opposites: 'something and nothing are not opposed to each other but need each other to keep on going.' The problem of language: 'it is difficult to talk when you have something to say precisely because of the words which keep making us say in the way which words need to stick to and not in the Way which we need for living.' The development of a negative ontology: 'it is of the utmost importance not to make a thing but

rather to make nothing. . . . Done by making something which then goes in and reminds us of nothing.' "

 45. *For The Birds,* 151.

 46. *For the Birds,* 173. Cage, *A Year from Monday,* 33. Pritchett notes these influences: "Just as McLuhan had served as a guide and inspiration for Cage's use of electronic technology, so Buckminster Fuller served as a source for his new approach to simultaneity and multi-media." According to Pritchett, Cage's primary way of using the new electronic technology in the 1960s was by treating composition as the design of electronic sound systems. This view of composition is in keeping with McLuhan's image of the artist as the prophet of the new media, the designer of environments that can enlighten the audience about the effects of the new technologies. McLuhan, by declaring that the new media are not passive wrappings but active processes, reinforced Cage's position that a composer, by designing an electro-acoustic system, is also creating a compositional process. Cage, again in agreement with McLuhan, felt that it was totally irrelevant what sounds were to pass through these technological systems. Any interaction with the system would be conditioned by the system itself, and it was the nature of the transaction between participant and system that was musically and socially of greatest importance. Pritchett, "The Music of John Cage," 152, 156.

 47. Cited in Daniel Charles, "Music and Technology Today," in *Art and Technology,* ed. Rene Berger and Lloyd Eby (New York: Paragon House, 1986), 93.

 48. *John Cage,* 167.

 49. For more on 9 *Evenings,* E.A.T. and its projects, see my *And Then It Was Now* Web publication at the Daniel Langlois Foundation for Art, Science and Technology, www.foundation-langlois.org.

 50. "Remarks by John Cage," Daniel Langlois Foundation, Montreal, E.A.T. archives (EAT C1–27/3; 27).

 51. "What Really Happened at the Armory," Daniel Langlois Foundation, Montreal, E.A.T. archives (EAT C1 –27/3; 15).

 52. Klüver, "Interface: Artist/Engineer," Daniel Langlois Foundation, Montreal, E.A.T. archives, E.A.T. proceedings, No. 121, April 1967 (EAT C2).

 53. Daniel Langlois Foundation, Montreal, E.A.T. archives, audio tape, part 3, EAT 9E, SIDE B, Ref no. 37.

 54. Ibid.

 55. "Remarks by John Cage," Daniel Langlois Foundation, Montreal, E.A.T. archives (EAT C1–27/3; 27). (Press release for 9 *Evenings,* by Nina Kaiden/ Elanor Howard, 29 Sept. 1966, quoting Cage "Remarks by John Cage.")

 56. As Cage would in later years. Pritchett recalls a performance of Solo 35 of the Song Books, "where Cage had the performers raise the black flag of Anarchy while proclaiming that 'the best form of government is no government at all.' " Pritchett, "The Music of John Cage," 192.

 57. Chiding Rauschenberg for "using the ideas of Cage in a half-baked manner," Antin observed that "while interactive art is not inherently or necessarily technological, . . . with the exception of certain open-structured transient works they have almost always appeared in the context of technological art.

For the art world it would seem that interaction with people is seen not as inter-action at all but as manipulation, that is, technology." David Antin, "Art and the Corporations," *Art News* 70, no. 5 (1971): 22–56.

58. R. Murray Schafer, *The Tuning of the World* (Philadelphia: University of Pennsylvania Press, 1980), 5.

59. "For some time I have also believed that the general acoustic environment of a society can be read as an indicator of social conditions which produce it and may tell us as much about the trending and evolution of that society." Ibid., 7, 11.

60. Ibid., 10. For instance, particular forests deliver a unique wind-sound, and snow, which absorbs sound, will affect the spectrum of sounds that can be heard.

61. Schafer notes, for instance, the onomatopoeia associated with words for animal sounds (dogs *bark,* cats *purr,* pigs *squeal,* etc.) and the frequent use of bird song in the music of Olivier Messiaen.

62. Schafer, *The Tuning of the World,* 11, 71, 78.

63. Schafer, "The Music of the Environment," in Cox and Warner, *Audio Culture,* 33.

64. Jonathan Sterne, *The Audible Past: Cultural Origins of Sound Reproduction* (Durham: Duke University Press, 2003), 21.

65. Rick Altman, "Introduction: Sound's Dark Corners," in *Sound Theory/ Sound Practice,* ed. Altman (New York: Routledge, 1992), 29.

66. Alan Williams, "Is Sound Recording Like a Language?" *Yale French Studies* 60 (1980): 51–56.

67. Martin Heidegger, *Early Greek Thinking* (New York: Harper & Row, 1975), 82, 56.

68. Heidegger, "Science and Reflection," in *The Question Concerning Technology,* trans. William Lovitt (New York: Harper Torchbooks, 1977), 159–63. See also Heidegger, *Being and Time* (New York: Harper & Row, 1962), 99.

69. See Eric Partridge, *Origins: A Short Etymological Dictionary of Modern English* (New York: Macmillan, 1966), 701. For additional etymological read-ings, see *Displacement: Derrida and After,* ed. Mark Krupnick (Bloomington: Indiana University Press, 1987), 22.

70. Don Ihde, *Consequences of Phenomenology* (New York: State University of New York Press, 1986), 33.

71. Christian Metz, "Aural Objects," *Yale French Studies* 60 (1980): 24–32. See also Altman, "The Material Heterogeneity of Recorded Sound," in *Sound Theory/Sound Practice,* 15–31.

72. That it seems natural to qualify a sound with its source is, for Metz, an example of Western culture's tendency toward a "primitive substantialism," reflected in the "object-centredness" of language. Metz, "Aural Objects," 27.

73. Michel Chion, *Audio Vision: Sound on Screen,* trans. Claudia Gorbman (New York: Columbia University Press, 1990), 143. Relatedly, for Walter Murch, the audio recording and tape recorder immediately challenged sound's secondary status, giving it an organic, independent life: "Recording magically lifted the shadow away from the object and stood on its own, giving it a mirac-ulous and sometimes frightening substantiality. . . . The tape recorder extended this magic by an order of magnitude, . . . it was now not only possible but easy to change the original sequence of the recorded sounds, speed them up, slow them down, play them backward. Once the shadow of sound had learned to

dance, we found ourselves not only able to listen to the sounds themselves, liberated from their original causal connection . . . but also,—in cinema—to reassociate those sounds with images of objects or situations that were different . . . than the objects or situations that gave birth to them in the first place." In an amazing community of coincidence, Murch introduced Michel Chion's theory of film sound by relating his own early experiences with his prized "Revere" recorder. Dubbing from radio and then cutting and splicing the magnetic tape to assemble new sound collages, Murch was astounded one night to hear similar creations broadcast on the radio: "It turned out to be the *Premier Panorama de Musique Concrète,* by Pierre Schaeffer and Pierre Henry, and the incomplete tape of it became a sort of Bible of Sound for me. Or rather, a Rosetta stone, because the vibrations chiselled into its iron oxide were the mysteriously significant and powerful hieroglyphs of a language that I did not yet understand but whose voice nonetheless spoke to me compellingly. . . . I mention this fragment of autobiography because apparently Michel Chion came to his interest in film sound through a similar sequence of events . . . having Schaeffer and Henry as mentors." Walter Murch, introduction to Chion, *Audio Vision,* xvi.

74. Chion, cited in Jean-Jacques Nattiez, *Music and Discourse,* trans. Carolyn Abbate (Princeton: Princeton University Press, 1990), 100–101 (my emphasis).

75. Chion, *Audio Vision: Sound on Screen,* 29.

76. Ibid.

77. Jonathan Sterne, *The Audible Past: Cultural Origins of Sound Reproduction* (Durham: Duke University Press, 2003), 50.

78. Ibid., 51, 21.

79. Ibid., 65, 21.

80. Ibid., 83.

81. See, for instance, Kahn, *Noise, Water, Meat,* 16.

82. Hubert Greusel, *Hours with Famous Americans: Thomas A. Edison* (n.p.: Greusel, 1913), 85.

83. Varèse cited in Schuller, "Gunther Conversation with Steuermann," *Perspectives of New Music* 3, no. 1 (1964): xxiv.

84. Schafer, *The Tuning of the World,* 259.

85. Cited in Cox, *Audio Culture,* 35.

CHAPTER 4

1. "What we 'first' hear is never noises or complexes of sounds, but the creaking wagon." Martin Heidegger, *Being and Time,* trans. John Macquarrie and Edward Robinson (New York: Harper & Row, 1962), 207. On death, Heidegger writes: "Dasein's primordial Being towards its potentiality-for-Being is Being-towards-death—that is to say, towards that distinctive possibility of Dasein which we have already characterized. . . . We have conceived death existentially as . . . the possibility of the *im*possibility of existence—that is to say, as the utter nullity of Dasein. . . . When the call of conscience is understood, lostness in the 'they' is revealed. Resoluteness brings Dasein back to its ownmost potentiality-for-Being-its-Self. When one has an understanding of

Being-towards-death—towards death as one's *ownmost* possibility—one's potentiality becomes authentic and wholly transparent." Ibid., 354.

2. See Heidegger, *Early Greek Thinking,* trans. David Farrell Krell and Frank A. Capuzzi (New York: Harper & Row, 1975), 16–30. Heidegger shows the dependence of the concept of Being as thought in metaphysics on notions of substance, extension, duration—in short, presence. See Heidegger, *Being and Time,* 18, 19.

3. See David Michael Levin, "Decline and Fall: Ocularcentrism in Heidegger's Reading of the History of Metaphysics," in *Modernity and the Hegemony of Vision,* ed. David Michael Levin (Berkeley and Los Angeles: University of California Press, 1993), 195.

4. Heidegger, *Being and Time,* 176. Note that the translators have chosen "mood": cf. Heidegger: "What we indicate ontologically by the term 'state-of-mind' is ontically the most familiar and everyday sort of thing; our mood, our Being-attuned" (ibid., 172). Throughout the text these terms seem to be interchangeable.

5. Leo Spitzer, *Classical and Christian Ideas of World Harmony* (Baltimore: Johns Hopkins Press, 1963), 3–5. Spitzer adds that these translations fail to express "the unity of feelings experienced by man face to face with his environment (a landscape, nature, one's fellow man)" and the idea of a harmonious unity "between the factual (objective) and the subjective (psychological)." Ibid.

6. Ibid., 7. Giorgio Agamben writes: "The term *Stimmung,* which we usually translate as 'mood,' should be stripped here of all psychological significance and restored to its etymological connection with the *Stimme,* and above all, to its originary acoustico-musical dimension; *Stimmung* appears in the German language like a translation of the Latin *concentus,* of the Greek *armonia.*" Agamben, *Language and Death: The Place of Negativity,* trans. Karen E. Pinkus with Michael Hardt, Theory and History of Literature, ed. Wlad Godzich and Jochen Schulte-Sasse, vol. 78 (Minneapolis: University of Minnesota Press, 1991), 55–56.

7. "[While] any cognitive determining has its existential-ontological Constitution in the state-of-mind of Being-in-the-world; [attunement] is not to be confused with attempting to surrender science ontically to 'feeling.'" Heidegger, *Being and Time,* 177.

8. "[Which] corresponds to the 'clearedness' which we took as characterizing the disclosedness of the 'there.'" Ibid., 187.

9. Ibid., 187 (quotes cited in paragraph above are from pp. 175, 187, 189, 187).

10. "By showing how all sight is grounded primarily in understanding . . . we have deprived pure intuition of its priority, which corresponds noetically to the present-at-hand in traditional ontology." Ibid., 187.

11. For Heidegger, meaning is the "'upon-which' of a projection in terms of which something becomes intelligible as something"; it is the "disclosedness which belongs to understanding." It is therefore not a property of things themselves, but a property, "an existentiale," of *Dasein.* Ibid., 193.

12. "All entities whose kind of Being is of a character other than Dasein's must be conceived as unmeaning, essentially devoid of any meaning at all." Ibid., 175, 176, 193.

13. Ibid., 201, 207.

14. Aristotle, *De Anima, in the Version of William of Moerbeke and the Commentary of Thomas Aquinas,* trans. Kenelm Foster and Silvester Humphries (New Haven: Yale University Press, 1954), par. 466–77.

15. Heidegger, *Being and Time,* 207.

16. Heidegger introduces the metaphor of silence as a feature or analogue of "reticence"—a self-imposed distancing and quietude that *Dasein* adopts in order to engage in genuine discourse with others: "As a mode of discoursing reticence [silence] Articulates the intelligibility of Dasein in so primordial a manner that it gives rise to a potentiality-for-hearing which is genuine, and to a Being-with-one-another which is transparent." Ibid., 208.

17. "Dasein hears the call not through words, for 'the call asserts nothing, gives no information about world-events. . . . [Rather] conscience discourses solely and constantly in the mode of keeping silent.'" Ibid., 233, 314, 318.

18. Ibid., 321. The full quote reads: "The discourse of the conscience never comes to utterance. Only in keeping silent does the conscience call; that is to say, the call comes from the soundlessness of uncanniness, and the Dasein which summons is called back into the stillness of itself, and called back as something that is to become still" (343). *Dasein* hears the call not through words, for "the call asserts nothing, gives no information about world-events" (318). Nor does it, like the anechoic, ontotheological interior voice of metaphysics, "try to set going a 'soliloquy' in the Self . . . [rather] Conscience discourses solely and constantly in the mode of keeping silent" (318).

19. Heidegger, *What Is Called Thinking* (New York: Harper & Row, 1968), 130.

20. Ibid.

21. *Early Greek Thinking,* 64–65 (my emphasis).

22. Philip Wheelwright, *Heraclitus* (New York: Atheneum, 1964), fragment 54.

23. As both the revealer of truth and the vehicle for discourse, the logos is in direct opposition to *Gerede,* which masks the true being of entities as in-the-world or "ready-to-hand" with the illusion of their separateness from the subject, their "present-at-handness." The voices of the masses, which for Heidegger are inseparable from rumor, gossip, hearsay, thus stand in direct opposition to the ancient Greek conception of truth as *alethia*—the presencing of what is present that the logos unconceals.

24. *Early Greek Thinking,* 64. As he writes in *Early Greek Thinking:* "Heraclitus begins the saying with a rejection of hearing as nothing but the passion of the ears. But this rejection is founded on a reference to proper hearing. . . . If there is to be proper hearing, mortals must have already heard the 'logos' with an attention [*Gehor*] which implies nothing less than their belonging to the logos" (67).

25. Ibid., 67. Heidegger, *What Is Called Thinking,* 206.

26. *What Is Called Thinking,* 206.

27. M. M. Gehrke and Rudolph Arnheim, "The End of the Private Sphere," in Anton Kaes, Martin Jay, and Edward Dimendberg, eds., *The Weimar Republic Sourcebook* (1928; repr. Berkeley: University of California Press, 1994), 614.

28. See Avital Ronell, *The Telephone Book* (Lincoln: University of Nebraska Press, 1989), 37 and passim.

29. Jacques Derrida, *Of Grammatology* (Baltimore: Johns Hopkins University Press, 1974), 12.

30. The system of "hearing (understanding)-oneself-speak through the phonic substance—which *presents itself* as the nonexterior, nonmundane, therefore nonempirical or noncontingent signifier—has necessarily dominated the history of the world during an entire epoch, [producing] the difference between the worldly and the non-worldly, the outside and the inside, ideality and nonideality, universal and nonuniversal, transcendental and empirical etc." *Of Grammatology*, 7.

31. In his essay "Différance," *Speech and Phenomena* (Evanston: Northwestern University Press, 1973), 133, Derrida writes: "The inaudible opens the two present phonemes to hearing, as they present themselves. If, then, there is no purely phonetic writing, it is because there is no purely phonetic *phōnē*, the difference that brings out phonemes and lets them be heard and understood [*entendre*] itself remains inaudible." In *Positions*, Derrida states: "Spacing designates nothing, nothing that is, no presence at a distance, it is an index of an irreducible exterior, at the same time the index of a movement, of a displacement which indicates an irreducible alterity." Derrida, *Positions*, trans. Alan Bass (Chicago: University of Chicago Press, 1981), 81.

32. Derrida writes: "It is as if the Western concept of language (in terms of what . . . attaches it *in general* to phonematic or glossematic production, to language, to voice, to hearing, to sound and breath, to speech) were revealed today as the guise or disguise of a primary writing" (*Of Grammatology*, 7). Derrida's "writing" is inscription as technics/technology. It includes such things as cinematography, choreography, music, etc. and describes "not only the system of notation secondarily connected with these activities but the essence and the content of these activities themselves." Ibid., 9.

33. Derrida, "Différance," 130, 134.

34. *Of Grammatology*, 12 (my emphasis). Jean-François Lyotard, "Voices of a Voice," *Discourse* 14.1 (Winter 1991–92): 129.

35. With the gerundive *legendus* (cf. "legend") we have: needing to be read, a life-story, a narrative. Lyotard, "Voices of a Voice," 130. Note that Lyotard cautions against creating an opposition between *phōnē* and *lexis:* "Two temptations need to be avoided here: that of hypostatizing the *phōnē* into the metaphysical entity of an 'absolutely other,' and the temptation to bring the *phōnē* back to articulation by means of a rhetoric of the passions, by a treatise on tropes . . . where affect is thought out of principle as if it belonged to articulated signification." Ibid., 133.

36. See Eric Partridge, *Origins*, 346–47.

37. Derrida, *Speech and Phenomena*, 154.

38. Agamben continues: "Metaphysics is always already grammatology and this is *fundamentology* in the sense that the gramma (or the Voice) functions as the negative ontological foundation." *Language and Death*, 39 (emphasis in original).

39. Derrida, *Cinders*, trans. Ned Lukacher (Lincoln: University of Nebraska Press, 1987).

40. Ibid., 22, 23.

41. Ibid., 23, 39.

42. Because of the extreme density of this very poetic work I will not attempt a reading here or a full elaboration of the term "cinder." The text, being overtly concerned with the Holocaust, is laden with esoteric metaphors and difficult not to read in the light of Jewish mysticism. However, the parallels with Derrida's concept of "trace" and "space(ing)" are many, such that the cinder occupies the chiasmus between the signifier and signified, allowing signification to occur; and it also occupies the absence within the "is" (being) of the "there is," which cannot be named but only unconcealed through the cinder (cf. Heidegger). For instance, Derrida writes that: "The name 'cinder' figures, and because there is no cinder here, not here (nothing to touch, no color, no body, only words), but above all because these words, which through the name are supposed to name not the word but the thing, they are what names one thing in place of another, metonymy when the cinder is separated, one thing while figuring another from which nothing figurable remains." Ibid., 71.

43. *Cinders*, 42–46. The "setting of the sun" is a reference to Heidegger's expression *Abend-land*, literally "the evening-land," which refers to the "monstrous transformation" of metaphysics whereby Being came to be thought in terms of presence. "Do we stand in the very twilight of the most monstrous transformation our planet has ever undergone, the twilight of that epoch in which earth itself hangs suspended? . . . Are we to strike off on a journey to this historic region of earth's evening? . . . Will this land of evening overwhelm Occident and Orient alike?" Heidegger, *Early Greek Thinking*, 17. The term *Abend-land* also appears in Jewish mysticism as the destiny of the Jewish people to face "the land of the setting sun." The message is the word, cinder or trace thought of as a movement that makes audible the voices in a text, and on a deeper register, calls forth the voices hidden and unpronounceable in the mystery of "the house of Being," also a metaphor for the cinder. *In Early Greek Thinking*, Heidegger refers to language as "the house of Being"; in *Cinders*, Derrida states: "There are cinders only insofar as there is the hearth, the fireplace, some fire or place. Cinder as the house of being" (41).

44. *Cinders*, 42–46, 37. The sentence is an "almost" silent monument to the "all burning" flux reminiscent of Heraclitus, symbolized by the fire that dies and rekindles, as its sound becomes audible and then fades away. It is also a "monument," a visual sign, of the Being constituted by the "there" reminiscent of the "being-there" of Heidegger's *Dasein*: "the cinder is the being [*l'etre*], rather, that there is—this is the name of the being that . . . remains beyond everything that is, . . . remains unpronounceable in order to make saying possible although it is nothing." Ibid., 73.

45. While space doesn't permit me to pursue this issue here, it is interesting to note that in *Cinders* the tape recorder appears at the archetypical moment of the dissemination of this "almost" silence; the moment when Word becomes flesh, when the thundering heavens are given to utterance: "For that it is necessary that you take the word into your mouth, when you breathe, whence the cinder comes to the vocable, which disappears from sight, like burning semen. . . . Cinder is only a word. But what a word for consuming itself all the way to its

support (the tape-recorded voice or strip of paper, self-destruction of the impossible emission once the order is given), to the point of assimilating it without apparent remainder? And you can also receive semen through the ear" (*Cinders*, 71–73). The instrument of the soul is, in Derrida's phonographically inspired science of writing, an analogue to the tape recorder or amplification device; it transmits and makes audible a message from elsewhere. Derrida's insertion of a tape recorder at the site of the Immaculate Conception provides a different angle on the notion of transmission (emission) outlined in chapter 1. The Word, I had suggested, was transmitted via a "speaking tube," a proto-telephone, and this transmission set it within a particular metaphoric circuitry that includes notions of *pneuma*, electricity, mysticism, mass communications, and disembodiment. In the context of phonography and inscription, it appeared that the voice exits the flows of transmission and inclines instead toward *lexis;* articulated, arbitrary, and sign-like speech. Within this schematic it would seem that the phonographed or inscribed Word ceases to travel the transmissive trope of Christianity and rests instead in the inscriptive trope of Judaism, and Derrida's tape recorder suggests this reading.

46. *Cinders,* 25.

47. Ibid., 22.

48. Derrida, "Ulysses Gramophone," in *Acts of Literature* (New York: Routledge, 1992), 267.

49. Ibid., 256, 269–70. The "tetragram" is one of the fourfolded letters spelling God's name in the Kabbalistic tradition, a tradition that, according to Scholem, is "both historically and metaphysically . . . a masculine doctrine, made for men and by men." The phone call, containing the "yes" of *différance* and the cinder, put through by women operators in the feminine sphere of rumor and "hear/say," nonetheless "takes place" in the vicinity of the silent cipher of the tetragram, site of an originary "emission." In other words, rumor occurs within the sphere of a silent deciphering, onto-theology itself, *différance* is not only already within the sphere of technology, be it writing, phonography or telephony, it is absolutely contained by it. Gershom G. Scholem, *Major Trends in Jewish Mysticism* (New York: Schocken Books, 1941), 37.

50. "Ulysses Gramophone," 269 (my emphasis).

51. Ibid., 291, 294. With the letter/signal/tongue of fire Derrida includes the "speaking tube" present in depictions of the Immaculate Conception, describing it as a "navel cord," which "interrogates the consubstantiality of father and son . . . close to a scripturo-telephonic and Judaeo-Hellenic scene" (290).

52. Mladen Dolar points to the importance of Derrida's work, that is, the voice, and situates it within metaphysics, a home or base to which Derrida consistently adheres: "If the entire metaphysical tradition 'spontaneously' and consistently espoused the priority of the voice, it was because the voice always presented the privileged point of auto-affection, self-transparency, the hold in the presence. . . . The Derridean turn has . . . turned the voice into a preeminent object of philosophical inquiry, demonstrating its complicity with the principal metaphysical preoccupations. If metaphysics . . . is carried by the propensity to disavow the part of alterity, the trace of the other, to hold onto some ultimate signified against the disruptive play of differences, to maintain the purity of the origin against supplementarity, then it can do so only by clinging to the privilege

of the voice as a source of an originary self presence. The divide between the interior and the exterior, the model of all other metaphysical divides, derives from here. . . . This illusion—the illusion par excellence—is thus constitutive of interiority and ultimately consciousness, the self and autonomy." Mladen Dolar, *A Voice and Nothing More,* Short Circuits, ed. Slavoj Žižek. (Cambridge, MA: MIT Press, 2006), 37–39.

53. "Ulysses Gramophone," 272. Compare with Heidegger: "the call asserts nothing, gives no information about world-events." *Being and Time,* 318. Nor does it, like the anechoic, onto-theological interior voice of Western metaphysics, "try to set going a 'soliloquy' in the Self . . . [rather] Conscience discourses solely and constantly in the mode of keeping silent." *Being and Time,* 318.

54. Derrida, *Speech and Phenomena,* 154.

55. Derrida and Bernard Stiegler, *Echographies of Television,* trans. J. Bajorek (Oxford: Polity Press, 2002), 38.

56. "These machines have always been there, they always are there, even when we wrote by hand, even during the so-called live conversation. And yet, the greatest compatibility, the greatest co-ordination, the most vivid of possible affinities seems to be asserting itself, today, between what appears to be the most alive, the most *live,* with a reference to this present and this moment anywhere anytime." Ibid., 38, 40. The following quotes in this section are from *Echographies of Television,* 108, 134, 108, 111, 109–11.

57. Agamben, *Language and Death,* 59.

58. See especially Heidegger, *The Question Concerning Technology,* trans. William Lovitt (New York: Harper Torchbooks, 1977).

59. As Kroker writes: "Heidegger was apocalyptic in his prognosis of what is disclosed by the coming to presence of completed technicity: '*objectification*' as the result of technological willing; the '*harvesting*' of humans, animals, plants, and earth into a passive '*standing reserve*' waiting to be mobilized by the technical apparatus; the liquidation of subjectivity itself into an '*objectless object*' streamed by the information matrix; the appearance of '*profound boredom*' as the essential attunement of the epoch of the post-human; the potentially fatal transition of the language of destining to the last '*enframing*'—post-human culture under the ascendant sign of 'completed nihilism.'" Arthur Kroker, *The Will to Technology and the Culture of Nihilism: Heidegger, Nietzsche, and Marx,* Digital Futures, ed. Arthur Kroker and Marilouise Kroker (Toronto: University of Toronto Press, 2004), 25.

60. Ibid., 45.

CHAPTER 5

1. Davies continues: "There have been certain elements recurring in my work for more than 30 years—an iconography of elements, a vocabulary, including boulders, flowing streams, and trees, often bare-branched as in a Canadian winter. One of the earliest paintings I ever made, in 1974, was an ink wash of semi-transparent boulders in a stream with luminous particles flowing between them, and more than 20 years later, in both *Osmose* and *Ephémère,* there are transparent boulders, flowing streams, bare-branched trees, etc. And here at

Reverie I am among these same elements, except now they are actual, physical—note that I say 'among' as in 'enveloped by,' so even my language is the same—and when I am engaged in moving 3 ton boulders from one place to another on the land—I see this as placing still points among the flux—my creative process is very similar to how I worked with my former team in VR, except that now I am working with a team of traditional stone-cutters, farmers and foresters as well as technicians. My conceptualization of this land is almost as if it's this huge sphere all around us—I don't see a distinction between what I'm creating *with* the land—in terms of making paths through it, pruning or planting trees, surveying its salamanders and so on—and the schematic drawings I'm making of it—I see it as all part of the same creative process. But most importantly, in 'being among' what's here on the land, I have an overwhelming sense of being among all these *life flows* . . . so when I say that for me this land is an immersive environment that's what I mean—I'm not talking about technology and that has to be very clear." Interview with Davies, 15 October 2006, *Reverie,* southern Quebec.

2. This aesthetic impetus is very much informed by Davies's reading of Heidegger, in particular of his concept of *Gelassenheit,* artistically realized as her attempt to move "beyond habitual seeing and behaving towards the world—conventionally categorized as a collection of separate static objects, all treated as 'standing reserve' for human use—and instead approach life with a sense of wonder and humility for how extraordinary it is to be here, embodied as we are so briefly, among its flux and transformation. . . . this is what *Ephémère* was pointing towards." Interview, *Reverie.*

3. Cited in Andrew Treadwell, "Virtual Transcendence" [online] (Oxford: Oxford Brookes University, Jan. 2002), last accessed June 2006.

4. Ibid.

5. Ibid.

6. Tomkins notes with some irony that the Pepsi public relations department—at a loss to find a name for the *Pavilion*—was considering the word "Sensosphere" until they realized that in Japanese "senso" means war. Calvin Tomkins, "Outside Art," in *Pavilion,* ed. Billy Klüver, Julie Martin, Barbara Rose, Experiments in Art and Technology (New York: E. P. Dutton, 1972), 134.

7. Davies is an example of this, as she was a founding director of the very software company whose technology she was using, yet whose role in the initial shaping of the company was later forgotten.

8. The full list of these are as follows: "(1) Technology directs our attention to the practical rather than to the abstract, . . . to physical rather than intellectual activity. (2) Technology is neutral. It possesses no inherent values, value judgments, teleological direction, or normative goals. It is a tool. (3) Technology separates and defines functions. Understanding and interacting with these functions can take place outside a specific cultural environment or value system. (4) Technology generates activity. The introduction and use of technical products leads to development of skills and involvements and generates work activity. (5) Technology and technical activity promote agreements between individuals. . . . Technology demands and, at the same time provides, accessibility to information. . . . (6) Technology encourages the individual to engage exploratory

intellectual activity, rather than accumulating facts. (7) Technology promotes individualistic behavior." See my Web publication *And Then It Was Now,* Daniel Langlois Foundation.

9. See the Immersence Web site: http://www.immersence.com/ and Char Davies, "Changing Space: Virtual Reality as an Arena of Embodied Being" (1997), in *Multimedia: From Wagner to Virtual Reality* (New York: W. W. Norton, 2001).

10. As Davies elaborates: "It is important to understand that virtual space is not neutral. The origins of the technology associated with it lie deep within the military and western-scientific-industrial-patriarchal complex. . . . As a realm ruled by mind, virtual reality—as conventionally constructed—is the epitome of Cartesian desire, in that it enables the construction of artificial worlds where there is the illusion of total control, where aging mortal flesh is absent, and where, to paraphrase Laurie Anderson, there is no 'dirt.' I believe such desire to escape the confines of the body and the physical world is symptomatic of an almost pathological denial of our embodied embeddedness in the living world. . . . In the virtual environments *Osmose* and *Ephémère*, I have proposed an *alternative* approach to virtual space, intended to resist the cultural trajectory described above." Davies, "Virtual Space," in *SPACE in Science, Art and Society,* ed. François Penz, Gregory Radick, and Robert Howell (Cambridge: Cambridge University Press, 2004) [online, www.immersence.com]. Davies, "Landscapes of Ephemeral Embrace" (PhD diss., University of Plymouth, 2005), 32.

11. "The intent of the breath [and balance] interface wasn't merely about making the graphics change, it was about *facilitating a certain way of being* in that virtual space. It was about deliberately taking use of the hands away. . . . away from domination and control, from doing-this-to-that, and instead shifting the experience from one of *doing* to *being*." Interview with Davies, Montreal, 1996. For a more detailed account, see my article, "Charged Havens," *World Art* 3 (1996): 42–47.

12. As she writes: "I have attempted to use the medium of immersive virtual space to . . . situate the previously externally situated (and disembodied) viewer as an embodied participant *within* the scene: a scene which is no longer merely viewed as a statically-composed and framed two dimensional representation, but which can be visually, aurally and kinesthetically experienced as an animated and bodily-enveloping *place*." Davies, "Landscapes of Ephemeral Embrace," 47.

13. The full argument runs as follows. Interpreting Aristotle, St. Thomas Aquinas decides that the phantasm must be an "image" and that since "vocal impact proceeds from the soul" and "operations proceeding from imagination can be said to be from the soul," then "the principal cause of the production of voice is the soul, using this air, i.e. air inhaled, to force against the windpipe the air within it. Not air, then, is the principal factor in the formation of voice, but the soul, which uses air as its instrument." Now that the proper voice is devoid of unintentional sound ("the cough or the clicking of the tongue"), it bears no traces of the body, representing or "voicing" only the signifying "image." *Aristotle's De Anima, in the Version of William of Moerbeke and the Commentary of Thomas Aquinas,* trans. Kenelm Foster and Silvester Humphries

(New Haven: Yale University Press, 1954), par. 466–77. "We cannot produce voice while inhaling air nor while exhaling it, but only while retaining it." Ibid., Aristotle, par. 478.

14. Centering becomes an essential step in the development of one's "ontological capacity to open oneself to the larger measure of Being and to encounter other beings with equanimity, justice, and a presence that is deeply responsive." For Levin, being "well centered in Being," is at the very root of what he calls "Gelassenheit," that "way of being" in virtue of which, according to Heidegger, we are going to be most favored with a deeper experience of beings, and the presencing of Being as such. David Michael Levin, "The Body's Recollection of Being," cited in Davies, "Landscapes of Ephemeral Embrace," 272.

15. Davies learned this skill when deep sea diving and describes it as a state of hovering rather than being absolutely still—and in my reading I have incorporated this sense of focused, or "poised," stillness.

16. Steve Dietz, "Ten Dreams of Technology," published in *Leonardo*, 35, no. 5 (2002): 509–13. For writer Erik Davis, the paradox *Osmose* presents revolves around the high cost of the technology, its origins in the military-industrial complex, and contradictions involved in "making art at the edge of a gargantuan multinational industry, [which] forces those artists who are even able to get their hands on high-end tools into all sorts of anxious compromises." Erik Davis, *Techgnosis* (New York: Harmony Books, 1998), 247–48.

17. Oliver Grau, *Virtual Art: From Illusion to Immersion,* trans. Gloria Custance, ed. Roger F. Malina (Cambridge, MA: MIT Press, 2003), 200. Grau identifies his concerns through a summary of what he sees as two basic, polarized trends in the reception of *Osmose:* "First, the work promotes a new stage in an intimate, mind-expanding synthesis with technology—this is a comforting argument, an old variant of uncritical faith in machines. Second, *Osmose* confirms the opinion of those who see in the ideology of the natural interface a new level in the history of ideas and images of illusionism, or who dismiss *Osmose* as virtual kitsch. The adherents of virtual reality, who have often reiterated their claim that immersion in virtual reality intensifies their relationship with nature, might ponder the following question: Why the immense technological effort in order to return, after a gigantic detour, to the real? Does not the quest for nature using technical means resemble the plane curve of a hyperbola pretending to be an ellipse?" Ibid., 201.

While there is no doubt that hype has been immensely important in preadvertising the emergence of VR, the ellipse that Grau is referring to may also be a rhetorical construction of his own making. For the total immersion that he suggests is more fictive that actual, and the notion of oneness with nature presumes a correspondence between the technology and the philosophy that motivates Davies, which simply does not exist. As Davies has commented many times, her virtual environments are not intended to illusionistically conjure an alternate space—which is why she constantly refers to VR as a medium like film, or painting, or sculpture.

18. Grau, *Virtual Art,* 202. Further: "Inside the 'omnipresence' of virtuality, any mechanism of knowledge acquisition will be affected and influenced. In virtual environments, a fragile, core element of art comes under threat. . . .

Notwithstanding the longing for 'transcending boundaries' and 'abandoning the self,' the human subject is constituted in the act of distancing. . . . However, being enveloped in a cocoon of images imposes profound limitations on the ability for critical detachment, a decisive hallmark of modern thought that has always played a central role in experience of and reflections on art" (203).

19. Producing perhaps "a voyeuristic, dissecting penetration of representations of objects and bodies." Ibid.

20. "These ephemeral image spaces, which change within fractions of a second, achieve the effect of existing only through a series of computations in real time, 15 to 30 per second. The image is constituted as a spatial effect, via the interposing program and HMD, only on reaching the cerebral cortex thus it leaves its medium in a twofold sense. Recently developed laser scanners can project virtual reality images directly onto the retina; in this case, the category 'image' does not disappear altogether—if the retina will suffice as a medium— but this must surely constitute the most private form of image currently imaginable: an image that is seen only by the observer, who triggers or retrieves it through actions or movements. Moreover, these virtual images will be seen only once by one person before they disappear forever—something that is entirely new in the history of the image." Ibid., 206.

21. Interview with Davies, *Reverie*, April 2006.

22. Coyne continues: "It was perhaps this Heideggerian perspective that Davies was trying to convey, except the re-focusing she was aiming for was on the body and being, rather than more external distractions." Richard Coyne, *Technoromanticism: Digital Narrative, Holism, and the Romance of the Real* (Cambridge, MA: MIT Press, 1999), 159.

23. Margaret Morse, "Aesthetics and Immersion: Reflections on Martin Jay's Essay 'Diving into the Wreck,'" Asthetik-Colloquim vom 27.02. bis 01.03.03 in Berlin, October 2003.

24. Mentioned in conversation with Morse, San Francisco, 1990.

25. Margaret Morse, *Virtualities: Television, Media Art and Cyberculture* (Bloomington: Indiana University Press, 1998), 209.

26. "I remember when I had begun paying close attention to the way I was seeing, without corrected vision, and deliberately attending a party in Toronto without being able to see, that is without wearing my contact lenses. It was rather frightening because it made me very vulnerable. . . . I couldn't operate by any of our normal social cues because I couldn't read people's faces." Interview, *Reverie*.

27. "And I think that made me want to live in that vision . . . I remember the very first painting I made with this 'soft sight' . . . I was visiting a friend in Vancouver and we were just sitting around the kitchen at night and there were two cups on the table and I began painting them without being able to see, and I thought 'You know . . . this is really interesting. Maybe I'm just going to . . .'" Davies, April 2006.

28. Davies emphasizes that she increasingly attempted to go beyond the depiction of recognizable, hard-edged, solid objects so as to represent the luminous space they inhabited, through what she calls her "soft vision": "At one point, I had half glasses made so I could still see the brush-tips on the surface I was painting while looking beyond it with soft vision, which enabled me to see

beyond the particular object as, say, 'only' a cup or a jar with distinct edges, to instead seeing *freshly,* whereby the object itself had disappeared and I was drawing or painting a spatial volume of light . . . a semi-transparent luminous voluminosity or voluminous luminosity." Ibid.

29. "In the late 80s, there was a huge commercial demand for more and more photo-realism in the computer graphics industry—I used to call it 'the hard-edged objects in empty space syndrome.' As someone who had been involved in building a world-leading 3D software company, I was well aware of this 'syndrome' and the various cultural values which it reinforced. This awareness, and the ensuing desire to demonstrate an alternative—based on my previous explorations as a painter, that is, my already established painterly aesthetic of transparency and spatial ambiguity—was key to my approach to VR. I don't think you can simply reduce it to myopic eyesight, but I do believe my *alternative* way of seeing has played a significant part." Ibid.

30. Ibid.

31. Levin, cited in Davies, "Landscapes of Ephemeral Embrace," 88.

32. For instance, Davies writes that by "subverting, redirecting, or even turning [the medium of VR], in Heidegger's sense" she hopes, paradoxically, "to release [the viewer] from the constraints of a technologically-objectifying worldview" while focusing their attention on the sensations of their "own embodied being, thereby providing an opportunity for wonderment at the very mystery of the presencing of Being itself." "Landscapes of Ephemeral Embrace," 25.

33. Maurice Merleau-Ponty, *The Visible and the Invisible,* ed. Claude Lefort (Evanston: Northwestern University Press, 1968), 32.

34. Ibid., 31, 33, 36–37. Merleau-Ponty describes this "high altitude" thinking as being at one with the "eagle eye" of the Hegelian subject: "I no longer think I see with my eyes things exterior to myself who sees them: they are exterior only to my body, not to my thought, which soars over it as well as them." Ibid., 30.

35. Ibid., 37, 97, 122. Also note that the "seeing apparatus" Merleau-Ponty refers to is "presupposed in every notion of an object" (37). Merleau-Ponty describes language as "a world and a being to the second power, since it does not speak in a vacuum, since it speaks of being and of the world and therefore redoubles their enigma instead of dissipating it." Ibid., 96. "If I express this experience . . . I immediately make the experience itself impossible: for in the measure that the thing is approached, I cease to be; in the measure that I am, there is no thing, but only a double of it in my 'camera obscura.' The moment my perception is to become pure perception, thing, Being, it is extinguished; the moment it lights up, already I am no longer the thing" (122).

36. See Ibid., 120.

37. Ibid., 38, 130. "This red is what it is only by connecting up from its place with other reds about it." Ibid., 132.

38. Ibid., 132 (emphasis mine). The full quote runs as follows: "a naked colour, and in general a visible, is not a chunk of absolutely hard, indivisible being, offered all naked to a vision which could be only total or null, but is rather a sort of straits between exterior horizons ever gaping open . . . an ephemeral modulation of this world . . . not a thing but a possibility, a latency, and a flesh of things."

39. Ibid., 134. This movement occurs as an exchange between the subject and the world: "By means of this mediation, . . . this chiasm, there is not simply a for-Oneself for-the-other antithesis, [rather there is] an exchange between me and the world, between the phenomenal body and the 'objective' body, between the perceiving and the perceived." In severing this primary linkage to the world, philosophy conceives of Being as an "*objective* presence" a "visual picture." "The specular image, memory, resemblance: fundamental structures (resemblance between the thing and the thing seen). For they are structures immediately derived from the body-world relation—the reflections resemble the reflected =the vision commences in the things. . . . Show that the whole expression and conceptualization of the mind is derived from these structures: for example, *reflection*." Ibid., 215, 258, 271. The last quote in this paragraph is from p. 114.

40. Ibid., 143. See editor's note (3).

41. The full quote is as follows: "[Circularity] . . . exists in other fields; it is even incomparably more agile there and capable of weaving relations between bodies that this time will not only enlarge, but will pass definitively beyond the circle of the visible." Ibid., 144.

42. Ibid., 144, 145, 211. "Speech, . . . goes unto Being as a whole. We dream of systems of equivalencies, and indeed they do function. But their logic, like the logic of a phonematic system, is summed up in one whole tuft . . . they are all animated with one sole movement, they each and all are one sole vortex, one sole contraction of Being." Ibid., 211.

43. Heraclitus, fragment 110, cited in Wheelwright, *Heraclitus,* 90. For instance, when Heraclitus speaks of "the warm becoming cool," he invokes a conceptual schema in which what we would normally consider a quality (e.g., warmth) is given object status ("the warm"), which can nonetheless change its identity: the warm *becomes* cool. See Wheelwright, *Heraclitus,* 33.

44. Heraclitus, fragment 43, cited in Wheelwright, *Heraclitus,* 58. "Soul" provides an originary movement, but this movement involves both the ascent of vaporization and the decent of condensation and therefore cannot be interpreted in terms of the telos of spiritual ascension characterizing Christian and later Idealist thought. Ibid., 43, 62.

45. As Davies writes in "Virtual Space": "When visual acuity is decreased, one also becomes more aware of sound: and sound, as an all-encompassing flux which penetrates the boundary of the skin, further erodes the distinctions between inside and outside. Sound, like soft vision, also returns us to what I have come to call the 'presence of the present.' In this perceptual state, rather than being mentally focused on the future and thus inattentive, even absent, to the present, one becomes acutely aware of one's own embodied presence inhabiting space, in relation to a myriad of other presences as well." "Virtual Space" [online, www.immersence.com].

46. Brian Massumi, *Parables of the Virtual* (Durham, NC: Duke University Press, 2002).

47. "With our use of gaze, it was more a sense of approaching slowly and becoming *near*—while maintaining a certain tactful proximity—this involves a kind of *Gelassenheit*—which is very different from staring to make something happen, which is more conventional—whether it's using hand, gaze or voice—

do this to make that happen. . . . I was interested in enabling an experience whereby the particular element, such as the seed, when gazed upon and slowly approached, would respond by opening, by revealing itself. . . ." Davies, "Virtual Space" [online, www.immersence.com].

48. As Serres puts it: "The condition of being a receiver, a subject, an observer, is, precisely, that he make less noise than the noise transmitted by the object observed. If he gives off more noise, it obliterates the object, covers it or hides it. . . . Cognition is subtraction of the noise received and of the noise made by the subject." Michel Serres, *Genesis*, trans. Genevieve James and James Nielson, Studies in Literature and Science (Ann Arbor: University of Michigan Press, 1995), 61.

49. "To be able to change the quality or timbre of sounds at times to be exterior or interior, . . . maybe the sound of breathing (a very powerful aural sensation when one is diving). The heartbeat sound could be linked to the speed of the immersant through the work, and a myriad of other heartbeats of the other entities in the world, all different pulsations of life flowing." E-mail correspondence between Davies and Bidlack, 1996.

50. Rick Bidlack identified the sounds in *Ephémère* as belonging to four major categories: viola sounds producing tonal sounds from various manipulations of the strings (bowing, plucking, spiccato, tremolo, etc.) and percussive, timbral sounds from the body of the instrument; animal sounds; nonpitched noises; pure sine wave tones and white noise. All of these sounds were then digitally manipulated: through changing their speed and pitch; editing each sound's initial attack—which, in digital audio, carries the major portion of the sound identity; shifting the amplitude or volume of the sound, using filters, adding reverberation, and finally using sound spatialization, a process that simulates the position of a sound in three-dimensional space. Sounds are subcategorized into assemblages that act according to particular behaviors triggered by the visual scenes and their durations. Bidlack gives the example of the scene of a falling tree in the virtual forest: "if the immersant stares long enough at one of the many trees, a ghostly image of a tree falling will appear. This tree falls for three seconds . . . the fall is accompanied by a sound—any of seven sounds, actually—which have all been carefully chosen to convey a general impression of a tree falling in the woods." Bidlack, "The Sound World of *Ephémère*," appendix to Davies, "Landscapes of Ephemeral Embrace," 11.

51. Ibid.

52. Mark Hansen, *Bodies in Code: Interfaces with Digital Media* (New York: Routledge, 2006), 125.

53. Ibid., 111.

54. Ibid.

55. Hans Jonas, *The Phenomenon of Life: Toward a Philosophical Biology* (Evanston, Illinois: Northwestern University Press, 1966), 137–38. Jonas continues: "These more temporal senses therefore never achieve for their object that detachment of its *modus essendi* from their own, for example of persistent existence from the transitory event of sense—affection, which sight at any moment offers in the presentation of a complete visual field."

56. Ibid., 148–49.

57. Ibid., 153.

58. Ibid., 154.

59. Ibid., 137. "The gain is the concept of objectivity, of the thing as it is in itself as distinct from the thing as it affects me, and from this distinction arises the whole idea of *theoria* and theoretical truth" (147). The remaining quotes are from pages 137, 147.

60. "The object-reference of sounds is not provided by the sounds as such, and it transcends the performance of mere hearing. All indications of existents, of enduring things beyond the sound-events themselves, are extraneous to their own nature." Ibid., 137. "Since this synthesis deals with succeeding data and is spread over the length of their procession, so that at the presence of any one element of the series all the others are either no more or not yet, and the present one must disappear for the next one to appear, the synthesis itself is a temporal process achieved with the help of memory. Through it and certain anticipations, the whole sequence, though at each moment only atomically realized in one of its elements, is bound together into one comprehensive unity of experience" (138).

61. Ibid., 139.

62. Ibid. By this we can infer that Jonas is ascribing to sound what is true for noise and analyzing noise in terms of its phenomenality, rather than its sociality.

63. Ibid.

64. Ibid., 139.

65. Ibid., 141.

66. Ibid., 146.

67. Hansen, *Bodies in Code*, 118.

68. Ibid., 123.

69. Hansen, "Embodying Virtual Reality: Touch and Self-Movement in the Work of Char Davies," in *Critical Matrix: The Princeton Journal of Women, Gender and Culture* 12 (2001): 112–47.

70. Hansen, *Bodies in Code*, 123.

71. Ibid.

72. Davies, Interview with author, San Francisco, 2006.

73. "If I can prove my thesis (that the digital image demarcates an embodied processing of information), I will, in effect, have proven it for the more embodied registers (e.g., touch and hearing) as well." Hansen, introduction, *New Philosophy for New Media* (Cambridge, MA: MIT Press, 2004), 12.

74. Further, the "reality conferring experience of touch" is based, in Jonas's analysis at least, on grasping a material object with intentional force. Yet Davies's work cannot be associated with either this experience or this force, since both are far from her aesthetic intention. Furthermore, Jonas's notion of force is materially circumscribed—it excludes the force of sound, for instance, a force that happens to be more virtual and more immersive than that of a material object.

75. Whereas the standard premise of VR is that only the user makes a choice, *Ephémère* allows the immersant to float up or sink downward among its various realms and simultaneously sweeps the immersant along in a predefined temporal narrative that necessitates surrender, a giving up of control. *Ephémère* was a further step beyond *Osmose* in this respect and an attempt to move beyond the latter's realism.

76. It is fair to say that audio technologies generally attenuate certain frequencies while amplifying others, in order to reduce "noise" and produce the greatest "fidelity" to the desired (imagined) source. In terms of noise, what is filtered out is often the "background" sounds that would interfere with the listener's focus— a process that occurs "naturally," without the aid of technology, but is enhanced through such technology.

77. Hansen, *New Philosophy For New Media,* p. 146. Proximity is important here because, in contrast to the stereoscopic image, Hansen argues that in VR environments: "an intuition of the space of the body takes the place of the intuition of an extended, geometric space. . . . the VR interface mediates an absolute survey of nothing other than the space of the body itself—that paradoxical being which is neither object nor absolute subjectivity" (177).

78. Ibid., 146.

79. Arthur Kroker, *The Will to Technology and the Culture of Nihilism: Heidegger, Nietzsche, and Marx,* Digital Futures, ed. Arthur Kroker and Marilouise Kroker (Toronto: University of Toronto Press, 2004), 64, my emphasis.

80. Timothy Morton, *Ecology without Nature* (Cambridge, MA: Harvard University Press, 2007), 77.

81. Ibid., 42.

CHAPTER 6

1. For example, a "typical" sound shape is sketched for an instrument, and only its "attack" (generally occurring in the initial part of the sound shape's curve) is sampled and repeated or "looped"—in theory, the attack is what makes the instrument recognizable as a violin, or a tuba.

2. Brenda Laurel, *Computers as Theatre* (Reading, MA: Addison-Wesley, 1993), 125.

3. As Rick Bidlack, who with Dorota Blaszczak designed the sound environment for Char Davies's *Osmose* and *Ephémère* (discussed in the previous chapter), describes: "Typically, these sound sources are attached to graphical objects in the virtual space; as the user navigates through the space, the location of these objects, and hence the direction of the virtual sound sources, change relative to the user's point of view. At a higher level, an interface has been designed which allows the creator of the virtual space to specify the behavior of specific sound objects in the space, as well as to create a responsive and dynamically changing aesthetic sonic environment as the user interacts with the space." Rick Bidlack, Dorota Blaszczak, and Gary Kendall, "An Implementation of a 3D Binaural Audio System within an Integrated Virtual Reality Environment," unpublished paper, Banff Centre for the Arts, 1993.

4. As Durand Begault writes: "You could describe the sound of a reverberate environment by showing a direct sound and its 'early reflections' (the first bounces of the sound off the walls) coming towards you. Then you calculate the early reflections' angle of incidence to a listener and you apply head-related transfer functions to the delayed sound as well as to the direct sound. Then we simulate dense reverberation, which basically is many, many reflections, by using exponentially decaying white noise with different distributions, and the

result is spatial reverberation." Durand R. Begault, "The Virtual Reality of 3-D Sound," in *Cyberarts,* ed. Linda Jacobson (San Francisco: Miller Freeman, 1992), 83.

5. Ibid.

6. Scott Foster describes the process in reference to the Convolvotron, a three-dimensional audio system that he helped develop for NASA-Ames, which is used primarily for virtual reality systems: "When you wear the headphones and peer into the stereoscopic display in a Convolvotron set-up, the system's headposition tracker lets you look around and move through a simulated environment, with the sounds adjusting accordingly. We can adjust the sounds' reflections and even the positions of the simulated walls at any time through the computer system, based on an IBM PC/AT. The head-related transfer function essentially represents a measurement of the transfer characteristics of sounds from points in space to the eardrums of a listener. This measurement takes into account the effects on the sound of the head, pinna, shoulders, nose, paunch, and other body parts." Scott Foster, "The Convolvotron Concept," in *Cyberarts,* 93.

7. Begault, "The Virtual Reality of 3-D Sound," Ibid., 84–85.

8. See Steve Aukstakalnis and David Blatner, *Silicon Mirage: The Art and Science of Virtual Reality* (Berkeley: Peachpit Press, 1992), 28, 102.

9. Laurel, *Computers As Theatre,* 207.

10. John Belton, "Technology and Aesthetics of Film Sound," in *Film Sound: Theory and Practice,* ed. Elizabeth Weiss and John Belton (New York: Columbia University Press, 1985), 66.

11. Linda Jacobson, "Sound Enters the Third Dimension," in *Cyberarts,* 78.

12. Anna Munster, *Materializing New Media* (New Hampshire: Dartmouth College Press, 2006), 96.

13. Jaron Lanier, "Life in the Data Cloud," *Mondo 2000* 2 (Summer 1990): 50.

14. Slavoj Žižek, "From Virtual Reality to the Virtualization of Reality," in *Reading Digital Culture,* ed. David Trend (Malden, MA: Blackwell, 2001), 22.

15. Charles and Cage, *For the Birds,* 221.

16. In all the press releases, reviews, and public statements, the *Pavilion* is described less as an artwork than an experience within an immersive environment. The concept of the *Pavilion* as an environment came originally from Robert Whitman, whose suggestion, of course, was very much in keeping with the insistence of many artists at the time that the spectator *participate* in the art process.

17. "That was the turning point," said Bob Breer. "We had knocked ourselves out because we were all visual artists and were unconsciously refusing to change our visual ideas. But, by concentrating on the sound, we could now operate because we were in an area where we didn't have built-in biases." The press release continues: "This channeling of thought led to a main part of the *Pavilion:* the sound loop system in the floor which makes possible the major idea for the *Pavilion*'s environment. In this environment, the visitor can move in the *Pavilion* and create his own sound experiences as he moved." Daniel Langlois Foundation, E.A.T. archives, d9422/2; EAT Box 2:C7, Press Release "Expo 70, 'An Artists View,'" 2–3.

18. Cited in Nino Lindgren, "Into the Collaboration," in *Pavilion,* ed. Billy Klüver, Julie Martin, Barbara Rose, by Experiments in Art and Technology (New York: E. P. Dutton, 1972), 11.

19. Ibid., 61.

20. Gene Youngblood, "The Open Empire," *Studio International* 179, no. 921 (April 1970): 177–78, FDL archives (EAT Box C 23–3 /4; 446).

21. As it happened, the artists bore the weight of this realignment, demonstrated most ironically perhaps by E.A.T.'s move to Automation House (a building originally established to assist workers who had become unemployed through automation) following the massive debt it incurred as a result of its collaboration with Pepsi-Cola. The final days of the *Pavilion* were instructive: while the collaboration between E.A.T. and Pepsi-Cola was beset with funding problems from the start, issues around intellectual property and ownership of equipment motivated the final transformation of the *Pavilion* from an artist-run project into something more "user friendly," managed ultimately by Pepsi. When questions were raised regarding both the funding of the *Pavilion*'s operating budget for the duration of the Fair and ownership of tapes, ideas, and software once Expo closed, the relationship between E.A.T. and Pepsi essentially went into meltdown. The artists left for New York on April 25 after secretly removing all the programming tapes. Alan Pottasch, the president of PepsiCo's Japanese company, immediately substituted tapes borrowed from a Japanese television station.

22. Heimo Ranzenbacher, "The Evolution of Future," *Ars Electronica 96: Mimesis: The Future of Evolution* (Vienna: Springer, 1996), 152.

23. Ibid., 145.

24. Jonathan Cott, *Stockhausen: Conversations with the Composer* (New York: Simon and Schuster, 1973), 37. As he wrote: "The sound that I hear is me. I become the sound, otherwise I'd never hear it. The air that I inhale is me because this air is my life, that's what I am. I'm a machine in so far as I'm ventilating and burning oxygen. . . . The sounds that come into me are me, and the same with all the electric waves and thoughts that come into me" (79).

25. Ibid., 32.

26. For the Scientific Institute for Paranatural Research, see Sommerer and Mignonneau's introduction, in *Art@science*, ed. Christa Sommerer, Laurent Mignonneau (Vienna: Springer, 1998), 18. Louis Bec, "Artificial Life under Tension—A Lesson in Epistemological Fabulation," in *Art@science*, 96.

27. Ibid., 96.

28. Ibid., 93.

29. Sarah Kember, *Cyberfeminism and Artificial Life* (London: Routledge, 2003), 9.

30. This distinction is used by Kevin Kelly, *Out of Control: The New Biology of Machines, Social Systems, and the Economic World* (Reading, MA: Addison-Wesley, 1994). For WELL, see Fred Turner, "Where the Counterculture Met the New Economy," *Technology and Culture* 46 (June 2005): 485–512 (498). Douglas Rushkoff, "It Ain't Eugenics, It's Just Mimetics," *Ars Electronica*, 112.

31. Kevin Kelly, *Out of Control*, 3.

32. "The billion-footed beast of living bugs and weeds, and the aboriginal human cultures which have extracted meaning from this life, are worth protecting, *if for no other reason than for the postmodern metaphors they still have not revealed.*" Ibid., 4 (my emphasis).

33. "Whether we are talking about organisms or economies, surprisingly general laws govern adaptive processes. . . . Technological evolution may be governed by laws similar to those governing prebiotic chemical evolution and adaptive coevolution. The origin of life at a threshold of chemical diversity follows the same logic as a theory of economic takeoff at a threshold of diversity of goods and services. . . . Like coevolutionary systems, economic systems link the selfish activities of more or less myopic agents. Adaptive moves in biological evolution and technological evolution drive avalanches of speciation and extinction. In both cases, as if by an invisible hand, the system may tune itself to the poised edge of chaos where all players fare as well as possible, but ultimately exit the stage. The edge of chaos may even provide a deep new understanding of the logic of democracy." Stuart Kauffman, *At Home in the Universe: The Search for the Laws of Self-Organization* (New York: Oxford University Press, 1995), 27.

34. Ibid., 27, 14, 192.

35. Ibid., 16.

36. Kelly, *Out of Control*, 2.

37. But also, according to Vincent Mosco, their longevity is a sign of an emerging theo/technocracy. Citing Kelly's claim, "the universe is not merely like a computer, it is a computer," is not just extreme, but it shows that "new media convergence may have failed, but there is a 'new convergence' between technology and religion." See Vincent Mosco, *The Digital Sublime* (Cambridge, MA: MIT Press, 2004).

38. In this respect it is interesting to note that Kelly wrote the prologue to *Out of Control* while in residence at *Biosphere 2*, an exemplary site for the passage between the physical and the virtual, the natural and the artificial. Established in Oracle, Arizona, on 26 September 1991, *Biosphere 2* was subtitled "A Laboratory For Global Ecology" and involved the total enclosure of eight "Biospherians" in a tightly sealed glass and steel structure that housed seven miniature ecosystems or "biomes." These resembled and were referred to as an ocean, a desert, a savanna, a rainforest, a marsh, an area of intensive agriculture, and a human habitat. All were designed to be self-regulating and self-sustaining, with water, air, and waste products fully recycled. Over 1,000 sensors monitored the climate, air, soils, and water; mechanical wave action supported the coral reef ecology, and the air circulation and pressure were regulated by two geodesic domes known as the *Biosphere 2* "lungs." As a "living" laboratory, the *Biosphere 2* project also had the advantage of evolutionary speed, moving through earth cycles, as a founding Biospherian, Mark Nelson, put it, "on 'fast forward.' " Mark Nelson in interview with Dyson, April 1992.

39. See the *Telegarden* Web site: http://www.ieor.berkeley.edu/~goldberg/garden/Ars (last accessed Dec. 2008).

40. Cited in Ken Goldberg, "Telegarden," *Ars Electronica*, 298.

41. See *Telegarden* Web site: "Frequently Asked Questions" (FAQ).

42. Margaret McLaughlin, Kerry K. Osborne, and Nicole B. Ellison, "Virtual Community in a Telepresent Environment," in *Virtual Culture*, ed. Steven Jones (Thousand Oaks, CA: Sage Publications, 1997), 146–67.

43. Jon McCormack, "(Re) Designing Nature" talk given at *Artificial Life: Hard/Soft/Wet' symposium.*

44. "I don't believe in the complete liberation of society through technology or that science and technology offer a utopian vision of the world." Jon McCormack, *Impossible Nature: The Art of Jon McCormack* (Melbourne: Australian Centre for the Moving Image, 2004), 6.

45. Ibid., 28, 31, 39. See also Jon Bird's essay "Containing Reality: Epistemological Issues in Generative Art and Science" in the same volume.

46. *Eden:* http://www.csse.monash.edu.au/~jonmc/projects/eden/eden.html (last accessed Nov. 2008).

47. McCormack continues: "The scope of reality is too excessive for any representation, and hence the truths we draw from it, to fully contain. This seems to be forgotten by many who deal with computer simulations, who refer to behaviours and properties exhibited by the simulation as though there is a transparency between what is observed as a drawing on the screen and what is 'real.' . . . But if you look at the serious scientific literature people use those terms as conveniences—when they say something is mating for instance then what they're referring to is really just two computer programs exchanging symbols and they're well aware of that. If evolution is thought of as adaptation to environments that is dictated by the particular environment itself, and if the computer is interpreted as an environment then in that strict sense then, yes, evolution happens, but well so what!" Interview with author, Sydney, 2000.

48. McCormack, *Impossible Nature,* 37.

49. Ibid.

50. Jon Bird, "Containing Reality," 44.

51. McCormack, interview with author.

52. See McCormack, "On the Evolution of Sonic Ecosystems," *Artificial Life Models in Software,* ed. Andrew Adamatzky, Maciej Komosinski (Berlin: Springer, 2005), 227.

53. McCormack continues: "The approach used here has been to measure components of the real environment, incorporating them into that of the virtual one, thus enabling a symbiotic relationship between virtual agents and the artwork's audience, without need for explicit selection of phenotypes that engage in 'interesting' behavior." Ibid., 228.

54. Jon Bird, "Containing Reality," 44.

55. See, for instance, Paul Virilio, *Open Sky,* trans. Julie Rose (London: Verso, 1997), 20.

56. As Sean Cubitt notes, this kind of surveillance benefits consumerism: "The intimate utopia of cybernature is, however, a lure. Its function is the opposite of social stability: it is to create a globally predictable consumer culture." Cubitt, "Supernatural Futures: Theses on Digital Aesthetics," *Future Natural,* ed. George Robertson et al. (New York: Routledge, 1996), 249.

57. This is not only the most economical architecture for computer-based production, but it provides a fairly easy way of monitoring that productivity. See, for instance, Andrew Ross, *Strange Weather* (New York: Verso, 1991), 95.

58. Tom Sherman, "Nature is Perverse Sometimes," *Ars Electronica,* 130–31.

59. Donna Haraway, "A Manifesto for Cyborgs: Science, Technology, and Socialist Feminism in the 1980s," in *Feminism/Postmodernism,* ed. Linda J.

Nicholson (New York: Routledge, 1990), 191, 195. Originally published in *Socialist Review*, 80 (1985).

60. Philip Mirowski, *Machine Dreams: Economics Becomes a Cyborg Science* (Cambridge: Cambridge University Press, 2002), 441.

61. Hayles, *How We Became Posthuman*, 192, 198. Hayles continues: "Relative to the body, embodiment is other and elsewhere, at once excessive and deficient in its infinite variations, particularities, and abnormalities. . . . Experiences of embodiment, far from existing apart from culture, are always already imbricated within it. Yet because embodiment is individually articulated, there is also at least an incipient tension between it and hegemonic cultural constructs. Embodiment is thus inherently destabilizing with respect to the body, for at any time this tension can widen into a perceived disparity" (196).

62. Ibid., 200, 207. "Telephony and radio thus continued to participate in the phenomenology of presence through the simultaneity that they produced and that produced them. By contrast, the phonograph functioned primarily as a technology of inscription, reproducing sound through a rigid disk that allowed neither the interactive spontaneity of telephone nor the ephemerality of radio." Ibid., 208. Hayles elaborates: inscriptive technologies "initiate material changes that can be read as marks. Telegraphy thus counts, it sends structured electronic pulses through a wire (material changes that can be read as marks) and connects these pulses with acoustic sound (or some other analogue signal) associated with marks on paper." Hayles includes the computer, film, video, X-rays, CAT scans: "Even nanotechnology slouched its way toward inscription when scientists arranged molecules to form their company's logo, IBM." N. Katherine Hayles, *Writing Machines* (Cambridge, MA: MIT Press, 2002), 24.

63. Hayles, *How We Became Posthuman*, 211. "Technology is not merely a medium to represent thoughts that already exist but is itself capable of dynamic interactions *producing* the thoughts it describes" (217).

64. Ibid., 3–5. The full quote reads: "First, the posthuman view privileges informational pattern over material instantiation, so that embodiment in a biological substrate is seen as an accident of history rather than an inevitability of life. Second, the posthuman view considers consciousness, regarded as the seat of human identity in the Western tradition . . . as an epiphenomenon, as an evolutionary upstart trying to claim that it is the whole show when in actuality it is only a minor sideshow. Third, the posthuman view thinks of the body as the original prosthesis we all learn to manipulate, so that extending or replacing the body with other prostheses becomes a continuation of a process that began before we were born. Fourth, and most important, by these and other means, the posthuman view configures human being so that it can be seamlessly articulated with intelligent machines. In the posthuman, there are no essential differences or absolute demarcations between bodily existence and computer simulation, cybernetic mechanism and biological organism, robot teleology and human goals. . . . The posthuman subject is an amalgam, a collection of heterogeneous components, a material-informational entity whose boundaries undergo continuous construction and reconstruction . . . To the extent that the posthuman constructs embodiment as the instantiation of thought/information, it continues the liberal tradition rather than disrupts it" (2–3).

65. "Just as the metaphysics of presence required an originary plenitude to articulate a stable self, deconstruction requires a metaphysics of presence to articulate the destabilization of that self." ". . . it is not a question," Hayles continues, "of leaving the body behind but rather extending embodied aware-ness." Ibid., 290. As Hayles writes: "What is lethal is not the posthuman as such but the grafting of the posthuman onto liberal humanist view of the self" (285).

66. Ibid., 196."Normalization can . . . take place with someone's particular experiences of embodiment, converting the heterogeneous flux of perception into a reified stable object. . . . Embodiment never coincides exactly with 'the body,' however that normalized concept is understood" (196).

67. Ibid., 220, 205.

CHAPTER 7

1. Mark Hansen, *Embodying Technesis: Technology beyond Writing* (Ann Arbor: University of Michigan Press, 2000), 57. Further he states: "We must view technology as the product of a never entirely theorizable feedback loop involving such forces as the logic of global capitalism and the cosmological imperative of material complexification—forces that are, in some sense, extra-cultural, extrascientific, and extrahuman. . . . Without existing outside concrete social networks that exert constraints on its development, technology nonethe-less resists cultural and scientific contextualization to the extent that it 'obeys' a (natural or cosmological) imperative" (60). This extra dimension presents us with ethical challenges to intervene in what being evolutionary is to an extent suprahuman as well as "inhuman." Introducing ethics into what has thus far been a purely philosophical investigation, Hansen marshals the very cultural constructs he is attempting to go beyond, implying the possibility of human intervention in and control of a force that is elsewhere.

2. Ibid., 73.

3. Hayles, *How We Became Posthuman* (Chicago: University of Chicago Press, 1999), 5.

4. Timothy Lenoir, introduction to *Configurations* 10 (2002), 375. While it is true, for instance, that the increasing interpretation of data is automated—producing "knowledge" that, as strings of zeros and ones, is unrecognizable to humans, it is also true that perception is always analog and necessarily embod-ied. In this respect Lenoir draws an important distinction between the approaches of Hayles and Hansen with regard to the precultural or exocultural status of technology: "For Hayles, there is no getting outside of discourse. While we may want to recognize technology or material agency as things in themselves outside of discourse, what matters are the interfaces that embed technology in human culture and the (discursive) moves made to erase these processes of inscription. The contrast with the approach that Mark Hansen advocates could not be stronger. Whereas for Hayles the key point is how technology is brought into discourse and what opportunities there are for redirecting that discourse, Hansen has pressed for a radical break with representationalism, and indeed with the linguistic model altogether. He simply cuts the Gordian problematic of

how inscription relates to incorporation, and similarly the relation of theory to practice and of representations to material agency." Ibid., 373.

5. Hansen argues that in VR environments "an intuition of the space of the body takes the place of the intuition of an extended, geometric space. . . . the VR interface mediates an absolute survey of nothing other than the space of the body itself—that paradoxical being which is neither object nor absolute subjectivity." Mark Hansen, *New Philosophy for New Media* (Cambridge, MA: MIT Press, 2005), 177. However, if this is a unique attribute of VR, then why? One could argue that the stereoscope does the same. Indeed, an intuition of the body—an autoaffectivity—can be produced by any number of means.

6. This statement refers to Hansen's critique of Heidegger. See *Embodying Technesis*, 108–9 (trans. Hansen).

7. Hayles, *Writing Machines*, 134.

8. Hayles, *My Mother Was A Computer: Digital Subjects and Literary Texts* (Chicago: University of Chicago Press, 2005), 40, 41, 46.

9. Ibid., 47–48, 51, 55.

10. Richards comments: "[What] caught my interest was that moment in the history of science, where those devices that we take for granted as obsolete now, were just ways our culture tried to reveal what they thought the invisible sphere was doing." Interview with Richards, Ottawa, October 2006.

11. Interview with Richards, 2006.

12. "I was making parallels between how developed we are visually, but all the other senses are beneath our cultural consciousness, and I came across a scientist who was working with proprioceptive illusions, so I went to his lab in Boston to try it myself. . . ." Richards was intrigued by the similarity between the scientists' equipment and VR: both entailed donning a mask—in this context the illusion concerned the whereabouts of one's body rather than the simulation of a space through which the body moves: "So for example, you would close your eyes, shut off your visual sense, and put the mask (and to me this was like VR gear) on, you supposedly can see better, but you're blind, you can't see the world, and it's with this illusion, that you close your eyes and then you vibrate a certain point, you feel your arm in another place, sometimes inside your body. So you could disturb your sense of where your body is, change your body map, and thereby transgress it." Ibid.

13. As she writes: "[*Spectral Bodies*] is concerned with virtual reality technology, which literally reads and writes our bodies. As a whole, [the piece] opens the door on the permeable and flexible mapping of the imaginary body with the material one, pointing to the role of technology as an instrument that intervenes in both the physiological and the imaginary. . . . Technology is treated as instrumenting (if I can use this word), or rendering instrumental our preoccupations and desires in today's culture. As a result, this science fiction is as much a fiction of science as it is a fiction about contemporary subjectivity." Artist statement, www.catherinerichards.com (2006).

14. Interview with Richards, 2006 (my emphasis).

15. Artist statement. See n. 19.

16. As Richards comments: "To throw away the idea of the autonomous identity is also to throw away the idea of what we've understood as privacy and

we're having a lot of difficulty sorting that out. That's the contradiction—you get people saying—we want to have distributed identities, but I still want to be autonomous—I want to be in charge, I want copyright—this is my work—and you can't have it both ways." Interview with Richards, 2006.

17. In this way the constituents of embodiment are altered: some viewers remarked to Richards that it felt as if "something dropped off, something dropped away." Ibid.

18. "I don't use that image at all—I don't even consider it—because being penetrated to me automatically implies that older image of our bodies that we have more of a kind of physical limit—whereas in the field of electro/magnetism I realize I haven't ever thought about it in that way." Ibid.

19. See Richards's Artist Statement, "Engaging the Virtual," Dalhousie Art Gallery, Halifax, 2000, Canada. See also Kim Sawchuck, "Catherine Richards," *Parachute* 89 (1998): 49–50.

20. "In this way the 'virtual environment' becomes material, and our own part in this environment is tangible." Artist Statement, "Engaging the Virtual."

21. Artist statement, www.catherinerichards.com.

22. As Richards says: "There's a combination of fragility, vicariousness and power—in terms of the high voltage. So using glass gives a sense of barely containing that. At the same time you can only see [the gases] because they're contained and there's a transparent field—because I also wanted that feeling that these are forces that we're dealing with but they're usually disguised. We try to domesticate it—so I try to strip that away." Interview with Richards, 2006.

23. "So there are all these combinations of electromagnetics and materials that react to electromagnetics, so that is the material. It's not immaterial—so that's why I insisted on using that—because using the word virtual the way it has been used—it's like using the word disembodied—that fantasy again subscribes to this whole sense that somehow there's something magical and has no physical manifestation, and therefore we can't really engage with it—and it's just not true." Ibid.

24. Conversation notes with author.

25. According to Todd Murphy, "The sensed presence is only one example of a whole class of experiences called visitor experiences, or just visitations (Persinger, 1989) [and] can include visions, smells, tastes, vestibular feelings of falling or rising, parasthetic feelings of tingles, 'buzzes,' or more difficult to describe 'energies' in the body." Todd Murphy, "The Sensed Presence and the Sense of Self," Web article at www.shaktitechnology.com/sp.htm (last accessed Dec. 2008).

26. As writer Jack Hitt commented in *Wired:* "Simplified considerably, the idea goes like so: When the right hemisphere of the brain, the seat of emotion, is stimulated in the cerebral region presumed to control notions of self, and then the left hemisphere, the seat of language, is called upon to make sense of this nonexistent entity, the mind generates a 'sensed presence.'" Jack Hitt, "This Is Your Brain on God," www.wired.com/wired/archive/7.11/persinger.html.

27. This disjunction between the viewer and the exhibit is elaborated in Richards's other piece in *Excitable Tissues,* "Shroud/Chrysalis," and her previous work *The Curiosity Cabinet at the End of the Millennium.*

28. According to co-researcher Todd Murphy, "The Sensed Presence and the Sense of Self."

29. After emerging from Persinger's helmet, writer Jack Hitt, who experienced Persinger's helmet firsthand, wondered if "the throbbing with pulses of electromagnetic fields . . . may be tinkering with our consciousness?" And from this question he made a conceptual leap that, while enormous, seems perfectly reasonable: "Is it a coincidence that this century—known as the age of anxiety, a time rife with various hysterias, the era that gave birth to existentialism—is also when we stepped inside an electromagnetic bubble and decided to live there? We have never quite comprehended that we walk about in a sea of mild electromagnetism just as we do air. It is part of our atmosphere, part of the containing bath our consciousness swims in. Now we are altering it, heightening it, condensing it. The bubble is being increasingly shored up with newer, more complicated fields: computers, pagers, cell phones. Every day, entrepreneurs invent more novel ways to seduce us into staying inside this web. The Internet is well named." Hitt, "This Is Your Brain on God."

30. Cited in Iwan Rhys Morus, *Frankenstein's Children: Electricity, Exhibition, and Experiment in Early-Nineteenth-Century London* (Princeton: Princeton University Press, 1998), 138.

31. Hayles, *How We Became Posthuman,* 284.

32. Interview with Richards, 2006.

CONCLUSION

1. Pierre Schaeffer, *Solfège,* 15.

2. Murray Schafer, cited in Cox, *Audio Culture,* 35.

3. Michel Gaillot, *Multiple Meaning, Techno: An Artistic and Political Laboratory of the Present,* trans. Warren Niesluchowski, ed. Danièle Rivière (Paris: Éditions Dis Voir [1998?]).

4. Ibid., 22. As he elaborates: "Without in any way making it its theme or message, techno, in its loud silence, implies that the old socio-historic figures of meaning no longer make sense, and consequently can no longer fragment or partition the world according to an ethnic or political score that until now has divided it up into separate and opposed identities. The new music, eminently cosmopolitan, will be that of the commons of the world" (28).

5. Ibid., 31.

6. Ibid., 33. See also the passage: "it is now time to accept that what we find so frightening about technics and machines comes only from our lack of being or essence, that is, from our finitude (whose particular technics is the prosthesis)" (38).

7. Ibid., 40, 55, 40.

8. Bussotti, 1949, 27.3.1959. Many thanks to Vincent Bonin, researcher at the Daniel Langlois Foundation, for pointing out this inclusion.

9. Cage says much the same regarding E.A.T. in an interview with Alfon Schilling (Daniel Langlois Foundation, E.A.T. archives).

10. Gilles Deleuze and Felix Guattari, *A Thousand Plateaus* (Minneapolis: University of Minnesota Press, 1987), 11, 266–67.

11. Ibid., 344.

12. Ibid., 343.

13. Ibid., 95.

14. Of interest here is the process by which glissando achieves multiplicity: for it is the machine—the synthesizer—rather than, for instance, the fog horns used by Varèse in *Ionization,* or the variety of microtonal musical instruments, that effects this transformation, or "deterritorialization."

15. Deleuze and Guattari associate being minor (in music or language) with the becoming of everybody, echoing Cage once again: "There is a majoritarian fact but it is the analytic fact of Nobody, as opposed to the becoming-minoritarian of everybody." *A Thousand Plateaus,* 105.

16. "Today there is nothing left to define existence other than this new relation to technics. . . . This interpenetration of man and technics engages our very existence in what is called 'virtual reality,' a new world no longer based on 'being' but as Bernard Stiegler has demonstrated, on the 'possible.'" Gaillot, *Multiple Meaning, Techno,* 66n.58.

17. Ibid., 66.

18. This may account for the "radical material exteriority" that Hansen attributes to technology, but at the same time it produces something of a metaphysical gridlock. It is no coincidence then, that, in the project of theorizing "embodied technologies," new media art has appeared at the site of a reduction—this time not of the materiality or sociality of sound, but of the materiality and sociality of the body, hypostasized as "embodiment." *Embodying Technesis,* 112.

19. Serres, *Genesis,* 61.

References

Adamatzky, Andrew, and Maciej Komosinski, eds. *Artificial Life Models in Software*. Berlin: Springer, 2005.

Agamben, Giorgio. *Language and Death: The Place of Negativity*. Translated by Karen E. Pinkus with Michael Hardt. Theory and History of Literature, edited by Wlad Godzich and Jochen Schulte-Sasse, 78. Minneapolis: University of Minnesota Press, 1991.

Altman, Rick. "Introduction: Sound's Dark Corners" and "The Material Heterogeneity of Recorded Sound." In *Sound Theory/Sound Practice*, edited by Rick Altman, 171–77 and 15–31. New York: Routledge, 1992.

———. "Introduction." *Yale French Studies*, no. 60 (1980): 3–15.

———. "The Technology of the Voice." *Iris* 3, no. 1 (1985): 3–20.

Amarkanian, Charles, sleeve notes to "John Cage, Imaginary Landscape No. 1." In *25-Year Retrospective Concert of the Music of John Cage*. New York: Peters Edition, 1959.

Antin, David. "Art and the Corporations." *Art News* 70, no. 5 (Sept. 1971): 54–55.

Appelbaum, David. *Voice*. Albany: State University of New York Press, 1990.

Aristotle, *De Anima, in the Version of William of Moerbeke and the Commentary of Thomas Aquinas*. Translated by Kenelm Foster and Silvester Humphries. New Haven: Yale University Press, 1954.

Arnheim, Rudolph. *Radio*. New York: Da Capo Press, 1972.

Arnheim, Rudolph, and M. M. Gehrke. "The End of the Private Sphere." In *The Weimar Republic Sourcebook* (1928), edited by Anton Kaes, Martin Jay and Edward Dimendberg, 613–15. Berkeley: University of California Press, 1994.

Artaud, Antonin. *The Theatre and Its Double*. Translated by Mary Caroline Richards. New York: Grove Press, 1958.

———. "There Is No More Firmament." In *Collected Works*. Vol. 2. Translated by Victor Corti. London: Calder and Boyars, 1971.

Aukstakalnis, Steve, and David Blatner. *Silicon Mirage: The Art and Science of Virtual Reality*. Berkeley: Peachpit Press, 1992.

Bachelard, Gaston. *The Right to Dream*. New York: Orion, 1971.

Barber, Stephen. *Antonin Artaud: Blows and Bombs*. Boston: Faber and Faber, 1993.

Barthes, Roland. "The Grain of the Voice," and "Music, Voice, Language." In *The Responsibility of Forms*. Translated by Richard Howard, 267–85. New York: Hill and Wang, 1985.

———. *The Pleasure of the Text*. New York: Hill and Wang, 1975.

Beaumont, Antony. *Busoni: The Composer*. Bloomington: Indiana University Press, 1985.

Bec, Louis. "Artificial Life under Tension—A Lesson in Epistemological Fabulation." In *Art@science*. Edited by Christa Sommerer and Laurent Mignonneau, 92–98. Vienna: Springer, 1998.

Bedau, Mark A., "Philosophical Content and Method of Artificial Life." In *The Digital Phoenix*, edited by Terrell Ward Bynum and James H. Moor. London: Blackwell, 1998.

Begault, Durand R. "The Virtual Reality of 3-D Sound." In *Cyberarts*, edited by Linda Jacobson, 79–87. San Francisco: Miller Freeman, 1992.

Belton, John. "Technology and Aesthetics of Film Sound." In *Film Sound: Theory and Practice*, edited by Elizabeth Weiss and John Belton, 63–72. New York: Columbia University Press, 1985.

Benedikt, Michael. *Cyberspace: First Steps*. Cambridge, MA: MIT Press, 1991.

Bergson, Henri. *Matter and Memory*. New York: Zone Books, 1988.

Bernard, Jonathan W. *The Music of Edgard Varèse*. New Haven: Yale University Press, 1987.

Bidlack, Rick, Dorota Blaszczak, and Gary Kendall. "An Implementation of a 3D Binaural Audio System within an Integrated Virtual Reality Environment," unpublished paper, Banff Centre for the Arts, 1993.

Bird, Jon. "Containing Reality: Epistemological Issues in Generative Art and Science." In *Impossible Nature: The Art of Jon McCormack*, by Jon McCormack. Melbourne: Australian Centre for the Moving Image, 2004.

Bolter, Jay David, and Richard Grusin. *Remediation: Understanding New Media*. Cambridge, MA: MIT Press, 2000.

Cage, John. "Forerunners of Modern Music" (1949). In *Silence*. Middletown, CT: Wesleyan University Press, 1961.

———. "Imaginary Landscape No. 1." In *25-Year Retrospective Concert of the Music of John Cage*. New York: Peters Edition, 1959.

———. "Juilliard Lecture." In *A Year from Monday*. Middletown, CT: Wesleyan University Press, 1967.

———. "Remarks by John Cage." Daniel Langlois Foundation, Montreal, E.A.T. archives (EAT C1–27/3; 27).

————. *Silence*. Middletown, CT: Wesleyan University Press, 1961.

Charles, Daniel, "Music and Technology Today." In *Art and Technology*, edited by Rene Berger and Lloyd Eby. New York: Paragon House, 1986.

Charles, Daniel, and John Cage. *For The Birds*. London: Marion Boyars, 1981.

Chion, Michel. *Audio Vision: Sound on Screen*. Translated by Claudia Gorbman. New York: Columbia University Press, 1990.

Copleston, Frederick. *A History of Philosophy*. Vol. 1. Westminster: Newman Bookshop, 1946.

Cott, Jonathan. *Stockhausen: Conversations with the Composer*. New York: Simon and Schuster, 1973.

Cox, Christoph, and Daniel Warner, eds. *Audio Culture: Readings in Modern Music*. New York: Continuum, 2004.

Coyne, Richard. *Technoromanticism: Digital Narrative, Holism, and the Romance of the Real*. Cambridge, MA: MIT Press, 1999.

Cubitt, Sean. "Supernatural Futures: Theses on Digital Aesthetics." In *Future Natural*, edited by George Robertson et al. New York: Routledge, 1996.

————. *Digital Aesthetics, Theory, Culture and Society*. Edited by Mike Featherstone. London: Sage, 1998.

Czitrom, Daniel. *Media and the American Mind*. Chapel Hill: University of North Carolina Press, 1982.

Dahlhaus, Carl. *The Idea of Absolute Music*. Translated by Roger Lustig. Chicago: University of Chicago Press, 1989.

Davies, Char. "Changing Space: Virtual Reality as an Arena of Embodied Being." In *Multimedia: From Wagner to Virtual Reality*, edited by Randall Packer and Ken Jordan. New York: W. W. Norton, 1997.

————. "Landscapes of Ephemeral Embrace." Unpublished PhD diss., CAIIA, University of Plymouth, 2005.

————. "Virtual Space." In Space: in *Science, Art and Society*, edited by François Penz, Gregory Radick, and Robert Howell, 69–104. Cambridge: Cambridge University Press, 2004.

Davis, Erik. *Techgnosis*. New York: Harmony Books, 1998.

Deleuze, Gilles, and Felix Guattari. *A Thousand Plateaus*. Minneapolis: University of Minnesota Press, 1987.

Derrida, Jacques. *Cinders*. Translated by Ned Lukacher. Lincoln: University of Nebraska Press, 1987.

————. *Of Grammatology*. Baltimore: Johns Hopkins University Press, 1974.

————. *Positions*. Translated by Alan Bass. Chicago: University of Chicago Press, 1981.

————. *Speech and Phenomena*. Evanston: Northwestern University Press, 1973.

————. "Ulysses Gramophone." In *Acts of Literature*. New York: Routledge, 1992.

Derrida, Jacques, and Bernard Stiegler. *Echographies of Television*. Translated by J. Bajorek. Oxford: Polity Press, 2002.

Dickson, W. K., and Antonia Dickson. *The Life and Inventions of Thomas Alva Edison*. London: Chatto and Windus, 1894.

Dietz, Steve. "Ten Dreams of Technology." *Leonardo* 35, no. 5 (2002).

Dolar, Mladen. *A Voice and Nothing More.* Short Circuits. Edited by Slavoj Žižek. Cambridge: MIT Press, 2006.

Douglas, Susan. "Amateur Operators and American Broadcasting: Shaping the Future of Radio." In *Imagining Tomorrow,* edited by Joseph J. Corn. Cambridge, MA: MIT Press, 1987.

Edison, Thomas A. *The Diary and Sundry Observations of Thomas A. Edison.* Edited by Dagobert D. Runes. New York: Philosophical Library, 1948.

Freud, Sigmund. *The Standard Edition of the Complete Psychological Works.* Edited by James Strachey. Vol. 22. London: Hogarth Press, 1964.

Gaillot, Michel. *Multiple Meaning, Techno: An Artistic and Political Laboratory of the Present.* Translated by Warren Niesluchowski. Edited by Danièle Rivière. Paris: Éditions Dis Voir, 1988.

Goldberg, Ken. "Telegarden." *Ars Electronica 96: Mimesis: The Future of Evolution,* edited by Gerfried Stocker and Christine Schöpf. Vienna: Springer, 1996.

Grau, Oliver. *Virtual Art: From Illusion to Immersion.* Translated by Gloria Custance. Edited by Roger F. Malina. Cambridge, MA: MIT Press, 2003.

Greusel, Hubert. *Hours with Famous Americans: Thomas A. Edison.* n.p.: John Hubert Greusel, 1913.

Hansen, Mark. *Bodies in Code: Interfaces with Digital Media.* New York: Routledge, 2006.

———. *Embodying Technesis: Technology beyond Writing.* Ann Arbor: University of Michigan Press, 2000.

———. *New Philosophy for New Media.* Cambridge, MA: MIT Press, 2005.

Haraway, Donna. "A Manifesto for Cyborgs: Science, Technology, and Socialist Feminism in the 1980s." In *Feminism/Postmodernism,* edited by Linda J. Nicholson. 190–233. New York: Routledge, 1990.

Hayles, N. Katherine. "Flesh and Metal: Reconfiguring the MindBody in Virtual Environments." In *Data Made Flesh: Embodying Information,* edited by Robert Mitchell and Phillip Thurtle. New York: Routledge, 2004.

———. *How We Became Posthuman.* Chicago: University of Chicago Press, 1991.

———. *My Mother Was a Computer.* Chicago: University of Chicago Press, 2005.

———. *Writing Machines.* Cambridge, MA: MIT Press, 2002.

Heidegger, Martin. *Being and Time.* New York: Harper & Row, 1962.

———. *Early Greek Thinking.* Translated by David Farrell Krell and Frank A. Capuzzi. New York: Harper & Row, 1975.

———. "Science and Reflection," and "The Question Concerning Technology." In *The Question Concerning Technology.* Translated by William Lovitt. New York: Harper Torchbooks, 1977.

———. *What Is Called Thinking.* New York: Harper & Row, 1968.

Hitt, Jack. "This Is Your Brain on God." www.wired.com/wired/archive/7.11/persinger.html.

Ihde, Don. *Consequences of Phenomenology.* New York: State University of New York Press, 1986.

———. *Listening and Voice: A Phenomenology of Sound.* Athens: Ohio University Press, 1976.

Johnson, Lesley. "Radio and Everyday Life: The Early Years of Broadcasting in Australia, 1922–45." *Media Culture and Society* 3, no.2 (1981): 167–78.

Jonas, Hans. *The Phenomenon of Life: Toward a Philosophical Biology.* Evanston, IL: Northwestern University Press, 1966.

Jones, Ernest. *Psycho-Myth, Psycho-History: Essays in Applied Psychoanalysis.* New York: Hillstone, 1974.

Kahn, Douglas. *Noise, Water, Meat.* Cambridge, MA: MIT Press, 1999.

Kahn, Douglas, and Gregory Whitehead, eds. *Wireless Imagination: Sound, Radio and the Avant-Garde.* Cambridge, MA: MIT Press, 1993.

Kauffman, Stuart. *At Home in the Universe: The Search for the Laws of Self-Organization.* New York: Oxford University Press, 1995.

Kelly, Kevin. *Out of Control: The New Biology of Machines, Social Systems, and the Economic World.* Reading, MA: Addison-Wesley, 1994.

Kember, Sarah. *Cyberfeminism and Artificial Life.* London: Routledge, 2003.

Kittler, Friedrich. *Discourse Networks.* Translated by Michael Metteer, with Chris Cullins. Stanford: Stanford University Press, 1990.

Klüver, Billy. "Interface: Artist/Engineer." Daniel Langlois Foundation, Montreal, E.A.T. archives, E.A.T. proceedings, No. 1, 21 April 1967 (EAT C 2).

Klüver, Billy, Julie Martin, and Barbara Rose, eds. *Pavilion,* by Experiments in Art and Technology. New York: E. P. Dutton, 1972.

Kostelanetz, Richard, ed. *John Cage.* New York: Praeger, 1968.

———. *Conversing with Cage.* New York: Limelight, 1988.

Kroker, Arthur. *The Will to Technology and the Culture of Nihilism: Heidegger, Nietzsche, and Marx.* Toronto: University of Toronto Press, 2004.

Krupnick, Mark. *Displacement: Derrida and After.* Bloomington: Indiana University Press, 1987.

Kurth, Ernst. *Bruckner.* Berlin: Hesse, 1925.

Lanier, Jaron. "Life in the Data Cloud." *Mondo 2000* 2 (Summer 1990): 44–51.

Laurel, Brenda. *Computers as Theatre.* Reading, MA: Addison-Wesley, 1993.

Leed, Eric. "'Voice' and 'Print': Master Symbols in the History of Communication." In *The Myths of Information: Technology and Postindustrial Culture,* edited by Kathleen Woodward, 41–61. Madison, WI: Coda Press, 1980.

Lenoir, Timothy. "Introduction." *Configurations* 10, no. 3 (Fall 2002): 373–85.

Levin, David Michael. "Decline and Fall: Ocularcentrism in Heidegger's Reading of the History of Metaphysics." In *Modernity and the Hegemony of Vision,* edited by David Michael Levin, 186–217. Berkeley: University of California Press, 1993.

Lewis, Tom. *Empire of the Air.* PBS documentary, Sept. 1991, KAET television.

Lindgren, Nino. "Into the Collaboration." In *Pavilion,* by Experiments in Art and Technology, edited by Billy Klüver, Julie Martin, Barbara Rose, 3–59. New York: E. P. Dutton, 1972.

Lyotard, Jean-François. "Voices of a Voice." Translated by Georges Van Den Abbeele. *Discourse* 14, no. 1 (Winter 1991–92): 126–45.

Marty, Daniel. *The Illustrated History of Phonographs.* New York: Dorsett Press, 1981.

Marvin, Carolyn. *When Old Technologies Were New.* Oxford: Oxford University Press, 1988.

Massumi, Brian. *Parables of the Virtual.* Durham: Duke University Press, 2002.

Mattis, Olivia. "Edgard Varèse and the Visual Arts." PhD diss., Stanford University, 1992.

———. "Varèse's Multimedia Conception of Déserts." *Musical Quarterly,* 76, no. 4 (1992): 557–83.

McCormack, Jon. *Impossible Nature: The Art of Jon McCormack.* Melbourne: Australian Centre for the Moving Image, 2004.

———. "On the Evolution of Sonic Ecosystems." In *Artificial Life Models in Software,* edited by Andrew Adamatzky, Maciej Komosinski, 211–30. Berlin: Springer, 2005.

———. "(Re) Designing Nature." Talk given at *Artificial Life: Hard/Soft/ Wet futureScreen00,* curated by Leah Grycewicz and organized by dLux media/arts, in collaboration with The Powerhouse Museum, Australian Centre for Photography and Artspace, 2001.

McLaughlin, Margaret, Kerry K. Osborne, and Nicole B. Ellison. "Virtual Community in a Telepresent Environment." In *Virtual Culture,* edited by Steven Jones, 146–67. Thousand Oaks, CA: Sage Publications, 1997.

McLuhan, Marshall. *Understanding Media.* New York: Signet, 1964.

Merleau-Ponty, Maurice. *The Visible and the Invisible.* Edited by Claude Lefort. Evanston, IL: Northwestern University Press, 1968.

Metz, Christian. "Aural Objects." *Yale French Studies* no. 60 (1980): 24–32.

Miller, Henry. "With Edgar Varèse in the Gobi Desert." In *The Air-Conditioned Nightmare.* New York: New Directions, 1945.

Mirowski, Philip. *Machine Dreams: Economics Becomes a Cyborg Science.* Cambridge: Cambridge University Press, 2002.

Moncel, Count Du. *The Telephone.* New York: Harper & Brothers, 1879.

Moores, Shaun. "'The Box on the Dresser': Memories of Early Radio and Everyday Life." *Media Culture and Society* 12, no. 1 (1988): 23–40.

Morse, Margaret. "Aesthetics and Immersion: Reflections on Martin Jay's Essay 'Diving into the Wreck.'" Asthetik-Colloquim vom 27.02. bis 01.03.03 in Berlin, October 2003.

———. *Virtualities: Television, Media Art and Cyberculture.* Bloomington, Indiana University Press, 1998.

Morton, Timothy. *Ecology without Nature.* Cambridge, MA: Harvard University Press, 2007.

Morus, Iwan Rhys. *Frankenstein's Children: Electricity, Exhibition, and Experiment in Early-Nineteenth-Century London.* Princeton: Princeton University Press, 1998.

Mosco, Vincent. *The Digital Sublime.* Cambridge, MA: MIT Press, 2004.

Munster, Anna. *Materializing New Media.* New Hampshire: Dartmouth College Press, 2006.

Murch, Walter. Introduction to *Audio Vision: Sound on Screen,* by Michel Chion. Translated by Claudia Gorbman. New York: Columbia University Press, 1990.

Murphy, Todd. "The Sensed Presence and the Sense of Self." Web article. http://www.shaktitechnology.com/sp.htm.

Nattiez, Jean-Jacques. *Music and Discourse.* Translated by Carolyn Abbate. Princeton: Princeton University Press, 1990.

Ong, Walter. *Orality and Literacy*. New York: Methuen, 1982.
———. *The Presence of the Word*. Minneapolis: University of Minnesota Press, 1967.
Oppenheim, Janet. *The Other World: Spiritualism and Psychical Research in England, 1850–1914*. New York: Cambridge University Press, 1985.
Ouellette, Ferdinand. *Edgard Varèse*. Translated by Derek Coltman. New York: Orion, 1968.
Partridge, Eric. *Origins: A Short Etymological Dictionary of Modern English*. New York: Macmillan, 1966.
Pioli, Richard. *Stung by Salt and War: Creative Texts of the Italian Avant-Gardist F. T. Marinetti*. New York: Peter Lang, 1987.
Pritchett, James. *The Music of John Cage*. Music in the Twentieth Century. Edited by Arnold Whittall. Cambridge: Cambridge University Press, 1996.
Ranzenbacher, Heimo. "The Evolution of Future." *Ars Electronica 96: Mimesis: The Future of Evolution*. Edited by Gerfried Stocker and Christine Schöpf. Vienna: Springer, 1996.
Rickels, Laurence. *Aberrations of Mourning*. Detroit: Wayne State University Press, 1988.
Ronell, Avital. *The Telephone Book*. Lincoln: University of Nebraska Press, 1989.
Ross, Andrew. *Strange Weather*. New York: Verso, 1991.
Runes, Dagobert D., ed. *Dictionary of Philosophy*. Totowa, NJ: Littlefield, Adams and Co., 1962.
Rushkoff, Douglas. "It Ain't Eugenics, It's Just Mimetics." *Ars Electronica 96: Mimesis: The Future of Evolution*. Edited by Gerfried Stocker and Christine Schöpf. Vienna: Springer, 1996.
Russcol, Herbert. *The Liberation of Sound*. New York: Prentice-Hall, 1972.
Russolo, Luigi. *The Art of Noises*. New York: Pendragon Press, 1986.
Sawchuck, Kim. "Catherine Richards." *Parachute* 89 (1998): 49–50.
Schaeffer, Pierre. *Solfège de l'objet Sonore*, 1967. Translated by Livia Bellagamba. 2nd ed. Paris: Institut National de l'Audiovisuel and Groupe de Recherches Musicales, 1998.
———. *Traité des objets musicaux*. Paris: Éditions du Seuil, 1966. In *Audio Culture: Readings in Modern Music*. Edited by Christoph Cox and Daniel Warner. Translated by Daniel W. Smith. New York: Continuum, 2004.
Schafer, R. Murray. *The Tuning of the World*. Philadelphia: University of Pennsylvania Press, 1980.
Scheer, Edward, ed. *100 Years of Cruelty*. Sydney: Power Institute, 2000.
Scholem, Gershom G. *Major Trends in Jewish Mysticism*. New York: Schocken Books, 1941.
Schopenhauer, Arthur. *The World as Will and Representation*. Translated by E. F. J. Payne. New York: Dover Publications, 1969.
Schuller, Gunther. "Conversation with Steuermann." *Perspectives of New Music* 3, no. 1 (1964): 22–35.
Schwartz, Elliott, and Barney Childs, eds. *Contemporary Composers on Contemporary Music*. New York: Holt, Rinehart and Winston, 1967.
Sconce, Jeffrey. *Haunted Media: Electronic Presence from Telegraphy to Television*. Durham: Duke University Press, 2000.

Serres, Michel. *Genesis*. Translated by Genevieve James and James Nielson. Studies in Literature and Science. Ann Arbor: University of Michigan Press, 1995.

Sherman, Tom. "Nature is Perverse Sometimes." *Ars Electronica 96: Mimesis: The Future of Evolution*. Edited by Gerfried Stocker and Christine Schöpf. Vienna: Springer, 1996.

Sommerer, Christa, and Laurent Mignonneau. *Art@science*. Vienna: Springer, 1998.

Spitzer, Leo. *Classical and Christian Ideas of World Harmony*. Edited by Anna Granville Hatcher. Baltimore: Johns Hopkins Press, 1963.

Sterne, Jonathan. *The Audible Past: Cultural Origins of Sound Reproduction*. Durham: Duke University Press, 2003.

Tausk, Victor. "On the Origin of the 'Influencing Machine' in Schizophrenia." *Psychoanalytic Quarterly* 2 (1933): 519–56.

Tomkins, Calvin. "Outside Art." In *Pavilion*, by Experiments in Art and Technology, edited by Billy Klüver, Julie Martin, and Barbara Rose, 105–65. New York: E. P. Dutton, 1972.

Treadwell, Andrew. "Virtual Transcendence." [online] Oxford: Oxford Brookes University (Jan. 2002), last accessed June 2006.

Varèse, Edgard. "The Liberation of Sound." In *Contemporary Composers on Contemporary Music,* edited by Elliott Schwartz and Barney Childs, 196–208. New York: Holt, Rinehart and Winston, 1967.

———. "Music and the Times." Santa Fe. 23 August 1936. Cited in Olivia Mattis, "Edgard Varèse and the Visual Arts." PhD diss., Stanford University, 1992.

Varèse, Louise. "Correspondence with Peter Garland." In *Soundings* no. 10. Berkeley: Peter Garland, 1976.

———. *Varèse: A Looking Glass Diary*. New York, W. W. Norton, 1972.

Virilio, Paul. *Open Sky*. Translated by Julie Rose. London: Verso, 1997.

Weiss, Allen. "Radio Death and the Devil." In *Wireless Imagination: Sound, Radio and the Avant-Garde,* edited by Douglas Kahn and Gregory Whitehead, 269–307. Cambridge, MA: MIT Press, 1993.

Wheelwright, Philip. *Heraclitus*. New York: Atheneum, 1964.

Whittall, Arnold, ed. *Music in the Twentieth Century*. Cambridge: Cambridge University Press, 1993.

Woodward, Kathleen, ed. *The Myths of Information: Technology and Post-industrial Culture*. Madison, WI: Coda Press, 1980.

Youngblood, Gene. "The Open Empire." *Studio International* 179, no. 921 (April 1970): 177–78, FDL archives (EAT Box C 23–3 /4; 446).

Žižek, Slavoj, "From Virtual Reality to the Virtualization of Reality." In *Reading Digital Culture,* edited by David Trend, 17–22. Malden, MA: Blackwell, 2001.

Index

acousmatics, 10, 12, 13, 55, 58, 64, 74, 77, 192n9
acoustic ecology, 72
Agamben, Giorgio, 25, 97, 104, 208n6, 210n38
alterity, 5, 6, 11, 45, 79, 120, 130, 137, 157, 160, 182, 210n31, 212n52; aurality and, 5, 27, 58, 88, 100; of technology, 103, 144, 184, 192n10
Altman, Rick, 53, 74, 76, 201n67
Anderson, Laurie, 215n10
Antin, David, 72, 205n57
Applebaum, David, 193n21
Aquinas, St. Thomas, 23–24, 113, 215n13
Abend-land (evening-land), 211n43
Aristotle, 23–24, 89, 97, 113, 121, 215n13
Arnheim, Rudolph, 49, 50, 52, 54, 64, 72, 81, 86, 93, 200n64, 201n65; "The End of the Private Sphere," 93–94
Artaud, Antonin, 22, 33–46, 79, 83, 170, 180, 197n10, nn14–16; *L'astronome (The Astronomer)*, 33–34, 39–40; *The Theatre and Its Double*, 35; "There Is No More Firmament," 34, 39–41; *To Have Done with the Judgement of God*, 45
Artificial Intelligence (AI), 15, 84, 147, 180

artificial life (A-life), 1, 2, 15, 37, 77, 147–48, 151–54, 161, 174; theorization of, 158; vitalism of, 79
Art Nouveau, 72
audio. *See specific media*
audiophony, 6, 45, 75, 77, 80, 93, 97, 130, 136, 143, 182
Augustine, 20
aurality, 3–7, 11, 12, 28, 51, 84, 97, 109, 189, 192n10, 200n62; alterity and, 5, 27, 58, 88, 100; of Artaud, 36, 42, 45; of Cage, 63; Davies and, 121–22, 126, 130; metaphysics and complexities of, 25; phenomenality of, 55; radio and, 31, 32, 49; rhizomic representation of, 186; sound recording and, 75, 77–80, 143; of Varèse, 43
Automation House, 224n21

Bach, Johann Sebastian, 39
Bachelard, Gaston, 49–50, 81, 199n48
Barthes, Roland, 18–19, 26, 53, 192nn1–2
Baudrillard, Jean, 156
Bauhaus, 72
Beaumont, Antony, 197n20
Bec, Louis, 37, 147
Beethoven, Ludwig van, 186, 203n30

Befindlichkeit (state-of-mind), 86
Begault, Durand, 140, 222n4
Belton, John, 140
Benedikt, Michael, 48, 191n1
Bergson, Henri, 33, 36, 79, 122, 128, 129
Bidlack, Rick, 123–24, 220n50, 222n3
Biosphere 2 (Oracle, Arizona), 225n38
Bird, Jon, 152, 153
Blaszczak, Dorota, 222n3
Bolter, Jay David, 13
Boulez, Pierre, 184
Brazil (film), 116
breath, 14, 18–20, 24, 109, 154, 189, 210n32; interface of balance and, 112–14, 121, 129, 132, 215n11
Breer, Bob, 223n17
Buddhism, 119; Zen, 63, 203n29
Burroughs, William, 137, 157; *The Ticket That Exploded*, 156
Busoni, Ferruccio Benvenuto, 197n20
Bussotti, Sylvano, *XIV Piano Piece for David Tudor*, 184, 186

Cage, John, 10–12, 55, 58–73, 83–85, 95, 103–4, 108, 118, 127, 143–44, 147, 157, 180, 183–89, 202nn24,25,27,28, 203nn29,30, 205nn46,57, 232n15; *Cartridge Music*, 64; *Concert for Piano and Orchestra*, 203n33; *Fontana Mix*, 203n33; *4'33"*, 65, 66; *HPSCHD*, 126; *Imaginary Landscapes*, 61, 62, 66, 203n33; "Lecture on Nothing," 204n41; "Lecture on Something," 204n38, 205n45; *Music for Piano*, 203n35; *Music Walk*, 203n33; *Radio Music*, 203n34; *Rhythm Etc.*, 66–67; *Song Books*, 205n56; *Sounds of Venice*, 203n33; *Three Dances*, 56; *Variations*, 203n35; *Variations VII*, 70, 137, 186–87; *Water Walk*, 203n33; *WBAI*, 203n34; *Williams Mix*, 65, 67, 203n33, 204n36; *0,00"*, 65
Cartesianism, 11, 12, 14, 23, 31, 110, 112, 129, 166, 215n10
Charles, Daniel, 69
Chiarucci, Henri, 55
Chion, Michel, 10, 76–78, 192n9, 207n73
Christianity, 19–20, 26, 28, 219n44
cinema, 3, 19, 28, 46, 140, 142, 207n73. *See also* titles of specific films
clairaudience, 55, 72, 80
CoEvolution Quarterly, 148
Congress, U.S., 48
Constant Note test tone records, 61
Convolvotron, 223n6

Cornish School, The, 61
corporeality, 41, 42, 114
Cott, Jonathan, 224n24
Coyne, Richard, 4, 115, 124, 217n22
Cronenberg, David, 156
Cubitt, Sean, 154, 191n4, 226n57
Cybercultures (Casula Powerhouse, Sydney), 151
Cyber Futures (Sydney, 2000), 161
cyberspace, 1, 2, 32, 45, 47–48, 131, 143–44, 148, 149, 199n41; absolute immateriality of, 161; democratic potentials of, 158; infosphere of, 147; myths surrounding, 83; rhetoric of, 109; sonic, of Cage, 59–65
Czitrom, Daniel, 29, 196n42, n43

Dahlhaus, Carl, 204n43
Dasein (being-in-the-world), 11, 85–93, 98, 104, 189, 207n1, 208nn11–12, 209nn16–18, 211n44
Davies, Char, 14, 107–19, 121–32, 135, 151, 214n7, 215n10, 216n15, 217nn22,26–28, 218nn29,32, 219nn45,47, 220n49, 221n74; *Among the Myriads*, 133, 134; *Ephémère*, 107, 108, 113–14, 117, 121–24, 127, 135, 213n1, 214n2, 220n50, 221n75, 222n3; *Osmose*, 14, 107, 109–17, 121, 123–25, 127, 213n1, 216nn16–17, 221n75, 222n3; *Reverie*, 107, 135, 214n1
Davis, Erik, 216n16
Deitz, Steve, 114
Deleuze, Gilles, 33, 84, 183–87, 232n15; *A Thousand Plateaus*, 184, 185
Derrida, Jacques, 11, 12, 24, 83, 84, 95–104, 160–61, 188, 212nn45,51–52; *Cinders*, 12, 98, 211nn42–45; *Echographies of Television*, 102, 103, 213n56; *Of Grammatology*, 210n30; *Positions*, 210nn31–32; *Speech and Phenomena*, 97, 102, 194n23; *Ulysses Gramophone*, 100–101
Descartes, René, 24, 96, 104. *See also* Cartesianism
Dolar, Mladen, 8, 212n52
Douglas, Susan, 31–32, 48, 196n40
DXers, 48

ecology: acoustic, 72; cultural, 154
Edison, Thomas Alva, 29, 46, 47, 79, 198n38
eidetic knowledge, 21
embodiment, 2–4, 12, 16, 20, 51, 130, 155–57, 159, 162, 163, 165, 182, 188, 227nn61,64, 228n66, 230n17, 232n18; deferred onto transcendental

subjectivity, 131; mapping of narrativity upon, 187; mythos of, 141; predigital understanding of, 129; resituated, 108; rhetorics of, 6; technically augmented, 83–84; trope of, 7; virtual, 25, 113, 117, 119, 124, 138, 143
Enlightenment, 194n26
ephemerality, 63, 204
epistemology, 7, 12, 28, 122, 151, 154, 21, 102–3, 141, 147
Evenings (performance), 16
Experiments in Art and Technology, Inc. (E.A.T.), 70–72, 111, 224n21; *Pavilion*, 16, 144–45, 149, 223n17, 224n21

Ferreyra, Beatriz, 55
Fishinger, Oscar, 60
Foster, Scott, 223n6
Frelischmann, Monika, 2
Freud, Sigmund, 29–30, 50, 195n35, 200n57
frontality, 14, 113
Fuller, Buckminster, 69, 205n46
Futurism, 28, 33, 36, 146
futurity, 14, 113

Gaillot, Michel, 183, 184, 187, 231nn4,6, 232n16
Gehrke, M. M., "The End of the Private Sphere," 93–94
Gelassenheit (letting-be), 85, 119, 122, 214n2, 216n14, 219n47
Gerede (idle talk), 89–90, 93, 95, 127, 209n23
Grau, Oliver, 50, 116, 124, 216nn17–18, 217nn19–20; *Virtual Art,* 114–15
Greeks, ancient, 20–24, 75, 170, 209n23
Greusel, Hubert, 29, 46, 79, 80, 198n38
Groupe Solfège (Music Theory Group), 55
Grusin, Richard, 13
Guattari, Felix, 84, 183–87, 232n15; *A Thousand Plateaus,* 184, 185

Hansen, Mark, 16, 124–31, 158–59, 192n10, 221n73, 222n77; 228nn1,4, 229n5, 232n18; *Bodies in Code,* 124–25, 128; *New Philosophy for New Media,* 125, 128; *Technesis,* 125
Haraway, Donna, "A Manifesto for Cyborgs," 155
Harrison, Lou, 67
Hayles, N. Katherine, 6, 16, 155–57, 159–61, 176, 180, 182, 228n4; *How We Became Posthuman,* 155, 227nn61–64, 228nn65–66

head mounted display (HMD), 25, 111, 112, 116, 130, 141–42, 217n20
head-related transfer function (HRTF), 139–40
Heidegger, Martin, 11, 12, 75, 84–95, 97–99, 101–5, 119, 127, 129, 131, 135, 165, 179, 189, 192n10, 208n2, 209n23, 213n59, 216n14, 217n22, 218n32; *Being and Time,* 85, 86, 91, 93–95, 207n1, 208nn4,7–8,10–12, 209nn16–18, 213n53; *Early Greek Thinking,* 91, 209n24, 211n43; *What Is Called Thinking,* 90, 94
Heim, Michael, 5
Helmholtz, Hermann von, 78
Henry, Pierre, 10, 55, 91, 183; *Astrologie,* 137; *Bidule en ut,* 56; *Premier Panorama de Musique Concrète,* 207n73; *Vocalises,* 137
Heraclitus, 91–92, 99, 121, 193n10, 209n24, 219n43
Hitler, Adolf, 80
Hitt, Jack, 230n26, 231n29
Holocaust, 211n42
Holy Trinity, 19–20
Husserl, Edmund, 97

I Ching, 67, 203n33, 204n36
Idealism, 219n44
Ihde, Don, 4, 53, 76, 193n12
immersion, 1, 3, 8, 83, 89, 107–35, 178, 191n3, 216n17; conflict between autonomy and integration resolved by, 16; electromagnetic, 166–70; embodiment and, 138; pretechnological, 108; rhetorics of, 6–7, 15; role of artist in, 146; transcendent, 5, 15, 182; trope of, 45, 49
Industrial Revolution, 73
interactivity, 1, 2, 83, 107, 109, 112, 123, 124, 159
International Conference on Acoustic Ecology, 72
Internet, 1, 2, 49, 149–51, 231n29

Jacobson, Linda, 141
Johnny Mnemonic (film), 116
Johnson, Lesley, 199n44
Jonas, Hans, 220n55, 221nn59–60, 62,74; "The Nobility of Sight," 125–28
Journal musical français, 39
Joyce, James, 100; *Ulysses,* 100–101
Judaism, 211nn42–43, 212nn45–46
Juilliard School of Music, 202n28
Jung, Carl, 195n37

Kaballism, 212n49
Kauffman, Stuart, *At Home in the Universe,* 149, 225n33
Kelly, Kevin, 148, 149, 225n37; *Out of Control,* 149, 224n32, 225n38
Kember, Sarah, 148
Klüver, Billy, 69–70, 72, 111
knowledge, 5–7, 110, 127, 162, 165; bodily, 78, 154, 155, 164, 167; in Greek philosophy, 21–22, 24, 193nn13–14; perception and, 13, 58, 126, 127, 139, 159, 200n62; self-, 58, 86–89, 91, 92
Kraftwerk, 183
Kroker, Arthur, 105, 131, 213n59
Kurth, Ernst, 204n43

Lacan, Jacques, 120
Laurel, Brenda, 137
Laurentian University, 172
Leed, Eric, 200nn52–54
Lenoir, Timothy, 159, 228n4
Leucippus, 24
Levin, David Michael, 85, 113, 118, 216n14
Lyotard, Jean-François, 97, 195n36, 210n35

Mackintosh, Thomas, 175, 177–78
magnetic tape. *See* tape recording
Marconi, Guglielmo, 31, 195n40
Marinetti, F. T., 19, 28–29, 33, 196n1; *Zang Tumb Tumb,* 137
Marvin, Carolyn, 195n33, 199n45
Massenet, Jules, *Clair de lune,* 39
Matrix, The (film), 116
Mattis, Olivia, 197n19, 198n32
Max Headroom (film), 116
McCormack, Jon, 151, 154, 226n44, n47, n53; *Eden,* 151–53
McLuhan, Marshall, 49, 50, 69, 72, 199n41, n49, 205n46
memes, 154
Merleau-Ponty, Maurice, 84, 119–21, 128, 129, 218n34, n35, n37, n38, 219n39, n41, n42
Messiaen, Olivier, 206n61
metaphysics, 3–6, 8, 9, 11–14, 31, 33, 79–80, 83–84, 138, 139, 161, 183, 185–88, 212n49, 228n65. *See also* ontology; of Artaud, 34, 35, 38, 44, 45, 197n10; of Cage, 59, 62, 66, 104; of Davies's works, 112, 117, 119, 121, 122, 127, 130, 135; Derrida on, 95–99, 101–3, 212n52; Heidegger on, 75, 87, 87–89, 98, 99, 208n2, 209n18, 211n43; inner voice of, 47, 53; materialist, 77;

posthumanist, 156, 157; of Richards's works, 162, 180; visualist, 21, 28; of voice, 18–21, 23, 25, 30, 52, 210n38
Metz, Christian, 4–5, 206n72; "Aural Objects," 76
microphone, 9, 13, 52, 54, 81, 84, 93, 130; Cage and, 61, 64, 65, 67, 70, 144
Minority Report (film), 116
Mirowski, Philip, 155
Moncel, Count Du, 52
Moores, Shaun, 199n44
Moravec, Hans, 156
Morse, Margaret, 116–17, 191n3
Morse code, 39, 41, 42
Morton, Timothy, 132, 135
Munster, Anna, 141–42
Murch, Walter, 206n73
Murphy, Todd, 174, 230n25
Musée d'Art Contemporain (Montreal), 109

Nada Yoga, 81
Navy, U.S., 48
Nazis, 94
Nelson, Mark, 225n38
9 Evenings: Theater and Engineering (New York, 1966), 69–71, 144, 186
1984 (Orwell), 116
Nishitani, 119
noise, 7, 17, 21, 56, 103, 130, 132, 188–89, 220n48, n50, 222nn4,76; alterity of, 5; Artaud and, 35–37, 42, 46; Cage and, 60, 61, 65–66, 84, 185, 186, 188, 189; Hayles's use of, 155, 157, 160; Heidegger on, 85, 88–90, 92–94, 97, 179; Jonas on, 126–27, 221n62; of mass communication, 26; materiality of, 20; Ray's use of, 161–62; Shaffer on, 73, 80–81; voice and, 21, 30–31, 53
non-intentionality, 55

ocularcentrism, 10, 13, 14, 21, 112, 125, 129, 132
Olson, Harry F., 47
Ong, Walter, 50, 51, 53, 72, 200n62
onomatopoeia, 8, 22–23, 35, 40, 76, 91, 306
ontology, 1–3, 5–7, 9–11, 13, 16, 27, 28, 40, 60, 118, 151, 155, 170, 187; Derrida on, 102; in Greek philosophy, 21, 24; Heidegger on, 86, 87, 208nn4–5,10; negative, 205n45, 210n38; of reproduced sound, 54, 58, 63, 76, 77–79; of virtual images, 114–15, 118–19, 122, 125–29, 142; visually-based, 75; of voice, 25, 47, 95

Oppenheim, Janet, 194n28
Osaka World Fair (1970), 144, 224n21

Panzera, Charles, 19
Paranoia 1.0 (film), 116
Parmenides, 21, 193n10, n11
Pepsi-Cola, 111, 144, 224n21
Persinger, Michael, 172–74, 231n29
phonocentrism, 95
phonography, 3, 19, 29, 46–47, 62, 78,
 79, 98–102, 138, 140, 143, 155,
 198n36, 212n45, n49, 227n62;
 objectification of speech in, 93
Plato, 21–23, 36, 193nn13–15
Platonism, 35–37, 86, 155
Plotinus, 20
pneuma, 20, 24–26, 30, 212n46
posthumanism, 1, 2, 15, 17, 103, 105,
 159, 163, 173–79, 182, 227n64,
 228n65; rhetoric of, 158, 162; in
 techno-utopic and dystopic narra-
 tives, 146; theorizing, 154–57
Pottasch, Alan, 224n21
Powers, Horatio Nelson, "The
 Phonograph's Salutation," 46
pre-Socratic philosophy, 91–92, 99, 121
Pritchett, James, 65, 205n46
psychoanalysis, 29–30, 50, 195n35, n36,
 203n29
Pythagoras, 36, 58

Ranzenbacher, Heimo, 146
Rauschenberg, Robert, 70, 72, 144,
 205n57
Ray, Thomas, 152, 174, 188; "A Wildlife
 Reserve in Cyberspace," 161–62
Reibel, Guy, 55
Reich, Steve, 183
Renaissance, 53, 71
representation, 6, 11, 13, 26, 28, 35–37,
 54, 66–69, 77–79, 88, 131, 140,
 151, 162, 169, 184, 216n12; aural,
 45–46, 54, 58, 74, 81, 186, 192n10;
 authoritarian logic of, 160; critiques
 of, 2, 10; negation of, 187; systems
 of, 180; theory of, 3
Rheingold, Howard, 50
Richards, Catherine, 16, 17, 151,
 161–81, 229n10, n12, n16, 230n17,
 n18, n20, n22, n23; *Charged
 Hearts*, 168–69, *169*; *The Curiosity
 Cabinet at the End of the
 Millennium*, 166–67, 169, 176–78,
 230n27; *I was scared to death/I
 could have died for joy*, 171–74,
 171, *172* ; *Shroud/Chrysalis*, 169,
 173–77, *178*, *179*, 230n27; *Shroud
 II*, 162, 177; *Spectral Bodies*,

162–66, *164*, 229n13; *The Virtual
 Body*, 163, 165, 166
Riley, Terry, 183
Romanticism, 61; neo-, 138; techno-,
 109, 135
Ronell, Avital, 94, 194n31, 195n37
Rose, Barbara, 145
rumor, 8, 17, 36, 89–90, 95, 100, 127,
 188, 189, 209n23, 212n49
Rushkoff, Douglas, 148
Russcoll, Herbert, 198n34
Russolo, Luigi, 33; "Intonarumori," 186

Sarabhai, Gita, 203n29
Schaeffer, Pierre, 10, 12, 55–59, 64, 66,
 72, 77, 80, 91, 182–84, 201nn3,7;
 Bidule en ut, 56; *Premier Panorama
 de Musique Concrète*, 207n73;
 *Treatise on Musical Objects (Solfège
 de l'objet Sonore)*, 55–58, 201n8
Schafer, R. Murray, 11, 55, 59, 72–74, 77,
 80–83, 103, 132, 182, 206n59, n61;
 The Tuning of the World, 72–73
Schilling, Alfon, 71
schizophonia, 73–74, 77, 79, 80, 82
Scholem, Gershom, 212n49
Schopenhauer, Arnold, 3, 68
Schwitters, Kurt, *Ur Sonata*, 137
Scientific Institute for Paranatural
 Research, 147
Sconce, Jeffrey, 46
self-knowledge, 58, 86–89, 91, 92
Serres, Michel, 80, 158, 188, 220n48
Sherman, Tom, 154
silence, 5, 11–12, 53, 55, 121, 173,
 192n10, 231n4; Cage's use of,
 59–60, 62, 64–66, 68–69, 84, 85,
 103–4, 180, 184, 188, 189, 204n40;
 Derrida on, 95–98, 100, 102,
 211n45; Heidegger on, 84–85, 90,
 92–93, 95, 104, 105, 179, 209n16;
 Schafer on, 80, 82
simulation, 14, 15, 79, 143, 156, 169,
 226n47, 227n64; digital. *See* virtual
 reality; of "liveness," 102; theory of, 3
solipsism, 15, 25, 31, 53, 102, 155
spectatorship, theory of, 3
spiritism, 28–29, 194n28, n31
Spitzer, Leo, 86, 208n5
Stelarc, 156
Sterne, Jonathan, 27, 74, 77–78, 194n26
Stiegler, Bernard, 232n16; *Echographies
 of Television*, 102, 103
Stimmung (attunement), 12, 52, 85, 86,
 88, 92, 135, 179, 208n6
Stockhausen, Karlheinz, 39, 146–47
Stockholm festival, 69–70
Storm Trooper University Bureau, 94

Strauss, Wolfgang, 2
Suzuki, Daisetz, 203n29
synesthesia, 4, 6, 109, 126, 202n28

tape recording, 3, 10, 54, 80, 138,
 206n73; Cage and, 64–65, 67,
 202n26, 203n33, 204n36; Derrida
 and, 12, 95–99, 104, 211n45;
 Hayles and, 155–57; Schaeffer on,
 57–58, 182
Tausk, Victor, 195n37
Telegarden (Internet "art installation"),
 149–51
telegraphy, 29, 43, 194n28, 195n35,
 196n40, n42, 227n62; "celestial,"
 34, 42–45, 180
telephony, 3, 16, 22, 28–32, 45, 48, 52,
 83, 93–95, 105, 138, 140, 146, 151,
 196n40, 212n49, 227n62; Cage
 and, 70–71; Derrida and, 100–102,
 212n51; embodiment and, 8–9, 19,
 104, 155–57; Heidegger and, 78–79;
 psychoanalysis and, 29–30, 50,
 195n35, n37; spiritism and, 28–29,
 194n28, n31
telepresence, 1, 3, 7, 45, 150, 162, 177
television, 1–3, 9, 101, 102, 142, 167, 168
Tesla, Nikola, 31
Titanic disaster, 48
Tomkins, Calvin, 214n6
trompe l'oeil, 166
Tudor, David, 70, 144–45, 184;
 Bandoneon!, 126, 187

Varèse, Edgar, 33–36, 39–44, 58, 79,
 146, 185, 186, 196n5, 197n19;
 L'astronome (The Astronomer),
 33–34, 39–40; *Espace*, 40, 43;
 Ionization, 126, 232n14; "An Open
 Letter to Youth," 39
Varèse, Louise, 39
Victor Frequency test tone records, 61
Videodrome (film), 156
Virilio, Paul, 154
virtual environments (VEs), 125, 128, 129
virtuality, 1, 4–7, 46, 128, 130, 141–43,
 153, 216n18; pretechnological, 108;

rhetoric of, 59; theorizations of,
 124–25
virtual reality (VR), 1, 9, 25, 83, 135,
 136, 145, 154, 158, 217n20,
 222n77, 223n6, 229n5, 232n16;
 Artaud's use of term, 38; Cage's par-
 allels with, 65; Davies's works in,
 107–12, 114, 116, 119, 121–24,
 129–30, 132, 214n1, 215n10,
 216n17, 218n29, 221n75; embodi-
 ment in, 3, 138, 141–42; frontal per-
 spective of, 13–14; posthumanism
 and, 154; Richards's works in,
 163–66, 229n13
vitalism, 58, 79, 98
voice, 7–8, 14, 15, 18–28, 78–80,
 88–104, 113, 129, 130, 189,
 193n21, 207n73, 215n13; Artaud
 and, 23, 33, 35–37, 45, 46; Barthes
 on, 18–19, 26, 192n2; Derrida on,
 24, 83, 95–103, 210n32, 212n45,
 n52; electronic, 8–9, 26, 30–32,
 46–49, 51–53, 104, 136–37,
 155–57; embodiment of, 3; Greek
 philosophers on, 20–24,
 193nn19–20; Heidegger on, 11,
 88–95, 104; inner, 25, 76, 209n18,
 213n53; Merleau-Ponty on,
 120–21; in psychoanalysis, 29–30,
 195n36
voice-boxing, 29

Watson, Thomas, 194n31
Wheelwright, Philip, 193n10
Whitman, Robert, 223n16
Williams, Alan, 74, 78
Woodward, Kathleen, 202n24
World Soundscape project, 72
World War I, 32
World War II, 175

Youngblood, Gene, 111, 145; "The Open
 Empire of the Cybernetic Age," 145

Zen Buddhism, 63, 203n29
Zeno, 193n11
Žižek, Slavoj, 142

Text:	10/13 Sabon
Display:	Sabon
Compositor:	International Typesetting and Composition
Indexer:	Ruth Elwell
Printer & binder:	Sheridan Books, Inc.